The Guerilla Guide to Performance Art

Related titles

The Guerilla Film Makers Handbook, 2nd edition
Chris Jones and Genevieve Jolliffe

The Guerilla Guide to the Music Business
Sarah Davies and Dave Laing

The Guerilla Guide to Performance Art

Leslie Hill
Helen Paris

continuum
LONDON • NEW YORK

Continuum
The Tower Building
11 York Road
London SE1 7NX

15 East 26th Street
New York, NY 10010

First published 2001
This edition published 2004

British Library Cataloguing-in-Publication Data
A catalogue record for this book is available from the British Library.

ISBN 0–8264–7398–9 (paperback)

Library of Congress Cataloging-in-Publication Data
Hill, Leslie, 1967–
 The Guerilla Guide to Performance Art / Leslie Hill and Helen Paris /
 p. cm.
 Includes bibliographical references and index
 ISBN 0–8264–7398–9
 1. Performance art–Management. 2. Performance art–Marketing. I. Paris, Helen,
 1968–II. Title.

NX600.P47 H55 2001
702′.8′1–dc21 2001028025

Layout and design by Leslie Hill and Helen Paris

Printed and bound in Great Britain by CPD Wales Ebbw Vale

for Lois and Lois

Acknowledgements

First and foremost our deepest thanks to all the incredible people who have contributed their personal expertise and passion so generously to this book. In a field that has no straightforward recipes for success or even financial survival, we like to think of this book as a well stocked bar of diverse experiences and insights where hard working guerillas can refresh themselves in good company. The strength of this book is in the tremendous range of wit, wisdom, strategies and sheer bloody mindedness of the contributing artists and administrators. Thank you all!!!

Special thanks to Manick Govinda and the staff of Artsadmin, London for their support of the project.

Special thanks also to Dean Helen Swain and the London College of Music and Media and the Institute for Studies in the Arts, Arizona State University for research support towards this project.

Tremendous thanks to Janet Joyce and Val Hall of Continuum for their enthusiasm for the project and all their support on helping these pages get to press.

Posthumous thanks to Lawrence Steger for the true guerilla inspiration of his life and performance work.

Grand Finale thanks to the multi–talented Ian Grant (iBoy) who not only helped us tremendously with formatting this book in Adobe InDesign, but also rewired the electrics in our kitchen! What a pal!

Contents
Introduction 1

Section 1: Artists in Profile 3

Section 2: Organizations in Profile 109

Section 3: Funding 177

Section 4: Production 209

Section 5: Documentation & Marketing 247

Section 6: Stay Out of Jail 265

Contacts 305

Contributors 318

Introduction

That's my mom on the cover. Last summer she was at a conference in New Zealand and every day a new email would arrive telling of fresh sights and adventures – flying over the Southern Alps to Milford Sound, moonlight sailing, Antarctic cruises … and then on the last day of their trip she wrote, 'We are on our way to the "Sky City" – the tallest structure in the South Pacific – where we will have a bite of lunch and may consider a bungee jump!' I thought she was just joking, but the next day's email proclaimed, 'We did it and we've got the photos to prove it!' And then a couple of days later the photo actually arrived. I was stunned. I couldn't stop thinking about this. It changed my life. I told everyone about it. I considered my childhood in a different light. I kept thinking about my mom jumping off the edge of that tower. What was it like? What was she thinking about? How did she work up to it? Why did she look so happy in the picture? During a phone conversation I kept returning to these questions – 'What happened right before you jumped?…How long did it take you to jump? … What were you thinking about before you jumped? What were you thinking about after you jumped?

My mother finally sighed and answered, 'For someone who makes performance and multimedia work it seems kind of ironic that you're the *only one who believed* this.' My jaw dropped. My mom had strapped on bungee boots and hung upside down in front of a blue screen and then been digitally edited into the Sky City photo. I had been the unwitting audience to a multimedia performance by my own mother.

Bloody hell.

Anyway, despite her recent dazzling bungee performance and her great skill at making digital home movies, this book is not really designed for the likes of my mother, even though she has graphically demonstrated that in this day and age we have more company than ever before in the world of performance and multimedia. This book isn't designed for multimedia performance artists like my mother simply because my mother doesn't try to MAKE A LIVING or a reputation as an artist.

This book is for anyone who is working or is planning to work professionally as an artist in the related fields that we have loosely described as Performance and Multimedia, particularly in the US and the UK. What we have tried our best to compile in the following pages is the book that we wish we'd had when we were starting our careers – not the stuff you learn in school, but the stuff you really need to know when you get out. We sincerely hope that this book will prove a valuable resource to fellow artists on both practical and creative levels. The more people who can juggle making good work with making a living at it, the stronger and richer the scene will be for everyone, artists and audience alike.

A couple of years ago the Arts Council of England put out a call for publication proposals that would 'raise the profile of Live Art' internationally. We thought that the best way to raise the profile of Live Art/Performance internationally would be to publish something that might help artists get their hands on more funding to make their work. So that's how the idea for this collection came up. There is no 'how to' in performance – the field isn't nearly mainstream or homogeneous enough for that (which is part of what we like about it, of course). There are no set steps or procedures, no well–trodden path, no industry around the art form as there is for film or music or dance. There is, however, a great wealth of individual and collective experience, history, wisdom and advice in the field. This book is devoted to making a space for this expert experience and advice as a collective resource for practitioners.

The Artists in Profile section of this book asks established artists questions that are about how they get their work produced, how they organize their companies, what strategies they use for funding, touring etc. The answers are as varied as the artists themselves. Likewise, Organizations in Profile features case studies of how certain guerilla–type organizations and festivals were founded and how they are run. In the Funding section, highly seasoned veterans who have judged applications for organizations such as the Arts Council of England and the Rockefeller Foundation give artists advice on how to put proposals together and avoid common pitfalls. The Production section deals with the nuts and bolts of theatre and video production with practical advice from professionals. The Documentation & Marketing section gives excellent professional advice on putting together publicity, press packs, mailing lists, demo tapes and archival materials as well as strategies for audience development. As the title implies, the final section is full of legal and accounting advice from experts who share tactics to Stay Out of Jail. The world of performance is a pretty fluid world, and as such is it impossible to produce telephone directories of people and places that aren't dated within months, but at the back of the book we have also included a web directory of useful sites.

This book is intended as a good solid resource for practitioners as well as an invaluable guide for students who are making the transition from student work to professional work. Along the way the book has developed another very interesting characteristic as an informal history of how performance work has been created and sustained over the past 30 years in different countries. And so, with most gracious thanks to all the contributors who have freely proffered their wisdom and experience and with all best wishes to the artists who will benefit from this collection, here's the book.

Leslie Hill and Helen Paris
London, May 2001
(the mom on the cover belongs to Leslie)

Artists in Profile

Bobby Baker

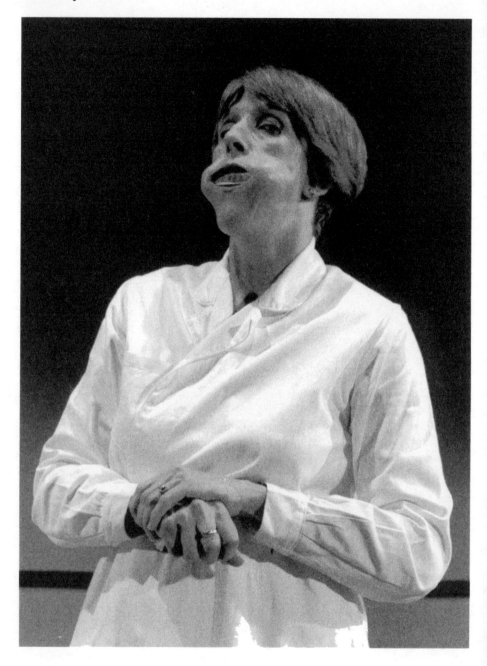

Q – How did you start out?

Bobby – I started as a painter and I got very frustrated with the sorts of painting I was doing and I started making edible sculpture and then got very frustrated about what to do with these sculptures and I met some performance artists who said – 'Hey, I'm a performance artist, why don't you be a performance artist too?' So I joined them and I used to take my edible sculptures along to performances.

Q – What sort of edible sculptures?

Bobby – Well – life sized babies made out of cake – or I used to make meringue women and I would dress up as a meringue so I just went along to a lot of performances and that is really how I got going.

Q – Has it ever been problematic finding the right spaces and/or audiences for your work – theatres, galleries, private kitchens, schools ...?

Bobby – It is problematic – yes. I tend to get an idea for a show and then decide on which is the right space, and then negotiate for that space. Very often the shows are now part of festivals, so the festivals will negotiate for the space. I like to keep a good range going, so at one point I will be performing in a theatre and the next show will be in a kitchen, and the next show will be in an art gallery – changing the tune all the time.

Q – You are supported by Artsadmin – how important has that been to your work?

Bobby – Essential. I wouldn't have been able to do the work I have done these last nine years without them. What happened was I was completely on my own, I was completely independent until ten years ago and I increasingly became aware that if I wanted to carry on and do the particular type of work I wanted I would need to be with an administrator or a particular type of organization so I set out to find that organization and was lucky to locate it in Artsadmin.

Q – How did you find them?

Bobby – Just looking around, hearing on the grapevine about them and then pursuing them! I wrote to them and kept on letting them know about my work until they actually came to see a show. At which point we did a kind of half deal where they represented me but they didn't take on all the running of my company. But the work has expanded since being with them because so much more has been possible.

They administer projects that I am working on and they run my company – they do the day–to–day running of that, they find me work, they act as friends, and confidantes, and psychotherapists. They are extraordinary and I feel exceptionally lucky to be in with them. We work very closely together.

Q – Do you prefer to work solo?

Bobby – No. I used to work on my own quite a bit of the time but I now collaborate with people on all the projects that I do – there is a team of people I work with. However, I have principally worked with Polona Baloh Brown over the past ten years. She is my codirector and collaborator. I work with her on most projects and my relationship with her is essential to the work. I find it adds a great deal of strength to the work to be able to work with other people.

Q – Did the transition between making the sculptures and making performance work seem like a natural one?

Bobby – I spent a great deal of time just standing and smiling at people. I wasn't really clear about what I was doing but that was what was so exciting and enjoyable about the process – that I was taking risks and doing things that were unformed. And that was the only way that I learned what I did want to do – by just going out there and getting on with it.

Q – Where do you make work?

Bobby – I work all the time – I am having ideas all the time wherever I might be. I have now, after 30 years of working as an artist, got my own studio for the first time but I used to work in the kitchen – a very big kitchen – and I would do my painting and drawing and work on ideas with Polona or work in her kitchen. But now I have a studio at the end of the garden – an off the peg studio plopped at the end of the garden. I could work anywhere.

Q– How important is it for an artist to have a space?

Bobby – It has become increasingly important to me but I have managed very well without it for many years. Just out of carrier bags and chaos. Now my work has expanded I need space more. But I would still rather not be too pinned down by it – hence moving around and working in different places.

Q – Is the process drastically different every time you go about making a new piece or are there patterns in the process?

Bobby – There are definite patterns. I get the beginnings of an idea – an overall framework

of a piece of work and I spend several years usually thinking about that – periodically having very intense space/places working on it and gradually as it expands I start to tell people about it and get very excited about it. Then things get put away for several months at a time and then I may come back to them and work on them some more until it gets to the point where I start applying for money. Then I usually fall out of love with an idea – it becomes very burdensome. As it gets closer and closer I more and more collaborate with other people – there is usually a period of years when I am working on an idea in the distance, so to speak.

Q – Does the funding application procedure – the budget, the marketing etc. dull the excitement? How do you maintain the excitement?

Bobby – I fall in and out of love with ideas. I am just going through the process of working on a show that is going to happen in the summer and I can't think about it – it is too close so I spend all my time working on the next two projects beyond that. It is a question of procrastination and avoiding. But as I get close and closer to doing a show the more excited I get.

Q – In the last few years there has been something of a hemorrhage of people from live art into mediated formats like web and video. How much has digital technology impacted your work?

Bobby – I have been quite involved with 'new' technologies. The influence of technology on my work is dictated by the nature of the idea and how much I have to resort to that. I go through phases where I would be enthusiastic or passionate about using different media and at other times all I want to do is stand on a table in the street and get an audience that way – so I fluctuate

Q – Does it feel harder to connect with audiences on the web or on video than in 'real' venues?

Bobby – What I like is not knowing what people think – sending ideas off into the ether is wonderful. When I am doing my shows I like to actually see what people's responses are, see their faces. I always have the houselights up so I can see their faces but it is lovely to do something for a change where I don't know and I'll probably never know – just to send ideas off out into the world is a wonderful change.

Q – What's the most useful thing you've learned in the last three years?

Bobby – How to enjoy myself. My big discovery is the Adult Pleasant Events List – a list of things that you keep adding to, things you like doing. That is my big discovery – you

can get a bit carried away, it can be extremely expensive …! You can completely transform your life if you are doing pleasant things all the time.

Q – You've toured your shows all over the world – any advice for artists putting together a tour for the first time?

Bobby – You have to be very organized. The thing that I find most important is to have some kind of telephone contact with the people at the venue so that it does not just all happen by paper or email – I discover things when I converse with people on the phone. The best thing of all is to actually go to visit the site. You can find out all these sort of subtle things about what kind of audience you are getting, sight lines – detail to do with the performance. My shows all have a set structure but I ad lib a great deal so the more I can find out about the venue and the sort of people who are going to be there in advance the better it is. So a great deal of work and research should go into that – the more time you spend, the better your show is likely to be.

Q – How much of your time do you think you spend on fundraising?

Bobby – About 20 percent, 15 to 20 percent – no, that is too much, maybe between 10 and 20 percent. I am constantly working on the next set of fundraising – not working on it practically but actually working on it mentally – preparing the application in my head. The actual time spent writing an application is quite small but the time that goes into planning that application can be extensive.

Q – Can fundraising be a creative or guerilla act?

Bobby – Oh yes, it can be a very exciting process – one has to be very creative about it about how you approach people and how you put your package together.

Q – Do you add quirky things?

Bobby – No, it all goes into the work. We do send images but I was on a panel once and in my experience there is very little time to look at images – most of it goes on what is on the paper. So I spend a lot of time with Artsadmin on the words. It is fun to be imaginative but I think the fun comes with the nature of the ideas and the way you communicate with them rather than doing zany things just for the sake of it.

Q – Did you ever think about getting a day job?

Bobby – I am freelance. I have always been self–employed. I do jobs sometimes as they come up but I spend most of my time on my work and I have never had a nine to five job

in my life – I have existed with little bits of teaching and different work but I find it hard to imagine existing in any other way – a sort of hand–to–mouth existence.

Q – Can you tell us a happy story about being an artist?

Bobby – Something that makes me very happy is when I get ideas to do things that make me laugh a lot. I was trying to convey the idea of obedience and I got the idea of putting a tin of anchovies into my mouth. The first idea was to put a tin or sardines in my mouth but I went to the supermarket – that is where I enjoy myself most usually, walking up and down the aisles of the supermarket – and so I was standing in the supermarket aisle trying the size of tins in my mouth. That made me very happy. So doing things like that – being in public spaces and thinking about very different things to the sort of things that people are generally experiencing is one of my high spots in my life.

Q – Can you tell us a sad story about being an artist? A sad story or a scary story?

Bobby – Feeling very isolated and different to people which sometimes feels wonderful and sometimes feels very lonely.

Q – Where do you shop?

Bobby – Waitrose at the moment. I am in my upmarket phase so I go to a supermarket I can't afford. It is my luxury at the moment, it's terrible. I am addicted to it. I pretend I am somebody else while I am there. I like to go to shops and pretend I am other people. I don't go clothes shopping. I buy all my clothes by mail order. But if I had really met you where I wanted to meet you I would have met you in John Lewis.

Q – Is there a special staple ingredient no artist should be without?

Bobby – Courage.

Q – Are you a member of any terrorist organizations?

Bobby – No.

Q – Do you have three top tips for the emerging artist?

Bobby – Trust your intuition more than you ever thought possible.
Get in touch with the business part of you.
Do things that make you laugh.

Johannes Birringer

Q – In your experience is there a 'horse and carriage' dynamic between art and academia, or does it feel more like a tug of war?

Johannes – I don't know much about horses although I grew up in the countryside. My first mistake was to think that I could study theatre in a German university. What I was able to learn from the university was a way of doing research on literature about theatre/dance and art, on criticism and theory, of investigating methods of thinking, approaches to writing on performance, and to making transitions.

After I finished my PhD I knew that I wanted to make theatre and be involved in creative production. I think I directed my first performance experiment in 1984 to 85, the same year in which I had a residency with Pina Bausch which changed my life. After that, I found myself learning new ways of thinking through moving, and there is always a time of reflection on one's experience in rehearsal, or in composition. That time I used for writing, but my heart was in the physical process of creation.

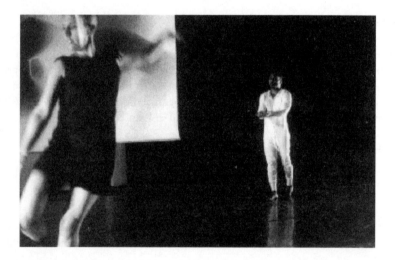

Universities occasionally invited me to teach theatre or dance or media, but I saw these visits to the universities as experiments in production (can one create in a highly structured, often highly administered and segregated/polarized academic/intellectual environment?). I had some positive, short–lived experiences in schools that wanted to 'invest' in experimentation or in new forms such as performance art or 'interdisciplinary' studies, but also ended up, quite often, feeling alienated or isolated, and my most creative work has always happened

when I was out there, working as an independent choreographer or video artist, learning new approaches to collaborative processes, and making work with artists and cultural workers in different locations, different countries.

I am being quite personal here, perhaps for the only reason that I don't want to theorize or generalize about academic limitations or pretensions. They are not that interesting to me any more, I frankly don't think one can create art in universities. There are too many boundaries one has to cross, constantly. And so one is always leaving. That is my experience, and I am not troubled by it any more.

Universities need artists and will continue, on occasion, to invite them to their departments, studios or conferences. I currently conduct a laboratory in dance and technology at a dance department, and I am in a creative and supportive environment. But I am not an academic, and don't wish to have any horses or carriages. If I could not create new ideas, and rehearse them, if I could not open up spaces for experiments and take risks, I would have to leave. In my writings, which get published despite the fact that I am unaffiliated, I can always say what I think, and I seldom have to rely now on any decorum, or theoretical imperative that is in fashion.

Universities, in that sense, are like the fashion industry, and they sometimes have the same vanities. The latter are of little use when you work as an independent artist, supporting yourself with odd jobs and a few public grants and commissions. Most of my commissions over the past years have been community–based performance and media projects. Associations with communities are balancing acts, too, and I think to discuss the tightropes of an alternative or active culture, where artists have to reinvent processes of production/collaboration, networking, and marketing of noncompliant ideas, negotiate their positions vis à vis local communities and a vast sea of commercial entertainment industries, might be rather more interesting than wondering whether one can keep a balance with institutions. Which balance?

Q – But aren't you working at a university now? At Ohio State?

Johannes – Yes, after several years of working independently with our ensemble in Houston and on touring, I was invited to join the dance department at OSU to help build a new program in dance and technology. I had struggled to build a digital dance/art studio in an old warehouse in Houston, and we were able to create some really interesting work, I believe, using the unusual, vast concrete architecture of the warehouse, and using the setting also to offer media arts workshops to the community and to middle and high school students in what the city arts council refers to as 'underserved neighborhoods.' I was broke at the time, and so I chose to move to OSU Dance to see whether I could create a radical program in long–term process experimentation, and whether good facilities and dedicated

art students can allow for a mix of challenging experiments – finding out why and how we use media, how we understand interactive and sensitive environments, and how we imagine the arts and sciences utilizing the so–called motion capture data.

I consider this an exciting experiment in shaping a new island of independent creativity within an institution (after all, the program I designed conflicts with the entire 'required course' structure since it is built on a freedom of long durational independent study), an island on which we explore new techniques that we can then disseminate, share, exchange with others as we go back to our communities along the rivers that flow across the countries.

I don't see the 'Environments Laboratory' we have created at OSU as an academic program at all. We designed it as a module for interactive performance, and as such it is a social laboratory, since I understand interactivity more in an ecological, not a technological, sense. It falls outside of the pattern. It must.

Q – What pattern?

Johannes – To discern larger patterns, it would be necessary to ask, for example, whether new technology–oriented arts programs in universities, or digital art shows in the galleries or at SIGGRAPH, are subject to pressures that we see in liberal arts and science parks that are no longer interested in the art process, the humanities, or critical theory but invested in 'sponsored research and development' (applied science), in efficient, profitable applications of new knowledge ('technology transfer').

A tiny example from an experience I had in Germany last summer. While working at the Hellerau performance workshop on 'computer/body/brain interfaces,' I found out that the city of Dresden is cutting (the budget for culture, the arts, youth culture and sports) and shifting its funding to the economic and infrastructural development of the new 'Biopolis' in Dresden (i.e. the construction of a major biotechnology science park, with the relocation of the Max–Planck Institute to the area, where the life sciences will cohabit with the already booming information and electronics industries in the city).

It would interest me to know who, amongst us, is invited to be a consultant for interactive media/communications, for biotechnologies research, for movement therapy technologies in the medical sector; who has considered to become a start–up company in biofeedback engineering/robotics, with application programs for athletes, adventure tourists or entertainers, or stress management, etc?

Secondly, I would encourage us to address the question of the future role of performance technology in view of cuts in arts and humanities funding, and of university investments

in distance learning or in concentrating technology development for the hard sciences. It would interest me a lot to learn how you, if you have been invited to develop software or work with motion capture or telematic technologies, devise artistic, practical research in dance technologies, in the context of technology transfers to the life sciences as indicated above cf. Innovation Works, Inc., in Pittsburgh, or BioSTAR at University of California).

Q – How do private industry interests connect to public art?

Johannes – One may assume that universities or foundations that support communications technology may not be interested in artistic process. There is a possibility that the new motion capture studio at OSU will only be accessible to the new 'Research Partners' program (science/engineering) and their sponsored research (for commercial applications, connection to the movie industry, advertising, industrial design, new licenses, etc). The program was set in motion while I was doing workshops in Europe over the summer. So I came back and formed an independent focus group, to investigate other pathways and portals. How do independent artists produce knowledge and resist institutionalized tele–communications or the demands of 'globalization' understood as corporate take–overs and alignments of 'artistic freedom of research'?

Q – Do you think community–based art projects are ultimately less compromised for artists than university–industry sector research opportunities?

Johannes – Of course they are, since the communities, under–served, at the low end of the consumer spectrum or windows of opportunity, will always have less money so will be more creative (under less pressure to succeed or improve stock market values), and I am glad to say that community artists and the alternative network constitute an enormous, wide field of resources of human energy, hopes, and canny inventiveness, and this networking reaches into the schools, and the cultural centers of activity around the world. I believe it is not so much a question of location or position, but it comes down to a question of how we politically see our networks as creative laboratories: public art, community art, teaching, and making connections to people – these actions matter, and they have an influence on how we understand and enact culture, and thus share our visions or our images, or our way of making music and dance, or our way of articulating dissent, with others who may be doctors or scientists or biotechnologists or political agents.

As I write this, the coal miners in Serbia are on massive strike and the students have occupied the state television and radio center. No electricity, no radio.

Q – Is the process drastically different every time you make a new piece or are there patterns to the way you approach a new piece regardless of whether it is a high tech or low tech?

Johannes – We always work with a mixture of low and high tech, and over the past year of working in our 'Environments' Lab, we basically spent a lot of time learning a new integrated process, starting with spatial studies and drawing, diagraming environments, and then building them, engaging a plastic arts process that was very sculptural, allowing us to see movement in conjunction with materials, sound, sculptural and kinetic objects that could become surfaces or volumes for video projection and light, become more tactile in other words, and also allow us to be in a continuous process of changing the space and the way perception works, once you no longer have a separation of stage and auditorium. In our hall, there is no stage, and when we exhibit the new work, our audiences walk into the spatial interfaces (movement–performance, sculptures, video projections,

sound) and become part of the event and its transformations. We are currently working on an installation called 'ghost island,' and it is changing all the time, and we are learning a pattern of composition, editing, live mixing and re–mixing that will help us conceptually when we start another cycle of the Environments. Depending on the members of the ensemble, and the focus of the experimentation, the process of composition might change again. Once we start working with motion capture, a technology we don't know yet, or with telematics and videoconferencing, we may ask new questions, for example about our relations to real and virtual space, or our recompositioning of captured movement data. Again, we most likely will mix low tech media that we know with the new possibilities of digital transformation we don't know, and in that sense we also act as 'MIDI–performers,' in the way I heard Steina Vasulka use the term. At a recent gathering of media artists at the Choreographic Center in Essen (Germany), Vasulka argued that conceptually the aesthetics of digital art is involved with MIDI performance, exploring the pure potential of (unexpected) connections that can be made between instruments and media, as well as directing critical or subversive attention to our unstable relationships to sound and image environments that seem to have a life of their own. Our approach is similar, since we are learning new 'techniques' of creating performance, and the results cannot be known.

Q – Does it feel harder to connect with audiences on the web than in actual geographical venues?

Johannes – I am not sure I know how to 'connect' with audiences on the web. Web browser users, who may stumble onto our website or log on to a live webcast, are unknown to us and we cannot feel the connection, as long as they won't be able to influence the 'work' as it is being created. At this point, our website, which is modified every week after rehearsals,

functions as a monitoring site, disseminating information, providing perhaps a reference point to a larger networked community, but once again, it is difficult for me to think of the web users as a community, since such an environment is largely virtual and unstable. Once we know more about how to link remote sites in actual creation processes, live mixes, then perhaps we can figure out how the audiences can be linked also through the Net, and how such communications work and affect people who are not in one place. I think that at this point, our environments can affect audiences who experience the environment physically, with all their senses, noticing that there is not one stable or determined angle from which to witness a performance installation. As you move through the field, your perceptions of field will change. I don't think you can reproduce such experience via the Net, since as a web user you sit in front of the screen and interact with the mouse, as you would when you explore a CD–ROM. This may change when the interface becomes unwired and, for example, your movement in a room, say, a club or a networked performance space, influences and changes what you experience.

Q – How much of your time do you think you spend on fundraising?

Johannes – I have to write grants because we need to upgrade our old hall and make it ready for networked performance, and add some equipment here and there, run some new softwares and add some flexible lighting instruments. I have to write grants when I want to get travel support to take our group to places elsewhere. I don't enjoy the fundraising, but it has always been part of the organizational life of my independent work, trying to create opportunities for the company, get the work we create out there.

Q – Can fundraising be a creative or guerilla act?

Johannes – All independent art is disseminated in creative ways, using alternative channels and venues, and often one has to invent (conceptually) scenarios that are fictional or unconventional and daring, say, if you want to get permission and funding from a city to perform a site–specific work in a public space. I am not sure whether I would call it a guerilla strategy, but sometimes the fictions are elaborate and obscure, at other times you may use a 'public service' language to raise funding for an event that the city will find politically worthy or exciting to support. In 1998, I raised support for a cycle of performances called 'Parachute' in abandoned or unused buildings near downtown Houston, and I claimed that bringing art and audiences to these buildings would help the city's 'downtown revitalization' efforts, which of course was true, except that we used the performances to draw

attention to some of the problems connected to 'refuse' or 'abandonment,' all the while claiming, in our publicity, that independent art is the new 'parachuting' – it drops into vacant lots and buildings because it has no home in corporate America.

Q – What's the most useful thing you've learned in the last three years?

Johannes – How to survive continuing to do the kind of work I believe in. Alternative art teaches you a lot of stamina and resourcefulness, and of course the good thing is that there is an international network, and one finds like–minded people in many parts of the world. I met with young Chinese theatre artists who were struggling with problems of how to create independent performance venues against state censorship, which reminded me of ACT UP demonstrations in the early 90s in Chicago or New York, demonstrations which dealt with public silence, media disinformation and institutional repression. I worked in Slovenia in the mid–90s and noticed how the independent dance scene was struggling to find a voice and a public, at the very time when government support for the arts was undergoing major changes in the wake of the new venture capitalism instructing people to make work that is profitable. Public money, in those times, tends to get reserved for the bastions of cultural or national identification, opera, symphony, ballet, and not for experimental art. It might be interesting to investigate the links that media artists perhaps tried to make with industry or private sponsors, and then to ask ourselves whether our work with new technologies is indeed an unwitting form of 'compensation design.' We don't have access to commercial television to reach a broader audience, and the dream of community access television is dead. What I am trying to learn to understand right now is whether designing performance for video, CD–ROM or the Internet is a valid compensation for the lack of space we have, whether it links to the club scene and the youth cultures and their interest in techno music and new media, or whether performance must always have a distinct site and social context in order to be effective. Dance, I suspect, can travel across the world and connect to local practitioners and audiences, because it moves people to dance and to recognize movement potentials inherent in human bodies, it mobilizes participation. We will need to find out whether media and the Internet can mobilize participation in a similar way.

Q – Any advice for new artists? What about artists with PhDs?

Johannes – Every generation of young artists will go through the process of experimentation, adopting ready–made techniques that are taught in the academies or manipulating them, expanding and converting them to discover possibilities of expression that are not taught or considered legitimate. If I look at young artists or performers pursuing an independent course, even if it means to reinvent conceptual strategies or certain modes of objectification to which the body can be subjected, I am not too worried. Many of them are pursuing a necessary process of discovery, which today often means experimenting with a huge

combinatory of cultural media, after so many years of the Duchampian 'ready–made,' or the Rauschenbergian or Warholian 'combine' and media image collage, including the sampling capabilities of the VCR, computer, and synthesizer. I'd welcome the surprises we might see in the composition of new narratives, unexpected combinations of material and virtual cultures.

Artists with PhDs will do the same, probably adding textures derived from theory, writing, literature, film, scientific thought; perhaps some the work coming out of the academic realms will draw on possible interdisciplinary convergences, inflected by the recent critical emphasis on gender studies and postcolonial studies. I have seen some performances that resembled laboratory tests (Critical Art Ensemble's work on biological reproduction, Laura Kipnis's work in video, Terri Kapsalis's work on gynecology, Susan Kozel's work with motion capture, Blast Theory's collaboration with the Mixed Realities Lab in Nottingham, Mike Pearson's collaboration with the Theoretical Archaeology Group at Universities of Swansea and Durham, Avanthi Meduri's critical revision of bharathanatyam, etc.), and some of it was inspiring, some of it caught in the loop of academic 'camp,' and the current generation of doctors of performance studies probably could use some empirical reality checking in front of audiences not versed in the complex theoretical idioms of Gilles Deleuze, Judith Butler and Donna Haraway. The curatorial praxis in museums has become more conceptually and theoretically conscious in recent years, and I can see some very valuable contributions to the debates on museum 'objects' coming from performance studies.

Q – Where to next for Johannes Birringer?

Johannes – It will depend on how my collaborations with other artists drive our investigations and installations. In December 2000, I joined a group of other choreographers and media artists in the creation of an 'association' of five dance programs in the US, with affiliates in Europe and Latin America, dedicated to the exploration of dance and performance telematics, which basically means we will link our dance studios and see what happens when we start rehearsing together across distances. I am sure we will bring different questions and diverse approaches to performance to the videoconference space, and we will soon discover whether we are able to negotiate, create, and find meaning in such an arena of 'distributed choreography.' What interests me and some of my friends is the question whether the 'virtual' changes our understanding of self–consciousness, and how an expanding consciousness affects our sense of being in the one body.

Laurie Beth Clarke

Q – Can you describe *The Everyday Life of Objects* **installation piece you recently made for an actual gallery space and how it has evolved into a parallel web piece?**

Laurie Beth – *The Everyday Life of Objects* is a project about the persistence of material culture in the electronic age. It consists of two installations, one physical and one virtual, that explore quotidian practices of accumulation, both functional and sentimental. My goal in this work is to contribute to the critical discourse that privileges the consumer over the connoisseur in defining the terms of contemporary visual culture. The pair of sites are meant to foreground timely questions about information technologies and embodied meaning.

The physical installation, realized in 1997, was a 1500 square foot irregularly gridded floor–to–ceiling maze that resembled urban architecture; it was dense vertically as well as horizontally, with an aesthetic sensibility somewhere between a thrift store and a museum. The audio component of the installation was gathered through a series of interviews with people who have and keep things – about what we acquire and why. The environment offered spectators an opportunity to move through a matrix of familiar objects and to reflect on the possessions in their own lives.

In hopes of directly addressing the persistence of material culture in the electronic age, sometime in 1998 I made a commitment to develop an interactive, virtual environment based on *The Everyday Life of Objects*. For the past two years, I have been working with

a number of assistants to construct an analogous interactive website. When complete, the work will be as full of objects as the physical installation; viewers will be able to activate each object to launch an associate sound file. Just as it was possible in the installation to go to a place and touch a 'physical' object, so in the website, it is possible to navigate 'three–dimensionally' to a 'place' and 'touch' a virtual 'object.' Doing so triggers a testimony to the acquisitive spirit or the 'life history' of an object, although not necessarily of that particular object.

Q – What was this process of transformation like?

Laurie Beth – For the first two years, we did nothing but look at and reject software for site development. My priorities were to be able to construct an environment for self–propelled, avatar–free navigation. Once the program was selected, we depended on someone who was very familiar with it to set up the structure and to teach several generations of my assistants to work within it. Now, as much as ten hours a week is spent gathering, cleaning up, and installing objects into the maze.

I went into this project thinking that the objects on the website would come from digitized photographs of actual objects, first our own, and subsequently those contributed by spectators. I soon realized that the web is already an environment particularly conducive to the acquisition of things, both new and used. Now, we do our image gathering on the web, so that every object in the virtual site has already had a virtual life.

I have been using mazes for a long time in my work, and the physical site of *The Everyday Life of Objects* was already structured as a maze well before I decided to convert it to a virtual environment. In the past, I have done this largely to disorientate spectators and thus reset the terms of their relationship to the environment, but also quite simply to increase the exhibition's surface, to make a short distance longer. Now, I must reconsider my use of the labyrinth in the virtual domain, given that is the dominant structural metaphor in video games, and even more importantly, I must come to terms with the ideological limits on my project that come from the historical baggage embedded in the perspectival system on which 3–D animation programs rely in order to make 'realistic' spaces.

In the physical installation of *The Everyday Life of Objects*, the different sound tracks emanated from speakers in six different locations; the effect was much like being in a crowd or at a cocktail party, where bits of conversation come into or go out of focus depending on proximity. The soundbites did not necessarily refer to any particular object in the installation. It was tempting, given the one–to–one physical structure of the virtual site, where clicking an object will be rewarded with the release of a sound, to tie the audio more literally to the object. But I have not paired any object with its own description, in hopes that this disjuncture will create more of a discursive field of objecthood.

19

Q – Have you made a lot of work for computer environments before?

Laurie Beth – I have not ever made work for/in the computer environment before. In fact, I was and remain quite skeptical about such work. I find both euphoric and distopic discourses on technology to be disingenuous. Electronic art is neither a panacea nor a demon. Rather, as Anne Balsamo and others have suggested, it is a technology that perpetuates and sometimes effectively highlights the possibilities and limitations of the cultures from which it has emerged and within which it is deployed.

I am also skeptical about certain technological issues. First, although electronic imaging techniques are used by the film industry to construct non–existent spaces (e.g. *Star Wars*), conventional film techniques are used to visualize virtual reality (e.g. *existenZ*). In other words, while we can imagine far more interesting VR than is technically possible to create at this point, our imaginations are also circumscribed by a dominant filmic vocabulary. Moreover, the technologies that set the standard for our expectations of virtual reality are developed by and for military and industry applications and are not readily available to consumers or artists. Those actually available look and feel clunky; they are not at all the fluid and seamless virtuality we have been led to desire by cyberdiscourse. But, finally, even if we convince ourselves of the political efficacy of 'clunkiness' (call it Brechtian), even these more rudimentary programs are not all that likely to download or function effectively on the average home computer.

Q – Is the process drastically different every time you make a new piece or are there patterns to the way you approach a new piece regardless of whether it is a

high tech or low tech?

Laurie Beth – What is consistent for me is that the work is on such a large scale that I am dependent on the labor and technical skills of many others in order to realize this project. In the case of *The Everyday Life of Objects*, Adelle Roberts, Michael Velliquette, Thomas Bleigh, and Andy Gardner have made the electronic version possible, while Stan Shellabarger coordinated the construction of the physical installation with a large team of assistants.

What is different for me is that I am much more alienated from electronic technologies. Even if I don't personally have the technical skills to build a maze myself, I do understand, basically, what a power saw or an electric drill does. On the other hand, not only do I not know how to work with the software, Maya, used to construct the virtual site, but I also do not understand, fundamentally, how electronic media actually function.

Q – Does it feel harder to connect with audiences on the web than in actual geographical venues?

Laurie Beth – Yes and no. It's certainly far easier for artists to put their work on the web than it is to gain access to museum and gallery spaces and certainly the statistics for people 'hitting' websites are vastly larger than the numbers that visit museums or galleries. But, as

21

I mentioned above, most home machines can't handle the memory requirements of most interactive art, so many of the counted hits may actually only be seeing error messages on their screen, or unnavigable stills.

There are also issues of corporeality and sociality. Physical installations engage audience members kinesthetically, while electronic work favors cerebral, ocular, and auditory stimulation. Moreover, because the space of the gallery is often shared with other spectators, both friends and strangers, audience members may be inspired to change their mode of participation based on others' behavior. And in the gallery, audience members may even talk to one another about the work. While this is possible on the web as well, and maybe even easier, it is not used all that often yet.

In the end, I would say that one connects with audiences differently on the web than in actual geographic venues, which is part of why I'm interested in making work concurrently for both types of environments.

Q – How much of your time do you think you spend on fundraising?

Laurie Beth – It has really varied over the course of my career and then, of course, it depends what you count as fundraising.

When I was first out of school, there seemed to be all sorts of money available to artists. Every year was structured around my calendar of proposal submission deadlines, and while none of these awards were very large, they did seem readily available to a motivated artist with good verbal skills. Since the demise of the National Endowment for the Arts, in the United States, most local and regional sources of funding have shut down, and those that remain have thoroughly revised their missions to exclude individual artists from the application process. These days, I spend much less time writing proposals, I pay for more of my own work, and I am tremendously grateful for the support of the University of Wisconsin, where, as a faculty member, I am eligible to compete for research support.

Years before I ever start work on a piece, I begin to propose it in a variety of settings. Each time I revise and submit a project description, not only for funders but also for exhibition venues, conference panels, etc., I am working to generate a groundswell of interest in a project. So, for example, the brief project descriptions offered below in response to your 'what's next' question are, in some ways, a part of the fundraising process for the next work. Then, there is a great deal of time spent writing proposals to actual funding agencies that may or may not succeed. Yet, each rearticulation also helps move the project forward, so that whether or not a grant is forthcoming, creative work has nonetheless been done.

Q – Can fundraising be a creative or guerilla act?

Laurie Beth – Absolutely! Often it means a subversive engagement with institutions, agencies, and bureaucracies, learning to use their vocabulary to leverage money for projects that would not otherwise be supported. For example, *The Everyday Life of Objects* was not built in an art space but in a warehouse. Galleries and museums do not generally allow much more than two weeks between exhibitions and it took over two years to construct *The Everyday Life of Objects*. Simply to make work using this 'outsider artists' paradigm for a construction schedule is itself subversive. But in this case, I was able to convince a funding board to subsidize the production of art work through drastic rent reductions on commercial space actually intended for small business development.

This is not all that different from a practice common to young media artists who use the technologies in the work place during non–working hours to create art. Bordieu/deCerteau talks about *la perruque*, the practice whereby workers make use of the workplace in creative ways that do not harm but do not necessarily benefit the employer. I would consider this an example of creative or guerilla fundraising.

Q – What's the most useful thing you've learned in the last three years?

Laurie Beth – Great question. Probably the single greatest lesson for me has been the correspondence between administration and art making. For the last three years, I've been chair of a large university art department. I have come to understand that this work *is* the large–scale site–specific art work I've been directing. In other words, being a chair uses up the energy I have had in the past for bringing large groups of people together to create projects collaboratively. This was a very important realization for me because it meant that if I want to produce work with the creative energy I have left over at the end of an administrative day, it's going to have to be something very different than I have been doing, something that allows for being much more solitary and contemplative.

I've also learned some things about the conceptual basis of my work, such as the historical correlation between the emergence of domestic material acquisition and perspectival pictorial systems. But explaining that fully requires another essay.

Q – Any top tips for fellow artists?

Laurie Beth – I would encourage us all to think about models for 'sustainable activism.' It's tempting, especially in the service of compelling, urgent, and just causes, to set one's mental and physical health limits aside and to work to the point of exhaustion. For our generation, this has resulted in many young idealists, at middle age, turning in disappointment and bitterness to mainstream jobs and practices. We need to look to older radicals to learn what it takes to sustain a 'guerilla' perspective throughout our lives.

Q – Where to next for Laurie Beth Clark?

Laurie Beth – It will take at least the rest of this year to finish up *The Everyday Life of Objects* and another one that I've been dragging my feet on called *Yarhzeit*, a video tape about the performance of truth. Next year, I'll be starting work on several new projects. I'm thinking an installation that pairs the sensory density of the market environments of developing nations with the sanitized excess of European and North American supermarkets and department stores. There's a video tape I'd like to make that places the relationship of my mother and the women who care for her in context of a long history of interactions between Jewish middle class women with African–American domestic workers. Finally, I'd like to write a book about the complex power dynamics between artists and academics, both historically and within the present day university context.

Toni Dove

Q – I've heard you say that you work in a field that doesn't exist yet, i.e. interactive film. Can you say a bit about the evolution of your career and how you arrived at making this type of work?

Toni – I started out as a painter – I did a lot of work with mixed media. Painting and working within the gallery world gradually started to feel like a shirt that was several sizes too small – as if the things I was most interested in were all things that broke the rules or were frowned on. I felt I was bumping into the walls all the time – the rules. Narrative was becoming more and more important to me and mixing moving images and text with sound. At first I did installations that used multiple computer programed slide projectors on three dimensional scrims accompanied by soundtracks. It was a way of being able to make movies on my own and to take the movie off the wall and bring it into the room. To make it immersive. I did a virtual reality installation – a murder mystery that was a forensic tour through the body and the city – at the Banff Centre for the Arts. After that I started working with interactivity as well as immersion. I've pretty much picked up the technology as I've gone along – I have no formal technical training with computers. Working this way lets me use all my facets – all the things that interest me – and I can make up my own rules.

Q – Can you describe your interactive film *Artificial Changelings?*

Toni – *Artificial Changelings*, an immersive, responsive, narrative installation, is the story of Arathusa, a kleptomaniac living in nineteenth century Paris during the rise of the department store. She is dreaming about Zilith, an encryption hacker in the future with a mission. Zilith is an 'informal' urban planner redesigning the virtual highways of information data. The character of Arathusa was developed using a conceptual armature based on the pathologies produced by the social changes that occurred during the industrial revolution. This subjective fictional armature – the character and her experience – becomes a glass through which to view the current changes of the technological revolution that are embodied in Zilith – a fractured character with multiple identities and almost no interior life. Urbanization, merchandising, the mechanization of travel and industry, and the birth of film are viewed against the evolutions of information technology as part of the conversation between viewer and characters. These references form an unstable ground against which the physical experience of a virtual conversation with two characters in different centuries unfolds. *Artificial Changelings* is more like a conversation with a schizophrenic video android with a history than it is like a traditional, plot–driven film. Things float to the surface and form an accretion.

A large curved rear projection screen with its curve bowing towards the audience hangs in a dark room like a large lantern. The choice of the curved screen was designed to pull the experience a step further away from film and to make the screen into a presence, an entity. In front of the screen on the floor are three flat black rubber floor pads approximately 3 ft. by 2 1/2 ft' each, in a line moving away from the screen. Embedded in the front end of each pad is an electroluminescent label that lights when a viewer steps on the pad. A fourth smaller pad is behind the three. The pad closest to the screen is labeled Close–up, next is Direct Address, then Trance/Dream and finally the smaller pad, Time Tunnel. Over

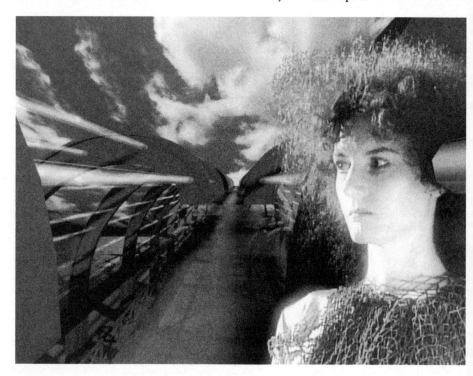

the pads are two hanging lights and a small surveillance camera.

The viewer steps into a pool of light in front of the screen and enters the interactive zones. When close to the screen you are inside a character's head; back off and the character addresses you directly; back off again and you are in a dream state; and back off again to enter a time tunnel that emerges in the other century. Within the zones, movement causes changes in the behaviour of video and sound. There are body, speech and memory segments – each with different behaviors. The characters become like marionettes with unpredictable reactions based on the movement of the viewer in front of the screen. Body movement will dissolve images, shuttle forward and reverse on the time line, trigger frame loops, and

change speed and color, as well as dissolve between segments and create superimpositions. Movement close to the screen will produce intimate revelations, close–up images and whispered sounds. Movement away from the screen will create memories clouded by layers of time, transparent images, and washes of sound. The sound environment and emotional tone of the piece are altered as well by the nature of a viewers' movements within each zone. Different viewer responses will produce different aspects of content and affect.

Q – How much time was involved in the making of *Artificial Changelings* from the concept and writing through post production and installation of the piece?

Toni – It took about four years from writing and designing until it debuted. I tweaked it for about a year after that so maybe I should really say it took five years.

Q – How much of your time would you estimate you spend on fundraising and does this drag down your creative work?

Toni – I spend more and more time on fundraising. Usually the first year is grantwriting, scriptwriting and interface and interactive structure design. I have a development officer who works for me part time now, but as the projects get larger it takes more and more time. I view it as a job I have to enable my work – a necessary evil. Sometimes the process is interesting – it can help to clarify concepts and to understand how people will view the work, to see whether it will communicate the way you hope. So there are times when it can actually move things forward conceptually. Often I just wish I could be doing something else. It's one of the things that makes me cautious about letting projects get too large – it can become more about administrating than content and hands–on involvement.

Q – You've said that working with a computer programer to construct an interactive interface in symphony with the narrative of a film is like building the piano every time you write a song. Is this interesting or productive for you as a filmmaker or it is it more of a ... pain in the ass?

Toni – I like the collaborative process of working with other people on my work. It's a process of opening up parts of my work for other people to occupy – finding people I trust and getting out of their way. There are times when working with a programer can be like eating with a fourteen foot fork and I wish that I had more sophisticated skills myself in this area so that I could experiment on my own with things, especially in the early stages of development of a piece. But I have chosen to focus on certain territories – writing, directing, video post–production and the designing of interface and interactive structures. I can't do everything effectively – it's too much in a large production – so the problems become more about economics than my own skills. Finding the people I'd like to work with and being able to work with them as much as I'd like. I'm basically working

on a 'piano' – an authoring system for interactive narrative – that is something I'm building on with each project. It grows and changes, but I'm not starting from scratch any more. It's one very big project that tells different stories along the way as it develops.

Q – Is the process drastically different every time you make a new piece or are there patterns to the way you approach a new piece regardless of whether it is a high tech or low tech?

Toni – There are patterns definitely – and also elements that are completely new. I used to think I would create an authoring system and then write and direct for it, but it's more like a conversation between the content and the structures that deliver it and I'm interested and engaged in the ways that those develop along with the stories. I always start out with research and reading no matter what kind of project it is – it gives me time to think and dream through the subtext.

Q – Can fundraising be a creative or guerilla act?

Toni –I think that funding work is part of the way that you connect or communicate with your audience – the way that you manifest in the world – and so it has real ramifications in the work. It can influence whether you want to work on a large scale or smaller, faster, in a more nomadic fashion. It determines where you want to place the work and who you want to talk to. When you are working outside of determined arenas of production and reception (and thus funding) you have to essentially invent or assemble your own frame. This is a creative process – it's really part of the work.

Q – You've been working very successfully for years – is it getting easier to make a living?

Toni – Yes and no. When you first start out no–one knows you and you have to convince people you can pull off projects. Once you have a track record it becomes easier to attract support. I find I tend to move across categories as the work develops and so I frequently find I have a whole new group to convince – it's not quite like starting over, but it's definitely work and time. And projects get bigger which changes the landscape and adds a different kind of stress. It is easier at this point to get teaching jobs or work that supports life and lunch.

Q – You're based in New York – why is that important for you?

Toni – When I first moved here it was important for me to be in a context where I could build something new for myself – in a context where there was access to a wide range of possible resources. In a sense anything goes here and you can find a resource for anything. And I wanted a place that had that sense of permission so I didn't feel as if I were climbing a glass hill if I did something off the program. I knew I wanted to get off the road with a machete, so to speak. New York is such a center – everything passes through here even if it's just on it's way somewhere else, so its easy to keep in touch with people and ideas and to make professional links. I was looking at a wide range of eclectic and esoteric things that would have been difficult to assemble easily in a smaller place. Now I have a whole support system here that would be difficult to replace.

Q – Do you have an agent or an administrator?

Toni – I have a development officer and a fiscal agent for fundraising. I'm now thinking about an agent for the large–scale event pieces and a distributor for smaller DVD projects. A new set of looming headaches.

Q – What's the most useful thing you've learned in the last three years?

Toni – I've learned so much it's hard to isolate one thing. I guess for me it's almost been the process of imagining and implementing what I would have to call a business plan. That it was necessary and that I could do it. It wasn't what I thought being an artist would be about, but it turns out that being responsible for that aspect of your work gives you a certain independence. It allows you to determine your own fate to some degree, and it includes a whole process of thinking through your practice in the world that really is a part of the work for me – a philosophical and critical position. Assuming that was a practical question.

Q – How do you avoid breaching copyright law without adding a hefty bill to the production costs?

Toni – Create original material and/or find archival material in the public domain. That's the first solution, and there are amazing archives available with public domain material available. Second – think about the nature of presentation, will it be a product, will it make money. If it's in the art performance arena, with a relatively small audience and not much profit possibility, then use the material and don't ask for permission. I think it's important to know the laws that apply to the use you are making of material – and the risks you are taking so you take them without results that could be an unpleasant surprise. Some people

use material they know will be a problem and that's an important part of the work. I think it's useful to do the research on the particular type of material that's at issue. It's also an interesting territory to think about: intellectual property. And one in tremendous flux at the moment, so it's not always easy to determine a course of action.

Q – Your work doesn't fit neatly into existing venues – it seems to require the focus of a theatre space, but the flexibility of a gallery space. How do you address these issues when you look at sites for installing the piece?

Toni – That's an area that's in the process of change for me as I'm moving away from the museum installation model and towards a more time–based performance/event model. I don't know yet how it will play out – it will probably cause me to focus on festivals and museum theatres, art center spaces. There are a growing number of venues interested in new media that are beginning to focus on the changing needs of presentation, but this is also something I need to think carefully about as I design the interface/delivery system for the new feature–length piece I'm doing. I'd like to make it flexible enough to work in a more conventional theatre space, but I don't know yet if this will really be possible.

Q – Does it feel harder to draw audiences in a gallery than in theatres – I mean draw an audience that will stay with the piece long enough to become involved in the narrative?

Toni – One of the reasons that I'm increasingly less interested in the gallery world is the issue of time. Galleries, and, to a somewhat lesser degree, museums – have certain patterns of reception that are problematic for time–based work. As my work becomes more about duration, it requires a certain kind of sustained attention, and an audience that arrives at the beginning and stays until the end. It's not harder to draw audiences at a gallery, but it's difficult to have them use the space in a way that currently interests me as it's counter to the common use of that space.

Q – Can you describe _Spectropia_, the piece you are currently working on?

Toni – _Spectropia_, a project currently under development, is an interactive feature length narrative designed to be responsive to two viewers or performers at a time – an immersive date movie. Its length – almost that of a feature film (70 to 90 minutes) suggested to me both serial form and a stronger narrative through line. Spectropia, a teenage girl, lives in the salvage sector of an urban center known as the Informal Sector. She is searching for her father, who disappeared in time looking for a lost inheritance. Using a scanning machine of her own invention she reads garbage and translates it into lifelike historical simulations she can enter that respond to her voice and movement. When her machine short circuits during her search she is transported to NYC 1931, where she finds herself in the body of another

woman – Verna de Mott, an amateur sleuth. The narrative structure of the piece echoes the economic and emotional structures it depicts. The infinite deferrals of desire present in consumer culture and advertising are viewed through economic events that emerged in the 1920s – the installment plan and buying on margin. The narrative (an uncanny ghost story) is haunted by the phantom of credit, the thing that isn't there, and by the desire created by commodity culture that is never satiated. This is paired with a voyage into the mysteries of adolescent sex – of approach and retreat, desire and repression, as each step towards physical intimacy pulls our heroine back to the future. The object of desire

is unstable, blurry; it keeps changing or morphing in an endless chain. The thing keeps slipping away. It is the desire itself that ultimately creates pleasure, the experience of eternally delayed conclusion as a thing in itself. Anticipation, frisson, and the adrenaline of seduction never quite consummated.

Spectropia's performance mirrors the theme of otherworldly possession. The cinematic action is projected on a central, wide movie screen, flanked by several smaller screens, allowing cinematic characters to break from the one screen and wander to others. Unlike a film, however, these projected screen characters are 'inhabited' by two players who use movement, vocal sound and speech to manipulate them like virtual marionettes. The players can make their on–screen character counterparts move, speak and navigate through space. Two players, inhabiting their onscreen characters, can engage in a telepresent dialog – karaoke flirting. Visual and audio cues tip off the audience as to how each player is shaping the onscreen action. In this sense *Spectropia* might be considered an advanced technology variation of Japanese Bunraku puppet theatre, in which shadowy black–clad

puppet masters perform onstage, articulating nearly life–sized puppets. When *Spectropia* is presented the event will include two trained tutor/performers. More than just mute puppeteers; the players may appear onscreen themselves, 'haunting' the movie, cast shadows into the film world, or engage members of the audience in interactive dialogs with characters. Their movements and vocal sounds contribute to creating a spontaneously composed interactive soundtrack. After demonstrating 'Spectropia', they will act both as performers of the piece and as guides to assist members of the audience to enter and 'play' the movie. In this way, *Spectropia* is an experiment in breaking down the barrier between audience and performer, between film and theatrical event. It exists somewhere between film, theatre and video game.

Q – Any advice for fellow artists?

Toni – Dogged persistance in the face of adversity pays off. Build a support structure of friends and colleagues to get you through the rough spots and to celebrate the great moments. And I guess the most important thing that I've learned is to get out of my own way.

Q – Where to next for Toni Dove?

Toni – I'm trying to get my balance with the new work infrastructure I'm creating. I'm looking forward to developing the more living room based aspects of the work – interactive DVDs. This will allow me to do some smaller projects along the way that come out of the larger projects as well as eventually porting the large projects. And I'm interested in doing more research on character intelligence and on the use of AI for emergent storytelling. That ought to help disrupt any stable notion of narrative trying to get a foothold in my mind.

Leslie Hill

Q – How did you start making performance?

Leslie – Well, I had quite a bit of experience in theatre and video growing up, but I would say that my move into 'Performance' or 'Live Art' really came from writing. In the early

90s I became intrigued by Audre Lorde's term 'automythography' and I worked on several 'automythographies' that seemed to require performance and of course it wouldn't really have made sense for anyone else to perform my automythographies.

I remember the billboard outside the Baptist Church in my grandparent's hometown of Stigler, Oklahoma asking: DO YOU HAVE A STORY TO TELL? This question often pops into my head. I think I started performing not out of a real desire to be on stage, but more in answer to that blunt, yet compelling question.

I had a lot of support for my early performance work from Lois Keidan at the ICA in London and Mark Waddell at the CCA in Glasgow and from Lois Weaver. They all really helped me get started in terms of gigs, commissions, residencies, funding etc. There was a lot of good work around, so I enjoyed 'the scene' and the connections between artists. Live Art/performance felt like a good context in which to make and show work.

Q – What guerilla strategies do you think you have incorporated into your career in performance?

Leslie – I suppose, if I think about it, nearly everything has felt like a guerilla strategy because performance isn't a straightforward, well defined or well funded art form, so even in the middle of a generously supported residency or commission it is possible to feel as though you are asking a big favor if you want to use the fax machine.

In 1996 Helen Paris and I formed our company, curious.com, which consists of the two of us at the core as artistic directors and then expands or contracts as particular projects require. As Helen and I are of different nationalities (Helen is British, I'm American), a lot of strategy has had to go into being in the right place at the right time with the right visas etc. This is one reason that in the last couple of years we have tended to take artist positions attached to universities – institutions that can apply for visas on our behaves to keep us legal whichever side of the Atlantic we are on.

Doing this book is definitely part of a guerilla strategy.

Q – How does working as part of a company compare to your career as a solo performer?

Leslie – Working as part of a company is more fun and more frustrating than working solo. I find it good artistic/mental exercise to go back and forth between the two. Some pieces are more contained and can benefit most from the quiet, intense focus of solo work. For me, solo pieces tend to be text–based.

The productions that I've been involved in that are either more theatrical, more filmic, or more technological have normally involved working with different individuals or groups, whether they are other artists or technicians or computer programers or terrorists and glass eye makers. Last summer, for example, during a residency at the Project Arts Center I worked with an Irish terrorist shop that sold all manner of tiny, tiny color video cameras and a Dublin occularist who recreated my great–great–grandfather's glass eye and fitted it so it could 'see' and record. They were quite intimately involved with this aspect of the piece, but working with another person on a particular element, like the glass eye camera, is very different from actually collaborating with someone conceptually.

True collaborations can generate really strong work, but sometimes there is going to be blood on the floor in the process. I think ultimately it can be helpful to have roles defined, especially in larger productions – Helen and I will often start a project together and very early on it becomes clear who is leading on a particular piece and who is doing the negotiating and liaison with the space and crew. These days I tend to be a little conservative about who I collaborate with. You can love someone else's work and like them personally and this doesn't mean you will make great work together collaboratively. I notice that artists who develop strong collaborative relationships tend to cherish those connections and stick together. Good working relationships are gold dust.

Q – How do you go about making a new piece? Is the process drastically different every time or are there patterns to the way you approach a new piece?

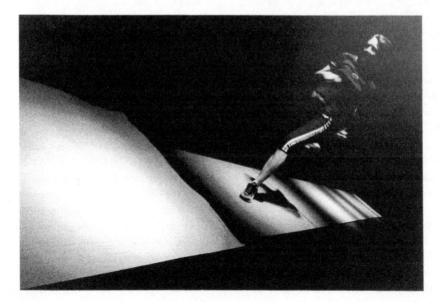

Leslie – I think the solo work always starts from the feeling that I have a 'story to tell' and then the question is how best to tell that particular story – through a live performance, through a linear filmic piece or an interactive piece for web or CD … Other than writing, which is a sort of backbone for me in my practice, I'm not loyal to any form. I like working in quite a range of different forms and for me that's one of the things that is most interesting – starting with some material, a story, a line of investigation and then seeing how it all shapes out. Collaborations can lead to more radical variations on process, which is one of the aspects that can be very refreshing about them as well as difficult.

Q – Do you think mediated work has the same guerilla potential as live work?

Leslie – I'm sure it does, though I've never seen a piece on the web, for example, that really hits me in the gut the way live work can. Sending an email virus may be more immediately far reaching than the Suffragettes smashing windows on Oxford Street and setting pillar boxes on fire, but does it really sear into our memories?

I think evangelists are good ones to watch to assess the radical, the guerilla potentials of mediated work. No one knows more about performance and interactivity than these folks and I notice with interest that *liveness* is still absolutely central to their business, even in their television broadcasting – it is important to see the live audience, to hear the live phone calls coming in, to know that you could call in if you wanted to and someone would answer your call – to feel that they are talking to you RIGHT NOW.

Q – You have worked as an artist both in the UK and in the USA. How do the possibilities for artists compare?

Leslie – The government funding situation is a lot more promising in the UK – at least there are funds to apply for, even if it is highly competitive to get them. The level of government support for the arts in the UK is also really reflected in the venues. In the UK, for example, you have the ICA in London and the CCA in Glasgow with their own gallery spaces, theatre spaces, cinema spaces, restaurants, bars, really great bookshops, etc. and they occupy CENTRAL locations in the city – the ICA shares The Mall with Buckingham Palace. American venues that might be showing the same artists – Highways, PS122, Franklin Furnace – are definitely more guerilla in the way that they were founded and the way they are run, and that's a good thing on some days and a bad thing on others, depending on the specific project. In the US the bread and butter work seems to often be attached to university gigs. If you are lucky enough to land a visiting or resident artist position at an American university, this is a pretty good way of getting paid to make your work, but in general, I think there are more opportunities for artists in the UK. I notice a lot more Americans coming over here to find funding for their work than British artists

crossing over in the opposite direction.

Q – How do you fund your work?

Leslie – Through grants, commissions, bursaries, residencies, artist fellowships, research and development funding, inkind support, help from my friends and family, etc. as well as through teaching performance and sometimes working as a resident artist attached to a university or institution.

Residencies within institutions can provide extremely good support for making work, but they can also bring up some tricky questions of ownership and copyright. Helen and I were resident artists at the Institute for Studies in the Arts at Arizona State University and the amount of time and support we were given was unbelievable. Inevitably, however, every once in a while issues would come up. One quick example: as part of a live video/ performance piece called *BULL*, we worked with Kelly Philips of the production crew at ASU to design and construct a stainless steel mechanical bull. Having support to the extent that an institution will actually pay an engineer and highly skilled technicians to construct something as complex as a working mechanical bull is amazing. But after the show was over, Elizabeth Streb saw the bull on video and expressed interest in borrowing it for a tour she was doing. This kind of situation brings up strange ownership issues – does the university own the bull because they paid for all the parts and the labor? Or do we own it because it is 'our art'?

I would advise artists and organizations to ask these sort of copyright/ownership questions as early as possible and not to be shy of asking for terms and conditions in writing so that all parties feel comfortable with the agreement. Sometimes being too casual can cause real problems later on. This is not particularly a criticism, more of a question mark that hangs over these sort of funded residencies. It is up to the artists and the institutions to make sure they are happy with the terms and conditions of the residency and the subsequent copyright and ownership of ideas and objects.

Q – How much of your time do you estimate that you spend on fundraising/grant applications?

Leslie – Keeping up with funding can feel like a full–time job in and of itself. An estimate is difficult, because it's the sort of thing that occupies a hell of a lot

of time, but in concentrated bursts. Maybe 10 percent? It depends. Sometimes you will be in the happy position of having someone else produce your work, so you don't have to take on all the fundraising, but you will still have to put in the work on clear statements that your producer will be able to use to make her/his job easier.

At times I would love to have an administrator, but to be honest, at the end of the day I wouldn't trust anyone but myself or an artistic collaborator to represent the work. It is tempting in the same way that having a body double is tempting, but for better or worse they just ain't you. Tackling the hard job of defining and communicating a project can be the first part of the process of making it and can serve as a conceptual road map that may

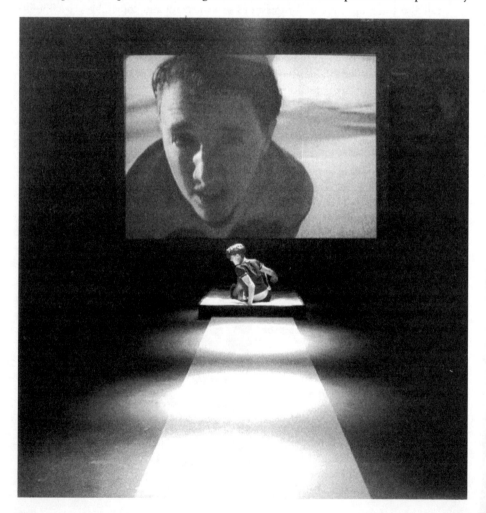

prove helpful to refer back to.

Q – Ever think about getting a day job?

Leslie – My strategy has been either to string together residencies and commissions or to have a resident artist position attached to a university where I teach and contribute to the faculty in return for a salary and research support. Helen and I are based in London which is outrageously EXPENSIVE, so you won't find many people able to live here without some kind of full–time or part–time employment, unless they are lucky enough to have low rent in a council estate or if they bought their place several years ago before the prices doubled and tripled. So yes, I have had day jobs. I have one right now and they are giving me research support to work on this book. I spend a lot of my time trying to find the best matches so that my day jobs support making work, rather than just making money.

Q – What one thing would improve the quality of your artistic life?

Leslie – More time.

Q – Any advice for emerging artists?

Leslie – Keep focused on the work you want to make. Learn to clearly separate personal from professional – this is key in artistic collaborations, and also in dealing with other professionals like technicians and funding officers, programers etc. Remember that for an artist time is more precious than money, so make choices that are about making as much time as you can for your work.

Q – What next?

Leslie – You know, sometimes I think it's best to keep the next project close to your chest... Even though I find it incredibly tempting to talk about new ideas, I personally find that getting ahead of myself by sharing ideas before they are fully formed can sometimes dissipate the great raw creative energy that bubbles up around an instinctive idea for a new piece. So I'll keep it under my hat for now, but if you want to check out some of my work, you can find it at **www.placelessness.com.**

Hsin–Chien Huang

Q – Can you describe the kind of work you make?

Hsin–Chien – There are two types of work that I do: the first one is for making a living, and the second one is for fun and sanity. The first one involves my daytime job, and usually is about game production. The latter is the various experiments that I created in computer. Some are computer interactive software; some are computer graphic animations and illustrations.

Q – How did you start out?

Hsin–Chien – In 1994, I won the New Voices New Visions award. At that time, Laurie Anderson was one of the judges. She likes my work and invited me to work on her first CD–ROM *Puppet Motel*. I guess this is how I started my career.

Q – What was it like translating Laurie Anderson's live performance material for a virtual environment for the *Puppet Motel*?

Hsin–Chien – In the beginning of the project, one of the possible directions was to record Laurie's performances and put them on the CD as interactive QuickTime movies. She didn't like this idea. Her goal was to create a new way of storytelling that fits the CD–ROM media. The final result is a collection of places with her stories embedded in them.

Q – What was this process of transformation like?

Hsin–Chien – It was a very intense and fun process. Although we kind of knew the direction that we wanted to take, the interaction that we created had a tendency to grab the attention of the audience away from her storytelling. We built many prototypes and disposed of most of them. Finally we found one that worked, and then we started to make variations based on that working prototype.

Q – Did it ever feel harder to connect with audiences in the virtual environment than in actual geographical venues?

Hsin–Chien – Definitely. I still feel that the stage is a much better place for performing art. The virtual environment has too many technical limitations, and it lacks of convention like we have for traditional media. Each person's computer set–up is different, and that adds a lot of noise for the audience to appreciate the content.

Q – What kind of work have you been making since Puppet Motel?

Hsin–Chien – I worked with Interval research on a next generation musical instrument project, and then I went to the video game industry and worked with Sega and Sony. In my spare time, I build web pages for friends, or write computer interactive toys.

Puppet Motel Hall of Time

Q – Is the process drastically different every time you make a new piece or are there patterns to the way you approach a new piece regardless of whether it is a high tech or low tech?

Hsin–Chien – The processes to reach the final results are always different, but the strategies are pretty much the same, which are to try as many different ideas as possible in the shortest time. I like to save all the explorations, since the process is more enjoyable than the result. I guess the goal is not to create stuff, but to satisfy my curiosity.

Q – How much of your time do you think you spend on fundraising for your work?

Hsin–Chien – Very little. I always hope that my personal work will have some commercial value, so that I can support myself with it. However, I am not a very good merchant. So I keep my daytime job.

Q – Can fundraising be a creative or guerilla act?

Hsin–Chien – I believe so. Some of my friends are very good at getting sponsors. But it can easily become a full–time job of its own. With the growth of the Internet, I am hoping a new type of sponsorship will appear based on the direct contact between artists and their audience.

Q – What's the most useful thing you've learned in the last three years?

Hsin–Chien – Relax and enjoy life. I believe that my work is a by–product of my life. And the experience of life can't be replaced by the experience of work.

Q – Any top tips for fellow artists?

Hsin–Chien – Having friends who understand your work is very important.

Q – Where to next for Hsin–Chien Huang?

Hsin–Chien – There are many topics I would like to explore. However, I feel that it is more important to establish the foundation that can better support myself to do the things that I want to do. For example, to integrate my work style better with my lifestyle and to support myself better financially.

Ruin Hsin-Chien Huang

Joe Lawlor
desperate optimists

Q – How did desperate optimists start out?

Joe – It really began the day we left Ireland for the UK. After five years 'studying' at Dartington College of Arts we found ourselves unable, artistically speaking, to return to Ireland. Oddly enough, between 1987 and 1992 we never thought we wouldn't return but clearly the five years away had changed us more than we realized. As a result we were cast into permanent 'exiledom.' Not a bad feeling this. We should point out though, Ireland has changed a lot since 1992 – not to the extent that we'd live there (too small) – but there's a lot more going on. Somehow, the name desperate optimists seemed right starting out in a foreign country, that is the UK, that we wanted to make artwork in.

Q – You've been going quite successfully for ten years with new projects each year and as far as I know funding every year as well – is it getting easier to make a living?

Joe – No. The only thing that gets slightly easier is the planning around what you do. On a certain level we can get a handle on the shape of a year much better, and the bits and pieces we need to put in place to make that year go the way we want it, more or less, the way we'd like it. We're far more strategic than we used to be. This is down to efficiency more than anything else. At the end of the day, though, the whole thing feels as short term as that – one year maybe, eighteen months maximum. It's seat of the pants stuff really. For the life of us though we can't imagine it any other way.

Q – desperate optimists is a registered partnership, right? Why did you choose this set–up rather than opting for a company with a board and all the trimmings?

Joe – Yes, we're a registered partnership. Well, basically that's most basic legal item you can be to have your company constituted properly. It's cheap and easy to set up. The only incentive to set up as a limited company and all that that entails (board meetings and so on) is that some funding is predicated on you being a fully constituted company. We're thinking here of National Lottery program funding. They won't give money to you unless you are a company. The thinking here is that no one is profiting by the award. It's accountability at the end of the day. A partnership is technically a profit making status organization!! So there's the rub – there is no reason to be anything more than a partnership except when it precludes you from bigger, more binding sums of money. But being a partnership, having the accountant and all that is good for desperate optimists.

43

Q – You're based in London – why is that important for you?

Joe – Yes. Big theme this one and we're right up to it with our new project map50.com location, geography, displacement is a big theme with us. We both grew up in a city (Dublin) and so we're very much city folk – but by any stretch London is a fantastic city, not like England at all, but the size, cultural diversity of the place makes it a very stimulating place to live and work. Can't imagine wanting to live in many places, cities that is, but London is definitely one of them. Actually, we're doing a lot of London–based work so that's also good – we're having a real love affair with the city right now. Another reason is the people we meet who share similar interests as ourselves. This is more likely to happen in a city and more so in London than, say, the Isle of Wight (although we could be wrong about that – as we've never been to the Isle of Wight, it could be great).

Q – Do you have an agent or an administrator?

Joe – No. We do all our own administration. But in the last eighteen months we've begun to feel it would be great to have someone part–time. The quantity of admin work is chewing up increasing amounts of time and of course this is taking us away from other, more important, or do we mean interesting things – but for now it's gotta be done!!! That said, for these projects we're involved in right now we have employed people on a project basis to pick up some of the administrative workload.

Q – How much of your time do you think you spend on the nitty gritty of funding?

Joe – Hard to calculate but we reckon on average about two to three months of each year are involved in preparing and researching appropriate applications. But several more

months will be spent on nitty gritty things in developing an arts program – we feel that this 'nitty gritty' stuff is in fact the stuff of making artwork!!!!

Q – What has kept you going when money was tight?

Joe – The next project.

Q – You've put together a lot of big tours over the past few years – any advice for artists when it comes to touring work?

Joe – Well, firstly we don't tour anymore. We've done our time (as they say in prison). But … this can be a real chicken/egg issue. Often programers won't book you unless: A) they've seen your work or B) they've heard of you from another programer. Either way it's unlikely that you'll be in either of those categories unless some programer or other has seen you or heard of you. The bottom line is, try to make sure that programers, other artists (we often recommend people), see your work in a context that will show your work in a good light. This is the only way we know of. It's work getting work. We like the idea of the work leading the way. At least then when people want you it's for the right reasons, i.e. the work.

Q – Are you going over to the dark side – I mean the digital side? Your projects over the last couple of years have moved into CD–ROM, web and digital video. Is this where you wanted to go with the work, or is this where the money is right now – or a bit of both?

Joe – We like that – the dark side!!! Yes, we have made a huge shift in our working practices over the last couple of years, especially the trip from the live to digitally based mediated and especially video and web based artwork. Money has not been the motivating force but potentially, we guess, you could earn more money – the transferable skills and all that – picking up the occasional commercial website here and there if you wanted. But in essence it seemed like a natural development for us. Something that threw up new challenges we were more interested in dealing with than the challenges of live performance which we had been heavily involved with for ages. In many respects we're not very loyal to any one art form. For example, if we have an idea to do something and the idea is really trying to be a video or a soundtrack as opposed to a performance or even a website – then we'll follow the form of the idea. Basically, we are slaves to whatever form the idea wants to take. But that's only something we have followed in recent years – before, we'd force the idea to be a performance when all along it really wanted to be a short film – and in the end you can't win, because form always rules!!!!

Q – Correct me if I'm wrong, but you've always wanted to eventually move into film – is that right?

Joe – Speaking now not as practitioners but as audience members, we guess if you were to put end to end the art form we engage with most frequently I guess film would be longest in the chart. It's the one we argue about most, play scenes out from the most, quote the most, refer to the most. We love film – is that coming across clearly here? Yes, we made a few short films and still feel we're dying to make something more substantial. We are, incidentally, working on a script for one right now, set, oddly enough in Dublin, Ireland. It would be great to make it.

Q – Do you feel that digital arts are bringing you closer to film–making than theatre work was?

Joe – Totally. Even if you take our web–based work (lostcause1–10.com and map50.com), these are so close to the process of making film but for the web. The shooting process is very similar, e.g. story boarding, sound design, performance, editing and so on. In some respects, if the bandwidth becomes super mega fast (not likely in the UK for some time) – we could become more ambitious about that process also. But film and its scale and especially its social context is very interesting and seductive to us – but one we're quite cool about – don't want to spend years getting that film we've slogged over not made!!!!

Q – *Urban Shots* **was a piece that really drew from all of these areas. Can you describe the piece and the context in which you made it?**

Joe – Well, we were asked to come up with the ideas for this big outdoor area in Jena, a large town in East Germany and home to Carl Zeiss lenses, as part of European Cultural Capital year. Because of the Zeiss connection we knew the idea of lenses, looking, cameras should/would feature quite heavily. Also, the area we had to create the event for, a car park by the way, was just below this huge tower. The tower was thirty stories high but the nice touch was that the fourth[th] and fifth[th] floors were missing and this was meant to represent a focus ring. A terrible building in many ways. A grand socialist statement. We quite liked it though. Anyway, the starting point was too good to ignore. We basically drew up plans for a live event by working on the premise of a film crew in Jena making a science fiction film (the tower for some years housed quite a secretive pharmaceutical corporation). Because we knew that the audience would be mostly local (in the end over 2000 people a night came along) also it would be summer so we felt like playing it like a spectacle. Stunts, huge dance routines, loud music, that kind of thing. Our thinking though, that if we gave all these very seductive trappings (which we liked a lot incidentally) we could then push it formally in other areas. A sort of summer spectacle but with heart of winter. Part of the event involved us shooting a 9 minute 16mm film. It was a big undertaking inside another big undertaking. But the experience was very enjoyable and educational. We've used that experience a lot since.

The context though was tough. We couldn't direct the production. Really, you would have needed German to talk to several hundred people and we didn't have the language. So we had to sit back and watch someone else (Albrecht Hirche) direct our concept. This was very odd and actually we saw some good things left to the side but some other things work in ways we never expected. To be honest we were not naïve and expected not to be precious and we think this was why things worked out so well.

Q – What's the most useful thing you've learned in the last three years?

Joe – That every day you must bow down to the God of art and show it your subservience and respect for if you do not you shall be punished.

Q – Will we be seeing any more live work from desperate optimists, or is your theatre–based work done and dusted?

Joe – Actually, throughout 2000 we worked with young people in Dublin on a live performance. By the time it premiered in November it had been two years since we made a performance. The process and the event itself was very satisfying. Suddenly here we were making a performance which didn't have us as performers in it, that didn't have to tour and one we made because we wanted to make it and not because it was that time of year again. Very pleasurable this experience. We'd almost forgotten it could be like that. So for now we'll keep it like that. Do something every few years, we still get a lot of pleasure from making live. So we're afraid we haven't left the scene yet.

Q – Is the process drastically different every time you make a new piece or are there patterns to the way you approach a new piece regardless of whether it is a live show or a web site or a radio broadcast?

Joe – Mmm. This one is a slippery question. Yes, there are patterns to the way we work AND there are also new things. Essentially you have to change how you work if the thing you're making is a 3–minute video as opposed to a 75 minute live performance. But I guess what were interested in are the similar patterns. We nearly always work with very practical/simpler things first, e.g. what color will it be? What sound design will it have? Who will be in it? Where will we do it? Will you do this if I do that?

In many ways when you answered these small but important questions you find yourself all of a sudden with quite a lot filled in on the canvas. Yeah, let's run with that metaphor … for us the recurring pattern is not to look at the big picture of an art work until it's 'got legs' as they say, but instead deal with the series of small things that go to prop it up. The idea of thinking about the bigger picture all the time would scare us and we'd stop. We tend to strategically oscillate between this small intimate experience of making with the occasional run back for the bigger, more wide–screen look. Mostly, because there are two of us only one will do the running back whilst the other keeps up close. And we communicate with each other 'how does it look back there?' 'shit!' or 'pretty good but louder or more red or more dirty or more cute or more hard…'

Q – Sound and music have always been really central to your work. How do you avoid breaching copyright law without adding a hefty bill to the production costs?
Joe – We have no idea what this question means!! What hefty bills? What copyright laws? Is there something we don't know? But to be serious, we work a lot with sound and this invariably involves sound sampling even quotes from films or more pure sound samples. The day it becomes an issue is going to be an interesting legal day in legal history. Our feeling is that unless there is serious amounts of money being made, no corporation in the world is going to sue anyone. Can you imagine if Sony or Viacom decided to sue us because we used a sound sample that they hold the copyright to? Bring it on!!!!!!!

Q – Does it feel harder to draw audiences on the web than in theatres or easier?

Joe – In terms of quantity no. We will get many more people seeing our work on the web than our live work. But really that's neither here nor there – the main thing is the quality of the engagement. This is, for obvious reasons, hard to gauge with web–based or film or video or visual or sound–based work. That's where the live event is quite unique and special. Oddly enough, we don't miss that – we're curiously content with looking at web statistics, which probably sounds like a lonely geeky kind of thing but it's amazing the pleasure you can get from those figures and numbers your ISP sends you. At the same time what's good

in all of this is that we feel excited about reaching new audiences. It's far less predictable as to who will engage with your work whereas by the time we finished our heavy touring schedule the audiences for performance can be too well known a factor and maybe the danger is you begin to enter into a sort of unconscious pact with them – you make work for them only. On one level this is fine but finding new audiences is somehow more interesting to us.

Q – Any advice for new artists?

Joe – Nothing profound here and certainly no nuggets of wisdom – we like what the film director Elia Kazan said, 'At the end of the day, the only thing is the work.'

Q – Where to next for desperate optimists?

Joe – After map50 we are making a large–scale event, again set in London. It's called Londonframed and will be set in 6 locations throughout London. It's an interventionist piece and will be a cross between a riot and a fashion shoot. We hope it'll be good fun but doubtless it'll also prove contentious. Big images of young teenagers dressed as Nazis hanging around street corners, that kind of thing. There will be a website to accompany it.

desperate optimists are Christine Molloy and Joe Lawlor.

Tim Miller

Q – What made you want to be a performer?

Tim – I always wanted to be a performer. I think I was a little queer kid putting on shows in my neighborhood as a way of claiming some little bit of agency in a homophobic culture. That hasn't changed much, I think.

Q – What was your involvement in starting PS122 in New York? Did you want to found and manage an art space or were you driven more by your needs as a performer?

Tim – I was one of the co–founders in 1980. I wanted to get PS122 rolling as a way to transform art and society and have a dependable gig in NYC. Not a bad mix of altruism and ambition.

Q – Were there elements of PS122 you set out to retain when you moved to LA and started Highways? Or were there characteristics or infrastructures of PS122 you purposefully avoided?

Tim – Starting Highways in 1989 with my partner Linda Frye Burnham of High Performance Magazine was a totally different impulse. We really wanted to create a laboratory for identy and community based performance that was fiercely engaging society. The energies and folks around Highways were people like me, Guillermo Gómez Peña, Rachel Rosenthal, the Los Angeles Poverty Department, Dan Kwong. This was the strongest community of artists I have ever felt a part of.

Q – If you were to start a new space from scratch today, what do you think would be the most important thing to get right?

Tim – Yikes. It's so hard to make these places happen, especially in the US and its anti–art policies. Plus, I am not even sure the alternative arts model has any contemporary currency. I guess it would have to serve a lot of different purposes and communities, queer arts center, cyber café, dance studios and rehearsal space, alliances with university performance studies programs and such.

Q – You are a very well known artist internationally, but even so, do you sense that you could make a living as a performer outside the US?

Tim – Hmm. This is something I am thinking about a lot since my partner Alistair and I will be forced to leave the US in 2002 (more on that later). I have always worked in other countries – the UK, Canada , Australia—but I have always had the most work in the US. That makes sense because I' a US artist and my work definitely is within an American vernacular. Plus the US is by far the biggest English–speaking country. I have always made a chunk of my living abroad, but I think it would be tough going without all those cities, universities, arts centers in the States.

Q – Do you have an agent or an administrator?

Tim – I have had many different arrangements over the years including several agents and booking people. I am a bit of a control queen and left arts–worker kind of guy though, so I like doing it myself. I also have started two artist run spaces and we always preferred dealing with other artists. On a more human level, I like knowing the people before I get off the plane for a gig. If we have talked and emailed a number of times it's more likely we can have the whole thing feel fun and friendly.

Q – Have you ever needed a lawyer?

Tim – Do I ever not need a lawyer? OY! In 1990, I, a wandering queer performance artist, had been awarded a NEA Solo Performer Fellowship, which was promptly overturned under political pressure from the Bush White House because of the lush, wall–to–wall homo themes of my creative work. We so–called 'NEA 4' (me, Karen Finley, John Fleck, and Holly Hughes), then successfully sued the federal government with the help of the ACLU (if you're not a card–carrying member, become one!) for violation of our First Amendment rights and won a settlement where the government paid us the amount of the defunded grants and covered all court costs. The last little driblet of this case was the 'decency' clause, which Congress had added to the NEA appropriation under the cattle prod of Jesse Helms. Judge Wallace Tashima of the Ninth Federal Circuit Curt had sagely declared this 'decency' clause unconstitutional from the bench and thrown it out.

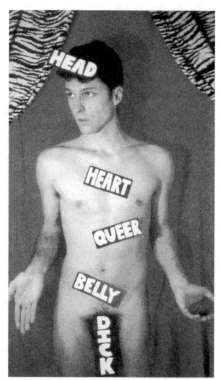

In 1998, the Supreme Court decided that it was okey–dokey not to fund 'indecent art' in their NEA 4 decision. The law 'neither inherently interferes with First Amendment rights nor violates constitutional vagueness principles,' Justice Sandra Day O'Connor wrote in her majority opinion. In a disappointing 8–1 decision the high court hitched up with Helms and his ilk and said the National Endowment for the Arts can consider 'decency' in deciding who gets public money for the arts. I was grateful that at least Justice David H. Souter showed he was sensible to the reality of how under assault artists have been in this country for the last ten years. He was the lone Justice who dissented, saying the law should

be struck down as unconstitutional because it was 'substantially overboard and carries with it a significant power to chill artistic production and display.'

Q – How much of a problem has it been getting your work funded over the years?

Tim – Since the NEA 4 dramas eleven years ago, I don't get any funding for the creation or performing of my work. Oh well!

Q – How do you deal with touring low budget work with quick turn arounds? Is it ever hard to keep going?

Tim – Of course it's hard work running around and performing, but I worked for two years as a construction worker and it's a lot easier than carrying sheetrock up six flights of stairs! There are moments I get wiped out with all the running around on my lean–n–mean constant touring, but I feel lucky to raise my voice as loud as I can.

Q – Do your shows have a shelf life?

Tim – Longer than a quart of milk, I hope! Most of my shows I do for two to four years then give them a cushy retirement. My current show *Glory Box* has a shelf life that depends a lot on the political environment in the US and how much time Alistair and I have before his visa runs out. A whole other kind of expiration date courtesy of the injustice of US immigration law!

Q – How important is it to you that academics and critics write about your work?

Tim – Well, I have taught in the MFA Theatre program at UCLA for ten years and do lots of University residencies. My academic pals and colleagues are very important to me and I see them as partners in this interesting time we are all in. I'm certainly pleased that lots of people want to write about my work. I also engage my audience as a writer about my own stuff in academic books and journals as well as more mainstream journalism. Basically, I want to engage the issues in my work by any means necessary.

Q – Why did you decide to make your current show *Glory Box?*

Tim – I am currently moving my butt all over the United States (from Salt Lake City to Chattanooga!) doing my solo performance *Glory Box*. The show deals with the situation Alistair, my Australian partner of six years, and I are facing in a country that gives lesbian and gay couples none of the 1500 'special heterosexual rights' afforded all straight married folks. For bi–national gay couples like us, the BIGGIE of the rights that gay people are uniformly denied are the immigration rights that all our straight pals get with their vast buffet spread of heterosexual privilege. Alistair and I face the likelihood that we will be

forced to leave the US next year when his student visa runs out and seek immigration asylum in Canada.

As you can imagine, this gives a particular urgency to *Glory Box* and my national art–activism shenanigans!

Q – Is *Glory Box* simultaneously the most personal and the most political show you've made? Did this make it harder to write and perform?

Tim – *Glory Box* is for sure my most personal piece and my most political — my funniest show and the most intense. The subject matter really cooks in that harsh reality of the fact that our most intimate and sacred love relationships are treated like shit in America. By necessity these charged feelings bring forward humor as a way of dealing with the situation. I worked on the show for about two years. A big chunk of it I wrote during a very hard time when the US Consulate in Australia had refused Alistair his student visa. This put us in a huge crisis, kept us apart for months, and ended up costing us thousands of dollars. I knew right then that I had to get my butt in gear and make a piece that would let people know about the unbelievable injustice that lesbian and gay bi–national couples face in our country. Creating the piece kept me from going nuts. In an ongoing way it makes performing the piece a really charged act of what my life feels like right now – a way to get pissed off, contain the feelings and imagine the future.

Q – What kind of impact do you sense that *Glory Box* has had on people who've seen it?

Tim – I spend about 25 to 30 weeks a year on the road performing. When I go into a community to do the show *Glory Box*, it's an opportunity to be a ruckus–raising, change agent and lighting rod for the local brew of activists and citizens. This is something that solo performance, the ever lean and mean culture tool, is especially good at. I assume before I get on the plane that I am parachuting into a community where there is precious little awareness about the gross injustice facing lesbian and gay bi–national couples. I assume the local press has probably never written about the subject. I assume that the local bi–national couples, and there are always several, even in tiny communities, are feeling isolated and freaked out by the kafkaesque injustice of US law that threatens to destroy every one of these thousands of lesbian and gay families. I hope the show helps address all these things.

Q – Do you believe that a solo artist can affect national politics?

Tim – What I think theatre and performance can do quite well is shine a light on realities that are just so damn unfair – in this case, a bright, exposing headlight on the stark reality of the array of US human rights violations against lesbian and gay couples. The real–time heat of live performing is an especially handy crucible for raising awareness and provoking

people to action. I believe the empathy and openness that comes through the seductive strategies of live performance – compelling narrativity, the performer's charisma, the group dynamic that comes with a live audience, etc – are the ideal lab conditions for conversion, the channeling of the audience's psychic and political energies toward fighting for social justice. I think theatre is primarily a site for liberation stories and a sweaty laboratory to model possible strategies for empowerment.

Q – Do you sense that *Glory Box* has impacted American politics?

Tim – What I have discovered is that I can parachute into Cedar Rapids or Austin and shine a big pulsating light on this injustice. I hit the ground running, ready to raise awareness, anger and action through the performances. The work starts long before I get off the plane though. I work closely with the national organization the Lesbian and Gay Immigration Rights Task Force to help connect me with local bi–national gay couples or other folks who have been active on the issue.

There are four main practical goals for what the performances can do in that city's extended community: to get people involved in this fight against US human rights violations against gay people by getting them to join, or start, a local chapter of LGIRTF and to raise money for the fight. To lobby specific Congresspeople to become sponsors of the Permanent Partners Immigration Reform bill that would make US law consistent with almost every other western country in providing immigrations rights for committed lesbian and gay relationships. To get virtually every person in the audience to sign the petition in support

of the bill which develops a significant data base of people who have spent a night of their lives thinking about this issue as they watch the performance. To maximize the awareness in their community by having the show serve as a media catalyst for newspaper, TV and radio stories to raise awareness about this issue. I use that crucial tenderized moment at the end of *Glory Box*, which is a very raw and emotional piece, to challenge the audience to do something so that this violence against lesbian and gay lives can stop. Those many hundreds of people that see the show wherever I do it are absolutely crucial change agents to get activated around the issue.

Q – What has the tour been like? Can you describe your best and worst gigs?

Tim – Hmmm. I've been doing the show all over the US and meeting hundreds of les/gay bi–national couples. I am really moved by the love and commitment these dykes and fags show, managing to maintain their relationships in a country like the US where we are offered only three options: breaking up, separation, or exile. It sucks. *Glory Box* opened in SF last year with a benefit for the Lesbian and Gay Immigration Rights Task Force. The theatre was packed and practically the whole audience was bi–national dyke and fag couples from all over the world. Russia, Thailand, Columbia, Switzerland, Columbia, Holland, Sri Lanka, Mexico. So intense to have all these people in the same room who are living the

situation that the performance deals with. It was a little overwhelming.

Probably the most intense and specific community–in–the–performance space that I've ever experienced. So much psychic energy of queer love under attack by the US. So much life in the room. Worst experiences…: in 1999 when I was performing in Chattanooga, as the audience arrives at the theatre so do the protesters. They set up shop across the street, a motley bunch of seven or eight men (they have stashed their wives and children at the corner). As the people began to arrive for the show, they were forced to walk by the protesters across the street who waved their confederate flags (the black cops we had hired for security didn't seem too thrilled about these characters) as they shouted at the audience the usual charming greetings, 'Faggots! God made Adam and Eve, not Adam and Steve! Sodomites Burn in Hell', etc. The children down the street join in these cries. This seemed to demonstrate this particular church's version of family values: The Family That Mates Together, Hates Together. There is both a rambunctious spirit of a carnival with the barkers as well as a public hanging full of blood lust. The situation is simultaneously absurd and terrifying.

Q – Will you keep doing the show until they change the law or now that the election is over do you feel that you want to go on to a new piece?

Tim – There is a deeper human goal to all this work though beyond the nuts and bolts activism. I am hoping the show can do some kind of emotional and psychic chiropractic adjustments! I am asking the straight folks in the audience to do some heavy lifting and acknowledge they're heterosexual and begin to extend their empathy to lesbian and gay relationships. I am also using the show to ask lesbian and gay people to wake up to the fact that we are second–class citizens in our country and to begin sifting through the millions of signs, signals and laws our culture delivers that tells us our relationships are worthless. This is a touchy oppression–culture ticking bomb that needs to be defused!

My journeys with *Glory Box* have been a real confirmation to me of the potential power of performance and theatre to really get a loud alarm bell ringing. As I travel the country and abroad doing the show, I have been deeply reassured that what we do on these performance art spaces and theatres has huge potential impact and ripple–effect on our inner selves and, hopefully, on our public identities.

Q – What advice would you give to a new performer who wants to set the world on fire?

Tim – Kerosene works better than perfume!
Talk loud. Kick ass. Dig deep.

Helen Paris

Q – What made you want to be a performer?

Helen – Instinct. I was born that way.

Q – You started one of the first physical theatre companies in Northern Ireland and managed to get a dedicated space and core funding, right? How did you do it?

Helen – Well, you know, I think a lot of it had to do with being 21 and feeling the invulnerability and 24–hour–a–day adrenaline rush that go with that age! The company, Out and Out Theatre, was initially comprised of five core members, Maggie Chilley, Steven Stagg, Jill Gresswell, Paul Norman and myself, and we were pretty relentless. Initially, support–in–kind came from two arts organizations in Belfast, the Crescent Arts Centre and The Old Museum Arts Centre who let us have access to rehearsal space and use of office facilities, in return for occasional administration duties or workshops. I think that the relationships between arts organizations and artists are crucial, for both parties. The support Out and Out had from these places enabled us to get an initial foot on the ladder so we could start developing a profile and an audience. Eventually, after a couple of years of mainly self–funding through teaching and workshops, we secured Arts Council funding. We used the money to rent a warehouse type space in the city. The space tripled as an office, a rehearsal space and performance space. The floor was concrete, there was no heating whatsoever but we had it seven days a week and we able to make and show work there – well, yes, I guess we did have a few Wooster Group illusions ..!

Q – You moved to London and began working solo – why was this important?

Helen – There was something about the challenge of working solo that gnawed at me. I had been working as a company member for four years and enjoyed the agonies and ecstasies of the collaborative experience. The solo journey seemed to offer something totally nerve–racking all of its very own, the complete responsibility, the writing, the choreography, the direction, the concept, the publicity – all were ultimately down to me. The thought terrified me and intrigued me in equal measure. At the time I was considering a change of focus I was invited to go to London to perform at the ICA. I think the invite gave me the push I needed. When I got to London I applied for a solo commission, was successful and it really went from there. The lone journey of solo performance is a very particular voyage. For me it is often the most pressured and most exhilarating way of making work.

Q – And how does working as part of a company now compare to your career as a solo performer?

Helen – I spent several years in London working both as a soloist and collaborator on and performer in other people's work. It is an interesting dynamic to go from being the sole voice in your own work to entering a place where ideas are up for collective grabs. Leslie Hill and I formed curious.com in 1996. We met through seeing and loving each other's solo performance work. Our styles are quite different and so collaboratively I think we

make work together that is very different from the work we make individually. It is as if the combination of our specific ideas and processes creates a wholly original compound.

Within curious.com we still both work on solo projects but often with a collaborative element. Our first joint piece was an Internet project, *I never go anywhere I can't drive myself*. The project was a road trip across Route 66, the old and now decommissioned highway in America which runs from Chicago to LA, linking East and West. The project was about simultaneously navigating the historic, physical highway and the new virtual 'Info Super Highway'. As well as 'real' performances in truck stops and diners, the project involved making a daily updated website of our trip as we drove the 4456 miles there and back again. Updated every few hours, our performance on the site engendered remarkably similar feelings to live performance, high pressure and high adrenalin. In live performance, however, there is always the reassuring certainty that if you make a mistake, you are likely to be the only one to be aware of it. Here, in our virtual venue, one missed–out dot or a misplaced '<' of the HTML code could render communication with the online audience impossible. Often, to make up time, Leslie would navigate the road while I navigated the website. The computer plugged into the cigarette lighter, I would dowload the digital photographs we had taken that day of people and places we had encountered on the road and prepare the day's pages of text and images. I think we realized that if we could do a project like that and remain on speaking terms we could work together! I don't think it is easy to find someone you can really collaborate with, so to negotiate a successful working relationship is great – inspiring.

Q – What guerilla strategies do you think you have incorporated into your performance work/your career in performance?

Helen – For me, being a performer *is* a guerilla activity! In terms of lifestyle and career options it is pretty non–conformist. One strategy I think I have developed over the years is to allow a single project to have more than one life, in a way, capitalizing on the amount of work that has gone into a piece to allow it to have a longer 'shelf life' than just, say, what is determined by the length of any particular run. So there might be a performance piece that also becomes an article in a publication. Or a video piece that also gets shown as part of a performance or installation.

Having said that, it can equally go the other way! For example, recently I am intrigued in exploring the one–to–one performer/audience relationship and the level of contact and communication that can be reached. In terms of 'bums on seats' this kind of work does not score high! For example, *Vena Amoris*, performed at Artsadmin in London was a one–to–one performance/installation piece conducted mainly over a mobile phone. The piece took about 20 to 25 minutes and was experienced, one at a time, by fourteen people a night. So not a big box office winner, despite the fact that I was performing for over five hours flat!

A piece like that has to be marketed in a very specific way. Some venues, like Artsadmin aren't concerned about the lack of box office they will accrue if it is right for the piece, but most venues are and I have been asked to 'adapt' the piece for a sit down audience of greater numbers – which is, of course, impossible.

In terms of guerilla strategies for the artist I think that the Internet allows the artist an alternative 'venue' – when, let's face it, a good venue is often hard to find. It offers another space to show work and make work – and virtual space is cheaper than the real thing ...

Q – How do you go about making a new piece? Is the process drastically different every time or are there patterns to the way you approach a new piece?

Helen – My practice is founded on a certain belief that performance, in fact all art, is, at its essence, about contact and communication. So this premise lies at the heart of all the work I make. The work itself shape–shifts between live performance, writing, film, video, installation, websites and Internet performances – each form dictated by the content. So, in that sense the process differs – but maybe not drastically, and certain patterns run through. For instance, in live work I often start with the rehearsal/ performance space itself and the body within that space and investigate those things that are for me unique to live performance – e.g. the role of the senses, body memory, performer/ audience same–time–same–space live dynamic. When working on an Internet project for example, these elements translate in a different way. Space now has more limitless potential. The memory of the machine integrates with the memory of the body. I look for things I can do in this medium that I can't do – or can't do as well in the live.

Q – How do you fund your work? Is it easier as a company or an individual artist?

Helen – The work is funded in different ways, through funding and commissions and through institutional support, artist residencies and teaching. As curious.com we work in both the UK and the USA. I think the situation for solo artists getting funded is particularly hard as funders don't necessarily know where to place the individual – and of course on paper it looks more cost effective to give a whack of money to a company of

four people than to just one. Often funding applications demand that the proposal DOES NOT come from an individual artist, but ONLY from a registered company. Having said that I think that the funding infrastructure within the UK at least is shifting to accommodate the solo practitioner.

One of the deciding factors in compiling this book was to attempt to demystify and personalize the funder/artist relationship by approaching some key funding organizations and venues and ask some straight questions. I would encourage funding committees to include a practitioner in their line-up when adjudicating a particular fund. Many already have a policy of doing this and I think both parties benefit hugely from that shared exchange.

Q – You work in both live and mediated formats. Is there a strong dividing line between the two for you?

Helen – Not really. It comes back to contact and communication. Technology is another tool for communication. Use whatever lets you tell the story best. For example, with the Route 66 project, Leslie and I were interested in negotiating the performer's relationship to place and placelessness and in exploring how artists might translate 'evidence' from the real to the virtual, how does one leave a cigarette smouldering in the ashtray in cyberspace? How might the artist mark their passing in either realm? I think the exciting thing about performance is its hybridity. Most people arrive at performance from other disciplines – fine art, theatre, dance, etc. Similarly, the form itself allows the artist to cut and paste from numerous other art and non–art forms. Technology, old and new, offers a myriad of creative tools for the artist. The relationship between live and mediated formats in performance fascinates me, the visceral and the virtual – the immortality and mortality of both forms. Artists are starting to act as collaborators on technological prototyping and using technology in incredibly innovative ways. I am not interested in work that is 'technology led' – it always has to be about the content – what is the story? The contact and communication which is at the heart of both live and mediated forms is safely yet always provocatively positioned on a solid and quintessentially human foundation.

Q – You have worked as an artist extensively in the UK and the USA. How do you think possibilities for the artists compare?

Helen – I think there is more money for the artist to apply for in the UK. Now the NEA has disbanded in the US there seems to be really slim pickings – in fact, I think a lot of US artists find more financial support for their work in the UK. On the other hand what the US does seem to have is better opportunities for artists within academic institutions. There are a few great artist research positions and artist professorships in some American universities, which are about the artist making work rather than simply teaching.

Q – What one thing would improve the quality of your artistic life?

Helen – Ideally? A rent–free existence. Realistically? An administrator.

Q – What keeps you making work?

Helen – Different things kick in at different times. Sometimes it is pure wilfulness, at other times the overwhelming desire to make a particular project happen – a gut instinct that is not going to go away until it has been made. Being open to the work taking different forms as directed by the story I want to tell – so sometimes it might be a live performance and other times it works best as a film or a web piece.

Q – What are your three top tips for the emerging artist?

Helen – Put the work first. Never undervalue the importance of your role as an artist in the world and what you have to say. Believe in your power to move, to make a difference, to communicate.

Q – What next for Helen Paris?

Helen – You mean there is life after formatting this book? Next I start work on The Seaside Towns Project which will exist as a documentary, a novel, a website and a performance/installation.

Guillermo Gómez–Peña

Guillermo Gómez–Peña's text in this section was extracted from a longer interview conducted by Lisa Wolford in Aberystwyth, Wales, May 1999.

Q – How did you start out?

Guillermo – I was very influenced by the grupos in Mexico City in the 70s, the interdisciplinary collectives of the generation prior to mine. Felipe Ehrenberg was one of my godfathers. Very much in the spirit of the times, his generation created interdisciplinary collectives and utilized the streets of Mexico City as laboratories of experimentation, as

galerias sin paredes, galleries without walls. At the same time in the late 70s when I moved to California, I was surprised to find that there were also many Chicano collectives, such as ASCO and the Royal Chicano Airforce. It was the spirit of the times. I think that the spirit behind it was a kind of utopian impulse, believing that to share visions, resources, and efforts could only multiply the impact of art in society. Also, the belief that collaboration is a form of citizen diplomacy, which later on became the original impetus behind BAW/TAF. If a multicultural, multiracial, cross–generational collective can in fact function in the real world, then maybe it's possible on a larger scale to sort out our differences and cultural conflicts. BAW/TAF believed at the time that if Chicanos and Mexicans, men and women, people from different generations, could in fact sit at the same table, then this would send a strong signal to the larger society that it was in fact possible to communicate across borders, to engage in cross–cultural dialog. I think that it's this kind of utopian impulse that has led me to work in a collaborative manner.

Q – As an artist with an equally strong solo identity, how did you negotiate these collaborative relationships and projects?

Guillermo – I think that this very utopian impulse I'm talking about carries its own seed of destruction, the fact that no matter how hip and progressive we think we are, we inevitably end up reproducing autocratic, separatist behavior ... It's basic human nature. If you work within a collective devoted to cross–cultural or cross–gender dialog in an effort to create a more enlightened model of racial and gender relations, trying to deal with these issues directly, in this very quest it's possible to end up hyperintensifying the problem, and being devoured by one's own utopian dreams.

Q – How is your current group Pocha Nostra organized?

Guillermo – The structure we have found that really works is very simple. You have three core collaborators, Roberto [Sifuentes], Juan [Ybarra] and I, who are involved in most of the performance projects. And Nola Mariano, of course, our beloved agent/manager and holy protector of our backs in the mean streets of the art world. It's like the first circle, the flota, so to speak. I still do some solo work, but it's really a small portion of the work we do. Then we have this outer circle of people who are involved in about half our projects, and who still have their own work outside. And then there is a third circle of people involved in specific projects. It's only for the major projects that the whole community comes together, and then once the project is over people go back to their own territories. This model of collaboration works very well. I don't want to romanticize it, because there have in fact been some minor problems within the group and I'm willing to talk about them, but I would say it works marvelously. We all respect one another, and we never have major fights. We are very close friends, but we never get too involved emotionally. We have all managed to maintain our friendship for years, and to be both very close friends and respectful

collaborators, so I think we are onto something. Still, there are incidents. Sometimes the temperature among the group involved in a project gets hot and the shit hits the fan. But through dialog and performance strategies, we manage to work things out. Another occasional problem is the fact that our extremely irreverent working methodologies don't necessarily jive very well with people who come from highly trained backgrounds, especially actors and dancers. So a lot of wonderful collaborators go crazy when they are in the room with us. They want more discipline, they want more rehearsal time, and less blah–blah. But we end up pretty much resolving these potential tensions. You know, when conceptual artists who use performance as a strategy get together with trained performers, major negotiations have to take place. It's inevitable. We now allow for the coexistence of a multiplicity of methodologies and preparation methods in our performance.

Q – Has it gotten easier to get your work funded over the years?

Guillermo – There are some difficulties. Mainly because I carry on my shoulders the sole financial responsibility for Pocha Nostra, and that is a problem we haven't been able to solve, a sort of paternalistic structure which can become a drag. When the shit hits the fan in terms of money, understandably, no one is there to help. I have to face the IRS. I have to go to the lawyers. I have to get out of debt. I have to go on the road as a solo performer for a couple of months to bring back money and pay our debts. But I assume full responsibility for not preventing this problem. Pocha is currently embarked on a process of reinvention in an attempt to decentralize this model after all these years, by demanding that each and every collaborator assumes more financial, creative, and political responsibilities. That has been a sour point for some members, the fact that I become 'Dad' in many ways. And believe me, I hate that patriarchal position of being the primary financial provider for the whole operation. But we are figuring out ways to decentralize the operation successfully. Next year is going to be an entirely different ball game. That has been one problem. It's very hard to talk about it, because every time we talk about money, everyone gets very quiet and politely disappears from the room.

Q – You are based in San Francisco – how important is this to your work?

Guillermo – In the last two years, San Francisco has turned into the center of virtual capitalism, the Mecca for the much touted 'new global economy.' The greed of our mayor and his macabre court of redevelopers has caused rents to skyrocket overnight, and artists are getting evicted left and right. The whole San Francisco bohemia is at risk of extinction, and this of course is causing tremendous financial hardships for the local art scene. People are less available to work on non–commercial projects because they need to take jobs outside the art world to be able to make enough money to remain in the city. Also, artists are increasingly less willing to participate in socially minded projects, because the Darwinian ethics of the dot com industry are also being internalized by our own

communities. What is probably saving Pocha from financial disaster is that we don't depend on the city financially. A large part of our income is from touring and from projects that we do outside of the city, or from my solo work. Also, we are developing a very tight administrative structure. We finally received our non–profit status. We now have a business manager, a grant writer, a board of directors, the whole enchilada. It's a drag, but it's necessary to outlive the times.

Q – Do you think there is less Grrrrr in the guerilla in this 'new global economy'?

Guillermo –Roberto and I come from activist backgrounds. Our work in the public sphere is completely connected to our work on stage. To do a benefit for La Galeria de la Raza or for a farmworker organization is as important for us as to perform for the Walker Arts Center or the Corcoran Gallery, if not more so. To do a workshop with Latino youth at La Peña or at MICA [in Montana] for Native Americans is as important as to go to an international performance festival. Roberto understands this because he comes from a family of Chicano activists, and I understand it because I have been politically active for years. The thing is that Roberto and I are very good animateurs and coordinators, but very bad directors in the traditional sense. We can get things going. We can spark energy. We can mobilize people and engage them in exercises of radical imagination, help them develop their own material, but we cannot 'direct' and we don't want to. 'Directing' implies authority, and not necessarily moral authority, and that we don't like. Because we do interdisciplinary projects, our working methods are interdisciplinary as well. We are not just a performance troupe or an ensemble. We also make videos, radio pieces, organize political town meetings, write books, and so on and so forth. And each metier, language, genre and/or format demands a different set of strategies and methodologies. Besides, most of these territories overlap in our work, so we have to be able to combine, sample, and pick from them all. But that is not necessarily the case for our collaborators working in particular realms, who demand more discipline specific methodologies.

Q – How would you describe your work – art? performance? guerilla warfare?

Guillermo – After twenty years of crossing interdisciplinary borders, I have managed to get good at it, to somehow solve this crisis of professional identity. No matter what I do outside the realm of performance, whether it is recording a radio commentary for *All Things Considered*, teaching a theoretical class, or organizing a town meeting, I try to do it from the positionality of a performance artist. Conceptually I always occupy a performative space, and my voice in that particular realm is an extension of my performance voices. I think this is one of the spooky byproducts of globalization. The more globalized the world becomes, the more unable we are to communicate across borders. But at the same time, performance artists have become extremely savvy linguistic alchemists. We understand the importance of cultural context and translation in the shaping of a message, and we know that art does

not necessarily translate to different contexts and audiences in the way the art world wishes us to believe. As artists constantly presenting work in different communities and countries, we know this very well. We know that the meaning of our actions and symbols changes when crossing a geopolitical border, sometimes dramatically so. And since Roberto and I are hyper aware of not letting ourselves be exoticized, since artists of color have suffered exoticization for so long, we want to make sure that something of the context we're putting into place to frame our work does translate. We operate as border semioticians. So our performance strategies are different, for example, when we perform in Mexico as opposed to working in the US. The proportion of English and Spanish shifts. The amount and nature of humor shifts, the notion of transgression. The positionality we assume within the work shifts. We can be more formally experimental or more sexually explicit. In certain circumstances, we have to do pieces that aren't language–based.

Q – How much have you had to adapt your performance persona for national media?

Guillermo – I have developed an interesting consensual agreement with my editors at *All Things Considered*. They understand the uniqueness of my voice: I am first and foremost a performance artist who also happens to be a cultural critic, as opposed to a performance artist trying to impersonate a journalist. They like that uniqueness, the fact that I speak as a performance chronicler. At the same time, I understand that I have to mimic the format to a certain extent. If I'm too experimental and too crazy in one of my radio pieces, I know that my editors will call me back and say, 'Gómez–Peña, it doesn't fly. It's too weird.' There is a constant negotiation, and I don't always win. The same goes for our work in TV. When we try to do a project for PBS, we know the genre very well and we know how far we can push the envelope, versus doing a project for German TV or for cable. The obstacles are different in every case. The envelope that we need to push is different, and the strategies we use are different as well. In order to operate in multiple realms and cross over with dignity into more populist domains, we have to be pop cultural semioticians before anything else, even before we are performance artists, otherwise we are out of the game.

Q – Any advice for emerging artists?

Guillermo – I know so many performance artists who work in a very rarefied, laboratory way, and then one day they decide to bring their pieces to the streets, because there is something romantic and tough and urban about bringing your work back to the streets. But people on the streets are very tough with your work. If the work is not strident enough, not iconic enough, not clear enough, it becomes invisible. If it's too rareified, people kick you in the ass. People leave or spit at you, and then you get heartbroken. Every context demands a different set of strategies of communication and presentation in order to be effective.

Nancy Reilly McVitie

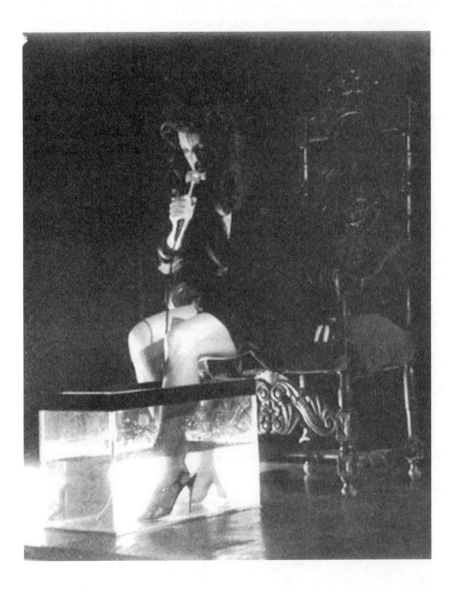

Q – What made you want to be a performer?

Nancy – High school plays . . . At sixteen my friend got killed in a car accident, sniffing glue and driving. I was in the high school play, playing the Mother in *Barefoot in the Park*. I was in first degree pain, I didn't go to school, just ran around the city all day, but at night I went back and when we did the play I forgot about her. When it was over I remembered.

Q – How did you start out?

Nancy – I did a degree in theatre, drifted around Mexico and Arizona, writing and hanging out, finally went to New York to be a playwright/poet. I ran into the Bunch Festival, which exposed me to Foreman, LeCompte, Mabou Mines, Chaikin, Monk. I was totally inspired to work like that ... so I auditioned for *The Balcony* and Richard Schechner put me in his new company which included, Phoebe Legere, William Dafoe, Peyton Smith, Sascia Nordavick and provisionally, Will Patton.

Q – How was The Wooster Group formed?

Nancy – It evolved from The Performance Group. Richard went to forge Performance Studies at NYU and handed Liz LeCompte, his brilliant protegé, the keys. The keys to it all, the building, the administration structure, the performers who were mostly working with her by this time anyway, with the exception of Nordia, Will Patton, Phoebe Legere, and myself. So I was there during the transition.

It took me a while to get Liz to see the importance of me working with her. Even though I was best friends with Peyton and Ron who were in the start of the formal company and I had a lead role in *The Balcony* with Richard, she just didn't twig. I was very persistent. But it wasn't just personal ambition, it was neo–religious, her work totally inspired me ... every image, the structures, the news eyes on O'Neil and Wilder. I probably feasted on *Point Judith* and *Route One and Nine* over 100 times a show. When she did call me up and ask me if I wanted to go to Europe with her to make *North Atlantic* I told her she really shouldn't kid a kidder. Again, the formation of the Wooster Group was nested in the dissolution of the Performance Group, there was an administrative structure, real estate/The Garage, and a board, which was recreated, all those things were there either to use directly or to model on, adapt, and change.

Q – Did you have an agent or an administrator?

Nancy – Liz works with an office staff of three. Each takes a slice of something, the bookings, fundraising, advertising, running of the Garage, grant writing. But remember, the Wooster Group owns and operates it's own performance space for half of the year. Real

estate has been key in securing the radical work of both Schechner, LeCompte, and Gray, and others who are supported through the Visiting Artist's Producing Series, including myself with my own work.

Q – What was it like working together?

Nancy – Monstrously engaging.

Q – What do you think were the most significant factors that contributed to the success of the company?

Nancy – It's definitely property before genius. Real Estate was prime. It was great foresight for Richard to get a producing venue in SoHo before the prices went through the roof. Liz's adept managerial savvy increased the power of its life–giving properties.

Timing, the alternative lifestyle scene of the late sixties helped to form a group structure that was communal. Talented, creative people responded well to working in that kind of an alternative theatrical configuration. After all, the agent, headshot, Off–Broadway show alternative is really corny and cheesy way to live as a radical.

Genius and Talented support – there was a genius at the helm of the Performance Group and a genius is still at the helm of the Wooster Group. This isn't being sentimental it is the power of the thinker that makes the power of the work. Spalding gets up in the morning too. Ron Vawter, he was the most gifted, glorious muse I've ever seen bring ideas into performative dimension, and then the others, Kate Valk, Whilem Dafoe, Peyton Smith, Mike Stumm, Jeff Webster, Anna Kohler, Jim Clayburgh. These were people during my time, but Liz LeCompte is still working at full stride surrounding by genius and new talent.

Q – Which do you find more guerillerish, working on you own or working with a group?

Nancy – Of course the answer is double–sided; in one way the most radical conceptual moments were spent under the spell of my adoration of Liz's mind, eye, and theatre

practice. It certainly culminated in *LSD ... Just The Highpoints ...*

The innovation in composition form and the profundity of political inquiry stretched the excitement of potential into inspiration, not with myself but with the compositional dexterity of my colleagues, especially Ron Vawter and Liz LeCompte. I also experienced radical moments of performative knowledge working with Ron and Spalding in *The Balcony* under the direction of Richard Schechner (who I must say was a radical influence in my formative thinking about perimeters of performance). When I went to New York I wanted to be Samantha Shepard, after I experienced Schechner and the radical practice and advice of the fantastic performers Spalding Gray and Ron Vawter; I knew that I was

suffering a dose of nineteenth century ambition.

I do think LSD was a lyrical moment of guerilla free fall; it was the grand grammar of American mythic failure dancing around the restless inconclusiveness of perception. Personally, I was also terrified of my task–oriented performing responsibilities in such a complex piece. Liz is a resolute technician when it comes to performance behavior and I just really wanted to muse on the conceptual turning points of American history that she had strung together and then strung out without mercy. Consequently, I think my guerilla

moments that offered the most ephemeral mind jarring cropped up in the hours I spent watching her pieces before I was ever in them. Memory sticks on the vicious unfolding of irreconcilable racism trapped and ugly in the elegant multimedia form of *Route One and Nine*. Spalding's early monologs certainly pushed the boat out from the shores of my theatrical/performance expectations.

The radical moments of my monolog work and the few group pieces I devised were very different. The guerilla smirk broadened every time I climbed on a plane to play *The Gangster and the Barmaid: An Inch of Pennies*. It was vengeance with the experience, but that had a cybernetic loop. Playing the barmaid made me back track over the dead–end territory of pseudo whorey nights in a Wall Street tit bar. Not quite the lofty conceptual heights of the LeComptian Universe, at least those watery Wall Street revisitations were only an hour long and not six shifts a week (due to the untimely cost of illicit substances in the eighties). Playing on my own was existentially chilly ... filled with ghosts. It certainly took too much guts to read the reviews in foreign cities. I didn't move with a team, I just went and did it. My own private apocalypse nightmare in which the rest of the group died and I was forced to replay the sleaziest and most fascinatingly nerve shattering way I ever made a buck, fictional or nonfictional ...

Q – How much of a problem was it getting your work funded?

Nancy – If you are referring to my own work, I was funded to produced three full–scale multiple person performance pieces. I was funded to produce my monologs. Both funding sources were small grants or commission money. I quit making work because the funding structures coming my way in contemporary performance were too meager to support my desire for children. I also found it stressful to live freelance. The Wooster Group funding is applied for on a yearly or bi–yearly basis; they have had their funding withdrawn in the past due to the radical nature of their political content. They have relied on people in the company working on incredibly low levels of pay or on working voluntarily. I haven't been there for ten years now but since I left there has been further erosion in NEA subsidies. It is always a struggle. That's why there is such a brain drain into film and media work, and most people in performance work are claiming some relationship to dual basis for their which might help the lifespan of contemporary performance or just erode it. Personally, after many years, I just lost imagination for the lifestyle on that economic lifestyle, and I really prefer new media, thinking or writing work now.

Q – Can fund raising be a creative or guerilla act?

Nancy – Yeah, you can get a balaclava and a gun and rob a bank. Go to jail and make work out of the experience, or write a best seller. Seriously, I am sure it can be but I have no imagination for it.

Q – What has kept you going in times of struggle?

Nancy – Vision, ambition, drive, love of the work. Love of a bohemian existence.

Q – Tell me a happy story about your life as an artist.

Nancy – I got to play with Ron Vawter and Liz LeCompte.

Q – Tell me a sad story about your life as an artist.

Nancy – Steve Borst, Ron Vawter died prematurely of AIDS. Kathy Acker of double breast cancer, and Michael Kirby of blood cancer.

Q – You've been based in the UK for several years now – how does living and working in the UK compare to living and working as an artist in the US?

Nancy – It's hard to compare because I ran away from life in New York to England. I was tired of it; I changed career structures from performer/devisor to full–time lecturer, got married to a fantastic person, and had two kids. I have a mortgaged garden now but I don't have rehearsals every day with a parallel British contemporary company. You know what they say, the past is another country they do things differently there. That's also literal in my case.

Q – Are you tempted by the possibilities of purely mediated work?

Nancy – What I say to it is 'You gotta live kid.' I keep writing too but I love Internet performance work; it's cool, the commitment time is great and you don't have to live in the city.

Q – Does it feel harder to connect with audiences on a CD–ROM or the web than in actual geographical venues?

Nancy – I don't know that.

Q – Any advice for a penniless performer who wants to set the world on fire?

Nancy – Move to a city and don't get your matches wet. Somebody has got to do it. With persistence it can be you but don't expect a middle class lifestyle unless you're privately funded.

Q – What's the most useful thing you've learned in the last three years?

Nancy – Cyberculture – cyberstudies – artificial intelligence awareness … And how to live with the death of my friends.

Q – Where to next?

Nancy – America or Spain.

Vanessa Richards, Mannafest

Q – How would you describe your work?

Vanessa – Expansive.

Q – Your work spans several diverse cultural perspectives as well as disciplines including carnival, performance poetry, music, new technologies. Do you see this as a strength in terms of receiving funding/getting gigs? Does it allow for more guerilla type approaches to marketing and funding?

Vanessa – It allows us to be mobile and fluid. The work has been funded across a number of departments from Combined Arts, to Music, Literature, New Technologies, Education and Access, and Youth Arts. Get in where you fit in. In terms of gigs, often promoters who have not seen the work have a difficult time conceptualizing what the shows actually are and how they fit in to their programing ethos. Even if you have been very clear in your proposal, if they have not seen anything like it, they have no reference. For the most part we are not looking for gigs but producing our own events and hiring venues. However, something like the Mango Lick UK Tour 2001 was an event that was programmed into venues. It took a leap of faith for programmers to understand what kind of event it was they were booking. As most established venues programme so far in advance, in order to book the tour much of the pre–show publicity had to be written before the show was actually birthed. What promoters had to grasp was the type of artists they were inviting and the kind of cross arts work we do. Describing the Mango Lick before the collaborators add their flavour is akin to discussing a themed potluck dinner before the guests have brought their dishes. I could tell you the setting, the time, what people have been invited and asked to bring but I can't tell you exactly what they will come with. The magic comes when it all gets laid out and the feasting starts. Symbiotics always come into play and make the unknowable perfect when it appears.

Other times we are invited to read our poetry in a much more straight ahead fashion. This brings a tight focus on the language and brings us back to the genesis of our work. However, we will often invite our musical director Marque Gilmore to accompany us with his rhythms and soundscapes.

Q – Do you feel there is the tendency for funding bodies or venues to try to categorize or pigeonhole your work, resisting its diversity?

Vanessa –Recently I was speaking with Kim Evans, Executive Directors of Arts at the Arts Council of England, and she commented that when they were discussing our last award

they found it very hard to categorize the work Mannafest does. She thought that this was a positive predicament. For the most part I agree but there are advantages and disadvantages this poses. Booking our last tour, The Mango Lick, it was extremely evident that only the most visionary of programmers could see how our work fit into their agendas. There are many areas of life that are harder to define but sometimes that is exactly as it is suppose to be, particularly in terms of making new work. We forge ahead and explore to satisfy our curiosity and broad interests. We do not care to be impeded by definition. Right down to our genetic code Khefri and I are implored to mix and blend streams of culture and influence.

Q – How do you go about making a new piece of performance? Is the process drastically different every time or are there patterns to the way you approach a new piece? What comes first – the form or the content?

Vanessa – Khefri and I are creative partners as well as committed friends. We have a lot of things to talk about. We are inspired by our ongoing interest and pursuit of well–being. This could be esoteric, physical or sociopolitical well being. Much of our work is collaborative, meaning that we are often working alongside artists who have differing methodologies and creative priorities. This gives us plenty of opportunities for new insights and approaches. Generally what we want to say or discuss instigates the idea for how the work can be made. The form is dictated by current interests, collaborators and availabilities. We respond to the initial impulse of the ideas and investigate appropriate forms after we have fleshed out what we want to say and how we want to express this. Sometimes the form is the idea. We wanted to create a space for critical

conversations and new technology so we devised *HeadRush* as an exploration of how new technology could encourage the development of our spiritual and social development. Architects, film/video makers, poets, musicians, visual artists, academics and cultural critics gathered for a weekend of panels, performances, exhibitions and a film/video festival to disseminate their ideas around this theme. *Sweet Shockout* married traditional and modern

Carnival elements. For the Carnival season Mannafest and our team of associated musicians did a remix of a rapso song by Trinidadian musicians, 3 Canal. We also introduced young rappers to an old time Carnival verse style called 'Robber Talk' in a series of workshops. They delivered their new lyrical fusion in concert with Ebonysteelband playing garage/ hiphop and R&B.

We wanted to express how Carnival history was relevant to today. We demonstrated how contemporary artists could use this history to reclaim Carnival back from the solely commercialized street party it has become. Carnival is cathartic street theatre born of resistance and liberation. It is not totally appropriate that this is subsumed in superficial representation and indulgences. However, there is an element of frivolity and bacchanal that is inherent and necessary in Carnival, nonetheless, but the two excesses are not the same. There is a movement of artists across the Diaspora who are committed to maintaining, resurrecting and developing the exquisite grace and beauty of Carnival and working with that political and spiritual energy. So in the case of *Sweet Shockout* we created a series of works that fed into our initial impulse of wanting to express these concerns.

When I made my first film, 'Travelling Light', the Poetry Society had commissioned me to work with new technology and verse. In this case it would appear I had the form before the content. However, the film's idea was consistent with an ongoing dialogue I have been creating around migration and identity. The new form served to reshape a constant theme of our work.

Q – What is the most significant support you have received for your work – either funding or support in kind or verbal, etc.

Vanessa – 2000 was a very good year for us as we received two major financial boosts from The Arts Council of England and The London Arts Board in the form of a major award and fixed term funding. Both of these organizations had in the past supported the work with project funding but a company cannot stabilise a foundation with that kind of income alone. To support the company we took on other commissions, educational projects and consultancy work which was rewarding but exhausting. So we are pleased to have the support that allows us more breathing space and resources to bring the work up to the next level.

We have always been blessed to be surrounded by enough believers. Sometimes this just meant Khefri and I talking clearly to each other but we have had much, much love from many, many people. Our families have been especially faithful in their encouragement and belief in the work. That alone is half the battle and double the strength.

Q – In the last few years there has been a noticible movement of people from live theatre into mediated formats like web and video. Do you think it is just a phase we are going through?

Vanessa –Everything we go through is a phase and one needn't judge that as good or bad, it just is. It is the process of discovery. I suppose some people will continue down that path and others will return to their first discipline while others will allow their explorations to lead them even further afield of where they started. It's all good as long as you do what you do with integrity and if you don't, that's fine too as long as I don't have to watch.

Q – What advice do you have for artists involved in interdisciplinary work? Are there certain marketing strategies you would advise?

Vanessa – Spend time getting your promotional material right. Make it look good, very good. You will betray the work and yourself if you spend all that time getting the work ready and then offer up poor visual representation. It is the only image some people will have of the work before they see the show, if they see the show, so make it count. Make relationships with press and media people who could profile the work on the radio, in print or the Internet. A simple call will tell you who does what at any paper or station. Community radio is particularly invested in supporting 'unfamous' artists. Make clear and interesting press releases. Have good images for print/internet media. Develop a mailing list and keep it up to date. Try and enter it into a data system as soon as possible cause working off of scraps of paper is a pain and most people's hand writing is barely legible and you will regret having to translate the same scrawl every time you want to do a mailout. Mailouts should be both land and email. Give out flyers at places you think your target audience will be. You can do it yourself or ask people who care about the work to. Whoever is handing out flyers must have knowledge and enthusiasm about the show.

Be very clear about what promotional work the venue or commissioning body has in place. Do not expect them to understand the work as well as you do or know how to access your audience. So work with them from the start and establish what both sides will do to bring in media support and audiences.

Q – Could you tell us a little about how your apply performance approaches to community/education projects?

Vanessa – Mannafest has worked across a very broad range of creative learning environments. The first thing to try and do is establish trust and enthusiasm with the group in order that participants be willing to move beyond what they thought they could do. It's also important to give clear direction as to why and what you are trying to achieve or explore. We generally start with the idea of getting participants to write authentically

and creatively. What happens next with the text could be anything from dancing it or to it, vocalizing it in extreme manners, creating new environments for performance, collaborating the text with another participant or just getting an honest and open vocal interpretation of the original impulse to write the piece. We have had young people, inmates, elders and corporate conferences using language as a base for movement, drama and sound expression and it is always advisable to leave room for happy accidents and inspirations that happen in real time and can't be planned for. One only hopes to always create a space for the wonder and the oneness of human nature self expressed.

Q – What are the three top tips you would give an emerging artist/company?

Vanessa –I would like to offer four:

Organize your information. Projects are far less daunting when you have at hand all your contacts for artists, venue, suppliers as well as your tech requirements, contracts and scripts. Give contact sheets to all involved. The time investment will give you so much more ease and confidence. It encourages people take you seriously if you have your act together.

Believe in the idea. One's initial impulse can feel overwhelmed by development ideas and details. Allow the newness to take shape and influence the work but remember WHY you wanted to make the piece in the first place. That can help keep the work fresh as it goes down is transformational path.

Hire the best available. From collaborating artists to tech teams, gear, admin support and PR, get the best you can access and then treat them well. If budget is limited trade, barter, or defer payment but most importantly engage the invited person in the magic of what you are creating. Everybody wants to be a part of something that is surrounded with goodwill and intentions. Many folks will take less than their usual rate if you allow them the space to be creative and valued within a clearly defined agenda. Again this is much easier when you have all the necessarily information at hand for people to get on with doing their best.

Learn to write a good proposal. Then deliver it with integrity. If you haven't tried for funding before don't be intimidated by the process. Ask someone with experience to help you. People who work in whatever art spaces, theatres or centers you work in or frequent will have experience with some kind of proposal writing. Ask them or the funders themselves to guide you through the process. Remember these organizations need artists to stay in work. Proposal writing can help clarify an idea or project in a way that would surprise you. Explaining and validating the work is empowering. Learn the language they speak and flip it on them. Develop relationships that are honest and personable with these people. They want to like their jobs. Empower them like you would any other person involved in making your work come to light.

Rachel Rosenthal

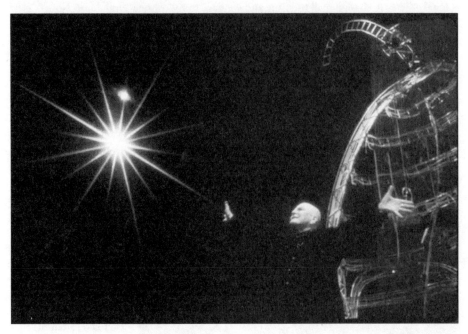

Q – What made you want to be a performer? How did you start out?

Rachel – I was a performer since I was three. Loved the attention, and was good at it.

Q – How was your company formed?

Rachel – I've had many companies since Instant Theatre in 1956–66, in 1976–77, and in 1989, 1994, and now, the Rachel Rosenthal Co.

Q – Did you start a formal company? Do you have a board and all that?

Rachel – Yes, since 1989, a non–profit organization with Board, etc.

Q – Do you have an agent or an administrator?

Rachel – No.

Q – How different are the funding infrastructures now compared to twenty or thirty

years ago? Are things getting better or worse?

Rachel – They're changing all the time and we have to follow new guidelines. Now, it's the presenters who get the dollars, not the artists. Emphasis is also on 'outreach', not the art itself.

Q –Do you think artists today feel as empowered as they did in the 60s, 70s or 80s?

Rachel – No.

Q – How much of a problem has it been getting your work funded over the years?

Rachel – I've been lucky.

Q – Can fundraising be a creative or guerilla act?

Rachel – I advocate that for my students.

Q – What has kept you going in times of struggle? Did you ever think about getting a day job?

Rachel –Never a day job. Major hustle. Also I've had the luck of having moneyed friends who bailed me out.

Q – What do you think are the most significant factors that contribute to the

success of your company?

Rachel –The success of my company, I assume, I think – good work, professionalism, and dedication.

Q – How do you go about making a new piece of theatre? Is the process drastically different every time or are there patterns to the way you approach a new piece?

Rachel – I always approach through reading research. My pieces are about things, and I need deep background. Also, I had deteriorating knees and relied more on text than on movement, after the 70s I tried to make each piece very different from others and unique.

Q – Does it feel harder to connect with audiences on a CD–ROM or the web than in actual geographical venues?

Rachel — I'm at my best in front of a live audience. But I have a website, videos and books. Still, they are all derived from live work.

Q – What's the most useful thing you've learned in the last three years?

Rachel – That I was unfortunately right about everything. In the global issues domain. The twentieth century set us up, and we're reaping what we sowed in the twenty–first. And that's not a pretty sight.

Q – Any advice for young artists?

Rachel – Art isn't something you choose to do. It chooses you. If you have the calling, you must follow the road, no matter what, or you're in deep trouble. The rest is easy: marketing, techniques, connections, whatever. The hard part is not getting discouraged. Art is its own reward.

Q – Any advice for old artists?

Rachel – Bravo, brava! Keep on trucking! The Universe loves you!

Q – Where to next for Rachel Rosenthal?

Rachel – No more performing and touring. Will continue teaching and lecturing, but shift my art to painting. Will also write.

Stelarc

Q – Do you think that some of your work – I'm thinking specifically of the 'Suspensions' pieces – has a definite 'Guerilla' flavor?

Stelarc – After the first suspension attempt at the Experimental Art Foundation in Adelaide, which attracted lots of media attention, I decided that these performances had to be done away from the public eye to succeed. The media had been primarily responsible for all the pressure put onto the Experimental Art Foundation to cancel the suspension event. So for the next thirteen years these were done in private gallery spaces or remote locations often without any invited audiences. Only the people assisting witnessing the performance. There were exceptions though. The two suspensions in city spaces became very public. That was inevitable. Got arrested in NY for being a danger to the public (had I fallen onto someone, ha, ha). It was between buildings over E. 11th Street. A 30–min performance only lasted 12 after police intervened. With the Copenhagen suspension when the body was hoisted up and swung around by a large crane about 60 meters up we did get permission to do it. The police actually assisted. We had to convince the union to allow two crane drivers to participate. We had to get permission from the Director of the Royal Theatre where the crane was set up. I guess over 10,000 people saw that one live. But these were the exceptions.

Q – Do you think artists today feel as empowered as in say the sixties or seventies?

Stelarc – It's not been an issue for me. I've just kept doing performance. But my actions were never really social or political statements. So these actions were hit–and–run, but not deliberately meant to provoke, nor were they meant to shock. At least not immediately. In the Seaside Suspension, the only people who saw the performance were a group of fishermen on another outcrop of rocks. In the last suspension event from the monorail station in Ofuna, only people in trains going by might have caught a glimpse. And the occasional person who happened to be walking past on the street. Oh, and is it about feeling or being empowered? What happens with me is increasing the feeling of insecurity and the experience of the involuntary and the alien.

Undermining convenient notions of identity and agency ...

Q – Are you surprised by all the attention your work has received from academics writers? In some ways your work seems to become a conduit for a new kind of digital performance theory focusing on technology and the body.

Stelarc – I don't think this stuff becomes representative for a new kind of performance theory. But certainly there are issues of Cyborg discourse that are touched upon by these performances. It's not enough for me to brainstorm and speculate in a kind of sci-fi way. The strategy is to construct and perform with intimate interfaces that are experienced and then articulated. Ideas need to be authenticated by actions. You have to take the physical consequences for your ideas.

Q – How much of a problem has it been getting your work funded over the years?

Stelarc – Funding has always been difficult. The Australia Council twice turned down funding requests for the Third Hand. I spent about $20,000 of my own getting it prototyped way back in the late 70's. The Extended Arm was researched during an Australia Council Fellowship but it was finally constructed with my own money. The Movatar motion prosthesis constructed last year cost me $10,000. But I was fortunate in Hamburg in 1998 to get substantial funding from Kampnagel, a performance space, for Exoskeleton. And all the pneumatic actuators and valves were sponsored by SMC. That turned out to be a $75,000 project – but it was a 600 kgm walking robot, ha, ha. We have been most fortunate this year though to get substantial funding from the Wellcome Trust. That is being matched by Nottingham Trent University and

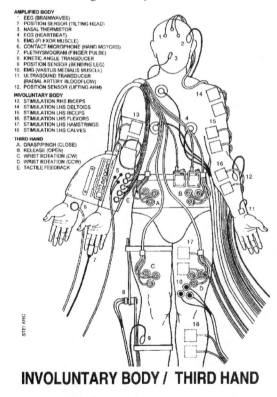

AMPLIFIED BODY
1. EEG (BRAINWAVES)
2. POSITION SENSOR (TILTING HEAD)
3. NASAL THERMISTOR
4. ECG (HEARTBEAT)
5. EMG (FLEXOR MUSCLE)
6. CONTACT MICROPHONE (HAND MOTORS)
7. PLETHYSMOGRAM (FINGER PULSE)
8. KINETIC ANGLE TRANSDUCER
9. POSITION SENSOR (BENDING LEG)
10. EMG (VASTUS MEDIALIS MUSCLE)
11. ULTRASOUND TRANSDUCER
 (RADIAL ARTERY BLOODFLOW)
12. POSITION SENSOR (LIFTING ARM)

INVOLUNTARY BODY
13. STIMULATION RHS BICEPS
14. STIMULATION LHS DELTOIDS
15. STIMULATION LHS BICEPS
16. STIMULATION LHS FLEXORS
17. STIMULATION LHS HAMSTRINGS
18. STIMULATION LHS CALVES

THIRD HAND
A. GRASP/PINCH (CLOSE)
B. RELEASE (OPEN)
C. WRIST ROTATION (CW)
D. WRIST ROTATION (CCW)
E. TACTILE FEEDBACK

STELARC

INVOLUNTARY BODY / THIRD HAND

Sussex University who were responsible for the grant application. I'm presently Principal Research Scholar in the Performance Arts Digital Research Unit there. So Barry Smith, Live Arts Archive, TNTU, and Inman Harvey, Cognitive and Computing Sciences, Sussex, were essential in securing the funding.

Q – Do you have an agent or an administrator?

Stelarc – Nah ...

Q – What has kept you going in times of struggle? Did you ever think about getting a day job?

Stelarc – My dad always wanted me to get a real job, ha, ha. Oh, I would enjoy teaching but not a fixed and daily schedule. There is less and less flexibility for practicing artists who also have to teach for a living. But Carnegie Mellon University and now TNTU has been very understanding about the necessity for pursuing my projects and the flexibility required for that.

Q – What advice would you offer to an artist who has made one fairly successful performance with regard to the next one?

Stelarc – It's not a matter of stringing together successful performances. It's a matter of maintaining some sort of trajectory of exploration.

Q – How do you go about making a new piece of work? Is the process drastically different every time or are there patterns to the way you approach a new piece?

Stelarc – Well, it is different each time. Sometimes there's an idea you've played around with but support or funding comes years later. Sometimes the project demands a combination of skills and expertise in different media and you need collaborative assistance. Other times with very little money it somehow comes together in a very short time. The Stomach Sculpture was constructed with the assistance of a jeweler and a microsurgery instrument maker. It was completed within a few months with very little funding. That project was prompted because the theme of the Fifth Australian Sculpture Triennnale was 'site–specific works'. So instead of a sculpture for a public space, one was designed for a private, internal physiological space.

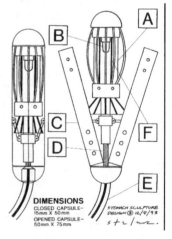

DIMENSIONS
CLOSED CAPSULE–
15mm X 50mm
OPENED CAPSULE–
50mm X 75mm

STOMACH SCULPTURE
DESIGN © 12/8/93

Q – How has digital technology informed your work?

Stelarc – The Virtual Arm Project, a phantom limb actuated by a pair of Cyber Gloves, Fractal Flesh people in other places, through a touch–screen interface and muscle stimulation system, able to access and actuate your body remotely. Ping Body, where the body becomes a barometer of Internet activity and Parasite, where a search engine optically stimulates and electrically activates the body. The images you see are the images that move you. The net as a kind of external nervous system for the body.

Q – What do you feel you really got right in your work?

Stelarc – Oh, I never feel I get anything right in these projects and performances.

Q – Any advice for new artists?

Stelarc – I guess to persist, be opportunistic and operate intuitively....

Q – Where to next for Stelarc?

Stelarc – The Extra Ear ...

Julie Tolentino

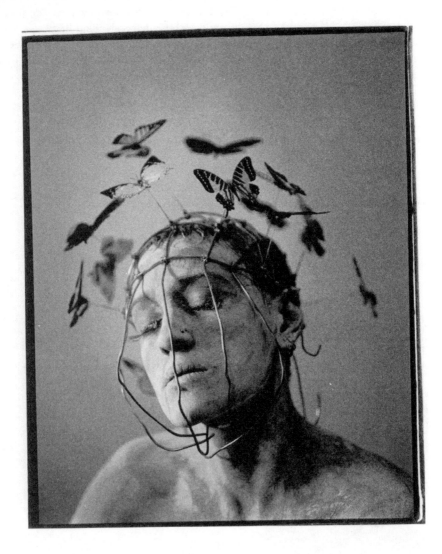

Artists in Profile

Q – What are the some of the guerilla strategies you have put into action in your career?

Julie – I consider everything I do as part of making work. For me, it is a radical challenge. The food I eat, the social time I carve out, the naps I take and the choices made during each and every day. Therefore, if you find yourself inspired at a restaurant, or while working a menial day job, you can find sources – and resources – at every turn. Guerilla Xeroxing, telephone calls, sneaky daydreaming, stealing latex gloves from the doctor's office, bartering resources, asking for frequent flyer donations, the usual prize set piece found on the sidewalk. Consider these accomplishments – not lowly means of self–support.

Performing in nightclubs has allowed me to experiment and explore, create audiences and new viewpoints for my work, even though the surroundings are never quite right – including the fact that my work is never quite on the forefront of anyone's mind. Dramatic, private and obscure information may be gleaned from these environs. Even if the WORK itself is not presented in full (as you wholly imagine), these alternative environments can tell you a lot about focus, vantage points of non–traditional viewpoints and performance space considerations, how our theories about the work play out. And you can get paid for your time when you work in a club, or before or after a band, or to support another event, cause, etc. If you have to do it for less than you prefer, get a big guest list and other perks so at least you can assure that you can have some feedback from a number of people who stay up late enough to come to see you. Because remember, they might not get to your performance in a theatre either so count your blessings.

Sharing my work as a contributor to other people's work also allowed me to work within my vision while also exercising the tasks of being involved in larger productions with more access or a larger audience or press machine. Make clear negotiations and allow the work that you perform to be billed and considered different than just the 'usual' collaboration. This work then can be 'yours' in other forms and spaces, as an outgrowth of the place that it was placed in your contributor space. Allowing rehearsals to occur in my kitchen can be both depressing and brilliant.

Q – You work both as a soloist and within companies – do you think that the solo artist in particular needs to adopt guerilla tactics?

Julie – Yes, learn from the 'big boys and girls' – get involved in the consideration of what makes an artistic environment to you. That is what artists with managers get to do. Be your own manager – ask yourself the question as the manager, and answer as the artist. And vice versa. Schizophrenic rallying allows you to see your diverse and often discordant needs. Let both people exist.

As a solo artist, I have had to rely more on my wit, willingness and find a gracious unprecedented trust that what I say is truth. When the thrust of the work is placed on your shoulders, often we can begin to identify what we do well and what scares us to death. Carry paper and pen with you everywhere. Feel free to conduct on–site interviews with anyone who inspires you. All mysterious information can be made available to you–if you ask.

Do not be afraid to create relationships between you and presenters, funders and arts administrators. Ask questions WHY if things don't go as planned – and especially when you don't get the gig, or the money, or the endorsement, etc. Of course, everyone is on limited time; it is hard to ask without regret or disappointment, but do know that there are so many places to explore by doing so. These conversations give information to presenters who spend a lot of time with their staff trying to develop understanding about what it is that artists make and how this work will strengthen their missions as well. Feel part of the larger picture in this way – when it goes your way – and when it does not.

Do not be afraid if you feel that you do not 'click' with someone. Find common areas of interest. Be firm in sharing who you are as a person – don't always feel you must sell yourself as a package. Artists are moving, living entities who shape–shift constantly and have creative roving minds, plans. But stay willing to be your own representative at the same time. Hold fast to the work, its needs – and continue to allow yourself the space to talk using your own language.

Don't fall into artspeak. Don't get small. This is a revolutionary state to be in, to work towards. It is not a place of aggression. Confidence is hard to harness. Learn to allow your idiosyncrasies, your ideas and your visions to be at the crux of your meeting points. Don't be precious. Presenters need you. Some need you to so they can 'sell' your work, and hopefully, most importantly, presenters need artists to understand what kind of climate, what discussion, discourse and argument is at the crux of your existence – and how it intersects with theirs and their audiences. Never forget this. Too often artists feel that their work, their identity is always forced to weigh against work that is currently being shown, toured or against other artists' visions. Stay on your own path and highlight the differences, as well as your influences.

Q – What advice would you give to artists in terms of arranging tours?

Julie – Decide WHY you want to tour. Examine the state that you are in. Are you an artist who has a body of work that you want to show and focus on? Are you building your vision and exploring? Do you want to just

perform? Do you need to make some money? Does the work that you are interested in presenting have a larger context that you wish to draw from? Are you working on a piece that will have a one–time run and how do you envision yourself before, during and after this experience?

Ask these questions to determine the KIND of tour you will create for yourself. Touring is not just getting a gig, or two. It is the first process in building the groundwork and requirements for your artistic expression. It is also the place that asks us to find flexibility and creative thinking and planning at the same time. A tricky, important, and affirming challenge if you see it this way. Don't get bogged down by your own vision. And in reverse, let your vision travel you to new heights.

Research spaces and organizations that seem to 'fit' first. Draw from your past performance experiences and make pro and con lists so you have something to work with when you are talking to a potential presenter about showing, presenting, producing your work in order to find overlap points and places of reference, as well as strengths in your partnership based on actual facts. Share lists with other artists who have varied experiences and who also work in similar field, yet different needs than yourself. Strategize while also staying open to the opinions of others.

Decide how much time you need for everything (read EVERYTHING) on a tour starting from preparation to traveling back home. How well do you travel? Can you come off a plane, go to a hotel or accommodation and start working that day? If you can't, don't make those allowances. However, if you can, build in other places of rest, recoup, creative and downtime, while also focusing on the immense work that takes place when touring. Travel time within a city and gathering material, going to interviews, while also rehearsing, thinking critically, thinking site–specifically and dealing with a whole team of new people can be daunting – add tiring, confusing. Build in time for the specific needs of the work itself, but also be realistic when planning. Hit and Run touring is tough – but exciting and worthwhile if you can handle it and prepare ahead of time. Do you need a team or are you an independent worker who can work with a tech team upon arrival?

Create consistent and careful dialog for several months or weeks prior to the tour. Most tech teams have no idea of the work that is coming each week – besides the information you provide them. How can you find the space to work with the many limitations and strengths of theatre spaces and their governing bodies that will support your work, while also exploring creative ways around the expense and difficulties that naturally arise?

Try to think regionally. Make graphs with titles like: art spaces that I respect; presenters that I want to work with; areas that you would like to travel to (and why); locate geographical similarities and share these with the venues. If you plan a performance in Los Angeles, see

how possible it is to share some of the costs with another space by doing something in San Francisco or San Diego. Sharing travel costs, shipping, etc are half of the battle. Ask for an intern or a local person who will be dedicated to your project. This person can help you cut corners, find special things, props, places for you and the work that needs to get done can be assisted more than if you spend most of your time perusing the local yellow pages. Don't expect this local person to be the space's technical director.

Obtaining copyright experience, my most used guerrilla tactics include using DJ compilations/mixed music from various sources, challenging the free–use 'minute–limit' by creating 'original soundtracks' by the DJs and the mixes themselves. This is dense and difficult territory, but for emerging artists who are not able to pay the $5000 per three minute usage fee, it is a way to work around it, if only temporarily. Be careful here. The UK is very strict in this category. Use live musicians or original composed soundtracks when you can. Use permission documents from all contributors and create sound contracts with all involved from collaborators to local performers.

Q– Documentation?

Julie – This is the last thing on your mind, for sure. Be sure to plan in advance by bringing or borrowing a camera and tripod and spending time with a local video artist or highly recommended video artist (perhaps ask the presenter to help partner you with someone they know in the community). The worst thing you will have is a tape that zooms too much or too little. The best thing is that there has been a vivid dialog about what you are hoping to see when you take that sweet tape back home with you. At least you know that the camera will be turned on and that a live person is behind the lens with your best interests at heart. Your strongest application or proposal may require you to have this same video or photograph to move you to your next opportunity!

Last thing about documented work: don't freak out if the work that you have available to send to share your work is not exactly what you want to do. Just be sure that the tapes are clearly marked and that you have an attached statement that talks about your use of this particular sample. Cue your tapes and don't expect anyone to watch a full hour of your performance. It is not unusual that three to ten minutes worth of your work is viewed. Aim for quality and clarity.

Q – You've performed in and administrated quite complex international tours for yourself, Ron Athey and David Rousseve – dare we ask about insurance ...?

Julie – Very tricky indeed. When traveling outside of the US, insurance becomes a large issue. I have relied on American Express card personal insurance as well as airport bought travel insurance to cover at least the accidental death portion of my travel. This does NOT

cover any overt insurance issue while sitting in the theatre focusing lights; however, it does allow for some kind of travel coverage that many presenters will overlook in support of you in their season. For real live insurance? Get a sugar daddy/momma. I have no other viable

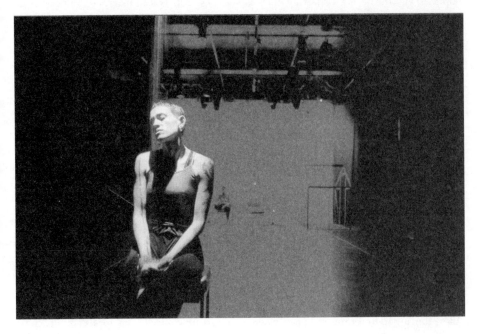

suggestions. Tough one.

Q – Press and publicity?

Julie – Get your smarty pants writer friends to write you three to five press releases. Take a different tack in each one: focusing on the work, yourself and accomplishments, the theme of the work and its place in the larger context of art, performance, politics, etc. Work in full partnership with the marketing team and ask for everything to be finally approved by you. TAKE TIME and feel responsible for every press bit and sleight of hand played by the marketing team. They need YOU to etch out the interesting things about your work, your artistry, yourself, your team. Always offer the biographies of all collaborators and focus on their strengths. Make a plan ahead of time–decide what you 'expect' in terms of pre–show interviews. Do research to make 'goals' for where you want your work to get coverage. Ask about the writers and reviewers. And consider not reading your reviews.

Send lots of GOOD photos. Spend money on getting good photographs done. Do not send what you might consider is standard: 8x10 size photos! Digitize your images – many

high–resolution images on a zip disk – send images that you will happily accept in the public realm. In other words, don't send photos that you don't like and you would hate for them to choose. If you send photographs: use 4x6 white border matte photos. Cheap to duplicate and the border assures a good scan – all newspapers scan images. If you use slides, be sure to 'anally mark' your images so that images are not swapped (left/right side or, god forbid, upside down – believe me, it has happened).

Call people you know in each city and get the scoop to find out how you might encourage outreach to the people. Your work and your mind must be matched by the diversity of your audience. Consider having posters, flyers, cards made withOUT the venue printed on them. As a negotiating tool, offer these to the venue and use funds in another area where you need it more. Be willing to tell the presenter where you can and cannot help. But aim to have an idea of what you need so that you feel like you are finding and creating goals and partnerships along the way.

Where you can, find other activities that keep you vital as an artist. Consider 'residency activities' as outgrowths of your work, not burdens on which you must base your contract. Do not teach if you dislike working with strangers and decide what KIND of post/pre–performance discussions will bless your life. Don't hesitate to always ask for a moderator in your public discussions and plan ahead the goals of the discussion so they do not stray.

Create a real live contract. Include all the necessities and also consider a hospitality section so that you may have your favorite tea or fruit sitting near the microwave in the green room. Allow touring to be a time and place where you nurture yourself. Ask for discounts, cheap (quality) eats, gym passes, swimming places, free faxing and telephone calls in the office, hotels with perks, hard beds, rooms with kitchens or whatever rocks your boat. Just ask. Don't be afraid to just have a wish list for what will make your environment supportive of what you need to make your work, and your body, work on the road.

Q– What are the three top tips you would give an emerging artist?

Julie – Prepare a kick ass (tidy) press packet based on yourself as an artist, using your strongest elements, and consider this press packet only a postage stamp of who you are. Spend the rest of your energy and time talking, sharing and writing about what you want to do and how you want to do it. A press packet is NOT the selling point of your work or of who you are, so don't spend too much money on it! This packet is only an introduction, a formal presentation of something you have done in the past, usually. Allow yourself to emerge as slowly and brilliantly as you are meant to emerge. 2. Be fearless; everything is just another attempt to find out what we are made of. 3. Be fearless, because there are no perfect scenarios and definitely no exact answers except the ones you can stand behind.

Lois Weaver

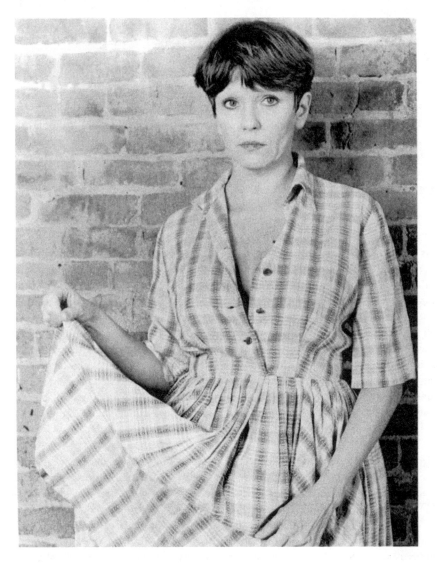

Q – What made you want to be a performer?

Lois – Resistance. I was born in the rural south to a Southern Baptist family and whenever I would get 'too big for my britches' (which translates into loud mouthed or loud dressed,

independent, or just plain smart) my mother would always say 'Don't show your self, Lois' So that is EXACTLY what I had to do. I had to become an exhibitionist. I was desperate to make myself visible.

Q – How did you start out?

Lois – In church. It was the only place we went aside from school and the grocery store. It was the closest thing we had to an arts center or social club. That is where I got my training for almost everything – acting, public speaking, leadership skills, public relations, touchy feelie group things. But most importantly it gave me a platform for political and social debate. The resistance thing again. The Southern Baptist doctrines gave me plenty to push against and unwittingly the institution of the church gave me the skills to do so. In this and other ways I got a lot of accidental training for the life and work of an independent artist.

Q – How did you get involved with Spiderwoman?

Lois – I moved to New York in the early seventies. A lot of the experimental groups that had formed in the sixties had just broken up so a lot of folks were floating around, teaching workshops and looking for new combinations. I think the woman were particularly at sea. Muriel Miguel was one of those women. She had worked in the Open Theatre and unlike some of the men it hadn't actually 'launched' her career. She got some of those women as well as some of her friends and family from the Native American community together to see what we could make. I was extremely lucky to be asked because I was younger than the others. In fact there was a long discussion as to whether I was too much of a rookie, fresh from the South. We met once a week for almost a year. Sometimes it was just a big gripe session complaining about husbands, families, lack of equity in the world. Sometimes someone would bring in exercises to try and sometimes we would end up just going out for food.

After a while we were invited to do a piece in an evening that was primarily for experimental music. We made 'StoryWeaving' which was a collection of personal stories woven around the idea of Spiderwoman, the Hopi Indian goddess of creativity. After that Muriel received a CAPS Fellowship which today is a NYFA [New York Foundation for the Arts] Fellowship and is one of the few fellowships, or 'grants with no strings' that exist in the US. Muriel decided she wanted to make a piece with this money. By then the larger group had scattered – one had died, another went to Washington to lobby for Native American rights, another had a kid and moved to the country. So Muriel invited two other women to join her two sisters and me and we made a company called Spiderwoman. I worked with them for seven years.

Q – Sometimes it seems like there was just a bit more Grrr in the Guerilla back then. Do you think artists today feel as empowered?

Lois – I do think that artists today are more empowered. This is represented in the most mundane sense by the fact that now there is a funding category for what we do: Live Art, Combined Arts, Performance. There are also more venues, particularly in the US, that support this kind of work. Perhaps that is where the Grrr has slipped out of the Guerilla. When I started in the 70s, we were riding on the wave of two decades of activism and experimentation. We were militant optimists who thought ANYTHING was possible if you threw yourself hard enough at it. We were having fun just breaking the rules. I wasn't thinking about 'becoming' a performance artist; I was just doing: celebrating outrageous identities, responding humorously to serious issues, screaming for visibility, turning my back on the establishment and in that atmosphere, I was not so conscious of the 'what' but the 'how.' We were inventing strategies for survival. We were making the work and creating the venues for the work at the same time and everything was political because we were always outside if not against the institutions. Whereas today there is (and rightly so) an expectation for support from those institutions. There is also the possibility of more widespread exposure–spreads in glossy magazines, appearances in movies, TV contracts, etc. And that's great in terms of the survival of the artists and the profile of the form but it can soften the Grrrowl of the lone and reckless wolf. It also doesn't help that transgression has become appropriated by the mainstream. The boundaries are harder to find.

Q – How was Split Britches formed?

Lois – I worked with Spiderwoman for seven years and I was beginning to get an itch to strike out on my own – take what I had learned from them and experiment with my own aesthetic. I wanted to test my directorial impulses. Even though we operated as a collective, Muriel Miguel was primarily the director or 'outside eye' as we called it then and it was a difficult dynamic to change. We tried though. I created the piece *Split Britches* while still with Spiderwoman and we produced it together in a season with a piece by the Native American members of the group called Sun, Moon and Feather. When I think of it now it was like we were all trying to squeeze into clothes we had outgrown long ago. There were rips in the seams, bulges at the waist and places were things just wouldn't meet. So we reluctantly let go (although that is too calm a description of how it happened) of our favorite old clothes and went our separate ways.

I left the company and Peggy Shaw came with me to continue work on the piece *Split Britches*. At that point we asked Deb Margolin (who had done some writing on the piece) to join us as a third performer. We carried on working on the piece and performed it at several festivals in the US but it was not until we toured the piece in the UK that we began to take on a 'company' identity. It was 1982 – 83 and, for the most part, work in Europe

and the UK was done through funded companies. So when everyone kept asking us what was the name of the company we finally said, "Well it's the Split Britches Company", and it stuck.

Q – Did you start a formal company? Do you have a board and all that?

Lois – No, we just made the work and split the expenses and the income. When we needed formality of a charity status we hooked up with a big not–for–profit arts organization (La Mama, for instance) and asked them if we could stand under their umbrella. Then we prayed for rain. Seriously, we often found that big organizations had resources and were willing to provide an official cover as well as some technical assistance. Then we could spend our time making work rather than buying refreshments for board meetings.

Q – When you work with a company, do you take on specific roles in the process, or does everyone more or less do everything?

Lois – We collaborate on everything but some roles are defined. Like director. In those very murky moments of final creation or even in those early moments when you're just staring at each other wondering why you didn't pursue a career as a plumber rather than as an artist – you need one person to stand up and take over. We almost always look to

outside people to assist with choreography, visual and sound design.

Q – How did WOW and LaMama come about?

Lois – La Mama is a huge story which I can't do justice to and can't always separate fact from legend. It started in 1963 as a cafe performance space – very radical in those times, so radical it was often shut down by the police! It was started by Ellen Stewart and she still is the artistic director and 'Mama' of all that goes on there. In fact, I would call her one of the original Guerrrrillas. She gave birth to experimental and avant garde theatre in the US by nurturing young and dangerous local artists as well as adopting truly international (that is, not only European) and truly experimental artists and giving them a home on the Lower East Side in NY. She has had brilliant successes but she has also struggled to hold on to and guard that very precious space. She doesn't always get the credit she deserves.

WOW is a first–hand experience. Peggy and I had been touring in Europe with Hot Peaches one of the first gay cabaret/theatre companies and Spiderwoman. We attended lots of festivals and visited theatres which offered a multi–arts experience. We were taken with the format: the ability to pay one admission and see a film, a performance, drink tea and then dance to the music. There was nothing like this in New York. Going to the theatre was at best an isolating and compartmentalized experience. We wanted to create the atmosphere we had found while on tour. Also many of the artists we met wanted to come and perform in New York. We knew of no venues that could afford to invite international groups and only a handful that could even offer a split of the door.

We added to that the fact that there was a growing community of local women artists with no place to show their work and we came up with a scheme: to host an international festival for women artists. It was called Women's One World Festival. It was produced by Peggy Shaw, myself and two other women, Pamela Camhe and Jordy Mark. It was a two week festival that ran for two consecutive years and hosted over 50 performances, concerts and exhibitions. We had absolutely no funding. We ran the entire thing on volunteer and community support and the willingness of the artists to come and work for very little. The sense of community that gathered around the event was staggering. Some artists came to New York and never left, some local artists booked their work in Europe; everyone received some level of critique and press coverage but most importantly a group of regulars and in fact 'irregulars' congregated and wouldn't disperse.

It was clear we needed a permanent space to gather, to socialize, to work. At the end of the second festival we went in search of a storefront and in 1983 we established the WOW Cafe which is now (20 years later) the WOW Theatre. It has evolved from a casual performance cafe to an ongoing performance space for women artists. It receives no funding and is run on a cooperative, or non–cooperative, as we like to refer to it, basis. If you work there,

doing box office, stage managing, answering the phone, buying toilet paper, etc, then you can get your own work shown with the same kind of support. There is no artistic director, or manager. It is run by collective Tuesday night 'staff' meetings, occasional Sunday policy meetings and a yearly retreat to plan the year's season. Hundreds of women artists have moved through that space – some are still there and sometimes I think of it as an outrageous social/political/aesthetic miracle. I am very proud that it still exists.

Q – In some ways your work seemed to become a conduit for a new kind of feminist theatre theory. Was that strange? Sexy?

Lois – I'll never forget the first time I walked into a university classroom and saw my name and some of my friends names on a blackboard. 'You see,' someone said, 'you're a question on a test!' That made me feel very strange. It had felt like 'just us girls' having fun, getting over, being outrageous and now suddenly it was a serious subject of study. That was very surprising and it made us laugh. We were particularly entertained when academics devoted many pages to the reading of a gesture, line, or image which had been put in the piece purely by accident or out of a last minute necessity. But then I have to admit it gave me a thrill. We put a lot of faith in power of accident and necessity when we are making work. So to have those particular moments picked out and illuminated reinforced that faith in our process. More importantly, though, I understood the power of documentation and the written word. I knew its effect on one of my key concerns: visibility. No matter how we joked about the incomprehensibility of the language or the arbitrary nature of some of the analyses we knew that this meant we would not disappear.

Q – How different are the funding infrastructures in the US and the UK?

Lois – I wouldn't say that the US HAD a funding infrastructure. Infrastructure implies something stable, something that bridges gaps and provides services. That is certainly not the case in the US. For one thing, it is constantly undersiege from the religious right or the ultra conservatives who would feel that funding the arts is a waste of tax payers money – unlike building obsolete weaponry!! And of course since the NEA Four anything that promotes the 'individual artist' is a considered a funding if not moral risk. I guess groups are easier to control than those wacky independent artists. Which is another distinction. The public funding organizations in the US spend a lot of time and energy trying to turn Arts organizations into businesses. And it seems sometimes they get funded more for their financial accountability than their artistic policies. Of course there are funding bodies and grants are available but it is just not a stable part of the society.

Q – How much of a problem has it been getting your work funded over the years?

Lois – We haven't tried all that much. We probably spend about five to ten per cent of

our time on grant applications. And more often than not they are unsuccessful. We tend use our time to work to support our work—either through other jobs (like teaching or even house painting) or by touring. When we do apply for funding it is often under the auspices of a venue or organization. Then we get paid to make a piece of work rather than get paid by a funding body to 'be' an organization.

Q – Do you have an agent or an administrator?

Lois – We don't have a full time administrator. We collaborate with people (often friends) as administrators on a project–to–project basis. Often when we have been commissioned or booked by a venue the venue administrator will assist on project details and sometimes even help us apply for funding. When we tour we manage it all ourselves. It used to be my job but now Peggy is doing it all. She is better at asking for money. But like everyone longs for a wife we long for an administrator who would phone us up and tell us where to show up.

Q – What has kept you going in times of struggle? Did you ever think about getting a day job?

Lois – There is always some point in the creation process when I say to myself – I should have been a plumber. I have almost always had a day job. It is just that recently that day job has been in the field of performance, like teaching, so it is not like getting up every morning to go paint a house so you can rehearse every evening. But that is what we did. We decided very early on that we would rather work a day job and contribute part of that salary to our work –which in some cases was more than what we would have received from a funding body for a whole lot more work on filling out the application. So we have ended up supporting our own habit which is part of the answer to your question. The real answer is the sheer love of the process keeps me going and often satisfies far more than any product.

Q – What advice would you offer to an artist who has made one fairly successful performance with regard to the next one?

Lois – Go to the heart of your desire, follow your obsessions not your expectations. Fall in love with risk and let failure always be an option if not an aesthetic.

Q – How do you go about making a new piece of

theatre? Is the process drastically different every time or are there patterns to the way you approach a new piece?

Lois – It always feels like I'm starting at the beginning – that I'm inventing the whole thing–both process and product. The truth is that after twenty years patterns have to emerge or you would never get off the couch. Usually we start with a gift of an idea. Someone says 'You should do *Little Women*' or 'have you looked into ...' Or maybe we stumble onto a 1930s recording of *The Shanghai Gesture* or become obsessed with an abandoned and decaying tuxedo shop holding its own in a gentrified neighborhood. We are great believers in accident and necessity. After the 'gift' comes the 'lists': what we hate, what disgusts us, what we WANT to do. Desire, fantasy and obsession play key roles at this point. Then using an old vaudeville trick we begin to fashion bits of the performance as you would build a number. It isn't necessarily a 'song and dance' (although it could be) but we use the structure of the freestanding segment or piece. Then we find a skeleton, like some poor old deconstructed classic like *Streetcar Named Desire*, to hang our 'numbers' on. The final layer is the personal. At every point we look at how the personal (history, values, aesthetics,..) intersects with or in fact explodes the material so far. Then cut and paste it all

together. That often feels like bricklaying or stone masonry but all the bricks and stones are different sizes, shapes and densities and some are even transparent.

Q – You've made a lot of work with Peggy Shaw. Do you have collaboration down to a fine art now, or is it a process you have to keep reinventing?

Lois – Collaboration is a necessity. I couldn't make work on my own nor would I want to. I guess it's a kind of dependency. Recognizing that makes it easier to be patient with personality and tolerant of the other person's 'really stupid' idea. In fact I think that is the main reason why I collaborate. I have an insatiable appetite for raw material. I love being in a room full of other people's ideas. I have worked with Peggy for twenty years and during that time we have developed a shorthand vocabulary but often the landscapes shift and the power roles collide so we have to be willing to try new strategies. Collaborating with other artists and or working solo can refresh that old process and break up the habit dynamic. I know you didn't ask for this but my advice to artists who want to form working groups is to keep them fluid. People work better and contribute more when they feel free to come and go.

Q – In the last few years there has been something of a hemorrhage of people from live theatre into mediated formats like web and video. Are you tempted by the possibilities of mediated work, or do you stake your flag firmly in the live performance camp?

Lois – I am intrigued and was tempted at first. But I love the body, the tactile, the visceral, the smell, the sweat of both performer and audience. I like being there. Besides, I feel like I don't have enough time to learn the things I still need to know about live performance. So the prospect of tackling the vocabulary and methodology of new technology makes me want to retire and take up embroidery.

Q – What do you feel you really got right in your work?

Lois – The thing I feel I have gotten right is not necessarily the most 'successful' aspect of my work. It is the thing I love: layering. It is the quilt, mosaic or prism like quality that often causes spectators to say they 'didn't get it.' There are always at least three things operating at once. For instance, a well–known story or text, a personal narrative and an outrageous performance fantasy or obsession. The audience can read one of them, all of them or perhaps none of them. They can enter wherever they wish. They can recognize a popular reference, wonder at a character's gender or identify with a personal detail and those fragments of story can inspire others. So performance can be like music or visual art–something you come back to and each time you see and new story find a new layer. But this is really more of a radical than an achievement – the desire for theatre/performance

to not be such an 'I've already seen that' commodity. One thing I do feel that we mostly get right and that is 'straddling.' My work with Split Britches straddles or blurs the line between things: between theatricality and performance, between humor and pathos. I like that blur, I like being able to see through the cracks, see the seams and splits.

Q – Any advice for new artists?

Lois – Don't expect to get famous. Do the work because you have to. Move to an environment that supports that. I find that hard–working cities like Glasgow, Birmingham, Chicago, San Antonio, Minneapolis can have healthy attitudes toward the WORK and working process of an artist. Get out of trendy cities and connect with a community who wants to see your next project and your NEXT transformation. Or work within a community that NEEDS you.

Q – What about advice for a performer with no budget who wants to set the world on fire?

Lois – Be relentless, get credit cards, do everything you can to get the show up and then work like hell to book it to pay off the credit cards. Answer those calls even when you don't feel like it. Take some time out and 'cultivate your reputation.' Write about your own work, encourage others to engage in public dialog. Go out for drinks with other people in the field. Don't be afraid to ask questions or look like a fool.

Q – Where to next for Lois Weaver?

Lois – In the past when people have asked me that 'what do you want to be doing in five years time' question, I always imagine they want to know what I see on the top of a hill in front of me. What I actually see is a flat but winding road ahead just wondering what is just around the next curve and I always answer, 'I just want to stay on the road.' And that's still true although now I admit that I'm getting tired of 'showing myself.' I am more attracted to writing and visual art or I'd love to be a performer in someone else's piece.

I also find myself wanting more involvement in grass roots work. I would like to develop firmer relationships with some community based arts groups that I have been working with: Clean Break Theatre Company in London, the Esperanza Center for Peace and Justice in San Antonio, Texas, the Roxbury Arts Group in upstate New York. I would like to do more work in Hong Kong and Rio.

I would like to be able focus on the small victories.

James Yarker
Stan's Cafe

Q – So how did it all start?

James – Stan's Cafe started with myself and a friend, Graeme Rose, deciding we wanted to continue making performance outside the safe confines of university.

Q – What were your goals?

James – We wanted to work collab–oratively with guest artists making new work that we would call theatre but which could encompass anything we fancied doing. We wanted to have fun, see the world and inspire people. These objectives have changed little since the start, fashions come and go but at its heart the work sticks to these principles.

Q – What are your tips for starting a company?

James – Starting a company requires finding the correct context, whether that's collaborators or location or media. Don't get carried away with the formal side of things too much early on, make art not admin. Get your work in front of people and inspire them, make them feel part of the project so they'll feel good about giving you/loaning you stuff. Rough it, work from home, keep your overheads close to zero. Keep your admin coherent and streamlined so people know who they're dealing with and what the deal is. Make a list of objectives from easy to super–ambitious, put down a timetable to achieve them and go for it.

Q – What about the official stuff? Status etc?

James – We were a little irresponsible, worked as partners with no official agreement, no insurance, nothing. Eventually we became a company limited by guarantee (find a friendly young solicitor working for a big partnership, buy them a drink and they'll sort this out for you free–ish). Limited by guarantee means no one has shares, if you go bust you only owe

debtors a quid, it makes you look more legit to commercial companies and you can qualify for grants.

Q – How long did it take to really make a name for yourselves. Any lucky breaks?

James – The plan was to give it all we had for five years and see how things went. Five years in we were at The Royal Court and it felt worth another five. There were no lucky breaks; we started small, approached small venues for box office splits, hired a couple of venues to get a vibe going and worked a couple of contacts to get London gigs. London's a nightmare but for profile it's still important. Two years in we did a show in a swimming pool, that raised our profile massively; in fact for years that's all many people knew about us. The very beginning is tough but exciting, then there's a fantastic period when all you are for most people is a rumor. As rumors are always more exciting than reality anything seems possible at this point. For us years six, seven, and eight were deeply unpleasant; now it's getting fun again.

Education work seems a logical first step to professionalism, it pays more than washing up, and it's kind of in the right field. My advice? Unless you're good at it and committed to it DON'T DO IT. Not because it won't be helpful but because you're f***ing with people's lives in the education business. Leave it to the many folk who are gifted at it and mad for it. Fortunately I'm great at it and have done loads. When running workshops play to your strengths, try to make workshop sessions fit with what you want to explore anyway. I try and major on devising shows with students, you put in a load of hours, work with big, enthusiastic casts and can kick around loads of ideas in a comfortable academic environment. Squint during dress rehearsals and pretend to be directing in a major European State Opera House. The trick is to have fun whilst treating teaching like all your other shows (the most important thing you've ever done). Most importantly, remember you should be collaborating with the students.

Q – Any top funding strategies?

James – Top funding strategies? I've lost it with these ... sorry. Talk to the people involved, they'll tell you what they want to hear, be honest with them and yourself. Any answers, you call me – james@stanscafe.co.uk.

Q – How do you manage rehearsal space?

James – We started in bedrooms, borrowed spaces after hours, worked space for workshop deals. For ages it's been weeks of space for cheap performances and now we're desperate for our own space so we can build mad machines and throw paint up the walls.

Q – Do you have a problem describing yourself to possible sponsors/venues/funders

or does it actually allow you a distinct marketability?

James – In many, many ways it would make much more sense to be a very predictable company, reliably producing variations on a theme, but where's the fun in that? Maybe having an umbrella organization and different trading names for different kinds of projects would have been a better idea than this brand name thing.

Q – Does having a great name like Stan's Cafe help?

James – Names are impossible but there are some obvious rules: No Puns, No Quotes, Nothing Too Wanky. Heaven knows about Stan's Cafe, it was supposed to be a non–name name but it's probably just rubbish. The good thing is once people know you, the name just means you.

Q – Do you have three top tips for artists?

James – Personal relationships are more important than genius, work at them in all areas. Things change and fast, be flexible in all but your principles. Remember you're owed nothing but a fair chance, work hard and be good at what you do. Oh yeah, find a charming, ruthless, highly literate, numerate saint and persuade them they want to learn to be an arts administrator at the same time you're learning to be an artist.

Organizations
in
Profile

Organizations in Profile

The organizations included in the following pages represent a cross–section of arts spaces and networks. In many cases their life trajectories have been as precariously balanced and exciting as the artists in the previous section, necessitating their own guerilla survival strategies. Art spaces, like artists, create and shape a movement, a body of work, in particular places and contexts in which the work happens. When these organizations alter, move or disappear, the effects are far reaching.

Performance, more so than art forms with greater mainstream stability, relies heavily on space, on place, for its identity, so much so that many artists have founded spaces themselves as part of their practice. Some have had a limited life span, others are still going strong and dozens of new organizations are starting up all the time. In many ways the arts organization can be one of the strongest manifestations of the 'guerillaness' of the art form. Many organizations and venues become synonymous with a certain type of work, a particular movement, a specific city, or specific artists.

As with the artists included in the previous section, the organizations referenced here represent only a few of the numerous arts organizations, institutions and artist-run spaces and festivals. We have tried to include a range, from relatively new startups to well established organizations whose names have become as famous as the artists who started them and who have performed in them. Alongside these are festivals which annually or biannually mark and create a space for performance work to be shown. Some organizations are established to archive and preserve performance documentation, others to engage with work using new technologies, reflected by the bodies that are establishing themselves to represent and foster cross-disciplinary, digital modes of expression.

The relationships between these organizations and the people who run them, the artists who work in them and the art that is supported by them is fundamental to contemporary performance practice. These places and spaces act as geographical markers, whether existing in real or cyber space, of a body of work that has been made possible by their presence and support.

Additional contact information about some of the organizations included here can be found in the contacts section in the end of this book. For a history of PS122 we recommend checking out Mark Russell's book *Out of Character*.

Judith Knight & Gill Lloyd
Artsadmin

Q – How did Artsadmin start?

Gill – Judith Knight and Seonaid Stewart worked together at the Oval House in the late seventies when it was a hotbed of 'experimental theatre' presenting companies such as the People Show, Pip Simmons Theatre Group, IOU, Hesitate and Demonstrate and many other well known companies of that time.

During their time at Oval House, they became increasingly aware of the lack of administrative support for this work and eventually decided to set up an organization to provide administration for several of these groups. They set up office in a tiny office in Clerkenwell and immediately were approached by artists and companies desperate for administrative support. The choice of companies they decided to work with, and the artistic policy which emerged, have been key to the success of Artsadmin.

Without any funding and only small fees from the companies, the first years were very difficult, but finally they persuaded Greater London Enterprise Board, and subsequently Greater London Arts, to offer them a small amount of core funding.

Q – What were the initial philosophies and objectives of the organization? Have they changed over the organization's lifetime?

Judith – Initially Artsadmin set up in response to the lack of administrative support for small companies whose only source of funding was from occasional project grants. Artsadmin was able to provide consistent support, and to develop opportunities for the artists that had not been previously possible.

ARTISTIC POLICY

1. Artsadmin supports, promotes and develops new theatre, dance, music, live art and mixed media work by providing efficient, affordable and continuous management for artists.

2. Artsadmin seeks to establish partnerships with producers, promoters and relevant arts organizations in order to bring the work of Artsadmin's artists to a wider public.

111

3. Artsadmin particularly offers its support to artists whose work is extending beyond areas of traditional artform practice. Artsadmin will take on projects where it considers its expertise to be relevant, and where the artist's proposals are deemed to be both financially and practically viable. Commitments to new projects will only be made if the required service fits within Artsadmin's overall framework.

4. Where artistic aims remain compatible with 3) above, Artsadmin can offer a commitment to artists over long periods of time, supporting their continuing development and yet remaining flexible enough to respond to the changing climate within which their work is seen.

5. Artsadmin can also respond to one–off projects where they fit the above criteria, and if there is capacity within the organization to undertake the project.

6. Artsadmin aims to develop and maintain relationships with a variety of venues, producers and programers and to place its projects in appropriate contexts which reflect the diverse scale and nature of the work it represents.

7. Artsadmin will formalize its advisory service to artists and companies whose work falls within the remit described in 3) above but who are not current Artsadmin clients.

8. Artsadmin will continue to extend its service to artists through the management and letting of spaces at Toynbee Studios. The studios offer theatre, workshop, rehearsal and research space not only to Artsadmin's clients but also to artists and companies looking for affordable work space in London.

9. Artsadmin will continue to seek out ways of profiling and supporting its artists' work outside of direct project management but in ways that will ultimately support their project development (for example the publication, the artists' resource, and the artists' attachments scheme).

Artsadmin has always had a strong artistic policy, working with innovative and inter–disciplinary artists and companies. Over the years this policy has not changed and many of the artists have stayed with Artsadmin for a considerable number of years. While welcoming this, we were concerned that we were having to turn away many younger artists, because of our ever–increasing workload.

In 1995 Artsadmin moved into Toynbee Studios which enabled an expansion in the resources it was able to offer artists with rehearsal spaces, video resources and occasional performance spaces.

A successful A4E application then enabled Artsadmin to appoint an Artists Advisor who has provided a vital link with all of the many artists who need support but who Artsadmin do not have the capacity to manage. The Artists Advisor has provided a wide range of advice to artists and has also run a mentoring scheme for young artists, a bursary scheme providing funds for developing ideas, a summer school, an admin traineeship and many other areas.

Q – What advice would you give to artists in the process of setting up companies, organizing rehearsal spaces, negotiating administration and office facilities?

Gill & Judith – Talk to people, make contacts, network. Many free resources can be found through word of mouth. Talk to other people, your peers who are in the same area and share their ideas and advice and equally be generous with yours in return.

Don't set up a limited company until you need to – it costs a lot of money to set up and to service annually which you could spend on your project. Be prepared to do a lot of your own administration to begin with; available administrators are becoming increasing rare.

Q – What might an artist approach Artsadmin for?

Gill & Judith – General and more specific advice from the Artists Advisor; a bursary, video resources, rehearsal space, a mentor, to be on the mailing list, to meet other artists, to invite managers to see your work, to launch your book, to showcase work at the studios, to be invited to showcases, for project management.

Q – What are the three top tips you would give an artist/company?

Gill & Judith – Compromise on anything except the work that you are making, but be realistic about what you can do with the available money.

When applying for funds, make sure that your project really fits the guidelines so that you don't waste your time making applications that are not very likely to be successful.

Balance total ambition with pragmatic realism.

Sara Diamond
The Banff Centre

Q – How did the Banff Centre start?

Sara – The Banff Centre began in the 1930s during the extreme hard times of the Canadian depression. It started by sending groups out into the countryside to organize poor farmers, using theatre techniques. It then grew to become an arts summer school for talented Canadian youth. By the 1980s it was serving the professional development needs of adults in many disciplines in the cultural sector. It has become an international arts training, professional development, presentation and research organization through the last two decades.

Q – What were the initial philosophies and objectives of the organization?

Sara – Banff is a major cultural organization dedicated to lifelong learning. As well as its work with the cultural sector it serves advanced management training, ecological and mountain culture communities. We collaborate a great deal with Theatre Arts, Music and Sound, Aboriginal Arts and other areas of the arts including Media and the Visual Arts.

The Banff Centre holds within its midst one of, if not the most advanced cross–disciplinary resources in the world, one accessible to creators from Alberta, Canada and an international context. Media and the Visual Arts is a deeply cross–disciplinary department, a reflection of its domain. This is a topography where the singular disciplines in its midst (photography, video, computer arts, sci/arts, painting, installation, performance, ceramics, etc.) are deeply penetrated by theories of language, philosophy, social science, aesthetics and science. In fact, the very technologies of these fields have merged and cross–influenced each other.

The context for the circulation of visual and media art are equally confounded and complex, encompassing the art market, galleries, self–organized contexts, narrow cast, broadcast, the Internet, commercial popular culture, design, architecture, publishing, the 'street', and research contexts. Artists need dialog and the space to create. MVA provides fundamental support to a significant number of artists and small, highly creative independent producers, enabling them to research or produce high quality new works within a professional development context. MVA is becoming and must become a world–renowned research Centre in cultural and social applications of technologies and related cross–disciplinary methods.

Media and Visual Arts on an international level is a malleable, generative terrain, responding to contemporary issues, emerging materials, feeding from and influencing mass media

and popular culture. It is no surprise, for example, that artists are working with genetic materials, bodies, animal and human, exploring the impact of forces such as the Human Genome Project, the shifting nature of time and dimensions, debating the self–proclaimed death of mathematics, topology as form, and accessing data streams as source materials. These interests are evident not only in the so–called new media, but also within painting, performance and other visceral, highly material practices.

This is and will continue to be an era where even science thinks of its raw material as data, where stock markets flounder and surge from virtual forces as well as real crop failures, yet where large numbers of the world's population continue to live without electricity, but with the desire for wireless access to health care and education. The product in MVA, as in much contemporary theory and practice, is in the network, the negotiation, the process, as much as or as well as the product. The material, the physical, the transformative are critical components of this world, but not as sources of nostalgia, rather as ways of providing human understanding, groundedness and a fundamental view towards collective and individual empowerment. This is our challenge.

The Banff Method

No way, the river is moving too fast now

Given that media and visual arts is one of the most challenging areas of contemporary culture, with its expression of extreme specialization, high levels of interpretive and technical skill, huge aggressive growth industries, a range of high and low cultures, individual versus collective production methods, its strong history of social critique, often in isolation, we must be a pressure cooker. We work with artists, cultural critics, researchers, scientists, and technical and cultural industry workers. We must and do provide leadership and assist leaders in these fields to sift, shape, synthesize and find opportunities.

MVA must and do enable cross–cultural exchange and research, based on respect for the source, as a key strategy for a global époque. We must continue to be instrumental in supporting Aboriginal Arts at Banff; key in promoting women in technology, incorporate cultural diversity into our programs and be strongly internationalist in our recruitment policies. We support much of this work through residential experiences that last from three days to two or more months. We co–produce major projects and in doing this, provide resources for artists to create new works that span from Internet interventions, improvised performances in new media and full–scale interactive experiences.

One of the unique attributes of the Banff Centre's program has been the hard–won and at times contested (internal and external) refusal of a neat and self–satisfied division of labor

between art, design, architecture, popular and even mass culture and cultural criticism. This does not derive from a cynical or opportunistic desire for resources, but from the belief in the need for social, cultural and creative agency, one that incorporates different social forces and strata.

MVA has brought together divergent economic zones and audiences, pressing for dialog and collaboration, between these, although certainly not resolution. It has created a 'topology' of interconnected but differing planes of practice, creating novel and instrumental networks that, at best, are capable of producing new forms of knowledge, transforming and bettering existing practices and creating exemplary projects. It has done this in a context where even a short–term residency (three days) demands the production of a sense of community.

MVA has developed a specific methodology, 'The Banff Method'. We practice peer–to–peer learning. We bring together leadership and key mid–career players who can address key questions, place them together, and facilitate an intensive probing dialog. We have a unique capability to synthesize and push forward discussion and practice. We provide participants with an opportunity to demonstrate their practice and critique it. We provide them with intensive, mediated networking and nature opportunities. We create pleasure and challenge within the process of creative exchange. We push participants to strategize, to develop projects and collaborations and we document this process. We follow up, as much as resources make it possible, with discussion through list–serves, the documentation and circulation of events and later results and international, at times casual, conversations. We return to the key issues in additive and refined form in later sessions of the Banff New Media Institute or residencies, pushing the next level of dialogue.

The method works best when there can be some level of cross–over between research, co–production, institute dialogs, residency practice and participation and exhibition or other form of circulation. This is what differentiates Media and Visual Arts residency or seminar programs from others around the world.

The Banff Method is most evidenced in four areas of the department. These are the future thinking summits and workshops of the Banff New Media Institute, in Media and Visual Arts' thematic residencies where there are strong faculty leaders and senior and mid–career artist participants, in the department's emerging research program and in the Banff International Curatorial Institute. Practically, the crossing of zones has

attracted increased research partnerships, international accolades and status and approaches to export the method to other events and venues. Its pursuit requires deep curiosity; willingness to challenge as well as support and a search for shared values such as democracy, accessibility, difference, complexity, and even beauty. It requires the level of international partnerships and networks (formal and informal) that this department has built.

In the last years we have centered on a number of key themes. Until the last few years the department considered the fundamental theoretical drivers of up to the turn of the century and the ways that these manifested within differentiated levels of culture. Response from artists to upcoming residencies again shows that this cross–disciplinary approach continues to draw strong interest, for example, in the exploration of the changing nature of time.

On the research and Banff New Media Institute side, MVA explores visualization (making data, science, social theory understandable to humans via machines); the role of the body in relation to technology (not only in performance research but in health); the ways that emotional process can be manifested within technology, including ideas about intelligence, immersive experience and agency; cross–disciplinary methods in developing and implementing research; tools that are culturally informed and enable creativity, collaboration and the cultural interface between biological sciences and other physical knowledge and the digital and the cross–over between digital arts and other forms, such as television and photography.

Q – Have they changed over the organization's lifetime?

Sara – The organization incorporates work with traditional forms and media in a contemporary context right through to cutting edge practice. We serve a range of communities. Banff has moved from being a regional to a national to an international organization encompassing these other territories. We also have a focus on the social meanings and implications of culture unusual for an arts organization. A major acquisition of The Banff Centre is its relationship to Aboriginal artists and communities throughout the world, where self–determination is the underlying framework for the development of partnerships and cultural knowledge. We are tremendously proud of this program.

Q – From an outsider's perspective, Canada seems very artist–orientated in terms of opportunities, funding schemes, residencies etc. Would you agree with this viewpoint, or do you think it is a case of the grass always looking greener ...?

Sara – Canada does have a history of arts funding that began with the post–war era and was expressed through cultural activism and the creation of the Canada Council. It has been a significant contributor to artists' capability to excel. Canada is bi–national [English and French] and also has strong Aboriginal language groups in its midst. Canada

has also responded to the needs of specific groups, such as women, Aboriginal people, cultural groups, with less discomfort than other nation states. We tend to see difference and inclusion as viable and exciting, not threatening and politically correct. I am always reminded in the UK and Europe how behind things are on the gender and cultural difference fronts.

Canada cut its cultural funding a number of years ago, and then realized that this was a dumb idea, increasing money to culture, to science and technology research and now to social science, science and cultural collaboration. We rely on communication to stay afloat: big land, small population, it's a voluntary nation state with lots of tensions. Definitely not perfect, lots of generational conflicts, but lots of voices that push to sustain our cultural specificities.

Q – What might an artist approach Banff for? Are you mainly project and residency orientated?

Sara – We support artists in residencies that are thematic, based on ideas and concepts in contemporary culture and society. We support larger projects through co–productions, with other agencies or with artists own companies. We provide workshops, brainstorm sessions and also residencies that are geared to making new work in visual art as well as new media.

Q – How does the Centre see the relationship between new media and performance? How does the Centre position itself in terms of the kinds of performance work it wants to develop?

Sara – This is a big question. The metaphors of choreography, composition, the virtual as theatre have long informed our work in new media. Our department has a research grant, entitled The Human Centered Interface Project. It looks at emotional computing, i.e. how to build from the knowledge that we have acquired from performance based media into new media. We also have a very strong base in performance art in our Centre. We work with streamed media as well. We have supported projects like Trajets, The Secret Project, The Shakespeare Project, all of which combine new forms of performance and new media. We are eager to continue this direction, as is our theatre program.

On the theory side, our annual think tank program also considers new media performance as one of the key areas of exploration. We have a think tank coming up called The Human Generosity Project that includes collaborative performance tools, and one that is called Emotional Architectures, that looks at cognitive science, performance theory and spaces. This area of theory is one of my personal focal points as artistic director.

Q – In terms of artist residencies do you prefer the artist comes to you with a project which is already fairly developed or that they begin working pretty much from scratch?

Sara – They can come either way. We support all stages of projects with different kinds of programs, thematic residencies more focused on research phases and integration of ideas, new works and co–productions on prototyping and then production. We are very flexible.

Q – As a research active organization how does the Centre balance process with product? Is there an overall objective for the artist to create a finished piece of work?

Sara – We are not only a research organization. Banff supports research in the true sense of high–risk generation of new knowledge as well as applied research, taking something into a new application. We also absolutely support production and the exposure of works to audiences. Hence the range of opportunities. We understand the need for artists to make work that is completed and gets out, we partner at times to make this a reality. Our gallery is an excellent venue, for exmple for new works to be shown, as are our theatres.

Q – What are the three top tips you would give an emerging or established artist/company?

Sara – Wow! Tough one. Stay true to your heart and your gut as an artist. Perhaps, somewhat contradictorily, know your field and the issues that are emerging in it and position yourself within these. Be able to speak to these but not at the expense of what you feel with passion. Third, what goes around, comes around.

Thomas Mulready, Cleveland Performance Art Festival

Q – How would you describe your role in the art world?

Thomas – What art world? I live in Cleveland, Ohio, USA. I never worried about the art world, because the art world never worried about performance art. I used to send big press packets with tons of info on our Performance Art Festival every year, but that was pointless. It's a marginalized art form that happens of the island of Manhattan, so the art world had no context for understanding it. One year, the magazine Art News sent a snotty one–line response to my press releases 'We received your material on your Performance Art Festival, and best of luck with it.' I still have it in our press kit and I show it to all our supporters.

With the PAF, we created our own performance art world. All the performance artists made the pilgrimage to Cleveland, even audiences. And we got regional writers to cover it, and write reviews about performance art work. You don't even find the media in the 'art world' cities like New York or San Francisco writing about performance art, but we generated dozens of reviews a year; critical, analytical, philosophical writings about performance art.

I was on the board of NAAO [National Association of Artists' Organizations] for a while in the 90s, and at one of our conferences in San Francisco, I happened to sit next to the arts writer for the SF Chronicle between events, and I was showing him our catalog for that year's Festival, and said to him, 'I get applications to our Performance Art Festival in Cleveland from San Francisco performance artists, and none of them enclose any news clips or reviews from the SF Chronicle. Why don't you write about performance art?' And he said, 'Maybe if they put together a slick catalog like this, I would,' and I just laughed and asked him how much he thought that catalog had cost to print, and how many artists he knew would be able to afford that. But that was his excuse. The audiences and media in Cleveland knew about performance art, they came every year and learned about performance art, and they wrote about performance art. That's more than the art world ever did.

Q – How did you get into performance art?

Thomas – I had been writing and playing drums for years, but always worked in business at Campbell's Soup and Vicks VapoRub. Then, I quit my job at Vicks, sold everything, and my wife and I moved to Europe, bought a car and lived there as long as we could. While in Paris, I had the opportunity to do a reading at Shakespeare & Co., the English–language bookstore that published James Joyce's *Ulysses*. We put together a little book as a guide to my reading, since I was doing audience–interactive works, songs, and poems in multiple

voices. I thought it was successful, but it wasn't a poetry reading. When I came back to the States, I got into video in the mid–80s and put on an evening–length performance, 'Tom Mulready Within and Without Television,' with twelve TV monitors, a computer on stage, and a live band. I talked to myself on the TVs, and we collected one word per person admission, then the audience picked the words out of a hat and spoke them into a mike, while I wrote a poem in real time on the computer. If you had good eyesight, you could watch on the TVs. It was always called 'The Most Avant–Garde Poem in the World, Ever,' because it was written right in front of the audience. These shows went over well and I had invited a number of people from the arts community in Cleveland, and James Levin from Cleveland Public Theatre not only showed up and liked it; he asked me to do something at his theatre. This was late 1987, and we presented our first Performance Art Festival in Spring of 1988.

Q – How did The Cleveland Performance Art Festival come into being?

Thomas – The first couple of years we were a projects of Cleveland Public Theatre (CPT) and used their non–profit status and they allocated some budget money for us – $3000 the first year. We put a panel together and invited everyone we knew who did performance art, mostly from the region. We didn't curate the first year, we simply scheduled performances, and the panelists all performed on the final night. There was tremendous electricity in the air for the first Festival, and it was standing room only, since CPT only had about 50 seats at the time. So I learned that the key to standing room only is to have fewer chairs. After the excitement and media attention of the first year, it was easy to raise money for a second Festival, in fact one sponsor, an insurance company headquartered in Cleveland, Progressive Insurance, gave us $20,000, no questions asked, and that allowed us to bring in Karen Finley and Paul Zaloom (from New York) and Zygmunt Pio Trowski (from Poland).

Q – How did the festival operate – were you a limited company? A non–profit organization?

Thomas – After a couple of years, the PAF was becoming a bigger and bigger portion of CPT's budget, with a lot of funding raised and earmarked for the PAF. It was also gaining in notoriety and infamy, especially after the Annie Sprinkle incident in 1990. And it was definitely not theatre, so the mission of CPT was being challenged with so much emphasis on performance art. So James and I met on the shores of Lake Erie and decided to spin the Festival off into its own non–profit 501(c)(3) organization. Then we called on all the funders and basically asked them to start funding two separate organizations when they had only funded one in the past, and they have been doing so ever since. However, if the funding climate had not been so supportive in the late 80s and early 90s (this was before the big NEA cuts), we might not have been able to grow on our own.

Q – Did you envisage that the festival would get so big when you first started?

Thomas – We never set out to become the largest festival of performance art in the world, and in fact, the surprising growth and popularity of the Festival was almost a problem, for funders (now forced to support yet another organization), for audiences (challenged to sit through our 2 to 12–week festivals), even for performance artists (who felt we were commercializing a very pure and conceptual art form).

There were tremendous pressures to remain marginal, to stay in the art ghetto, to preach to the converted, but I was always utilizing modern business and marketing techniques that I had learned in college (I have a triple major in marketing, advertising, and selling and sales management – with a minor in creative writing), and on the job at big consumer

products companies. And it wasn't so much about being big as it was about inclusivity. We struggled to find a way to not curate, and to challenge the art world's elitism. We knew that performance art was all about not being able to define quality, and we also knew that some of the 'best' works were done by regional and local artists who had no résumé, no news clips, and no reputation. So we expanded organically every year as our mailing list grew, as we invited national and international panelists who helped us select featured artists, and as word of mouth in the performance art community spread internationally.

Q – Why do you think it was such a success?

Thomas – It was a success to different people for different reasons. Artists loved it because many of them told us they got the best gig of their career in Cleveland, because we respected them, took our time and fulfilled their vision (kudos to our crack technical staff and volunteers). We put them in front of audiences – real audiences, not just other artists in their hometown, and audiences who had developed the patience and attention span demanded by challenging art.

Audiences loved the Festival because it was so different from anything else – that 'anything goes' atmosphere is positively addictive. And since we hosted a discussion between artist and audience after every performance, audiences felt more comfortable to raise questions, express their confusion and connect directly in a way that other art forms don't allow. Corporate funders loved it for all the attention it received, and foundation and government arts funders loved the multi–cultural art, the voice it gave to the politically disempowered, the access it offered to women, minorities, and people from a variety of races, genders, sexual orientation, cultural backgrounds, and political viewpoints.

The media loved it because it was visual, it was different, it was outrageous, it was colorful, it was controversial, it was courageous. And the artists always gave great quotes.

Q – Do you think it has been an advantage producing the festival in Cleveland rather than New York – it is easier to create a sense of event in a smaller city?

Thomas – I could name a hundred advantages to presenting the Festival in Cleveland, and I could also say that if I had lived anywhere else, there would have been advantages there as well. To give proper credit, without James Levin and the Cleveland Public Theatre, there would have been no Performance Art Festival, and not every city has a strong, politically committed and successful alternative arts theatre. Plus, Cleveland has a couple of courageous funders in the Cleveland Foundation (the largest community foundation in the country), and the George Gund Foundation, both of whom don't have to bend to political or conservative pressures. The Ohio Arts Council has also been especially sensitive to and supportive of performance art, intermedia art, interdisciplinary art, and art that falls between the cracks. They always found a way to give support. The city of Cleveland itself is a big reason that the Festival was able to thrive. It's a town that is known for its classical arts (Cleveland Orchestra may be the finest in the world, the Cleveland Museum of Art has always had a huge endowment and is a well–rounded and much–respected museum), and the cultural life in Cleveland is a few notches higher than almost any place else besides the world–class cities. The town has a ballet, an opera, multiple orchestras, modern dance, and these are the first things a community wants to put in place.

By the time the PAF came along, there was space and time and funding to support something totally alternative, since all the other cultural bases had been covered. The dynamics of a smaller town versus a large town can work for you and against you. We certainly took advantage of our ability to generate headlines each year, and we pulled down more column inches than the Nutcracker, probably in part because there was less competition. But it's also possible to do it in a large city; you just have to be savvy. When we toured with the 'Best of the Fest' in 1990, we got a photo in the Village Voice and a large article and photo in the Chicago Tribune, and we had good crowds. We did it by positioning ourselves in contrast to a lot of the other events going on, and by collaborating with dozens of other (more respected) institutions, such as galleries, museums, theatres, corporations, shopping malls, nightclubs, bookstores, universities. We all benefited from greater exposure and acceptance.

Q – How much of a problem has it been getting the festival funded over the years? Where do you find the money?

Thomas – We have been consistently funded by regional foundations that are liberal–minded and strong supporters of the arts. In addition, our state arts agency, the Ohio Arts Council has offered funding every year, including a small pilot grant the first year. However, these are modest grants and would not cover the expenses of our annual Festival. We have occasionally been able to attract some corporate cash funding, and for many years we were able to procure in–kind hotel rooms, airline travel and other necessities. We have also had significant but rare individuals who have stepped forward with substantial support for certain events. For the most part, however, it is a problem getting funding for controversial live performance art in this part of the world, although I wonder how easy it is anywhere.

Q – How much did the last festival cost to produce? Do you think that producing this type of work is getting harder or easier?

Thomas – Our last Festival budget was somewhere under 100,000 US dollars, which was about where it had peaked about five or so years ago. It would be difficult to produce the type of Festival we did for any less. A few of the qualities that we strove for included 1) presenting international artists, 2) paying all artists a fee, 3) presenting the Performance Open for all artists not recommended by the panel, 4) utilizing the highest quality marketing materials, 5) fulfilling the vision of each artist to the best of our abilities, 6) bringing strong, diverse and targeted audiences to challenging, boundary–breaking work, 7) partnering with the regional community. To do this type of Festival was not getting any easier over the years. In the early 90's we were among the first to offer corporate sponsors logo and ad placement in trade for airline tickets and hotel rooms. This effectively saved us tens of thousands of dollars and allowed us to bring in a higher caliber of artists

from further away. Nowadays, everyone is more marketing and sponsorship savvy. For a few years we were able to gain funding from the National Endowment for the Arts, but in the mid–90s, when they cut their budget by fifty percent, instead of trimming all their awards, they simply cut off the marginal organizations such as the Performance Art Festival. The NEA coordinator told me that they wanted to 'hold the large organizations blameless,' after the cuts, as if the smaller organizations were to blame. That accounted for tens of thousands more dollars that were lost.

Corporate funding of controversial art is never easy; the only significant support of that type that we received was from one or two unique corporations that had a history of strong arts patronage and iconoclastic and progressive leadership, two qualities that you usually don't find in corporations. Although we won many of the battles in the early 90s for censorship and arts funding, in many ways we lost the culture war. We lost the PR battle by being tarred and feathered and stereotyped as transgressive, and we lost the imprimatur of the NEA, which would have made it easier to raise additional monies. The NEA also stopped offering fellowships for individual artists entirely a few years ago, and a lot of those were performance artists. That also has an effect, with less money for them to tour and show their work.

The entire paradigm of how the arts are funded probably needs to be re–examined and overhauled. One only needs to look at the type of work that ends up being supported via government and corporate support – art which supports the mainstream culture. As an alternative, we might take a cue from capitalism's international hegemony, and find better success with an organization that supported itself with earned income (ticket sales, touring, merchandise, sponsorships), which would be insulated from the whims of current arts funders. Of course, they would need to continue to generate revenue and would always be under pressure to be commercially successful, and to strike a balance between popular programs and more challenging work.

Q – What was your selection process like for putting together the programs?

Thomas – The first Festival (1988) was not curated, we simply invited and scheduled all performances. Since we had an open application process where any artist from around the world could apply, we soon had more applications than space/time/money to present them all. After the first year, we assembled a panel, (usually made up of artists, volunteers, audience members, the media, and performance art presenters and professionals from around the region and around the world) who reviewed all applications. Artists were asked to complete a standard application form detailing basic technical needs, a description of the proposed work, artist bio and an artist statement. Artists also sent videotape and other support materials such as photos, news clips, music, etc. We built a giant binder for each panelist and we gathered around the table for two 10–hour days, and we reviewed usually

around 300 to 400 international applications in one intense weekend. This allowed for about four minutes per application (we had to use a timer to stay on track), which sounds cold, but with some experience, is really plenty of time to see if the artists were on the right track. Some were eliminated within a minute, others took an hour of debate.

We had a routine – we would start the videotape, while simultaneously reviewing the panel binder with tech needs, bio, statement and description of the work. Then a panelist might offer additional evidence if they had seen the artist or group perform in the past. With panelists from places like the Wexner Center, the Walker Arts Center, Highways, the Kitchen, the ICA in London, etc., our panelists had usually seen a lot of work. Plus, after a few years, our own local panelists had seen hundreds of performance artists in Cleveland and could speak to many of the applications. Then we would pass around the photos and news clips and the discussion would begin.

We always looked for evidence that the artists could pull off what they were proposing, since anyone can think up a cool idea for a performance art piece. When the buzzer went off after four minutes, the panel would give numbers. We tried a couple of different numbering systems with the intent being that we would end up with a list of artists in descending numerical order. We roughed out how many artists that year's budget could afford, and essentially drew a line. Then the panel's work would be done, and it would be up to our staff to fit the artists' needs and travel to the budget, and make the invitations to those artists recommended by the panel. That process took months.

While this process may seem mechanical or typically American to some, it was our attempt to allow any performance artist the opportunity to be reviewed by the panel for consideration. With few exceptions, virtually all venues and organizations that present art do so by curating and by invitation only. Young and unknown artists are almost always closed out of these events. Plus, the field of performance art is unique in that often artists create performance art only for a few years before moving on to other more traditional art forms in order to have a career. This combined with performance art's anti–authoritarian and anti–art leanings, along with performance art's tendency for ephemerality, all called for a process that would not only give equal access to everyone who wanted to do a performance art piece (not just established artists), but also encourage the creation of new work and give our Festival a chance to sniff out work that would normally fall between the cracks. We know that just the mailing out of the application form to our international mailing list of 7500 names,inspired performance art work to be created, simply in order to apply to the PAF.

But we also realized that the open application procedure and the panel process, while it evened the playing field for applying artists, still did not allow for a truly representative presentation of the vast array of performance styles and voices, that the art form offers, since

we could only afford to present a small number of featured artists. To address this, starting in 1990 we instituted The Performance Open, which offered 30 minutes, basic tech and a small stipend to all the remaining artists who were not recommended by the panel. We presented anyone who accepted the invitation and came to Cleveland, usually six to eight performances a night, as a part of the Festival. We essentially co–opted our own fringe. It became extremely popular with audiences and artists (less so with critics), and it was interesting that many Performance Open artists turned in some of the best performances each year.

There was never a theme to any of our Festivals we just featured what the panel felt was the best work. This led to many discussions about quality, criteria, affirmative action, and cultural differences. When we realized that the US–dominated panel had difficulties with international work (especially in languages other than English), we began asking artists and presenters from other countries who have seen a lot of performance art to serve as panelists. We tried to have past featured artists serve on each panel, and panelists were different each year. In fact, we tweaked and adjusted the entire process throughout the twelve years of the Festival.

Q – What aspect of running the festival did you enjoy most?

Thomas – I would like to say that watching the live performance work was the most enjoyable, and it was, but I was personally often busy or under pressure of one type or another (one year I had to shoot video every night, so I saw all the performances through a one–inch eyepiece). The panel process was intoxicating and sort of like dying and going to performance art heaven.

But I lived for the Performance Open, which was so unpredictable and so rewarding. To witness the flow of performance after performance after performance all night long was the greatest joy for me. The Open always offered the greatest surprises, and the prospect of finding that diamond in the rough. I have to stand up when I'm watching good art, and I could stand for hours waiting for that delicious, unexpected performance. I've also developed a high tolerance for crap, something that I realize not everyone shares. But I don't mind the crap as long as there is a payoff. Most movies are crap as well, but a film festival is great because if you hang around long enough, you'll see something really excellent that you would have normally missed. The problem is that as a society we have lost the appreciation for the variety show format. One of my heroes is Ed Sullivan because he would bring on sword swallowers, an opera singer, Topo Gigio the singing mouse, and The Beatles all in the same show.

Q – Why did you decide to retire the festival? How has the festival been documented and what will you do with the archive? What's your next project?

Thomas – After about ten years, I felt that we should bring someone else in to run the Festival to bring fresh ideas and creativity. I had explored a lot of avenues, some of which were dead ends, and sometimes it's helpful to bring in someone who doesn't have the history and can make different things happen. We looked around, but were challenged by the low budget. It would have been difficult to bring in a qualified professional for what we were able to pay for a full–time position. We had been working with Robert Thurmer at Cleveland State University for a number of years. We co–produced a number of events there, we co–produced a catalog, they sponsored performances almost every year that we were in existence. Robert himself was the Director of the Art Gallery at CSU, taught art there, and was a performance and visual artist himself. And he was passionate about performance art and the Festival. He also had a full–time job, so the money we offered for the PAF Festival Director position was in addition to his salary, not something he had to live on.

Unfortunately, the reality was that, in addition to his PAF duties, he also had a full–time job, and it became obvious that directing the Festival was a lot more work than anyone had realized. I had been devoting myself to it body and soul for ten years, and in the end, the Festival couldn't afford to pay someone to work it that hard, full–time. It was a revelation to everyone that in fact, the ends didn't meet, and the ends hadn't been meeting for a number of years. It's a common situation that a lot of arts organizations find themselves in – he need for experienced professionals to manage the venture to its potential, versus the budget to pay only younger, inexperienced administrators or people of independent means. After on Festival, 1998, we realized that the Festival could not support itself in the professional manner it required.

Since the long–term prospects were dismal, we then faced the prospect of folding the organization immediately or exploring the option of one final Festival to say goodbye. A number of our consistent funders offered small discretionary grants and Michael Herbst of Fourth World stepped forward with enough cash to produce a Festival of the quality that had come to be expected. We had worked with Fourth World in the past, as sponsors of specific performances or as supporters on a smaller scale, but this was an unprecedented and generous offer that allowed us to mount a final event with international artists, professional marketing and complete tech support, just as we had always done. The poster, by syndicated Cleveland cartoonist Derf, stated The Last Performance Art Festival, and we had unique presentations such as a regional Performance Open made up of many artists who had presented at the Festival in the past, and a sublime closing day and night ritual by Linda Montano.

Not only did this give us the chance to offer closure by bringing artists and audiences together one more time; it also gave us the opportunity to bring a strong message to the

media about the state of the arts and performance art in general. Any time something is billed as the 'first' or the 'last' it is bound to get extra attention, and in this case it certainly inspired enormous media attention throughout the region and even across the US. We were able to talk about the precarious funding situation that the arts face in the current environment, the relative apathy shown towards contemporary and living art and artists, and to talk about the cultural and economic benefits that organizations such as the PAF generate which would be missed as they go out of business.

We are now developing the Performance Art Festival Archives, which consist of over 2000 hours of videotape, over 6000 photos, and document the work of over 1000 performance artists over a twelve – year period. We have plans to digitize the video and photos and create DVD–ROMs, catalogs, interactive web projects and a network for performance artists, scholars, researchers, students and journalists, as well as the general public. All of this has a huge budget and will take a number of years, but we are currently in discussions with funding organizations, library and archival organizations performance art presenters and universities both in the Cleveland area as well as internationally. For example, we've been in discussions for a couple of years with Barry Smith of Nottingham Trent University, who runs the Digital Performance Archive, the Live Art Archive and is involved in the archives of the National Review of Live Art. We realize that the archival material that he manages and the archives of the PAF are complementary and would offer the perfect opportunity for collaboration and partnership on a variety of major, international projects to bring these archives to a wider public. We are also interested in working with other institutions and partner organizations, and I would encourage anyone interested to contact me at thomas@performance–art.org.

Q – Are you going digital in your interests? Do you prefer the art that demands sharing the same time and space between artist and audience?

Thomas – We are all watching carefully as Martha Wilson and Franklin Furnace move boldly into the twenty–first century with pure digital performance, broadcast live and in archive on the Internet. It is, as performance art has always been, an ongoing experiment and shouldn't be judged too quickly. In my day job as an e–commerce and Internet consultant, I am constantly advising large corporations against making too many assumptions this early in the Internet revolution. Many breakthroughs and innovations have yet to appear, and costs for technology only go down, making the most amazing technical feats possible to everyone on the economic scale, even to artists.

While the primal connection, community and communication that occurs between an artist and audience who are in the same place at the same time will never be replaced, technology's ability to augment that experience will improve to ways that we cannot even imagine today. Some of the best aspects of an intimate, personal live experience

129

are antithetical to the economies of scale that make larger events affordable and enjoyed by more people. The ultimate solution will inevitably be a mixed–media approach that combines live action for a necessarily smaller audience with technology–driven experiences for larger, probably unlimited audiences. This mixed–media approach is a milieu that performance art has always felt comfortable in, and I have no doubt that will come upon a satisfactory way to economically present their work in both a strong, physically immediate way as well as to a larger, more commercially supportive audience.

The problem is that, while technology always eventually gets cheaper and cheaper, new technologies are always expensive and therefore difficult for artists to experiment with. We are seeing some interesting experiments at major arts institutions with substantial budgets (such as the Walker Art Center and the Wexner Center for the Visual Arts), established acts such as David Bowie and U2, and even the mass marketing of artists such as Blue Man Group, Penn and Teller, and the Broadway musical *Rent*. None of these, of course, are performance art, but they might be indications of the type of inter–media presentations that one wishes performance artists had to budget to experiment with. One also needs to study the careers of Laurie Anderson (from fiddling with her skates encased in a block of ice to major venue rock operas), Karen Finley (from performance art rants to sculpture, visual arts and celebrity television appearances), Eric Bogosian (solo performance art to acting and one–man theatre) and to see how performance artists can evolve both their content and their form as they attempt to support themselves and expand their audiences via technology.

We are in the midst of a true revolution in how humans work, play, create and communicate with each other, mainly caused by technology. The Internet will change our culture as radically as Gutenberg, in ways that we can hardly imagine. In some ways, performance art as we have known it is actually a folk art, an oral tradition passed on from generation to generation by people who were there, by artists who became teachers and by the few books and images that remain as evidence. The way we fund the work and the way we present the work is currently in a crisis of transition. All of the major US performance art publications are out of business and most of the presenters are gone or do very little performance art. But we will navigate this transition, although probably not with the same institutions and artists.

Q – Any advice for people who want to make something big happen?

Thomas – Don't worry about making something big happen, just make something happen.

Barry Smith,
Performance Arts Digital Research Unit

Q – How did DPA start?

Barry – The idea for the Digital Performance Archive started as a series of conversation between Steve Dixon, Head of Performance in the School of Media, Music and Performance at the University of Salford and myself. We had initially met through 'SCUDD' meetings (Standing Conference of University Drama Departments) and both found ourselves singing from the same hymnsheet – essentially that the new digital and computer–related facilities were going to have a huge impact on performance work – both as an aspect of production and as a learning and teaching resource in Education in which they both worked.

Inevitably our conversations led to funding questions and a bid to the newly–available research grants offered by the national Arts and Humanities Research Board. This resulted in a two year project grant to record developments in this field at the end of the twentieth century, 1999 to 2000 inclusive.

The Project also undertook to seek out early examples of these developments 1990–1998 inclusive, as there had been no previous attempt to archive these developments for posterity and for access by future researchers. The project was originally nicknamed The DRIP–DROP Project (an acronym for Digital Resources IN Performance and Digital Performances ON Performance) and in 1997 we rather liked that nickname as it suggested a slow process of attrition. By 1998 it was already inappropriate and it might have been more useful to have thought up a description giving the acronym FLOOD.

Q – What were the initial philosophies and objectives of the organization?

Barry – The intention was to collate and record any developments in performing arts (production and teaching/learning) that 'used', in one way or another, digital facilities. We excluded musical composition from this aim from the outset, aware that music not only

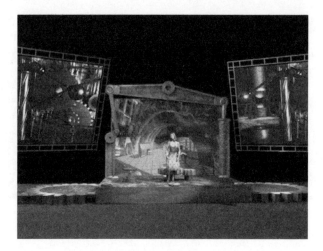

had a headstart in computer applications but also that much was recorded and available in permanent form in various recordings, professional CDs, etc. Our overriding concern was to capture and preserve/archive in some appropriate form all those examples that were time–based but not recorded (or intimated only by websites which would with time change or disappear).

An important aspect from the outset was to obtain the permission of the original authors /practitioners to preserve records (for example by cloning websites) or to draw together in a collection other audiovisual recordings of the work as it was made and first presented. Another indication of the rapid rise in applications was that we originally intended to film six 'exemplars' showing different applications – in the end we filmed twenty which was only a fraction of the range available within two all–too–short years.

Q – How important is documentation for artists?

Barry – Most artists wish their work to be preserved though a few will try to subsequently modify it in the light of later experience (which rather detracts from the notion of archiving of course, so some room for conflict there but seldom arises in practice). One does hear the view expressed that performance is a time–based medium that can only exist in its own time and should not be preserved in any way (or preserved only as fragments). Fragments are the best we can manage anyway.

Q – What is the role of a digital performance archive?

Barry – Primarily to act as a worldwide resource for those interested in 'researching' (in the original sense of that term re–search – 'to search again') the work of performance artists

that used digital facilities of one kind and another primarily in the years 1999–2000. That feature is the 'DRIP' aspect of the project. The 'DROP' aspect, Digital Resources ON Performance, is likely to become of limited application much faster (with the possible limited exception of educational history research) and has a more immediate application in drawing to attention what is, or recently was, available primarily for teaching and learning purposes (formal or informal).

Q – How do you think digital technologies are changing the shape of performance?

Barry – The original belief of the co–directors of this project was that 'digital technologies' would have a fundamental effect on the shape of performance – on how it was undertaken, how it was mediated, received and documented. Nothing has happened to dissuade us from this view, if anything we are even more convinced that our first hunches were correct. The only aspect of the hunch that may have changed a little is that whereas in 1997 we were convinced there would be an overriding torrent of applications (as indeed there was, greater than even we anticipated) the widest general application has been slower for a number of reasons (costs, something on the axis of unfamiliarity/fear/Ludditism, lack of bandwidth, bewildering complexity and techie–talk in some aspects, etc).

Can I immodestly refer the reader particularly interested in this aspect to an essay I wrote on the topic entitled 'Dramatic Forays into IT: working computers with a broom handle' see http://www.pads.ahds.ac.uk/introduction.html. The introduction, 'Guide to Good Practice in Creating Digital Performance Resources' deals with many aspects from the relatively straightforward to more futuristic predictions, worries and questions. It will itself of course very rapidly become a time–piece if it already hasn't.

Q – Who is DPA for? Artists, academics, promoters?

Barry – It's for anyone who wants to re–visit 'digital performance' at the end of the twentieth century 1999 to 2000.

Q – What are the three top tips you would give an artist/company engaging in digital performance work?

Barry – Currently work is often proscribed by what 'digital performance' facility is available to the particular artist/company. If it's a single laptop it's a very different entity to having access to a virtual reality lab and all the technical expertise that is likely to go with it. So my first tip would be not to be drawn into technological niceties and excesses but remain true to the intention behind the piece of work, and if a particular aspect (or even the totality) is best realized using digital facilities then investigate what's possible.

There was a very amusing moan on one of the electronic Live Art mailing lists recently that it seemed to be an imperative of arts funding applications that the proposal had to have the word 'digital' liberally scattered about to stand any chance of getting a grant ... hopefully that's already faded away as the notion of aspects being delivered via a digital technology

are taken for granted. So if a particular digital requirement becomes a necessity my second tip would be to research the field and see what's been done to what effect (and hopefully the DPA can serve some function here).

My third tip would have been to ensure that the work was included in the DPA but that particular route is closed now as the project officially finished on 31st December 2000 and will be lodged with the national Performing Arts Data Service for perpetuity by mid–summer 2001.

In the 'early days' of generally accessible email (c1994) when the medium was extremely arduous and unattractive compared to facilities a few years on, the then online community was extraordinarily generous in helping one another overcome the difficulties of the new medium ... As the facility has expanded out of all recognition much of that has disappeared (as much due to overload one suspects as the onset of mischief makers) so today you will need to target much more precisely people who you think might be able to assist – and then you will usually find the same level of generosity in giving advice or trying to assist.

So my third tip would be to ask questions and, just as important, try to assist when you're asked. Digital technologies have fundamentally shifted the time/space continuums in which we live and work and which traditionally have been (and still are) the basis of all performance events. The least we can do is to try to assist others acclimatize to the new environment and then get back to the bigger and more fundamental issues of the arts and humanities.

135

Paul Couillard, FADO

Q – How would you describe your role in the art world?

Paul – I work as both an artist and curator in the field of performance art. For me, the curatorial aspect of my practice – that is, organizing and contextualizing performance events featuring other artists' work – is an essential part of my artistic output. When I present other artists' work, I do so as a colleague, Curating and producing are essentially forms of networking, research and collaboration for me. Most of the work I do as a curator is through two different Toronto – based organizations, FADO and the 7a*11d International Performance Art Festival. FADO is an incorporated non–profit artist–run center, and I am its Artistic Director. 7a*11d is an unincorporated artists' collective, where I am one of several equal members (currently eight). The two entities have different mandates and different definitions of performance art, so it is useful to talk about each of them.

The phrase 'performance art' is problematic, since performance art is a self–defining medium. Theoretically, any artist – or non–artist, for that matter – can call what they do 'performance art.' Unlike media like painting, sculpture, or photography, which can be defined fairly easily by their form and how materials are used, 'performance art' is more a set of constantly contested practices that have a variety of historical, cultural and aesthetic lineages. Because of this constant evolution, what was understood as performance art in 1965 might sit more comfortably today as a music concert, or a dance, or a piece of theatre. There are also vast regional differences – so what commonly gets billed as performance art in the United States is often quite different from what gets billed as performance art in Canada or Europe, for example. FADO defines performance art in relation to the root elements of the medium time, space, the performer's body and the relationship between performer and audience. We are most interested in works that are innovative in their use of one or more of these elements, including those that are multi–disciplinary. We focus on artists who have chosen performance art as a primary medium to create and communicate provocative new images and new perspectives. FADO gets a lot of proposals from artists doing work that would not be at all out of place on theatre, dance or concert stages. Generally I end up referring those artists to other organizations that can do a better job of presenting their work. FADO's job is to present modest–budget projects that address aspects of live presence, but don't fit into the defined support structures of art. We like to challenge audience expectations.

7a*11d's programing mandate is a bit different, since we are a collective with an eclectic range of tastes. Our format has been to program the festival as a collection of curatorial series. Each series reflects the concerns and aesthetics of the individual curator or curators

involved. We haven't wanted to get into a group selection process, which could have the effect of watering down individual visions. We don't have a unified definition of performance art, so our programing has covered a very wide territory that constantly questions where performance begins and ends. We did an exhibition of machines, for example, where the objects 'performed' as a stand–in for the artist's body (JAWA:bot; Machines that perform (1997); we've done cabaret events (e.g. Terratoid Cabaret, 1997), raves (e.g. Samhain in Wasteland, 1998), street interventions (e.g. Field Trips,1998), theatre, dance and music performances, multimedia extravaganzas, performance installations – just about every performative form around.

Q – How did you get started?

Paul – I started doing performance art in the mid–80s in Ottawa, after a stint as a correspondence writer/editor for the government. I had worked my way through a series of well–paying jobs, and I was being groomed for high–level administrative success, but I felt like my soul was dying. Then I happened to see a performance by Rachel Rosenthal, called *Gaia, Mon Amour*. I was floored by it – by the work, and by its message. I remember sitting in my chair after the performance as the audience shuffled out, feeling absolutely shell–shocked and thinking, 'Well, I guess this is what I have to do with my life.' To make a long story short, I quit my job, started creating performances, and began working in artist–run centers as a way of educating myself about performance art. I had ideas for some big projects, and I thought working in an artist–run center would be a good way to pick up the administrative skills I'd need. I started programing almost anything that called itself 'performance art' to figure out what it was I was doing, and I also went to LA for four months to study with Rachel Rosenthal, the artist who had inspired me.

I didn't have a formal art training; in fact, it had never occurred to me that there might be a relationship between what happens in an art class and the kinds of events I was interested in creating. I learned by doing. (No doubt Rachel Rosenthal had an influence on my thinking; she calls her approach to performance DbD, or Doing by Doing). After about seven or eight years of working in various artist–run centers and trying to make my own work 'on the side,' it began to seem more like a badly paid job than a calling, so I had to reorient my approach. I continued to work in a voluntary capacity as a programer, but was rapidly becoming discouraged by an artist–run center climate of brutal politics, social dysfunction and crippling poverty.

Q – Could you tell us a little about FADO? When did it start? What were the initial aims?

Paul – FADO started in 1993 as an ad hoc group of performance artists. I had moved to Toronto in 1989, when

I realized that the only performance art projects happening in Ottawa were ones that I initiated and produced. I thought in the larger pool of Toronto, I might find somebody else to produce my work, but it was bad timing. The early 90s were a low point for Canadian performance. The artist–run centers who had been producing work since the late 70s were in a state of shock and retrenchment due to cuts in public funding, and the first thing to go was their performance art programing. A lot of artists had stopped making work, largely for financial reasons. So there was no one to produce work. In 1993, Tari Ito, a Japanese artist, was coming to Toronto, and some artists wanted to help her do some kind of performance while she was here. So we had an event to organize ourselves around. We gradually started doing other projects, often in collaboration with existing artist–run centers.

At that point, I was reluctant to delve too deeply into organizing, but the vision of a center devoted specifically to performance art was becoming clearer and clearer to me. I eventually came to the conclusion that the only way to realize the dream would be to take it on myself.

Things were beginning to look up for performance – FADO had organized some important events, like the 1996 RENCONTRE festival, when we collaborated with Le Lieu, a Quebec–based artist–run center that produces a biannual international performance art festival. That year we brought ten artists from their festival to Toronto, and combined them with several local artists in a three–day event. A number of small collectives similar to FADO had begun to form, and were also producing events. By this time I had completely abandoned the artist–run structures that existed in Canada, and was self–producing all of my work. But there seemed to be an explosion of performance art, so in 1997, a group of about fifteen artists got together and started the 7a*11d International Performance Art Festival. FADO co–produced one of the series in the first festival. The festival was an enormously successful and rejuvenating experience, and restored my faith in the concept of an 'artist–run' entity.

As a loose collective, the festival went through inevitable shifts of membership and structure, eventually settling into its current format. Some of the smaller groups that were involved in the first festival (all.at.onceness, FADO, Spank Performance Art, Liminal Labs, ¡The Cult of POPO!) disappeared or were folded into the festival, while other have continued as individual entities. 7a*11d now produces an international festival every two years, most recently the third 7a*11d festival in 2000. 7a*11d also does other kinds of projects in the in–between year. In 1999–2000 we co–produced an artist residency with FADO (Rachel Rosenthal), and for 2001 we are planning a three–city exchange project with Montreal and Vancouver called ReciproCity/ReciproCité. I was inspired by 7a*11d's success in pulling off an event as big as the festival, but I felt Toronto also needed a more sustained level of activity. In my opinion, the success of big international events is

best measured by how much grassroots activity they generate. So in 1999, FADO threw down the gauntlet with our TIME TIME TIME series. FADO was starting to get project support from the various arts councils, so I deliberately positioned this series to operate in a sustained way, with a new major exhibition each month. I wanted people to perceive FADO as operating like any other artist–run center, with year–round programing. The gamble paid off, and in 2000 FADO began to receive operational funding from two levels of government.

Q – How does the organization operate – are you a limited company? A non–profit organization?

Paul – After years of functioning as an unincorporated collective, FADO finally incorporated federally as a non–profit organization at the beginning of 2001. This was a requirement for receiving operational support. We have a seven–member Board of Directors, all performance artists themselves, and I am the Artistic Director. I look after the day–to–day operations, including administration and programing. I receive a small honorarium, but at this point it is still largely a volunteer labor.

In Canada's current public funding environment, securing operational support was an unprecedented coup, but funding levels are still very low in relation to our profile and level of activity. We represent a new way of thinking about what an artist–run center is in Canada. We don't operate a facility. Since the kind of space required for events varies widely, one artist wants to do a parade; the next needs a church; the next one an Olympic–size swimming pool, and so forth, it doesn't make sense to run a gallery or theatre. A physical plant would tie us to doing certain kinds of work. Instead, we go out and find whatever space is appropriate to the current project. 7a*11d, which operates on a project basis with a fluid membership and a willingness to reinvent itself with each new event, is an unincorporated non–profit artists' collective.

Q – Peggy Phelan has written that live performance is the 'runt of the litter' in the performing arts because of its non–commodity–based identity. What excites you about live work?

Paul – This question points to the underlying tension that I suspect drives all of my work. It's probably every artist's dream to be financially supported for doing what they do. But I was drawn to this work as a calling, something I had to do to save my soul. I believe that the artist's role is to be the conscience of society, which is a very heavy responsibility, and has nothing to do with the 'business' of art as it's generally practiced. Virtually all of the work I do calls our capitalist, consumer culture into question. Money is the glue that knits together civilization, a strategy that I think is fundamentally flawed and could destroy humanity in the long run. My work is a search for other reasons and ways for us to co–exist.

As such, the events I produce don't generally fit into the category of entertainment for the eyes and ears, which is the way performative experiences are generally packaged these days. So there's a basic contradiction there, in having to survive in a consumer culture, essentially by marketing events that try to shift us away from consumer culture. I suppose I'm enacting a dance of my conflicted self in my roles as artist and curator. Fortunately, the work I am most interested in right now is work that would be considered 'small,' so I've been able to juggle this contradiction. I value reaching a few people deeply over getting exposure to a lot of people with little lasting impact. I'm currently producing a series called PUBLIC SPACES/PRIVATE PLACES that is all about intimacy. Margaret Dragu, a Vancouver–based artist, describes this kind of work well in a rephrasing of something Gertrude Stein said: 'My performances are very small, but very legendary.'

Every live art event has its own set of achievements and disappointments, but I'm constantly overwhelmed by the intelligence, compassion, honesty and sheer ability of the artists whose work I produce. Nearly every performance I present evokes a profound emotional response within me; I cry a lot when I present these things, but in a good way.

Q – How supportive is Canada to live performance work?

Paul – The last five years have been quite remarkable for the development of performance art. There has been a huge resurgence of interest on the part of both artist practitioners and audiences. There seems to be a real hunger for experiential work as an antidote to the numbing passivity of consumer culture. It's a natural response to 'virtual' reality's promise of a world free of the physical resistances. Physical resistance is at the core of our experience as embodied creatures; cultural expression is centered around how we generate meaning from the struggle to overcome the limitations placed upon us by our living, breathing, mortal bodies. So I see young artists gravitating to performance art as a form in unprecedented numbers, and I'm finding audiences anxious to be a part of work that engages all of their senses and challenges the ways we expect experience to be structured.

In 1995, most Canadian cultural arbiters would probably have declared performance art 'dead' – a '70s and 80s blip on the art radar screen. Now the buzz is all about the resurgence of Live Art. Artist–run centers have renewed their interest in including performance art in their programing, and a number of regional performance art festivals have sprung up in many cities, including Toronto, Montreal, Vancouver, Edmonton, Calgary and Halifax. Public funding remains grim, as we continue to take major cuts at provincial and municipal levels – a situation that is particularly troubling given performance art's limited ability to find funding from other sources – but we have been enormously encouraged by increased support at a federal level. The Canada Council underwent a major restructuring of how performance art is funded when it consolidated what is now called the 'Inter–Arts Office,' and there is no doubt that this positive development is a contributing factor in the liveliness of the current scene. One of their most important initiatives was to put some money into networking, so that performance art presenters from across the country could meet for the first time in years. This was a huge boon, since our resource and networking structures had collapsed, and it had become virtually impossible to find out what was going on in other parts of the country. Now artists and programers from across the country are in more regular contact, and we are using tools like email to communicate on a more regular basis.

Q – What kind of support structures would you like to see exist for live performance?

Paul – In Toronto, performance artists have never been so well served. FADO is devoted exclusively to performance art and does year–round programing; 7a*11d presents a biannual international festival plus other major projects. Performance activity is programed on an occasional basis by various artist–run centers, and a few artist collectives and initiatives such as the International Bureau of Recordist Investigation and ¡The Cult of Po–Po! also organize events. We have two schools, the Ontario College of Art and Design and the University of Toronto, that offer courses in performance art. It's a lively local scene, fed by lots of opportunity for contact with artists from other regions and countries. Nevertheless, it is nearly impossible for an artist here to make a living doing this work, and despite the great leaps forward in terms of national networking, it remains difficult to find out about presentation opportunities. There is virtually no infrastructure in place to present works with ambitious technical, material or research demands. The already difficult process of accessing public funding support for individual artists is made even more unlikely at the provincial and municipal levels, where 'peer assessment' is done by a jury of artists that does not include any performance art practitioners. And finding critics who will write about performance in art magazines, let alone mainstream news publications, is a daunting task. We need more and better resources, venues, communication and critical discourse, all over the world. But then again, those are all the physical resistances that I posit are the essence of the struggle that gives our life meaning. And I am well aware that despite the fact that I am relatively impoverished by the standards of my country, I live in a world of vast material luxury when compared to human conditions throughout history.

Q – How much does FADO cost to run?

Paul – FADO's total cash operating budget for our 2000 to 2001 season was approximately 50,000 Canadian dollars, of which 60 percent went directly to artist fees, including honoraria, travel costs and accommodation. An additional 25 percent went toward production costs including equipment and space rental, insurance, shipping and materials costs. The remainder of the budget was spent on publicity, documentation, and administrative costs. It's a very modest operation, although I would estimate that the value of FADO's non–cash resources, in the form of sponsorships and donated goods and services, especially volunteer labor, is much higher – in the neighborhood of $150,000 or more.

Q – Where do you find the money?

Paul – Looking at our 2000 to 2001 figures, 40 percent of our cash budget came from the Canada Council, 25 percent from the Toronto Arts Council, less than 15 percent from the Ontario Arts Council, another 10 percent from donations and sponsorships, and the remainder from gate and other revenue (for example workshop fees for the Rachel Rosenthal workshop). There are very few possibilities for non–governmental support for performance art. Very few foundations are interested in this kind of work, although we hope that things will improve a bit for FADO now that we are an incorporated non–profit organization.

Q – How much of a problem has it been getting FADO funded over the years?

Paul – Our ambitions far outstrip what we are able to do financially. For example, it is very difficult to bring in high–profile artists because of the fees they require. So far, not receiving funding for a project has meant that we take a longer time to do it, rather than abandoning it completely. PUBLIC SPACES/PRIVATE PLACES, for example, turned from a two–year series into a three–year series when we didn't get enough money to do it in the timeframe originally proposed. As a curator, I've managed to carve out some financial flexibility for myself by programing through other organizations such as 7a*11d and artist–run centers as well as FADO, but this becomes more difficult as FADO solidifies its position as an artist–run center. The pool of available support is small enough that I end up competing with myself for funds. There has also been a profile issue: people have confused FADO and 7a*11d because of my involvement with both groups. Now that both groups have clearly defined mandates of activity, I am scaling back my curatorial contributions to 7a*11d to focus on FADO.

Q – How do artists fees get worked out? What is the policy as regards box office

split, marketing costs, publicity?

Paul – The bottom line is that as modest as budgets are, most projects would not be financially viable if they relied on box office. Because of the nature of our events, we generally don't charge an 'admission', though there is often an unmanned box requesting pay–what–you–can donations at events. FADO starts with a standard minimum artist fee of 1,000 Canadian dollars for stand–alone solo performances, and then negotiates adjustments for additional performers, well–established artists demanding higher fee scales, and additional costs for travel, accommodation and per diem as required. We generally provide the venue, and technical and publicity support, with extraordinary costs to be negotiated. We try to photo– and video–document all of our events, and that material is made available free or at a small cost to the artist.

As a festival, 7a*11d follows a similar structure, but starts from a base standard solo performance fee of 500 Canadian dollars (performances are usually presented in groups as part of a larger bill). In setting a basic fee, we don't make a distinction between, say, a twenty–minute cabaret piece or a three–day installational performance.

Q – What was your selection process like for putting together the programs?

Paul – Unlike most Canadian artist–run centers, FADO does not have standard annual or biannual submission deadlines. We look at proposals as they come in, and organize programs according to what interests us. That said, receiving annual operating support does necessitate organizing most of our programing well in advance, so there is often a gap of a year or longer between when a successful proposal is submitted to us and when it is actually programed. Sometimes an individual proposal will inspire the idea for a sustained series. We solicit proposals for specific curatorial series such as TIME TIME TIME or PUBLIC SPACES/PRIVATE PLACES. These series are programed through a combination of solicitations to specific artists (i.e. a pre–selection) and a public call for submissions. We present artists from all over the world at all stages of their career, from recent students to well–established professionals, based on how compelling we find their work and how well it fits our mandate or series guidelines. 7a*11d puts out a call for proposals for each festival. In the past, some of the curators already have specific themes or concerns in mind, which are included on the call, but we are also open to developing new programs in response to the proposals we receive. Again, the selection process usually ends up being a combination of work that is solicited and work that we become aware of as a result of the submission process.

Q – Do you think that producing this type of work is getting harder or easier?

Paul – This seems like as good a time as has ever existed for producing this kind of work in Toronto. FADO has managed to build up a basic infrastructure that allows us to achieve the goals we have set for ourselves. Because of the kind of work we do, every performance presents different challenges – securing adequate financial resources, finding the right venue, reaching the right audience – and there seems to be a fair amount of room for creative manoeuvring. That said, there are always many potential storms on the horizon, the most obvious of which are continued declines in public funding and spiraling real estate prices in Toronto. Many independent rehearsal and exhibition spaces have closed over the past few years, and industrial and warehouse sites are rapidly disappearing under the wrecker's ball to make way for infill condominium and townhouse development. What is easy is finding work to program. I am overwhelmed by the outstanding quality of thought and expression being produced, and it's a great privilege to be able to share that with FADO's audience.

Q – What was your worst mistake in the past?

Paul – I am relatively sanguine as I look back over fifteen–plus years of performance art production. The many crises along the way have been rather minor, thankfully. There are only two areas of concern that stand out. The first has to do with working with co–sponsors. It is a mistake to assume that sponsoring partners have any idea what is really involved in producing a performance art event. My experience is that every detail, from the artist's set–up and equipment requirements to financial agreements to public crediting arrangements, should be carefully discussed and, better yet, written down in a mutually shared document. (And no, I'm not going to share my horror tales in print – though they make good stories at a friendly dinner table.)

My second caution is about overusing one's resources. FADO and 7a*11d both exist by the grace of extended volunteer support. I have to be ever–vigilant about not counting too heavily on any one person, and making sure that those who do offer their services are rewarded in ways that make them feel their effort is worthwhile, acknowledged, and above all, not taken for granted.

Q – In your opinion and experience, what are the key elements to a good performance proposal?

Paul – Let's start by assuming that the proposal already fits into my basic programing criteria, and is the kind of project I would be interested in supporting. It is not, for example, another solo pseudo–autobiographical theatrical monologue that could as easily play in a mainstream theatre or stand–up comedy venue. It is not a classically constructed dance

piece whose innovation comes from the fact that it includes a media backdrop of slides or video projection, or because it is presented on an outdoor stage rather than an indoor stage. It is not an experimental music concert using classical instrumentation. I am not saying that there is anything wrong with these kinds of events – only that they are not typical FADO events. Let us say that the proposal is for an event that challenges our traditional expectations of time, space, the performer's body or the relationship between artist and audience. When I read a proposal, I want the artist to tell me, as clearly as possible, what they intend to do, and why. This is generally accomplished through a description of the proposed work, which should include an indication of what kind of space they need for the project, how long they need the space to set up and perform, what actions they will do or images they will make, what technical requirements need to be considered (lighting, equipment, materials, etc.), when the project would best take place, how long it would last, how the audience would experience the work –very basic stuff that gives me a sense of how the piece is likely to look, sound, feel, smell, etc. I want to know a bit about the artist's process in choosing to do this work – what they are thinking about, what they think makes it important, etc. – but I am not particularly interested in a long–winded critical or academic discourse on the work. I do want to know why the artist thinks FADO is the right place to produce their work.

The proposal should cover practical considerations in enough detail for me to know what kind of space the artist will need, how long they are going to need to be in town to do the work (for an out–of–town artist), and what the project is likely to cost FADO to produce. Generally, FADO can calculate a budget from what is requested (i.e. we know what accommodation, travel, space and equipment rental, technical personnel, insurance and permit costs will be based on what is requested), but any special budgetary requirements (e.g. specific material costs, extraordinary rentals, extraordinary artist fee costs, or special personnel costs such as additional collaborators) should be indicated and costed out by the artist.

The proposal should indicate what kind of audience the work is seeking, and what the work is about – issues being addressed, cultural context, etc. The proposal should also indicate what the current stage of development of the project is, and offer information that demonstrates the artist's ability and willingness to do whatever is involved to bring it to completion. In addition to the proposal, the artist should include a CV, a general artist statement if applicable, and appropriate support material. There are a couple of very practical considerations that can make my job as curator a lot easier. One is for the artist to include a SHORT DESCRIPTION (minimum two and maximum five lines) of the work. If the proposal is accepted, this saves an enormous amount of time when it comes to writing grant applications. The artist should include a two–page CV for the same reasons. Many artists are fond of long CV's with pages of information on publications, teaching experience, etc., but most funding agencies now restrict CV support material to two pages.

An artist with a long CV may want to send the full version for curatorial consideration, but they should also include a two–page version for grant purposes. A short bio is useful for similar reasons.

Q – How important is it to you that an artist be able to articulate the relationship between a proposed piece and the context in which it is shown or funded?

Paul – If an artist is responding to a specific curatorial call, FADO expects to see some information in the proposal about how the work relates to the specific themes, issues or formal considerations of the series. General proposals should give some indication of the context in which the artist places her work, and why FADO is the right organization to produce this project. Since FADO does not have its own facility, all proposals are ultimately site–specific, so the artist should articulate what kind of space is required and why.

Q – Are there any common pitfalls you have noticed among proposals by artists that you could advise emerging artists against?

Paul – Proposals are most often overwritten or underwritten. In the first category, I've found a tendency for artists coming out of a school environment to contextualize their work in ways that are not always borne out by the actual work. Artists should use clear, layman's language to talk about their work, and have some faith in curators' abilities to draw their own critical conclusions about work. In the second category, many artists seem to find it very difficult to simply describe what they want to do, and to articulate why they want to do it. FADO does more than most in following up with artists through phone, email and face–to–face contacts to find out just what they're proposing, but it doesn't help an artist's chances if she can't describe in writing what she wants to do.

Q – If you could say one thing to every emerging performance artist, what would it be?

Paul – Follow your heart. That may sound corny, but it cuts to the heart of why anyone would want to be a performance artist. Anyone seeking adoration, fame or money has probably made a huge tactical error by becoming a performance artist – there are a lot better ways of getting those things! Performance art is a calling, done out of an urgent need to express something in a new way. Don't just try to imitate what's trendy, or what seems to have worked for someone else. Be true to your own voice, because the only real reward is in hearing that voice speak its truth.

Martha Wilson, Franklin Furnace

Q – Can you give us the background of Franklin Furnace? How did it start?

Martha – Franklin Furnace's presentation and documentation of contemporary art is rooted in my personal perspective, which is that of an artist and a producer of art – a woman artist whose works were scorned in 1972 by her male colleagues. This invisible social position led me to found an institution that would champion forms of art that were not accepted by mainstream institutions, and were often politically in opposition to

mainstream cultural values. (I can conclude this now that I have 20–24–year hindsight.)

The concept for Franklin Furnace germinated in 1975, when I saw that major institutions were not accommodating works of art being published by artists. There was a vacuum, a hole in the artworld, and I decided to jump through it into the unknown. What was the worst that could happen to me? I would have to go back to work as a secretary again. I decided to gather, exhibit, and sell, preserve and proselytize on behalf of the intersection of word and image, the form that came to be known as 'artists' books.' I opened Franklin Furnace Archive, Inc. in my living loft (which happened to be a storefront) on April 3rd, 1976.

Q – What were your aims for Franklin Furnace?

Martha – Franklin Furnace's presentation of temporary installation work and what came to be known as performance art started right from the get–go. The artists who were publishing artists' books were the same ones who considered the text to be a visual art medium (Jenny Holzer and Barbara Kruger come to mind). Martine Aballea, whose book was in Franklin Furnace's collection, was invited by Jacki Apple, who served as Franklin Furnace's first curator, to read it in our storefront in June 1976. When she showed up in costume, with her own lamp and stool, the performance art program was born. Although I called it Artists Readings in the beginning, every artist chose to manipulate the performative elements of text, image and time, from a very simple 1977 performance by Robert Wilson of the word 'there' repeated 144 times with a chair on stage, to the more messy 1983 performance of Karen Finley taking a bath in a suitcase and making love to a chair with Wesson oil. Franklin Furnace's niche became the bottom of the food chain, premiering artists in New York, some of whom later emerged as artworld stars.

Around 1980, I perceived another vacuum in the art world. No one seemed to be researching the history of the contemporary artist book in any thorough–going manner, so I tried to do it in a year, hiring four guest curators/teams to tackle four twentieth century time periods of The Page as Alternative Space. Clive Phillpot organized material for 1909 to 1920; Charles Henri Ford from 1921 to 1949; Barbara Moore and Jon Hendricks from 1950 to 1969; and Ingrid Sischy and Richard Flood from 1970 to 1980. After this heady year, Franklin Furnace hired a slew of guest curators to explore the history of the published artwork in even more depth, organizing usually one big exhibit per season such as Cubist Prints/Cubists Books, The Avant–Garde Book: 1900–45, Fluxus: A Conceptual Country, Books by Russian Avant–Garde Artists, as well as thematic shows such as Artists' Books: Japan, Multiples by Latin American Artists, Contemporary Russian Samizdat, Eastern European Artist Books. Taken together, the magazines and catalogs published to document these exhibits form a history that is still not available under one cover.

Although we had been reprimanded in 1984 by Hugh Southern, Deputy Chairman of the National Endowment for the Arts and Benny Andrews, Director of the Visual Arts Program for our exhibition entitled Carnival Knowledge, the conservative tide in the United States was not strong enough yet to be taken seriously. 1990 was a fateful year, however. In this year, the Democratic Governor of New York State, Mario Cuomo, cut the NYSCA budget in half, decimating support of Franklin Furnace to the tune of $100,000 from one year to the next; and Franklin Furnace exhibited an installation by Karen Finley entitled *A Woman's Life Isn't Worth Much*.

This in itself was not a crime, but by May of 1990 she had already been branded 'the nude, chocolate–smeared young woman' by columnists Evans and Novak and conservative forces in Washington had gained much credibility and momentum. Following Karen's exhibition, Franklin Furnace was turned into the New York City Fire Department as an 'illegal social club,' closing the performance space; at this point the staff was divided over whether Franklin Furnace was being politically harassed. I spoke to Joseph Papp, who had lived through the McCarthy era; he said to blab to every single person who would listen because the goal of the opposition was our silence. Subsequently, our program and financial records were audited by the General Accounting Office, the Internal Revenue Service, and the New York State Comptroller. The National Endowment for the Arts audited Franklin Furnace continuoualy from 1985 to 1995.

Clarity started to be glimpsed through the fog. The cost of cataloging and conserving Franklin Furnace's collection of artists' books published internationally after 1960, by this time the largest in the United States, was going up; but the public support of small arts institutions, especially those that chose to exhibit 'difficult' art, was going down. Further, the beautiful, nineteenth–century Italianate loft in which Franklin Furnace was living was made of wood, while its collection was made of paper. Lastly, we did not own the building, so bringing the space up to code for performances and installing climate control equipment for the maintenance of the collection did not add up financially. Also the landlord was suing us to get us to vacate so he could sell the building. In the Fall of 1990, I made the decision to mount Franklin Furnace's performance program 'in exile,' in other institutions' spaces around town such as Judson Memorial Church, Cooper Union, The New School, P.S. 122, Dixon Place, the Kitchen, NYU. And then on Halloween of 1990, the landlord dropped dead, and his daughter offered the artists who occupied 112 Franklin Street the opportunity to buy the building.

Ideas were forming in the aftermath of the events of 1990. One was to place the collection of artist's books in the embrace of a larger institution that would value it, and continue to catalog, exhibit, lend and enlarge its scope. The Board made inquires at a few select institutions, but it was really Clive Phillpot's resolve to acquire Franklin Furnace's collection for the MOMA Library that made this deal happen in 1993. The terms that were

149

important to us were that Franklin Furnace's name would remain on the Museum of Modern Art/Franklin Furnace/Artist Book Collection; and that its collection policy would be open to any artist who claimed, 'this is a book.' In 1999, the collection became accessible through MOMA and Franklin Furnace's websites so artists and others may look up their works.

The other idea that galvanized the Board was that we should raise the money to make the down payment on purchasing Franklin Furnace's loft, and eventually bring the 'c' copies of the artist book collection home to be handled casually, get coffee stained and read, as the artists intended; and to bring the performance art program home as well. In short, our idea was to renovate Franklin Furnace's loft into a downtown art emporium. After a Summer long search in 1994, we hired Bernard Tschumi to prepare a physically and visually accessible design that was still sensitive to the historic nature of the building and the neighborhood. And we hired a Capital Campaign Consultant to help us raise the $500,000 it was going to cost to make the design a reality.

During the 1994–95 season, four separate donors asked us, 'Have you been to the American Center in Paris?' Here was an institution that sold its Beaux Arts building downtown to build a Frank Gehry building on the outskirts of Paris – and ran out of money to mount its program. The fog cleared in the Summer of 1995 when, sitting in my sister's kitchen staring at Mount Rainier, I realized that Franklin Furnace would never be remembered for its blonde oak floors, but rather for its program – and I was raising half a million dollars for the wrong purpose. Omigod.

Q – Why and When did you make the shift from Franklin Furnace as live programing venue to a virtual performance space?

Martha – In September of 1995, I took a radical concept to my Board: I wanted to sell the darn building, and concentrate the program on broadcasting artists' ideas. This was not really dissimilar from the original purpose publishing itself served in 1910 when the Italian Futurists threw 800,000 manifestoes berating past–loving Venice onto the heads of folks emerging from church. Except now there were all sorts of new ways to broadcast artists' ideas including broadcast and cable television, and the Internet. They really went for it, especially the plan to get performance artists on broadcast television, which I ultimately failed to accomplish.

Not too long after the decision to sell Franklin Furnace's loft was made, I was invited by performance artist Nina Sobell and artist Emily Hartzell to perform on ParkBench's ArtisTheatre. It was Nina and Emily who, in 1994, performed and archived their first realtime web performance via a remotely–controlled webcam; and saw the potential of the Internet as an art medium, with its new textual and visual vocabulary, as well as its potential

to draw artists and audiences into interactive art discourse. I decided to do Tipper Gore singing *The Star–Spangled Banner* to accommodate the one–frame–per–second speed of the netcast. The performance was a collaboration: they hung a red velvet curtain behind me, and an intern, Cory Muldoon, was inspired to superimpose the lyrics of our National Anthem, in blue, upon my body as I sang. I came away satisfied with my first virtual performance. This was in October of 1996. In December, Jordanh Crandall, Director of the X–Art Foundation, invited artists to curate works for Blast 5, and Adranne Wortzel selected Nina and Emily, who in turn invited Franklin Furnace to be a part of the cyber/physical space/time installation at Sandra Gering Gallery. I selected four artists/collaborations: Alexander Komlosi, Tanya Barfield/Clarinda MacLow, Anita Chao/Rumiza Koya, and Prema Murthy/Diane Ludin prepared works that are still archivally available at parkbench.org.

Altogether, Franklin Furnace got in trouble four times with the forces of darkness in Congress and among conservative Christian right groups. In September, 1996, the Christian Action Network mounted a performance art spectacular on the steps of the Capitol Building to protest the $132,000 in federal dollars (not true) we were spending on our Voyeur's Delight exhibition, and to call for the death of the NEA. Their press release linked us with the virus eating away at the health of the body politic, and the performance included two coffins and a guy dressed up as the Grim Reaper, (I think it says something when the Christian conservatives recognize the power of performance art tactics in getting their point across.) But this time, Franklin Furnace was building its website as its public face, so I decided to put up a page called U–B–D–Judge, to collect public comment, both positive and negative, regarding the works in exhibition. We reprinted CAN's press release in its entirety, and ours; and asked permission of the artists to publish their work on our site, each piece accompanied by the artist's statement explaining why Jocelyn Taylor had a speculum up her vagina, for example. Sure enough, this page has generated both positive and negative comment, intelligent and stupid comment, all of it valid and important to the discourse that surrounds and emanates from contemporary art.

In 1996–97, I mounted a pair of twentieth Anniversary exhibitions to go out of the physical space with a bang: Voyeur's Delight, organized by Barbara Rusin and Grace Roselli (discussed above) examined the power of looking; and In the Flow: Alternate Authoring Strategies, traced the evolution during the last two decades of art as flowing information rather than property, including works by Sol LeWitt, Group Material, Louise Lawler, Frank Gillette and David Ross, the Thing, X Art Foundation, Guerilla Girls and others. On February 1, 1997 this exhibition closed, and Franklin Furnace's website, www.franklinfurnace.org, was launched as the institution's public face.

Also during the fateful year of 1996 I developed a pilot tape to show to cable and broadcast television producers in what turned out to be a futile effort to get performance artists on

television. It was called 'Untitled', and it showed a wide array of artists' approaches to the subject of sex – since the commonly–held belief is that that's all we think about anyway, I wanted to show approaches that were humorous, despairing, scary, satirical of corporate exploitation – a wide range of approach. Some members of my Board felt this represented a tactical error, and that I would never succeed in catching the interest of TV execs. And indeed, after meeting with Lorne Michaels, Tom Freston, Eileen Katz, Mary Salter, Susan Wittenberg, Sue West and a bunch more executive types, it became clear to me that broadcast and cable television represents an entrenched industry, one that has become highly regulated, developing 'standards of conduct' and clear taboos in order to continue to blast content directly into our homes.

Meanwhile, I was being courted by Internet–based broadcast companies. Sensory Networks, Thinking Pictures, Pseudo Programs – these start–up companies were broadcasting streaming video over the net. At first, I was put off by the tiny, jerky image and the cramped, smoke–filled facilities that Sensory Networks was proposing to use to mount a performance art program. Galinsky, spoken word artist and Executive Producer of ChannelP, the performance channel of Pseudo Programs, Inc., had proposed a performance program in collaboration with Franklin Furnace during the Summer of 1997, but I blew it off because their studio was not capacious, nor set up for visual artists – Josh Harris, the founder of Pseudo, had established it as a radio network. But luckily at the same moment (Fall, 1997) Pseudo was preparing to become the largest producer of television–style broadcast over the Internet. Further, these guys wanted MORE Annie Sprinkle. They were not only not afraid of the tendency of artists to get naked, they embraced the challenging stuff wholeheartedly.

When the ink dried on the contract selling Franklin Furnace's loft in September, 1997, the Board went into a paroxysm of doubt about what a virtual institution was, what its programs should be and for whom, so we entered a soul–searching process that included a series of town meetings with artists and others within and without the artworld; I commenced an itinerary of travel and research, attending conferences such as Silicon Alley 98, Circuits@nys, and Museums and the Web; and commenced to meet and talk, to re–evaluate and re–imagine Franklin Furnace's role as an 'alternative space' at the end of this century.

At this same dark time, we were mounting our first ever netcasting program, Franklin Furnace at Pseudo Programs, Inc., in the Spring of 1998. Ten artists selected from among proposals to the Franklin Furnace Fund for Performance Art were invited to prepare performance works for netcasting to a worldwide audience. Galinsky and I winged a contract that gave artists six hours of production time for 50–minute shows uninterrupted by commercial breaks. Halona Hilbertz, Bingo Gazingo, Patricia Hoffbauer, Jon Keith, Jason Bowman, Anna Mosby Coleman, Kali Lela Colton, Lenora Champagne, Nora York

and Alvin Eng toured Pseudo's facilities and began to loft their ideas to Galinsky, who could explain how ideas might look translated into the new art medium of netcasting.

By our second season, September 1998 to July, 1999, we revised the length of the show to 30 minutes because our experience had demonstrated that artists did not usually have enough material to fill nearly an hour of air time; further, as the season progressed, it became clear that the discourse we had hoped to engender would need some priming at the pump. Consequently, Franklin Furnace and the participating artists developed a format that was optional, but got used much of the time: I would introduce the work; the netcast would proceed; then the show would end with a question–and–answer period with the artist, the public communicating on the 'chat' lines and invited guests of the artist and Franklin Furnace (such as Moira Roth, performance art critic; Jessica Chalmers, performance artist and critic for the Village Voice; Robert Atkins, cybercommentator). In this way, we successfully developed a dialog about the work, performance art, the new art medium of netcasting, the body of the artist and the net, among other more mundane subjects like what foods New Yorkers like.

Q – How did the shift in space alter the audience to Franklin Furnace work?

Martha – Our audience had fundamentally changed from 75 people sitting on hard folding chairs to an international audience of aficionados who view netcasts on their computer terminals: artists, art professionals, college students, office workers – and we think geeks and young folks, though we're not sure; we get statistical analyses of the number of .coms, .nets, .edus, .govs and have found that viewers in the United States are down the list after Japan, Australia, Eastern Europe, Western European countries! In gross numbers, we have seen our audience increase from an average of 500 'hits' a week in our first season, to 600 in our second, to 700 now.

With the change in the presentation of avant–garde art has come a fundamental shift in the relationship of the artist to audience as well. 'Chat' allows the audience to interact with the artist, to ask questions about the work. Artists may utilize chat commentary by members of the audience as part and parcel of their performance, as Anna Mosby Coleman did in *an non*, during which she sang words that appeared on the computer terminal before her. Artists may also pre–record their performance entirely as did Alvin Eng, in order to fully respond to questions and comments during the live netcast. An artist may build an analysis of digital technology into the content of the work, as did Rae C. Wright in her piece entitled Art Thieves, a send–up of the notion of originality in Western art. Or the artist may utilize chance to allow audience members to experience different versions of a performance, as Kathy Westwater used Shockwave to randomize dance sequences so that no two audience members see the same presentation.

On the receiving end, a netcast is slightly disynchronous, as sound and image signals are sent out separately; depending upon the congestion on phone lines, images and sounds may link, then go out of phase. Some artists view this as a unique feature of netcasting that may be exploited, as Irina Danilova and Steven Ausbury did in their performance *Mir is Here*, a meditation on inner and outer space, private and public space, which looked very much like images beamed to Earth from NASA's Apollo missions. Others view animation as a new visual tool, as Nora York's employment of Nancy Spero's images to augment the impact of her songs attests. Mark Fox created little bodies (puppets) especially for the scale of netcasting so that the figures would fill the small netcasting screen. Most profoundly, netcasting differs from presenting in other media because it may be viewed at the audience member's discretion; after the live netcast had been aired, it was stored on Pseudo Program's server to be viewed later from any point on the globe.

During Franklin Furnace's second netcasting season, I was struck by how artists (often dancers) were unwilling (perhaps because they view their bodies as their instruments) to make the leap from the human body to the body of the net, with its parallel circulatory system and interactivity. The netcasting experience was sometimes viewed as a means of broadcasting existing work, rather than a new art medium to be explored. (Granted, artists were still given only six hours of production time with Pseudo equipment and staff, so the artists who really wished to exploit the Internet as an art medium often did so on their own time, and at their own expense.)

For The Future of the Present 2000, Franklin Furnace's current season, we have reconceived this program as a series of month–long residencies in collaboration with Parsons School of Design, Digital Design Department, so that artists have access to the entire range of digital vocabulary (i.e. not just netcasting) and sufficient time to create 'Live Art on the Internet' – whatever that may be.

Q – As a curator and artist do you prefer the real or virtual Franklin Furnace?

Martha – Someone asked me what I would have done if I had had all the money in the world, and I had to admit I would probably be the director of a downtown art emporium today. I miss live performance, the smell of the beansprouts, the roar of the crowd. Going virtual has not been easy, but it has been challenging and important. Perhaps this contemporary moment bears comparison with the 'golden age' of American avant–garde practice in the 70s, when artists were encouraged to experiment wildly; the Internet is still a wide open frontier with very few fences (read: censorship) in place. Giving artists access to a 'team' of programers, engineers, designers may change not only the art and the definition of artist as a lonely dude in a garret, but the potential of art to affect broad social concerns–to change the world. This is the time for artists to get their underground ideas to the broadest possible audience through the convergent art medium I believe the 20th

century spent itself looking for.

Q – And the Future?

Martha – Life tends to be uncertain. That said, I am the happiest girl in the world today. I have one or two more decades to complete my mission from God: To make the world safe for avant–garde art; and I am embarking on a new life, however tenuously connected, with Vince, the fishmonger, my equal partner.

Lizbeth Goodman
INMPR

Q – How did the INMPR start?

Lizbeth – The INMPR (Institute for New Media Performance Research) was set up as sister site to the internationally renowned ISA (Institute for Studies in the Arts) at Arizona State University. It started as a place where intensive collaborations and the application of creativity in many linked art forms could be supported, and where new media experiments with live and virtual, real–time and distance performance research could be conducted, analyzed and shared. There seemed to be a space for such an organization in the UK.

Q – What were the initial philosophies and objectives of the organization?

Lizbeth – From the start, I wanted to bring a healthy respect for theatre and the performing arts (as distinctive disciplines) together with a healthy respect for the uses of new technologies; to make and share new media art by and for the people of the twenty–first century. The INMPR has therefore aimed to bring artists, scholars and technologists together in order to realize this vision. I didn't want to separate these creative people into categories, but rather sought research fellows and graduate students who were working across art forms and experimenting with digital technologies in and through their work. So the INMPR has aimed to facilitate these groups of people in their creative and innovative performance projects, supporting them in the use of multimedia technologies, and encouraging the documentation of these projects in digital formats.

The INMPR was from the outset, and is now, intended as a space where collaboration can happen across disciplinary and cultural borders and where people can work together in both 'real' and virtual time and space. Much of work is created online, or in shared environments and theatre spaces around the world. We meet in the email arena, on the phone, through use of each other's telematic performance tools. In all these 'spaces' we aim to apply ideas about collaborative practices and creativity. We work together to create ideas, tools, art works, performances and educational 'distance teaching' materials about performance: 'products' that could not have been created by any one of us individually: products that demonstrate as well as integrate the notion of the virtual community by making it mean something in real terms. It also aims to promote a closer connection between the performing arts and the industry and commercial sectors which seek quality 'content' for their new media applications: content that reaches beyond the standard fare of your average computer game.

To make art work and performance work that reaches out to a generation tuned into what

I tend to call 'replay culture,' it's vital to build in and around some real interactivity (not just pushing buttons or touching screens but actually making choices which determine the outcome of a story, the development of a work of art, etc.). The INMPR recognizes viewer choice and the increasingly short attention spans of the twenty–first century audience member and student. What we aim to do in all our work is to use the screen (whether the computer screen, the cover of a printed book, the canvas, the TV screen, the film screen, the WAP phone display) to reach in both directions: from the creator, to the creative interpreter, and back again.

Q – What projects/artists does the INMPR currently support?

Lizbeth – PAL (Performing Arts Labs) brought me in to co–direct the current series of Multimedia Labs with Frank Boyd (formerly of Artec and now with BBC Future Development). These labs have for three years now been widely recognized as the UK's leading seedbed for new media work. The lab formula is now being replicated within the BBC and Channel 4, and lab programs and 'clones' operating on a project–oriented basis are springing up around the world. Susan Benn's (Director of PAL) goal in bringing me into the directorship at this crucial juncture was to help to rethink the Multimedia Labs and to find new ways to allow them to grow in future years to meet the needs of a new generation of theoretically – and technologically–informed artists as well as a new breed of practice–based academics. The lab we directed in May in Kent was very successful, and the next lab in Rotterdam in November will mark the first move towards a European lab development arising from the PAL fold in this area.

In the years to come, the Multimedia Labs will be replaced by a new kind of labs: SMART Labs (Site–specific Media Arts Labs, with an emphasis on intelligent uses of 'smart technologies' which are sensitive to the needs of particular locations, landscapes, cultures and communities). These are now under development as the latest addition to the PAL fold of high–caliber labs. I developed the idea for SMART with the supportive framework of the INMPR in mind as a joint 'home' for these labs, in conjunction with the PAL 'home': Susan Benn and I plan to co–direct a company developing from the SMART labs, to provide follow–on support to artists and technologists, and to build up a steady stream of media training initiatives for all levels of community need.

The SMART labs will explore the relationship between 'smart environments and interfaces' and the 'intelligence' of local sites and communities of artists and audiences in real time and space. The SMART lab series should kick off in early 2001, with one pilot lab phased out over the year, to bring together a world–class team to explore this exciting subject.

Q – How does the INMPR see the relationship between new media and performance? How does the institute position itself in terms of the kind of work it wants to develop?

157

Lizbeth – The INMPR is about this relationship. It is for this relationship. It is becoming this relationship. It is therefore always growing, changing, developing.

It's always problematic to put the word 'new' in a title. What's new today, or even this minute, will soon be 'old' or dated. Yet the INMPR will, in each new minute, be looking to push the boundaries of the possible with 'new' forms and 'new' relationships between content and creative drive. That's what will keep us going in the long term. That's what keeps the technology developing, and what drives artists to keep on questioning the value of art with each new day.

Q – As a research active organization how does the INMPR balance process with product? Is there an overall objective for the artist to create a finished piece of work?

Lizbeth – Process definitely takes a front seat role in all of our projects. We are moving into new territories so there has to be some sense of experimentation and

exploration in everything we do. That's what we're about: pushing the limits of the possible, not accepting advice about what can't be done technologically or what shouldn't be done artistically, but rather always asking: what is worth doing?

In general, we begin each project with an open set of questions, usually arrived at collectively, to be addressed through practice–based research. At some level, we're always asking the same question, but asking it differently and exploring it differently in each new context. That is, our main question is simply: how do we best create art work (theatre, dance, etc.) collaboratively, both live and at a distance, in order to maximize the creative potential for all contributors whilst keeping the needs and interests of the

audiences (students, researchers, future scholars) in mind as we work?

This simple question is, of course, very difficult to 'answer.' It is important to take time away from the studio and the university, to bring teams of high calibre thinkers and makers together to explore joint ideas, themes, software packages, landscapes ... and to begin to make responsive work suited to the audiences of this new media age. It is also important not to 'end–gain.' Our product is determined through process. This is a relatively new form of 'research' – or at least, it is fairly recently that this kind of work has been recognized as research. The working process demands both artistic excellence and academic rigor.

Q – What are the future long–term plans of the organization?

Lizbeth – The INMPR will continue to develop new lines of work, or new threads to weave into the gorgeous fabric already on the loom, as each resident artist and technologist develops her or his work in new ways. We are an organic organization. Each new project will, to some extent, build upon the work of the previous and current ones: by sharing software and developing portable versions of shareware in development, as well as by drawing on the rich tapestry of critical thinking and constructive criticism that shapes the working relationships between members of this growing community. Some new projects will deliberately unpick the threads of previous work to see where the patterns might lead if woven against the grain, or will follow the threads left by others but invent new interpretive strategies for their reception and sharing.

As the realm of the possible shifts every day in this fast–paced high–tech age, our work develops and shape–shifts every day. Our associates and fellows come for 'real time real space' residencies and also work with us from wherever they are, online or in new mediated forms. We exist where our artists exist, where the students are, where the performers and audiences share their work in a two–way exchange through the screen.

I don't expect to sit at home by the fire anytime soon, reminiscing about the days gone by when 'new' media and performance first decided to speak to each other. That was long ago. And it is today. And it will be tomorrow, for each new day brings a new form of 'speech' or communication in performance: on stage, on screen, in everyday life. Rather, I expect years from now to find myself as I find myself today, sitting by the 'electronic campfire' which is the Internet, marveling at some work that couldn't possibly have been made without a large scale, ambitious, perhaps even reckless disregard for what is 'possible', and then looking across the room as I do now to see a creative team responsible for this kind of work looking back at me, through and beyond the screen.

Sophie Cameron
New Work Network

Q – What is New Work Network?

Sophie – New Work Network is a dynamic organization which brings together artists, producers, venues, academics and others working in performance, live and interdisciplinary art. NWN provides a forum for information exchange, advocacy, critical debate and professional development for a sector of artists involved in new and innovative work – the intent is that this sector, and hence the network, is self–inclusive. The Network intends to continue to build on the communication that already exists between practitioners across a wide range of artforms.

Q – How did New Work Network start?

Sophie – In 1995, a diverse group of practitioners began meeting as an informal steering committee. This group were all very concerned about the marginalization of new and experimental work and about a series of events that suggested a less than supportive environment for the production of risk–taking work. This group felt that it was high time that some type of forum existed where experiences, problems and information could be shared, from where a collective voice could emerge that would champion the cause of artists working within this sector. The Steering Committee began to oversee research into the demand for a network, with the future aim to facilitate the establishment of such a network. Funding was received from the Arts Council of England's Drama Department to enable a period of research, which confirmed that the idea of a New Work Network was overwhelmingly supported by artists, producers and educationalists who took part in the research process.

In January 1997, an inaugural meeting 'Towards a New Work Network' was held. This was an inaugural event with the objective of establishing a formal network. This meeting brought together as many representatives as possible from the diverse communities that exist within the sector of new work. Before any discussion took place, it was emphasized to those attending the meeting that the development of the proposed network would

be led by the autonomous initiative of all those active within the sector. The opinions of these representatives and the notion of being led by the sector itself was a crucial aspect in reaching a consensus about how a network should be developed. This aspect remains as crucial as it was then in terms of how the Steering Committee develops NWN's strategies, program of events and initiatives to this day. The meeting resulted in a consensus concerning the remit, objectives and structure of such a network. A new steering committee of self–allocated members was set up and the New Work Network came into existence.

Q – What were the initial philosophies and objectives of the organization? Have they changed over the organizations lifetime?

Sophie – The initial philosophies and objectives of the organization have not changed, however, NWN is still in the process of growing and developing. The research document 'Supporting A Landscape' recommends that networks that allow for gradual growth fare better and provide more support than those that aim for immediate results. The experience of NWN would appear to support this view. NWN's mutable but dynamic structure is now at a key moment in its evolution as soft links with partner organizations are becoming more formalized through increased communication. NWN continue to believe strongly that it is crucial to facilitate initiatives which respond to the changes in the arts and culture as well as to the changing needs and demands of its membership. The philosophy of an organization which is sector led is one that remains crucial to this day. It is for this reason that some aims and objectives can become prioritized due to a sector recognition of the need for perceptible and accessible support in particular areas.

NWN Constituency

NWN provides a meeting point, a space for dialog and an opportunity for collective action. It targets:

- artists whose work challenges or extends definitions of their art–form;
- artists working in live or performance art;
- cross–artform work which pushes at the boundaries between forms, or is not easily categorized by funding bodies;
- independent producers, cultural institutions, venues and festivals across the UK that commission and present this kind of work;
- academics and teachers who study, or train students in contemporary practices – such as experimental theatre, live art, installation, new dance, and the like.

Aims and Objectives

Focusing on information exchange, advocacy, critical debate and professional development

NWN aims to: offer opportunities for practitioners to meet, debate, discuss and learn new skills and thus reduce isolation and promote new collaborations; and thus contribute to the continuing development and appraisal of the sector; act as a national voice and advocate for the new work sector; to raise the profile of the work of its constituents in the media and improve media relations; function as an information resource for the creation and promotion of new work; offer advice, consultancy and problem solving through peer support and the exchange of skills and equipment between artists; maximize the earning potential of practitioners in the sector and improve the recognition of their skills.

Q – What advice would you give to artists in the process of setting up companies, organizing rehearsal spaces, negotiating administration and office facilities?

Sophie – Ask for advice from more established companies and practitioners. These people have been in exactly the same position as you and their experience will be extremely helpful in the process of setting up a company. The links that you make at this stage will create an important foundation from which you can expand. Networking is crucial, involving people during these early stages of development and building relationships will create a group of people who will be interested in your progress, who will feel involved and will therefore offer support. This support can range from friendly advice, information exchange, skills exchange, the lending of equipment, support in kind and even the beginning of an audience base. This is also true in relation to contacts you make with educational institutions, promoters and venues. Always remember that support agencies, networks and funding bodies often have people employed in a specific role to give just the sort of advice you will be looking for. Even if it seems that your efforts don't result in anything straight away, building these relationships will be invaluable for the future.

When organizing rehearsal spaces, make sure that you have sufficiently researched all the available options. There are often relatively cheap ways in which to do this and it is crucial to try and keep costs down at the early stages of development. Cheap or even free rehearsal spaces can be found in educational establishments, community centers and sometimes venues. Getting part–time work in a venue or doing some work experience for an organization can very often mean that you can unofficially use space to rehearse and make use of office equipment.

Students and graduates are often keen to build up their CVs and it is sometimes worth asking if anyone in this position would be interested in helping you out with administration, either for a small fee or for free. This opportunity will also give them valuable experience as well as useful contacts of their own.

Office facilities can often be quite easily shared with other companies for a contribution to costs. It is always worth asking if you can rent desk space within an office, rather then

having to front the rent for the whole office yourselves. If you have no need to store big equipment, then the 'virtual' office is always a very cheap alternative, e–mails and the mobile phone have freed companies from having to have one physical base.

Q – Should a company be limited, registered, co–operative, a partnership...? What's best!

Sophie – There are often mixed reactions to such a question, depending on the experience of those who have gone through different options. It is crucial to do as much research on this as possible. Often options are limited, due to financial restraints, so without recommending a 'best' option, NWN can offer some advice on becoming a company limited by guarantee. If this is financially possible then becoming a company limited by guarantee is often a relatively flexible option to work with. Many consider that it is the simplest option for emerging companies, as everything else often requires more demanding administrative (and financial) support. This option allows for easy expansion and gives a broad remit for operation. You are allowed to add to the number of directors of the company at any point. You are also allowed as many members as you like without relinquishing too much control of the day–to–day decision making and running of the company. It is very important as the company develops to have some kind of legal identity, not least because you are shielded from liability if things go wrong. Having a legal identity can also give you access to the larger pots of funding available. There are a number of organizations that can help set this up for you, such as the ITC in London or ICOM in Leeds. 'Theoretically' it should be possible for artists to set up a company limited by guarantee if they follow the guidelines offered by Companies House. Samples for creating the necessary documents are also offered by The Arts Council of England.

Q – What are the three top tips you would give an artist/company?

Sophie –Don't be afraid to ask for advice, make contacts and build relationships. Advice you gain and contacts you make will be invaluable to your development. Careful and systematic information gathering and observation of the 'scene' that you are involved in or want to be involved in is important. In this way you can be aware of what kind of work funding bodies are funding, what kind of work venues are programing and what kind of work producers are interested in supporting. Get organized, try and create a list of objectives and think carefully about achievable targets for development. Focus on what the best way might be to invest your time and money. Become pro–active, self–promotion is crucial, the more 'things' you do, the more opportunities you will be given. Most importantly, don't give up, be patient, it can take ages to get going, but be ready for when it does.

Q – What might an artist approach New Work Network for?

Sophie – Some of the Network's activities concern the whole membership, others are specific and relate to particular artforms or interests.

NWN's activities involve

- facilitating information exchange and debate between artists, programmers, teachers and others via open meetings, via issue–based symposiums or practical workshops. NWN also gathers and collates information relevant to the sector;
- promoting an appropriate context for New Work in terms of funding and support; advocating new work to funders, press, sponsors and others; NWN commissions, or assists with the commissioning, production and distribution of new work. NWN also intends to facilitate partnerships and collaborations; these might be between producers, between producers and artists and between artists;
- NWN creates links with other appropriate groups of artists and networks;
- NWN support and produce training events and initiatives in such areas as administration and documentation.

Specific areas of activity or focus are often dependent on NWN's planned program of research and events. NWN encourages artists to pick up the phone or e–mail NWN to make suggestions or to ask for advice. NWN will either be able to provide support or will provide the contact details of other support agencies or networks that might be more relevant to approach.

There is currently a core steering committee that is self–elected. It is important that the steering committee is representative of the diversity of the sector and has a committed amount of people prepared to be active. NWN take this opportunity to highlight the need for more people to be active and would welcome anyone who is interested in participating in the network by encouraging them to either join the Steering Committee, become a member, join the database or actively participate in debate and information exchange via the NWN electronic discussion list. By becoming actively involved people are enabled to shape and influence NWN's development as an organization. This is a crucial factor that enables NWN to respond significantly and productively in order that it continues to support the changing needs of practitioners in the field of new and experimental work.

Kathy McArdle
Project Arts Centre

Q – When did Project start?

Kathy – Project started in 1966 as a voluntary group of artists – four visual artists/painters, and a theatre practitioner who came together to present painting and theatre work which was not accepted or being presented in Dublin by mainstream galleries or theatre venues in the city. It was set up in the spirit of a 'project' and represented an attempt by the five founders to present artwork which reflected and engaged with the spirit of the times in new contemporary ways. It also was a departure, in that it was the first time in an Irish context that visual arts and the theatre artform came together under one roof/space in a dynamic relationship to each other. The 'project' gathered momentum very quickly and the initial group began to draw unto itself energies – other individual artists who identified with the idea of working together to offer an alternative vision of art to that peddled by other relatively conservative art institutions and who saw in Project a real living space in which to present their work to new audiences who were not part of a privileged elite.

Q – What were the initial philosophies and objectives of the organization?

Kathy – To present artwork (encompassing theatre and visual art practice) which was radical in its critical questioning outlook and/or in the form utilized to realize its interrogations. To create a space for artists whose practice was marginal (not of the centre) to make work which was driven by their own aesthetic/intellectual imperatives and enquiry and not subject to interference from the other more conventional channels of production and distribution. To find ways of showing artwork which recognized the shift towards the principles of cultural democracy and the rights or importance of every person in a society having access to artistic processes.

These fundamental objectives have not changed substantially over time. What has changed is the shift in emphasis from one objective to another, and, more fundamentally, the organizational structures in place to try to achieve these objectives. So, after the first, relatively loose, grouping of artists who came together and grew, from 1966 on, the structure shifted towards that of a artist led co-operative, which was very much in tune/in keeping with the spirit of the early 70s where the power of collective social and artistic

action was being tested and explored. So, after an eight–year period of a relatively nomadic existence moving from premises to premises, the group discovered an old disused factory at 39 East Essex Street (where it remains to this day). When they moved in to convert the space into what effectively became Ireland's first arts centre they worked as a collective to design, construct and reinvent the factory as an art space. The collective structure at this time consolidated itself into a company with members. This structure is still in place today. From the 70s through into the 80s, the collective structure changed and evolved, so that in the 80s, the Artistic Director (a creative directing decision–maker) was determining policy and programme. The 1990s saw a shift again, due to the ongoing professionalization of arts management in an Irish context, towards Project being managed by an arts manager responsible to a Board. Now Project exists as a space which is artist–centred in its focus rather than its being led by artists, and as a publicly funded space with responsibilities to a range of stakeholders (including communities of artists and its very varied audiences).

My aims and aspirations for Project would be that it can find ways of holding onto its marginal oppositional stance in relation to mainstream artistic practice, not out of any drive to be belligerent for its own sake, but to challenge and question the prevailing values of the society and the current mechanisms of production and distribution of art. There are huge shifts and changes going on in Irish society in the context of globalization, and I feel that work produced in Project should be taking a critical look at those changes, trying to articulate those changes and engaging the public in a questioning process in relation to the shifting contemporary experience. In order to do that, Project needs not to buy into the notion of art as a product. The idea of art as something that can be bought or comodified reduces its radical potential and can serve to diminish or negate its critique. So, in Project, I'm very interested in work which is genuinely contemporary in its investigations (this incorporates real exploration of the relevance of the canon), which is looking for new artistic form not for its own sake but out of the imperative to crack the meaning of new life–content as it is being experienced, and work which acknowledges in its making, structure and process that meaning is constructed by the viewer/audience member and that the construction of that meaning is an active critical process. So, I want to show work that is not interested in being a commodity, which cracks open new meanings and reveals new insights, which pushes the boundaries of form, which represents a challenge to the limits of what is currently perceived as artistic practice. I'm also interested in work which is socially engaged, which recognises the artist not as a quasi–mystical figure but as a active member of society engaged in the same social, cultural and political struggles as all of us and shaped by the forces of society and history. I would hope Project has a 'guerrilla' agenda, if by guerrilla you mean we would welcome artists who are making dangerous work. I would see Project as a 'safe house' for artists interested in intervening in the social fabric or striking against conservatism in all its forms.

I'm also interested in artists who are asking fundamental questions about the relationship

between the work and an audience, because it is in this space that an artistic/aesthetic experience occurs. This experience is shaped by the society and by context, subsumes into it questions of ethics, which some artists are exploring in really dynamic and powerful ways.

Q – What might an artist approach Project for?

Kathy – On an ideological level, for an exchange of ideas, for a critical perspective on their work and practice, for a forum in which to discuss ideas of art and artworking, for relationship with an organization which might represent a kindred spirit. On a practical level, one might approach project with an idea for an exhibition, a residency, research and development opportunities, to develop new models of working or to do a production. Fundamentally, Project is interested in new ideas and new energies with a subversive 'guerrilla' edge, so anyone approaching us with new thinking or new practice will be absorbed into our ongoing discussions and thinking.

Q – How do you see the relationship between new media and performance?

Kathy – Project has always had a history of supporting radical performance practice and would be one space in Ireland which has consistently presented work which experiments with new media and technology in order to deal with new thematic territories. Ultimately, we would view the diverse range of new media available as tools in the process of artistic enquiry. These tools are so often used in a social context to brainwash us or get us to buy more and more things, that it emerges as really crucial that artists have space to use them as active tools in a critical way. It is important that performance acknowledge and engages with these new media, which allow for all kinds of relationships to an audience, create a space for an examination of the nature of 'liveness' and opens out questions around absence and presence. New forms of performance can be generated when work doesn't depend for its existence on ideas of illusion and representation but which thrive on and play off the live, 'here and now' relationship between performer and audience, which can also be altered and varied by playing with the distancing potentials and devices of technology. Project would therefore position itself at the more radical end of the performance spectrum, celebrating a diversity of ways and processes by which performance work is produced, and wishing to create space and opportunity for individuals, and small groups of artists to make performance which eschews simplification and which is challenging, provocative, difficult, contemporary and ambivalent.

Q – Can you tell us about the support Project gives artists in terms of residencies?

Kathy – Project is open to artists coming to us with ideas or projects at any stage of

development. What is more important than the stage of development of a piece of work, is the quality of the conversations and dialogues that one can have around the ideas with the artist, and the rightness of its being placed in the unique context offered by a place like Project. Best of all is when an artist has incorporated Project into the devising of the work so there is the potential of a natural synergy or fit there. But the main thing would be the quality of the idea … I would also ask any artist coming to Project to consider carefully the relevance of the piece of work – what makes this work necessary now? And by necessary that could mean necessary for the individual artist or that they have perceived a fundamental need for that piece of work to exist in a questioning relationships to the wider cultural framework which it will occupy. So, those are the kinds of things that would concern me, rather than stage of development.

Project has an interesting history in terms of residencies, for example the previous artistic director put in place a Choreographer–in–Residence programme which had a timeframe of eighteen months, where a choreographer – without a building or space to work in, except occasionally – was a core member of staff in Project. Similarly, a new Playwright–in–Residence programme has just been put in place with a two–year timeframe. Both stress the need to create space for artists to develop their own artistic practice in very self–directed ways within a supportive organizational context but without the pressure of pre–ordained outcome. The emphasis in both is on the exploratory experimental space offered to try new ideas and approaches. Other residencies would have shorter timeframes and have a more product–orientated focus. This can be highly effective; for example *deserter* by curious.com evolved out of an intensive four–week residency process. Ultimately though, the emphasis has to be on the artist exploring and engaging with material which they want to engage with. The placing of the artist's own process – of interrogation, a trial and error, of groping towards a new form/context relationship – at the heart of a residency, is crucial. Only if that happens will each emerge which is truly compelling for an audience – if material ever reaches an audience. Each residency process really needs to be constructed or developed differently, in dialogue with an artist, and in a way which recognizes the resources Project can provide in a residency process, and the unique sensibility/make–up of each artist. Maurice O' Connell (in 1998) took on a residency in Project around the last weeks of the old Project building and presided over 'Demolishing Project', a three–week period when the public were invited to come in, share and record their memories of experiences in the old Project building. Project would be keen to support residencies of this nature which are completely process–driven, have no formal outcome, and which occupy ambivalent territories between performance and discursive practices, where distinctions between performer, non–performer, artist and non–artists, break down, and are replaced by a more fluid relationship, a sense of communion of individuals engaged in a shared exploration of, in Maurice's case, sentiment and memory, nostalgia, and the attachment to place.

Q – What do you think are the greatest challenges which confront the artist/

company starting out?

Kathy – The greatest challenges for an emerging artist/company has to be to find your distinctive artistic voice and to learn to be intellectually and creatively rigorous in your work. Crucial in the early life of a company or an artist's practice is being genuinely imaginative or different in the way you are operating with often very minimal resources. I am always attracted to work which reflects Grotowski's idea of theatre/performance which is poor financially, but rich in spirit. The other challenge is how to organize yourself according to your own needs rather than the demands of funding arts organizations. To articulate your own identity in ways that may not meet prevailing norms is sometimes really difficult, but it is crucial if you are to remain true to your initial starting principles. The last challenge is to continually find strategies to revisit being commodified, or assimilated into the centre, especially if your work has a challenging edge to it. These strategies would need to be built into the company's ethos from the very beginning and need to creatively evolve with circumstances and necessity.

Q – What does Project offer the artist in terms of showing work?

Kathy – With regard to anyone proposing a piece of work to Project, I would say we are not a wealthy organization, but we are keen to discuss proposals which are growing out of marginal practice. Ideas don't have to be on paper – a good conversation around an idea is just as valuable. Don't tailor your proposal to suit us, or what you think we'd like, come with something you really want to do and think is important to be done. Do come with notions that might provoke or challenge Project as an organization/entity which prides itself on taking on seemingly impossible tasks. Do come with work which may not be perceived as art at all. It helps if the objective of 'the show' or 'the gig' is held at by and the initial focus is on the work and ideas. Do come knowing why you are approaching Project rather than a million other galleries/organizations. And come prepared not to like us and to want to take your proposal/ideas elsewhere if that is what it requires to exist with integrity and purpose.

Q – What do you look for in a proposal?

Kathy – Clarity, imagination, relevance, rigour, potential, criticality, engagement with wider cultural questions, and purpose.

Q – What are your tips for the artist starting out?

Kathy – Don't get sucked into being a 'career artist' – follow your own instincts and path, not that of others. Find your allies strategically. They will probably be few, but crucial. You'll find them in all kinds of unexpected places.

Tanja Farman
queerupnorth

Q – How would you describe your line of work?

Tanja – I am a presenter and producer of British and international lesbian, gay and queer work. I work as part of the cultural industries in the broadest sense and am active within the arts sector regionally, nationally and internationally. In addition to this I work independently as a producer working on a number of cross–art form projects and/or festivals.

Q – How did you get into it?

Tanja – I worked previously for many years as a 'programmer' at a small–scale experimental arts space here in Manchester, the green room, where I brought in a lot of lesbian and gay work and work reflecting other so–called 'diverse' cultural communities'. In those days I was an arts administrator and programmer, buying in suitable work for various season themes or strands.

Q – How did queerupnorth come into being?

Tanja – queerupnorth first came into existence as a 'brand' in 1992 when I was still at the green room and my colleague Gavin Barlow was the marketing manager there. Together we felt that we wanted to profile, in some way, the growing number of artists and companies making work with a different aesthetic, and work examining lesbian and gay issues and queer identities. The socio–political climate was changing, Manchester was at the forefront of a burgeoning nightclub scene with the legendary gay night Flesh and the time was right to encapsulate the new energy and interest in all things 'queer'. Manchester was very much, and remains very much central to the development of the organization. There was incredible support from the City Council and the Regional Arts Board – not so much in terms of hard cash, alas, but in terms of advocacy for a new distinct and hopefully groundbreaking project. We always dreamt of building an organization that could grow up over the years but one which essentially never lost its core vision or goal to 'imagine new futures.'

Our founding mission was 'to promote and present new lesbian, gay and queer work across the performing arts and to make work accessible to a wider audience.' I think we have

come a long way towards achieving this.

We operated the organization as a business partnership until spring 95 when we realized we urgently needed to 'incorporate' and register as a company to ensure limited liability before our major festival in 96. Whilst we always focused on the 'performing arts' this was because the small amount of funding we could raise was from 'pots' linked to performance. From the very outset, however, we have included film within the program and visual arts wherever possible.

Q – How does the festival operate – what's your legal status? Are you a limited company? A registered charity? How does it work?

Tanja – Since 1995 we have been registered as IQUN Ltd, which is a non–profit distributing company limited by guarantee. There is a Board of Directors, now seven in total, which has included the two founders, myself and Gavin from the beginning. In addition to being the Director and figurehead of the organization I have always legally been a director of the company. I believe this has been important psychologically for the growth of the business and without doubt for my own involvement in it.

This model was unusual at the time, less so now, (and interestingly common practice in other countries such as Australia as I discovered later) having an employee who was also a board member. At the end of the day I had seen too many arts organizations that had been the brainchild of one or two individuals 'grow up', be overtaken by the funding system and all the associated rules and priorities and move away from the original vision of the founders– without them having any real, legal, say in the matter. We were determined that this would not happen here. The only disadvantage that I can see is that we have never been able to gain charitable status, but I believe there are now ways around this also such as setting up 'trust' status.

The company is office based, not venue based, therefore giving a certain additional autonomy to the organization. On the whole I think this has also been very important. Obviously in presenting and producing events we have in the past 'hired' performance spaces and theatres in the city. This has now changed and we have 'come of age' – having established a reputation and credibility we are now able to develop more equitable relationships with venues, as partners.

In terms of staff there are just two of us year round, myself part time as Director/Artistic Producer and a General Manager. We obviously bring other key people on board prior to each festival: a Marketing Manager and a Production Manager, essentially. Obviously I work full–time for about six months of any given two–year cycle before a festival. This pattern may all change somewhat in the future since we are looking at new directions and

171

a shift of emphasis within the organization away from being seen as a 'festival' to more of a presenting and commissioning body. We will look intelligently at our current position and the strength of the queerupnorth 'brand' and build on that in different ways.

Q – Did you envisage that the festival would continue to draw funding and audiences for so many years?

Tanja – In the beginning we thought we would just 'see how it goes' with a few events, never envisaging that there would be such a thirst for the work we were presenting. This first festival was funded by North West Arts Board and Manchester City Council, was produced with a turnover of £11,000. In contrast, the 98 festival had a turnover of £315,000 over the two year period. This was largely due to a successful Lottery Arts for Everyone Award but nonetheless this dynamic growth allowed the company to repeatedly extend both the range and scale of each festival's Artistic Programe.

Q – Why do you think it has been such a success?

Tanja – We have worked very hard to secure funding in a difficult climate and with a non–mainstream product. We had to very quickly become seriously organized and highly efficient, in order to gain credibility in a competitive market.

I believe we have been successful for a number of reasons: being in the right place at the right time; great artists to work with over the years; sheer perseverance and hard work to achieve financial goals; a huge amount of networking regionally, nationally and internationally to gain profile and recognition; investment in research and development of both product and partnerships which has paid off in terms of quality work presented and commissioned; having a unique and strong brand identity which in turn has enabled us to generate further income; a loyal audience with trust in the 'brand'; not losing sight of our objective to present the more experimental end lesbian and gay work and not bowing to the pressures of commercialism.

Q – Do you think it has been an advantage producing the festival in Manchester rather than London – it is easier to create a sense of event in a smaller city?

Tanja – This is definitely a yes and no answer! Yes it has been easier in that the arts sector is obviously smaller and the city region has less high profile activity. A unique and different well managed festival or organization like queerupnorth perhaps stands out more in a city such as Manchester. The Council here have always been very progressive in terms of support for lesbian and gay voluntary sector organizations so in some ways we have always met part of their agenda. The single biggest drawback not being London based is the size of the audience pool. Obviously there are far far more people to draw on in

London, being a huge metropolis. Manchester audiences also have on the whole less money. There are far few people in the NW region willing to take a 'risk' on new and different product. Audience numbers are fine but would be hugely increased were the events to take place in London.

Q – How much of a problem has it been getting the festival funded over the years?

Tanja – It has been hard, definitely! There is, in my opinion, a huge misconception that there is a great deal of 'pink pound' sponsorship out there to be tapped into if only we had time! Maybe there is more than we have been able to draw on but I don't think it is all that easy, we are, after all, first and foremost an arts and cultural organization with a focus on the experimental.

There has increasingly been pressure on us to look to present the more mainstream populist end of the work, the Lily Savage's of this world, in order to earn money to subsidize other activity. Whilst I can see good financial reason for this approach it is not one which has ever excited me! Quite the opposite in fact!

We have been fortunate that there has been real growth in the perceived lesbian and gay economy in Manchester, with the development of the so–called Gay Village. This has helped put our work onto the agendas of organizations like Marketing Manchester who exist to sell Manchester to the world, in part as a major lesbian and gay visitor destination.

Q – How much did the last queerupnorth cost to produce?

Tanja – The 2000 festival was not the biggest in terms of turnover– we had less money to spend than in 98 (due to the decrease in funds available) but we produced the festival on £294,000 – over the two–year period. Nonetheless, this was a substantial amount to raise.

Q – Where do you find the money?

Tanja – The funding comes from a whole variety of sources including the following: North West Arts Board and Manchester City Council (both core funders giving a small amount each year); Manchester Airport, the British Council, the Arts Council of England, the British Film Institute, European Funding channelled via both Manchester City Council and Marketing Manchester; the Association of Greater Manchester Councils, the Granada Foundation, sponsorship, and the box office.

In addition we have 'in kind' deals with media sponsors and for a small amount of production costs.

Q – Do you think that producing is getting harder or easier?

Tanja – I think it depends what sort of work we're talking about. I think producing for established companies and venues is perhaps becoming easier because there seems to be more money around, with lottery and all. But for experimental work or work that is not easily categorized, and for emerging artists I think it is getting harder. Unless you are already on the funding ladder it is very difficult. Inevitably for non–venue based producers it is even more difficult because we are reliant more on developing the right partnerships and/ or finding venue and production costs. There are clearly advantages and disadvantages to being non–venue based.

Q – What aspect of running the festival do you enjoy most?

Tanja – Well, I enjoy the travel very much and meeting new people, be they artists, funders or producers. That is a wonderful opportunity. I enjoy watching a huge diversity of work and identifying product that is suitable and appropriate for queerupnorth. I really enjoy working with artists that we have commissioned throughout the development phase, right up until the premiere of the new work.

Q – What was your worst mistake in the past?

Tanja — Hmm. That is a difficult one. I would say that bringing together two different sets of artists (visual and performance) to collaborate on a commissioned work, but then not having enough funding or time to properly 'manage' or oversee the development, resulting in a unfulfilling project for everyone – that I would say was a big mistake and from which many lessons were learnt all round.

Q – What do you think was queerupnorth's finest moment?

Tanja – Again, not an easy question but I would say for the organization the finest moment was hearing we had received our Arts for Everyone Lottery Award in 1997, enabling us to plan the 98 festival with proper resources for the first time. For me personally the finest moment was in presenting the UK premiere of *La Sepenta Canta* by Diamanda Galas at the Lowry as part of the 2000 Festival. Diamanda is an extraordinary artist whom I had always wanted to present.

Another highlight was the commissioning of the first solo work from Julie Tolentino entitled *Mestiza – Que Bonitos Ojos Tienes* (What Beautiful Eyes You Have) in 1998 and another work in 2000. The work was beautiful and we were immensely proud of both productions.

Q – You've done a lot of work in Australia over the years. How does producing performance work in Australia compare to producing in the UK?

Tanja – It is far easier to 'network' with the right people in Australia, at a high level. It isn't necessarily easier to get the money to produce, I don't really know just that there seems to be a different openness and support for work across all sectors. Certainly I have never felt uncomfortable representing a queer organization in any forum in Australia, everyone wholly embraces the culture on an equal footing, maybe because there are far more 'out' men and women in senior management positions or directorships in Australia than here.

One thing is for sure – that because this particular continent is so far away from Europe they recognize that they need to invest hugely into the 'export' of work. This is of course great for those of us wishing to present Australian work in the UK. The issue then becomes finding the 'on shore' costs!

Q – Any advice for would be entrepreneurs?

Tanja – I would say be as clear as possible about your aims, stick by your convictions and be honest and open with everyone. Winning respect at an early stage I think is pretty crucial. Don't be unrealistic about financial goals, which is an easy thing to do!

Q – What's your next project?

Tanja – I am actually doing a research project in Australia for the Commonwealth Games but this is not linked to queerupnorth. I am doing this independently. For queerupnorth the next big project is to redefine the organization and undertake a new three year business plan. We will seek to present and commission work as and when appropriate, not within a 'festival' context. Again times have changed and queer having become far more part of the mainstream, should be available for consumption at different times – not just for three weeks every two years.

The strength of queerupnorth has been about staying ahead of the game and this is what we must continue to do.

I am also working on our focus on Canadian queer work for presentation in 2002 and have in fact just been appointed joint Creative Producer for the Commonwealth Games Cultural Program. This is a major job, which I will combine with my queerupnorth responsibilities.

Funding

Funding

Creating, developing and presenting work are the obvious aspects of an artist's professional life, but that's just the tip of the iceberg. Especially early in your career, when you can't rely on promoters, venue managers or funding bodies to have prior knowledge of your work, much less to have seen it live, developing these skills can make or break your artistic and financial survival. The prospect of filling out forms, number–crunching budgets or cataloguing slides doesn't, perhaps, have quite the glamour appeal of a live performance in a good pair of false eyelashes but, ever optimistic, we see developing proposals as part of the creative process. Developing and maintaining these skills challenges artists to become better at articulating their ideas, more resourceful in documenting and re–formatting their works in innovative ways and can instill an important sense of professional confidence in presenting the work to a wider audience. Many of the American MFA students who have taken our professional development courses say that in honing their professional skills they feel they have actually improved their artistic work by securing support for larger–scale projects, by becoming more rigorous about articulating ideas and by sparking new ideas during their proposal research processes.

The bottom line is: if you don't take your work seriously, why should anyone else? First and foremost, take your work seriously. Take it seriously in the way you talk about it with others, in the way you solicit audiences, in the ownership you take over it, in the way you document pieces, in the care you take with publicity materials, in the range of venues you approach, in the amount of funding you seek, in the publications or events you propose … take your work seriously and others will follow suit. You are your own best ally, so work hard for yourself. Make your own circumstances.

Research

Do it.
As an artist you must become an adroit researcher, able to seek out all possible sources available to you for funding, promoting and showing your work. So first identify the possible research tools available to you and relevant to your project, for example, Internet resources, live art and performance archives, live art publications, artists' newsletters, other artists, etc. Use these research tools to find the venues; the theatres, the galleries, the arts institutions, the educational institutions, all the places where you might want to present your work. Who are the umbrella organizations that can offer you advice and support? Who are the relevant funding bodies? What areas can be investigated in terms of possible sponsorship? What festivals are forthcoming where you could show your work? What commissions are being offered? What are the funds which you can apply to and when are the deadlines? Who are the live art/performance programmers?

Funding

Quite apart from the constant flux of the art scene, it is important that each artist develops and updates their own list of current contacts and venues in order to keep abreast of the people and places most relevant to the type of work they make. One of the greatest research tools the artist has at their disposal is the Internet. If you don't know the URL or domain name of particular funding sites or of a specific venue use the online search engines, or better yet, use the links from umbrella sites, many of which are listed at the back of this book.

Be as creative as possible – if you are looking for sponsorship, what tie–in does a certain business or corporation have with your work? How can you make it a mutually beneficial encounter for both parties? Can you offer free advertising space in the publicity material for your show? This can be a good lure if you are showing either in one very prominent venue or touring to enough venues to ensure a large audience for the piece. If your piece incorporates technology in an innovative way, can the company be persuaded to sponsor you on the grounds that your work may provide 'research and development' for their product?

When you have done your research, act on it! For example, once you have got the names of the officers who work in the funding sector relevant to your work try to arrange a meeting with them. You can either to ask about a specific fund you are applying for, or simply introduce yourself to them and tell them about your practice. They will usually be happy to meet up with you, offer you funding advice and information. When you then come to submit your funding application at least one member of the funding committee knows you as more than just a name on a page.

Proposals

Finding a way to represent your proposed project in the truest, most engaging form you can devise is the most important aspect to applying for funding or submitting a performance proposal to a festival or venue. This poses a fair challenge to artists who work in live medium, especially if they are not confident writers. Viewing the articulation of your ideas as an integral part of the conceptual, creative process can make this aspect of your career as an artist much more natural. With every proposal be sure exactly what it is that you are applying for. Different proposals demand different criteria and although this sounds obvious it is easy to fall into the trap of not reading the guidelines properly or of submitting pre–prepared a generic proposal.

Know exactly what it is that you most need for the development of your work at any given time. Do you have a strong performance, a venue secured and a marketing strategy in place and now need to apply for a production grant to realize the project? Do you need a period of time to research your ideas and are better off applying for a research and development

grant? Do you need to apply for a travel grant to enable you to go and see other work, take part in a festival or conference or to research specific ideas for your work in another place? Are you applying for a specific commission? In which case is it an open submission policy or are there stipulations or a thematic context? Are you proposing to participate in a conference or applying for a residency within a university, arts organization or with a performance company? Each calls for specific approaches, some will demand a detailed budget and marketing strategy and all will require a clear outline of your key concept and a CV/résumé or biography.

Sometimes specific issues and/or biases are made clear in the funding applications or festival prospectuses themselves. Some funds are set up specifically to award grants to multimedia work, for example, or movement–based work, and some festivals and performance seasons are programmed thematically, such as seasons devoted to female artists or a season specifically showcasing work from certain countries or ethnicities. In clear–cut instances such as these, the artist knows from the outset whether the application in question is appropriate for them and their project and can emphasize certain aspects of their work in accordance but, as often as not, calls for proposals are Wide Open.

Every funding application, unless it is an individual artist bursary, will ask you to include a clear and detailed description of your proposed project. See Lois Keidan's advice in this section about outlining 'The Whys and the Hows and the Whos'. Next you may be asked to provide a summary of your career to date and asked to articulate how the proposed project will develop your practice and how it relates to previous work. It is not enough in this instance to simply write, 'see attached résumé/CV'. You can include a CV with your support material, but for a production grant you are asked to give a more narrative account of your experience, your practice and how the proposed project would further your artistic practice.

It is likely that you will also be asked to show what marketing strategy you have in mind for the promotion of the piece, where and when the work will be shown, whether a tour has been set up and, if so, will it be national, international or both. If you are proposing to tour the piece, the funding body may wish to see some evidence that you have prior experience of administrating a tour. They may also require you to seek funding or co–support from the areas and venues to which you propose to take the work, especially if you wish to tour to another country. You may also be asked questions about audience access to the work, for example what audience research have you done, who is the audience for your work and what could you do in terms of broadening audience access. Depending on your experience you may not have all the answers but you can always seek advice from more established artists or companies, and from your local arts officer. Ask to see previous successful application forms, speak to the marketing officer or administrator of the venue at which you are showing your work, etc.

Budget

If you are applying for MONEY you will normally be required to provide a detailed budget which clearly indicates areas of expenditure and identifies other sources of income, both projected and actual. Your budget should normally be balanced (income should equal expenditure). In terms of projected costs you may want to include some of the following expenditure categories: performers' wages; lighting design fee; stage manager wages; administrator's wages; administration costs including telephone, stationery, postage, fax, email, etc.; production costs including costume, set, props, travel, hire of equipment, video/film/camera stock, media lab hire, cost of rehearsal space hire; publicity and marketing costs including posters, flyers, postcards, advertisements, etc.

It is wise to add a contingency budget for unforeseen expenses such as replacing or repairing equipment or having to pay some overtime. Contingency is based on a percentage of your total project budget and usually runs between 5 percent and 10 percent of your total figure. In terms of projected or secured income include sponsorship, funding already secured or applied for and in–kind support. With all figures, state whether they are inclusive or exclusive of VAT/state tax.

If you are applying for funds for a project in which the budget exceeds £5,000/$8,000 it becomes a little less likely that any single arts funding body will grant the entire amount without asking for verification of other sources of support. Organizations often state in the guidelines what percentage of the total project cost they are prepared to cover. The Arts Council of England, for example, stipulates that for any given project proposal they will fund no more than 60 percent of the total project budget. Many funding bodies may want evidence that you are not wholly dependent on them for the support of the work. Often they will want to see that you have secured or at least applied for other sources of funding.

In terms of other sources of income remember that you can include in–kind sponsorship or funding as part of this, for instance if someone working on the project has volunteered their services for free or if you have been offered free space or equipment, put that into your budget as in–kind support. If you are using expensive items that you already own – like laptops or wigs (have you looked at the price of a really good wig recently?), the costings of these can also be incorporated into your 'secured' or 'incoming' budget.

Support Material

What support materials should you include along with your proposal? This brings us back to that old chestnut: how can you fit your art into an envelope. You will usually be asked

to list any support material which you have enclosed with your application and often either advised about what to include or specifically informed of the preferred formats – VHS videos, Mac–formatted CD–ROMs, slides, photos, etc. In our experience, it is advisable to be highly selective when it comes to the inclusion of support material. Often it is the case that less can be more; a few choice items such as a good video tape and brief company bio can look more professional than desperately cramming the envelope full with all the promotional material you have. You can always make it clear that additional materials are available on request and include URLs, etc that people can easily refer to if they wish to see more.

By being selective about the materials you include, you increase the chances that the committee members will pay close attention to the material that you judged to be the best representation of your work and the most relevant to the application. So exercise some self control, but DO trust your instincts! If you are applying for a production grant or a commission there may be a specific object that relates to the work which you may want to include.

If we take starting with a totally compelling idea as a given, then filling out funding application forms is really just a case of hard work, experience and practice. Being a lazy researcher is the worst mistake an artist can make when preparing a grant application. If you shirk on researching your project properly you are less unlikely to convince funders that it is feasible and even if you do get the funding, if you haven't done your research you can end up liable for a project that turns out to be a total nightmare to produce.

One other word of warning: don't be funding led. However tempting it may be to apply for all available funds, inventing projects based around the criteria of specific funds may not necessarily result in good work. If the fund does not fit the timeline or the nature of your project, don't apply for it. Spend your energies and time locating the right fund for you and making your application as clear, engaging and honest as possible.

Like art, arts administration, promotion and funding are dynamic, not static – things change and keep changing, so artists need to keep themselves up to date. Certain things, however, continue to ring true over time. The following section comprises of interviews with several veteran programmers and funding adjudicators, who offer extremely helpful advice to artists about representing their work and their ideas. The following contributors speak from a unique perspective: they are the people who actually review the proposals and slice up the pies. It's worth a good read, friend.

Daniel Brine, Live Art Development Agency

Q – In your opinion and experience, what are the key elements of a good proposal?

Daniel – A good proposal will always address the form (including working methodology), content and context of the work. I welcome anything that helps me understand a proposal. On the other hand I like artists to be selective – a good ten–minute show reel is more constructive than five full–length performance videos. Same with websites or photos – choose a few which really support the application.

Q – Do you have a preference as to what type of support materials artists include with proposals?

Daniel –I often recommend that support material be accompanied by a short description of what the material is and what is a priority for viewing. A good example would be an artist who sends in: a show reel and two videos explaining that if I am interested in the show reel I may like to watch documentation of a complete performance; and a short list of websites outlining why each one is relevant to the application. The bottom line is the same with all hints on applications: try to imagine yourself in the assessor's shoes. If there are a hundred applications there is no way any assessor will look at all the support material, especially if the artist has not been self–selective.

Q – How important is it to you that an artist articulates the relationship between a proposed piece and the context in which it is shown or funded? i.e. thematic season programing, venue–specific programing or sector funding?

Daniel – The context is extremely important. Not only in thematic season programing; venue specific programing and sector funding. but the broader context of artistic development in an area of practice. There is nothing wrong (in fact it often helps) to cite the work of relevant artists and how your work contributes to and extends the field.

Q – Are there any common pitfalls you would warn of?

Daniel –1. Where possible always talk to the person who manages the fund. Find out how much help they will offer – will they meet you, will they discuss a draft of your application? If the fund manager can't help is there a service organization that can offer advice such as the New Work Network, which can put you in contact with people who have experience of the fund.
2. Be sure the fund is right for you – there is no use having the world's best project and applying to the wrong fund.

183

3. Remember, funders have agendas. Read the guidelines carefully and ask yourself why the particular funder is offering the fund and what they want out of it.
4. Always type your application (it will be photocopied a lot).
5. Follow all guidelines (don't do something silly like forget to sign).
6. If you have to prepare a budget make sure you have a good idea of the format required. For instance, I always need a balanced budget where income is equal to expenditure.
7. Don't get so wrapped up in an application that you are the only one who can understand it. Make sure you show it to friends who are willing to be critical. (It is surprising just how many applications don't make any sense even though I read them again and again).
8. Don't leave the preparation of your application to the last minute – do drafts.
9. Make sure your contact details are correct and you can be contacted if necessary.

Q – On average, how much time do you imagine you can usually spend reviewing any one proposal?

Daniel – It depends very much on the fund. Some large applications have panels of staff working on them for months, like Lottery capital. Others like small travel and research grants I will read each application but do no follow up. A 'normal' grant I will read on average about three or four times plus often follow up with one or two phone calls or emails.

Q – Are you more likely to program or fund work by an artist whom you have seen perform live?

Daniel – Different funders have different ways to assess work. We draw on an experienced committee and also have an assessment system where reports are written about work. It isn't a golden rule but generally you have more chance of success if a funder knows your work.

Q – If invited to a performance by an artist whose work you weren't familiar with, would you try to attend?

Daniel – Yes, but I have to be selective. If I don't know an artist then the invite has to pull me in. Usually I will go if the artist has taken a little bit of effort to get me there. The best way is to put a short note in with the invitation that introduces the artist and notes that they may be a future applicant.

Q – If you could say one thing to every emerging artist, what would it be?

Daniel –You are not alone. Talk to people and get advice.

Paula Brown, London Arts

Q – In your opinion and from your experience what are the key elements to a good proposal?

Paula – I look for a range of things. Some of them may seem self–evident, like reading guidelines thoroughly and clarity of text and presentation. It also helps if applicants understand the process we use to assess applications. At London Arts, the sheer numbers we receive are huge – for the Combined Arts fund it is likely to be around 90 applications twice a year. You need to think about distinguishing your application in the light of such competition.

I am interested to hear the voice of the artist. People often ask me about language, and although this may be different in other art forms, in interdisciplinary work people are coming from all different types of backgrounds in terms of training and art forms and are also incredibly culturally diverse. I am interested in hearing the individual voice; I am not interested in jargon or only one kind of critical language. A lot of the work we fund is collaborative. It is important that if you are applying on behalf on several artists that you include their individual voices and not just background information. A good tip is to ask people to include individual statements from each artist – that really gives a flavor of why people want to work together.

Applicants also need to think hard about how much money it is appropriate to apply for. Appropriate not just in terms of the scale and the financial needs of the project, but also for the artist at the particular point they are in their development. I think that is key. When people are new to the game one of two things happen. Either they apply for ridiculously small amounts of money – for example, often they don't include fees for themselves or the fees are miniscule. Alternatively, they go the other way which is to apply immediately for £40,000 having not had any initial grants. So it is important to be clear about where you are in your artistic and developmental trajectory and to apply for something which reflects that.

Another key thing is to convey why you are making this particular piece of work at this particular point in time and who you want to make it for. It is essential that you show that you have a knowledge and understanding of your potential audience and that you have really thought through who you want to communicate with.

As someone who works for a London funding agency, I am interested in why people are making work in London. I want to be able to understand their sense of London and what their work means in a London context. Context generally is extremely important.

Q – Do you have a preference as to what types of support materials artists include with their proposals?

Paula – No. First of all do always include support material – this is key particularly because we receive so many applications and we will not know all the artists. We are very open as to what kind of support material can be included. The main criterion is that it is absolutely the highest quality artists can possibly afford. And I know that there is a real difficulty, particularly for emerging artists, in having the cash in the first place for a good video or for high quality photographs. Generally we receive videos, CD–ROMs, photographs, slides. People often send other items too – models, artefacts of different kinds. We don't mind what people submit but it must support their application in terms of telling us more about their work and practice and have a real connection to what they are proposing to do. This can be difficult when you are applying at the beginning of a project – but choose something from work you have already completed that relates as clearly as possible.

A practical point is for people to mark material in terms of context – what the piece of work is, when it was made, etc. Particularly in terms of video it is important to include an indication of what the circumstances were under which the video was shot, for example, is it work in progress? If you can do this then the people making the decisions are much more empowered and are going to make more accurate judgements.

Q – How important is it to you that an artist articulates the relationship between a proposed piece and the context in which it is shown or funded?

Paula – Extremely important. Within the funding system as a whole I would say it is becoming more and more crucial. The issue of audiences and of siting are paramount. Public funding bodies have a responsibility to everybody – not just to artists. You need to be very clear about what you want the impact of your work to be, who you want to reach, and what might happen next. I don't want to be didactic but I really think it helps shape better work if artists do have that clarity. In my experience it can be something that emerging artists are insufficiently conscious of. Obviously it is very important for artists to develop their own vision, but that can't happen in a void.

For our Combined Arts fund, it is mandatory that you include in the application a letter from a promoter or a venue indicating their commitment to place the work. Because of the kind of work we are talking about which is not – say – a theatre piece with a four week rehearsal period taking place in a conventional theatre setting and toured nationally – making sure that the work is well–produced is a real concern. Visibility is so important. We did find at the beginning of running these innovative interdisciplinary funding schemes that we sometimes made major investments into pieces of work which were often magnificent but were only seen by very small audiences. It is very important

with such exciting work being produced, that its impact is felt and that the profile of this kind of performance is raised.

Q – Would you advise artists against being funding led or would you encourage them to apply for anything that is going?

Paula – I don't think I would ever encourage artists to be funding led. I think that would be a recipe for bad art. I do think it is important to explore a range of funding possibilities. There is now an increased diversification of funding opportunities even within the funding system and the advent of the lottery has made a huge amount of difference. That is really where the substantial money now lies.

More and more artists are increasingly interested to work in interdisciplinary ways. This can raise the question of 'where do I fit in?' The interdisciplinary artist has to be, and is, by definition, the most flexible and multifaceted and seeking–different–opportunities kind of a creature. You have got to be like that to survive. In reality no one makes a living through funding.

Treading the tightrope of a creative life is hard – being as true to yourself as you can possibly can be whilst also managing to carry on and survive demands pragmatism and persistence. One of the things we are wrestling with, belatedly, within the funding system is the issue of how we support the professional development of artists at all the different stages of their career – not just in their 20s and 30s. How do we ensure, for example, that older artists with all their experience and everything that they have achieved don't just give up? The reality is – certainly in a field like live art – that it is virtually impossible for many of those artists to continue. That has to be something that we address.

In collaboration with the Live Art Development Agency we run an annual 'One to One' live art bursary scheme. This offers £8,000 to £9,000 to artists just for professional development – something that was hitherto unknown. Unfortunately, with a total funding of £60,000, it is a drop in the ocean. There are an awful lot of people out there who should be benefiting and the competition is massive.

Q – How much time can you usually spend in reviewing an application?

Paula – For our Combined Arts fund we are likely to get around 90 applications. In that context I would say that before the shortlist meeting each officer would probably be able to spend a maximum of one hour reading an application, looking at support material, and shortlisting according to agreed criteria. If an application does get over the shortlisting hurdle then it gets more detailed time and attention. The methodology that we have adopted means that if you are shortlisted an officer will then get back in contact with

you, follow up any outstanding queries and issues and also give you, the applicant, the opportunity to provide an update on your project. What I say to applicants at this stage is that I want to work with them to enable me to present the most accurate possible report and give them the strongest possible opportunity to put their case forward for a grant at the advisory meeting.

Q – Do you include other artists as part of your decision making process?

Paula – It is officers who shortlist but we work closely with a group of advisers. The advisers include practising artists as well as administrators, producers, directors, academics and critics – the whole spectrum. The inclusion of practicing artists is very important. Once we have done the shortlisting we work on reports and send those out to advisers. They get information about everyone who has applied and a short résumé of what the applications are. If they feel that there is any application that has not been shortlisted that we need to take another look at, then that can be raised. This sometimes means that an additional application is included in the shortlist. At the end of the day when the final decisions are made there is a sense of achievement – a whole new body of work will now be created. It is a very positive and privileged feeling to have this preview of the kind of exciting work that we are going to see in London over the next year or two.

Q – Are you more likely to fund work by an artist you have seen perform live?

Paula – I think it is absolutely true that an artist whose work has been seen by an officer or an advisor is in a stronger position in the funding round than one whose work hasn't. I know that it can be frustrating for artists who try very hard to get their work seen. We mail a monthly gigs list to about 40 assessors and include any appropriate events in it. My advice is to send out the information in good time, get it in the gigs list and also maybe give a follow up call or email. Once we have an assessment report you are, as an artist, in a stronger position. Let us know also if there are existing reports from other regional arts organizations or the Arts Council.

Q – If you could say one thing to emerging artists what would it be?

Paula – Being clear about potential audiences/participants/spectators is really important and will help shape the form of your work, determine where you place it and influence its impact. One of the difficulties artists have when they start out is isolation. This can be particularly true in London, where the situation is also so competitive. However, we do have both the Live Art Development Agency and Artsadmin, both of which are incredibly useful organizations for artists, for example, for getting advice and information, for networking and for profiling the work.

Helen Cole, Arnolfini

Q – How would you describe your role in the art world?

Helen – Strategist.

Q – How did you get into it?

Helen – Stumbled in and fought to stay.

Q – What are the main 'guerilla strategies' you think an artist needs to develop to get their work supported?

Helen – A manifesto, an identity, an ego, an alter ego, a protective shell, supportive comrades, shared understanding, unwavering belief, open mind, strong liver, thirst for knowledge and change, forgiveness.

Q – What advice would you give to artists in the process of setting up companies, organizing rehearsal spaces, negotiating administration and office facilities?

Helen – Learn from those who have already been there, done that.

Q – What about employing an administrator – should this be a priority?

Helen – Often not – the best person to manage and communicate around your work is you – although this does take time, effort and skill. Good administrators are hard to find.

Q – What might an artist approach Arnolfini for? What kinds of facilities do you have? Do you rent out rehearsal space?

Helen – Arnolfini is a producer that both commissions and presents work at its venue and elsewhere. It can offer only limited space to associated artists as it has to share one auditorium with a film program and has no rehearsal spaces.

Q – In your opinion and experience, what are the key elements to a good performance proposal?

Helen – Outrageous, charming, touching, challenging ideas presented with clarity of argument and approach, realism, research. A good track record and evidence of past work also helps.

Q – Do you have a preference as to what type of support materials artists include with proposals?

Helen – Non–edited video with images, past reviews/critical responses.

Q – How much can an artist expect to receive as a fee? Do you offer box office splits? Do you have any budget tips?

Helen – Generally we do not offer box office splits except in very extreme circumstances or as part of a bigger commission/fee. Fees range from £600 to £5000 depending on nature of work.

Q – Are there any common pitfalls you have noticed among proposals by artists that you could advise emerging artists against?

Helen – Sending expensive videos which showcase the video artist not the live artist.

Too much information – keep concise and brief – curators do not generally have time to read it all.

Q –On average, how much time do you imagine you can usually spend reviewing any one proposal?

Helen – Initial – five minutes. Review: fifteen minutes. Video: fifteen minutes. Performance/discussion: infinite

Q –Are you more likely to program or fund work by an artist whom you have seen perform live?

Helen – Yes.

Q – If invited to a performance by a new artist, would you try to attend?

Helen – Yes – unfortunately this is not realistic.

Q – What is your selection process like for putting together the programs?

Helen – Continuous. Seeing work, talking to artists (not just about their own work, often about other work they have seen), other promoters/curators. Program according to fluid criteria but work selected always challenges definitions, creates hybrid forms, experiments.

Q – How important is it to you that an artist be able to articulate the relationship between a proposed piece and the context in which it is shown or funded, for example, thematic season programing, venue specific programing or sector funding?

Helen – Knowledge of venue profile or sector is very important, as the program needs to reflect and contribute to current debate within Arnolfini's program and sector–wide. Season programing is not so important as we do not follow themes, rather accentuate them when desirable or applicable.

Q – How do you think digital technologies are shaping live performance/performers? Do you think live performance is a more guerilla art form than mediated work?

Helen – Creating new forms of dissemination, interaction, exchange, anger equals passion, ways of viewing space, body, time. Changing of established definitions. Nevertheless, live performance remains more immediate, active, exhilarating, annoying, touching.

Q – What aspect of curating/programing do you like most?

Helen – The chemical reaction.

Q – What are the three top tips you would give an artist/company?

Helen – Research venues to ascertain type of program. Don't bother if they don't support or present your type of work – you will waste your time and money.

See other work, meet other artists who do what you do. This way you will build your own network, get the best advice and learn from those who have gone before you.

Curators don't like to be sold to – they want to think it was all their idea.

Mark Dey
WestMidlands Arts

Q – In your opinion and experience, what are the key elements to a good proposal?

Mark – Clarity, rigor, practicality. Think about the person reading the proposal at the other end. Probably they're someone with an interest in performance/live art; it's likely they've read the same books as you. They don't want long critical essays and exegesis; they'll be able to work that out for themselves. What are you planning to do, how are you going to do it, what proves that you're the person able to do it, who's going to be interested in the fact that you're doing it? Synopses, samples of script, initial rehearsal tapes, anything that can give an overview or description of what the experience of the final piece might be. Tell me what I'm going to see and hear; I'll work the rest out without too much explanation. If your proposal is an application to an advertised opportunity or a grant scheme, what are the selection or assessment criteria? Are you addressing them clearly? If you're applying speculatively, say approaching a venue or promoter with an existing piece, have you made sure first that you know what kind of work they're interested in?

Plan ahead. It's tempting to think that you can have your proposal accepted, and then set about thinking about the piece of work. The reality is more like the proverbial iceberg. The majority of your thought processes, clarifying and finessing will need to happen before you can make a cogent case for other people to support your work. And the majority of organizations to whom you might be making proposals or applying are approachable, in fact usually prefer to be consulted before receiving applications. So talk to them. They know what you're applying for better than anyone. They've probably got other diary commitments. So talk to them early, get to talk again in more detail once you've done your thought processes. The development of a proposal can take several months. Be prepared for it. This is when you make your work. Other people pay for it when they can see enough to know what they're buying.

Q – Do you have a preference as to what type of support materials artists include with proposals?

Mark – Circumstance and preference are different from place to place. For instance, I'm on Apple Mac at home, and PC only at work. I can view DVDs at home, but can't at work. Generally, assume a basic common denominator of technology. Which I'm afraid probably still means typed scripts and/or 35mm slides and/or VHS cassettes. Phone people and ask what they'd prefer. For me, the problem is often less the format on which I'm able to view support materials personally than the equipment available to show other people whom I may have to convince.

Also, learn how to present material. There are standard ways to mark up 35mm slides. VHS cassettes with poor tracking are an irritation. Series of JPEG or PhotoShop images on a floppy disk are embarrassing to show to groups of people, because you spend longer opening and closing files than looking at pictures – a simple animated PowerPoint presentation of the images is better. Little things matter, and demonstrate that you're interested in and aware of how people perceive your work.

Q – How important is it to you that an artist articulates the relationship between a proposed piece and the context in which it is shown or funded? i.e. thematic season programing, venue specific programing or sector funding.

Mark – I think of context in this sense as more about the audience than the type of promotion, which is the programmer's problem, not the artist's. So has the artist thought about who is likely to see the work? It may be fine if that audience is just ten other artists in an independent space. As long as the work is made for the context. But generally I think this a matter of dialogue between artists and venue or promoter, rather than the sole responsibility of one or the other. Compromise isn't bad, it's adult. Getting a shared understanding of context is often more rewarding, and can help bring the audience closer to the core of the work, its meanings and experiences.

Q – Are there any common pitfalls you have noticed among proposals by artists that you could advise emerging artists against?

Mark – Like before, the most common one is not thinking about the criteria, about what the person receiving the application is looking for, not reading the questions. Often applicants are so busy telling me what they want to tell me, they forget what I'm asking them. The other one, like before, is too much critical discussion, too much trying to intellectualize the ideas. I can probably spot a flaw in a critical argument that might put me off an application, when I would otherwise appreciate a work whether or not I agree with its critical argument.

Q – On average, how much time do you imagine you can usually spend reviewing any one proposal?

Mark –These days I'm usually looking at proposals from the point of view of assessing grant applications. And I'd guess in most instances something up to half an hour. Five to ten minutes looking at an application, the same drafting an assessment, the same again getting other people's views an adapting my original assessment. But then I read fast and write fast – you get used to it. And grant assessment is only a small percentage of what I do, so it has to fit in with everything else. I've certainly heard of sectors other than the arts

where assessment has even less time.

This does mean that in making applications it pays to get to the point quickly. In journalism, they talk about writing in 'hour–glass shape' – wide at the top, skinny in the middle, etc., so that if the editor doesn't have space they can chop off the bottom of the hour–glass and the reader will still know what the article was about. Try to summarize the gist in your first few words, assume that interest may taper the further down the reader goes, that if they're going to cut out reading anything it's going to be the stuff you put at the end. A proposal or application is different to work. You can write an application that gets the attention quickly, even if the work it's about is a subtle slow–burner. A news article is a different type of writing to a short story or to a critical essay.

Q – Are you more likely to program or fund work by an artist whom you have seen perform live?

Mark – It can help, but as a funder it's not essential. Lots of choices are about taking risk, trusting people's ability. Definitely an application that suggests someone is together and knows what they're about helps. As a programmer, there's a bit more time and personally I've always liked getting to know people's work a bit more, becoming intimate with it and talking to the artist(s). If nothing else because programing is about contextualizing an artist's work for an audience, interpreting and staging. And to do that it helps to know the work as well as possible.

Q – If invited to a performance by an artist whose work you weren't familiar with, would you try to attend?

Mark – I try. Really, believe it or not. And sometimes I'll pop up at different ends of the country to see events. But on any given night I could probably be at two exhibition openings and one event. And sometimes like anyone else I have to work of an evening, or I just want to go home and read a book or watch television. So the more intriguing a work is, the more it's in my face, and the more impressively it's publicized (and that means invention, not just expense), the more likely I am to cease being coach potato and go and see it. There are some performance cliches of course. Frankly, I've spent too many evenings of my life waiting outdoors in winter for a performance that starts an hour late, lasts five minutes, involves lard and blankets and only really satisfies the performers and their mates. The professional courtesies of starting on time, giving a good show, thinking about the audience and meeting and greeting potential funders and promoters get more important.

Q – If you could say one thing to every emerging artist, what would it be?

Mark – Plug.

Manick Govinda, Artsadmin

Q – In your opinion and experience, what are the key elements of a good proposal?

Manick – As someone who has been on selection panels for a number of grants and awards schemes, I am excited by ideas – good ideas, strong ideas, controversial and challenging ideas – and the context that bore fruit to those ideas. The context could be personal, social, historical, philosophical, political, mythic, psychological, metaphysical, scientific, cultural or technological, the psyche, the body and so forth.

I also look at what form the work is going to take. How is the work going to be communicated, expressed or delivered? This is an area where I think some artists fail to articulate themselves well. Many artists like to talk about their work being hybrid, interdisciplinary, site–specific, installation based, multi–media, virtual, cyber and net–based but they don't exactly define why they are expressing themselves in any one of the above form. A good proposal should be able to articulate the relationship between the context, content, concept, form and audience/spectator.

Q – Do you have a preference as to what type of support materials artists include with proposals?

Manick – At Artsadmin, during the first round of the Artists Bursary scheme, we asked applicants to submit a video of their work no longer than twenty minutes duration, or up to twelve slides. However, during the selection process we realized that more and more artists have websites, documented their work on CD–ROM, and have had work published. We now accept all of the above forms as support material.

For performance work, the most desirable type of support material is still VHS video. The selection panel argued about whether this format was the best to represent an artist's work as most of the video documentation we saw in the first round was quite dreadful in quality. A shaky hand–held camera in a night club setting where the selection panel is straining to hear what is being said or done can get in the way of trying to critically engage with an artist's work! Many artists tend not to send documentation of the processes of making work when sending in visual support material. I would advise them to keep a video diary, which could subsequently be edited to capture those key moments. Conversely, wonderfully edited, MTV style 'soundbite' videos can reveal little substance, except showing off the skills of a good editor. The reason we decided that it was still important to ask for video documentation is that no matter how bad the quality of the video was, it would still be able to convey a sense of the work. A dodgy bootleg recording of a Laurie Anderson performance will still offer a glimpse of her genius and artistry!

Good documentation or visual material that has depth, clarity and substance can sometimes speak more loudly than a well–written proposal.

Q – How important is it to you that an artist articulates the relationship between a proposed piece and the context in which it is shown or funded? i.e. thematic season programing; venue–specific programing or sector funding?

Manick – I can only speak from my personal and professional position as Artists Advisor for Artsadmin. A grants officer for a local authority or a regional arts board may have different approaches. As I mentioned earlier, I am firstly far more interested in the context that the creative thoughts emanate from. At Artsadmin, through the bursary scheme we support the process of making work. It's an opportunity for artists to take risks, to experiment with new ideas and forms without the pressure of public scrutiny or creating a product for a wider audience. It allows the artist to demonstrate work in progress, to receive constructive feedback from fellow artists, curators, funders, writers and promoters who may wish to help them further the work for public viewing. It's an opportunity for dialogue, allowing the 'spectator' to have a discussion with the artist about the process for making work. In most cases the work is developed further and may be positioned in a specific sites or key venues.

Some of the work in progress that has been developed through the bursary scheme will be given a full public airing in festivals like The British Festival of Visual Theatre. However, there is no prerequisite at the proposal stage that an artist must identify other sources of funding or bookings by promoters or programmers.

I am deeply concerned that public funding for the arts in the UK is governed by government

dictate. Artists are being forced into social work positions, having to address 'social disadvantage, healthy living, social exclusion, education and other social dilemmas. This poses a real dilemma for live artists whose work is, in the main, provocative, oppositional, daring and where there are no limits to the imagination. I have no problem if an artist wants to make work that targets specific audiences, communities or groups. However, when the arts are uttered in the same breath by a group of people who go on to systematically bomb a Middle Eastern or eastern European state, then I do worry. The arts then become another tool for social and political engineering.

Q – Are there any common pitfalls you would warn of?

Manick –There are common pitfalls to avoid:
1. Ensure that your visual support material is relevant to the proposal. If you are a performer, submitting slides or stills of a performance will reveal little about the work you have created to date.
2. If you are venturing into new forms of communication or expression, for example, video, multimedia performance, installation, you must try to articulate why the shift, why the move, what is the thinking behind it.
3. Similarly, if you are collaborating with other art–form practitioners in the making or development of new work, the proposal needs to address why you are collaborating with this particular artist or art form. How did the idea to collaborate evolve? Why are you collaborating? There needs to be a strong artistic reason for doing so.
4. Ensure that your ideas are strong and convincing.
5. Artsadmin's bursary schemes are not commission or project funds, and therefore warrant a different application process. Previous applicants whom we turned down had a clear vision of what they wanted to do, how to do it and who it's for. Such proposals should go to the public funding bodies for project funding. We want to know why you want to explore or test out a particular idea. The outcomes are anyone's guess! However, it is important to find out exactly what kind of information–specific grant giving bodies or commissioning bodies need. Talk to them, attend surgeries, or try to get a meeting before putting in final proposal.
6. Before submitting the final proposal, find out whether it is possible to get feedback on a draft outline.
7. Ensure you have fulfilled all the criteria and submitted all the relevant material requested.
8. Most importantly, try to define your artistic practice.

Q – On average, how much time do you imagine you can usually spend reviewing any one proposal?

Manick – I usually put proposals into three categories:

A. Strong proposal and ideas, interesting, imaginative, unusual, exciting, unique, cutting edge, radical, ground breaking, strong body of work behind artist as demonstrated by CV and support material, at a critical juncture of artistic development.
B. Strong written proposal demonstrating good ideas, but need to see past or current work or support material before final review or decision.
C. Not a strong proposal, unconvincing ideas, lack of experience or relevant support material.

It usually takes me about 10 minutes to decide which proposals fall into category C. Nearly all the others go into category B which normally takes about twenty minutes to review. Very few proposals make the A list. When the selection panel meets each member respectively identifies which proposals made their A list. If there is a unanimous decision, then the merits of that proposal is discussed. However, unanimous decisions are extremely rare. The battleground lies mostly in the B list and, where there are differing opinions or views, a debate on any one proposal can take up to 30 minutes. Where there are unanimous Cs, those proposals are not discussed at the panel meeting.

Q – Are you more likely to program or fund work by an artist whom you have seen perform live?

Manick – Not necessarily. I try to see as much work as possible by prospective applicants but sometimes it's impossible. Of the 134 artists who applied to Artsadmin's bursary scheme, I personally had only seen the work of seventeen of the artists of which five, out of a total of nineteen, had received bursaries. We ensured that we had a good breadth of interests on the selection panel who see a diverse range of live, interdisciplinary or mixed media work. It is therefore important that proposals are strong, accompanied by relevant documentation and referees are cited who can offer a professional view of the artist's work.

Q – If invited to a performance by an artist whose work you weren't familiar with, would you try to attend?

Manick – If an artist who intends to seek support from Artsadmin personally invites me, then yes I try my best to attend. I also try to give honest and constructive feedback.

Q – If you could say one thing to every emerging artist, what would it be?

Manick – Communicate and demonstrate!

Lois Keidan
Live Art Development Agency

Q – In your opinion and experience, what are the key elements of a good proposal?

Lois – Performance proposals are for me about initiating dialogues between 'like minded people' and not about 'doing business' per se. Having said that, for me the really key elements are:

The Whys and the Hows and the Whos.

> I want to know what the ideas are (and what they relate to), what form/s their expression will take, who the artist is and what experience they have (no matter how limited).

> Beyond this I would want a sense of what was needed to present the work (spaces, technical stuff, number of people involved, time scales) as this will determine viability and budgets. Ideally (but not necessarily)

> I would like a sense from the artist of who they 'want to talk to' with this work, i.e. who the audience could be.

> I would also want a sense that this was not a blind proposal, i.e. that the artist had an idea of the promoter's programs and policies and how this work

'fitted into' these. I cannot emphasize enough the need for research in these matters and that there is no point wasting stamps and phone calls about a radical new installation project for a festival that actually specializes in Mime!

The other important thing to emphasize is that the language used in a proposal should be very different from the language used in publicity material. What promoters what to know is different from what audiences are seeking and hypey/jargony language promising a 'unique experience' etc, puts promoters like me off! If artists really want to take the hard sell approach they should make claims like a 'unique experience' appear as quotes or affirmations from someone else!

On a final note always expect, and indeed demand, a response. If your proposal was rejected try and find out why so you aren't disappointed next time. Having just asked a similar question of a gallery curator I know that in that sector the priorities for proposals are: what does it look like, who is the artist and what does it cost (it seems like ideas aren't too important here!!!).

Q – Do you have a preference as to what type of support materials artists include with proposals?

Lois – The ideal supporting material is a video (ideally unedited so it as close to the real experience as possible – flashy promos often belie the work) but we all know this is not always possible and not always a good representation of the work.

Sometimes still images are useful but don't always tell you enough. I would want a biography (more than a CV) and examples, if possible, of critical responses, i.e. press cuttings or a piece written by someone but not necessarily published.

Examples of previous bits of publicity (if available) are always useful.

Always include a covering letter, no matter how brief.

Q – How important is it to you that an artist articulates the relationship between a proposed piece and the context in which it is shown or funded? i.e. thematic season programing; venue specific programing or sector funding.

Lois – It is important to me that the artist is aware of the context the programmer is working within but I need to qualify this in relation to this specific question.

It actually all depends on whether it is a general 'unsolicited proposal' or a response to a particular commissioning or programing brief. If it is the latter then yes, absolutely, they should be able to articulate their response and relationship to the theme or context. If it is the former then it is more about being able to articulate how the work might relate to the venue's more general positioning/ongoing policies (for example, knowing that the ICA is a centre for radical new performance work rather than dance or puppets) and an inference that their proposed project might enhance and develop that positioning/policy, and may even suggest a whole new theme/context!!

As someone who had a policy of thematic programing when I was Director of Live Art at the ICA, I have to emphasize that the themes themselves were ALWAYS a response to the work of artists (i.e. we didn't think of a theme and find artists to fit it!). This is not necessarily the case with all programmers but artists should be bold and confident in their proposals and hope that it so catches the programmer's eye that they have to find an appropriate way of responding to, and representing, the work. And for god's sake, never try and make your work sound like something it is not – be true to yourself and your work or there's no point in making all those sacrifices to be an artist.

Q – Are there any common pitfalls you would warn of?

Lois – Don't try to make your work sound like something it is not.

Don't use hypey/promo–type language.

Provide enough information about who you are and what your work is for programmers to 'get it' without having to ask too many follow up questions – i.e. the whys, hows and whos.

I would also advise artists not to send out unsolicited videos but to make it clear that a video is available if promoters would like to see it. Videos cost a lot to duplicate and a lot to post and (unless they have a private income) emerging artists often cannot afford these kinds of expenses and actually should be investing any money they have in their work.

Unless you can afford it (or it is actually part of your process) I would advise against glossy and expensive promotional packs. Just because the print is good doesn't mean the work is and I actually respond better to well–articulated and intelligent bits of photocopy than snazzy brochures.

Always include a covering letter but avoid Dear Sir/Madam or To Whom It May Concern. Always try and find out the name and use it!

Funding

Q – On average, how much time do you imagine you can usually spend reviewing any one proposal?

Lois – Again, depends on the context – if it's a response to a particular commissioning/ programing brief approximately 30 to 60 minutes. If it's an unsolicited proposal approximately 10 to 20 minutes.

Q – Are you more likely to program or fund work by an artist whom you have seen perform live?

Lois – Sadly the answer to this is yes (live or on video) but this does not mean I would not program someone I haven't seen live – sometimes you have a hunch and go by your guts (for example I had never seen Raimund Hoghe's work before I programmed him at ICA). This is not necessarily to privilege artists whose work you have seen over artists whose work you don't know, but if you have seen it you have a better sense of how it could be best represented, contextualized and what it might need in terms of support.

Q – If invited to a performance by an artist whose work you weren't familiar with, would you try to attend?

Lois –Yes, but they need to provide as much information as possible as to why I would want to. I know this sounds arrogant and I do very much respect artists who are able to say 'fuck promoters, I don't need you', but there is always so much work on (especially in London) that promoters need to make choices and artists should assist them in making 'informed choices'.

Q – If you could say one thing to every emerging artist, what would it be?

Lois – Be bold, be confident, be clear about what you want and do your research.

Richard Loveless, ISA,

Q – In your opinion and experience, what are the key elements of a good proposal?

Richard – Evidence of risk taking is absolutely essential to 'chance a romance with success'. I am most interested in the passion, conviction, or devotion one has to a particular idea or ideal and its potential to resonate with multiple meanings to a myriad of audiences. Success in this sense means the performance can significantly change or alter the sensibilities of the audience. What's new and what's not varies depending on the experience of each artist, thus it is important to consider the proposed idea within two contexts: the performer's personal history coupled with an informed point of view regarding the history of performance.

Q – Do you have a preference as to what type of support materials artists include with proposals?

Richard – I am most interested in visual documentation, preferably video material that has been created for archival use. The moving and sound image can be supplemented with stills and other audio or video source materials as long as their inclusion informs the process of decision making that led to the final performance. I am not interested in video that has been manipulated by special effects that are not observable in the live performance. However, special effects are quite acceptable if the final outcome is a video or some other mediated format.

Q – How important is it to you that an artist articulates the relationship between a proposed piece and the context in which it is shown or funded?

Richard – A human performance by definition has to originate in a 'place', real or virtual, and be experienced in a 'place', in proximity or at some distance. It is important for the artist to communicate a sense of how well they have envisioned the relationship between a particular performance and a venue that suits the intention of the work.

Q – Are there any common pitfalls you would warn of?

Richard – 1. An idea is only as good as one's imagination to recognize the appropriate form. Anticipate that your initial vision for every project is barely formed. I can't think of a single successful project that didn't change, grow, expand, and in time exceed everyone's initial expectations.
2. If your proposal involves technology or collaboration with technologists, the appropriate use of technology in shaping the performance work and/or determining its presentational format (live in proximity to an audience, mediated or any combination) must be an

essential part of the initial conceptualizing process.

3. In joint proposals avoid the practice of rewarding everyone in the collaboration at your own expense.

4. Always think of yourself as 'emerging'! The moment you stop you are dead in the water!

Q – On average, how much time do you imagine you can usually spend reviewing any one proposal?

Richard – Processes for reviewing proposed projects vary widely in format and scope. If acting as a single reviewer I start with the assumption that the proposal writer's time is as valuable as my own. If I sense they have made a notable effort to prepare a proposal, I respect that commitment by scheduling as much time as it takes to read it carefully. I believe it is essential to provide a written evaluation whether you approve or reject a proposal.

Q – Are you more likely to program or fund work by an artist whom you have seen perform live?

Richard – Not particularly. In cases where I see a performance that just knocks me out, I make an effort to spend time with the artist to find out what they think 'the next' will be. Given their response, I try to imagine a win–win situation for the artist and the institute if we were to pursue a project together. Viewing mediated samples is highly desirable in the absence of the live experience. Experienced discriminating viewers are capable of evaluating the mediated aspects of the work as opposed to effects that are often used to distort the live experience of the work.

Q – If invited to a performance by an artist whose work you weren't familiar with, would you try to attend?

Richard – It would certainly depend on timing, distance to travel, and resources. It is routine to travel within the country to see performers, more difficult to get to international venues.

Q – If you could say one thing to every emerging artist, what would it be?

Richard – There are no clear relationships between an artist's age, the presence or absence of wisdom, and the quantity or quality of recognition they receive for their work. The process of emerging is a dynamic, not a static, concept. The challenge for all artists is to be emerging to your very last breath.

Mark Waugh
Arts Council of England

Q – In your opinion and experience, what are the key elements to a good performance proposal?

Mark – In the context of my role as the Live Art Officer within the Visual Arts Department, I am lead officer for all submissions from Live Artists for the National Touring Programme. When I receive an application I have in mind that this fund is for nationally significant work which delivers at least two of the key Arts Council of England criteria. These criteria are: new work, experimentation and the role of the individual artist, new art forms and cross–artform activities and new technology, diversity and social inclusion, children, young people and lifelong learning and finally touring and distribution. Within these parameters I have a specific interest in work which addresses key contemporary issues such as the impact of technology on the human condition. In post to serve the interests of those who define and have defined the territory through practice I don't aim to limit what does or does not constitute a good application. What is worth emphasizing is that Live Art competes for funding with other applications to the various art forms within the Visual Arts Department.

Q – Do you have a preference as to what type of support materials artists include with proposals?

Mark – Documentation is an increasingly key issue in the advocacy of Live Art practice. Without strong support material an officer is left with the interpretation of text or hearsay. I personally think it a myth that Live Art is difficult to document. I have found Live Artists visually erudite and able to either stage or include documentation processes within the strategic and logistical structure of their work. When considering the value of a successful application it is obvious that artists should attend in some detail within their means to creating material which is engaging not only for those with specialist interest but also for those with a broader interest in the arts. Therefore I would try and include video, transparencies, CD–ROMs, DVDs, URLs, publications and any other relevant media coverage in the form of press clippings, etc.

Q – How important is it to you that an artist articulates the relationship between a proposed piece and the context in which it is shown or funded?

Mark – Again my framework is very focused in terms of that which is or is not eligible for

the National Touring Programme. Touring projects must be communicative of the criteria which the curator, artist or producer is aiming to realize. If a thematic were part of the conceptual outline it must potentially engage both the lead officer and the other art form officers who would read it. That which fails to do so is very difficult to discuss in a context of open advocacy. In a media saturated environment a project is obviously in trouble if it does not have access to any useful semiotic code.

Q – Are there any common pitfalls you have noticed among proposals by artists that you could advise emerging artists against?

Mark – Common pitfalls include a failure to properly research costing. It should be remembered that officers have to read a lot of applications and are familiar with realistic and inflated figures or income and expenditure.

Q – On average, how much time do you imagine you can usually spend reviewing any one proposal?

Mark – Five to six hours including departmental discussions.

Q – Are you more likely to program or fund work by an artist whom you have seen perform live?

Mark – Obviously the ideal position for a lead officer in Live Art particularly is to have first–hand knowledge of work. That said this is not always possible and you can read quite a lot into an application form and the support material supplied. It is always in the interest of artists to get funders to attend their performances and indeed just keep them informed of events that perhaps they can't attend such, as media coverage, international commissions, etc.

Q – If invited to a performance by an artist whose work you weren't familiar with, would you try to attend?

Mark – Absolutely. I am personally always keen to connect with artists and experience their work.

Q– If you could say one thing to every emerging performance artist, what would it be?

Mark –Keep it real.

Production

Production

This section deals with basic nuts and bolts issues of performance and video production and includes detailed strategies for maximizing the two most precious resources in production – time and space. The name of the game is preparation – how much can you set in place before the day of the performance or shoot?

With the exception of residencies, it is rarely possible to make and rehearse a piece of work exclusively in the space in which it is to be performed or shot. Even in residencies, you will often initially work in a studio space and then move into the theatre or gallery later, just before your piece opens. In video and film production location shots are notoriously difficult. If touring you will have to adapt to a series of different spaces, all with different assets and drawbacks. Space is absolutely premium. It is more premium, by and large, than money and negotiations around space can be more difficult than negotiations around fees.

If possible, one of the best things you can do is to stalk your spaces beforehand. In video production you can build these recces into your budget. For theatre or gallery performance, many venues will compensate you for travel if they have already booked your piece and you request a site visit in advance of the actual gig – maybe a month or two in advance so that if you identify challenges in terms of the facilities, you and the technical director have time to devise solutions.

Let's face it: a lot of performance spaces are quirky. While some of them are really 'characterful' and 'atmospheric', they can be hard to transfer a piece to. It makes sense, where possible, to maximize the capacities of the venue to complement your work and vice versa. This does not necessarily mean making site–specific work or manipulating the work already made to fit the space, but there may be particular features that have resonance with the piece that you would want to be aware of beforehand, for example the texture of the floor, the shape of the walls. Alternatively, there maybe certain architectural aspects of the space that you have to work round. For example there may be pillars slap bang in the middle of the performance area. What if the seating is fixed when you have created a promenade piece or need the audience to move during the piece? What are your options when you find yourself confronted by a concrete floor when you have been working on a polished wood surface? Do you have to re–work everything at the last minute? Or do you find out in advance and get hold of some sort of floor cover? It is an absolute case of forewarned is forearmed and the last thing you want to deal with on the nervy performance or shooting day is re–working your piece around a spiral staircase stage left or realizing for the first time that there is a fire station next door.

If you live in proximity to the space you will be working in, another good approach is to

go and see other performances or screenings in the venue. Find out what the acoustics and sight lines are like from the audience. Make an appointment to walk the space with a technician and ask a lot of questions:

Can the seating be moved or removed?

What sound system is available?

What are the speakers like?

Do they have good mics or will you need to ask them to hire one or bring your own?

What are the capabilities of the lighting rig?

How much time will you have to hang and focus for your show?

What projection screens or surfaces are available? If your piece incorporates slides or video, demand a projection test.

Is their projector powerful enough for the size and intensity of image you want? If not can they hire one for the event?

Check out any safety/insurance issues you might need to know. And in true guerilla style, make sure you check out what other gear the venue has that you can use:

Can they give you a hot desk and a computer while you are working there?

Is there an Internet connection you can use?

Do they mind if you give out their fax number to other people who might need to contact you on the days you will be working at the venue?

If for some reason you are unable to see the space prior to your get in/load in then it is strongly advisable to speak to the venue's technical director and arrange to have the technical specifications (tec specs) sent with the dimensions of the space marked out and the facilities listed. Usually you can expect to have some rehearsal time in the space on the day of the show, but if you are on a touring schedule, this time goes by like a single shot expresso. Often the lights are being hung and focused more or less at the same time you are trying to walk through your piece. You are well advised to know ahead of time what potential problems to look out for and to arrive at the venue for the get in as prepared as possible, knowing your order of priorities.

In the following section Emma Wilson breaks down some of the key points of contact and communication between artist and the technical director and offers generous advice on how to prepare as thoroughly and efficiently as possible for a theatrical event. Emma is currently Technical Director at Sadler's Wells Theatre in London, but she has extensive 'guerilla' freelance and touring experience and knows the international performance sector first hand from her years as Technical Director at the ICA in London. She flags the issues that artists should watch out for when transferring a piece from one venue to another and demystifies some technical lingo. As a lighting designer, she also contributes good creative advice.

Zara Waldebeck focuses on video and film production, defining the elements of a successful production shoot and offering key advice to the artist new to working with these mediums. She offers advice for the artist wishing to incorporate film/video into live work as well as for those who want to start making their own films. She discusses some of the pitfalls of translating live work to film or video and offers low budget alternatives and high tech tips.

Ian Grant gives the low down on high—tech, debates the size of attachments and gives top advice on digital image processing and production. He offers some great URLs for free downloads and shares guerilla strategies for the artist working with digital technology.

Emma Wilson, Lighting Designer

Q – What does the artist need to know about lighting? Can you explain what the different lanterns do?

Emma – Lanterns (not lamps, they are the bulbs that go in the lanterns) come in all shapes and sizes. Following is a guide to the most common basic units to enable you to make informed choices as to the effect you would like produced. What is not explored here to any extent is the possibility of moving or intelligent lighting fixtures; by the time you wish to explore the possibility of using these you will be using a lighting designer. Or have gathered enough technical skills to work as a lighting technician yourself.

Fresnel: gives a soft–edged beam of light. It has one movable lens so the pool can be made larger or smaller as required. It has external shutters (barn doors) that can cut off the outer edge of the pool in a basic manner. Fresnels are often used for general cover, i.e. general washes of light that can be either over the entire playing area, or general lighting over more specific areas of the stage.

Pebble Convex, or PC: very similar to a fresnel, but with a more defined edge to the beam.

Profile: generally has two lenses; you can change the size of the beam thrown and also the edge of the beam, from hard–edged to soft. Comes in a variety of widths of angle of throw (minimum and maximum angle ability) so you will need to know if you need a wider or narrower width beam if asked. The technician should then be able to choose the correct unit for you. A profile is used when specific lighting with definite edges is needed, and it has internal shutters that can enable straight cuts to be made to the beam. Profiles are also unique in that they can be used with gobos. These are discs of steel that have a pattern cut from them, leaves for example, and then inserted in the lantern in a gate between the lamp and the lenses. This enables you to create patterns on the floor or set, which of course can be hard–edged and defined, or soft to give a vague impression. You will most commonly encounter leafy break–up, windows, blinds and so on, though they come in hundreds of designs and can be custom–cut with a design or logo of your choice.

Flood: does exactly what its name suggests. A very simple unit that is used primarily for lighting a cyclorama, used above and/or below to give an even wash of color.

Parcan: what most people recognize as rock and roll lights. Very simple, yet very effective in their own way. Often used as side lights in dance to throw good strong light across the stage. As with floods they can only be pointed in the right direction, there is no movable lens, but they give a definite pool of light. They come with different interchangeable lamps that give different sizes of pools; most commonly narrow (CP60), medium (CP61), and wide (CP62). Unless you need to be very specific you will find that in most cases wides will be used, and this is what most venues will have in the majority of their stock.

Fluorescent/Neon: these will generally not be held in stock by a venue, but if you decide to use them and hire them in there are certain considerations. A fluorescent light, for example, will operate only at full power, unless you ensure it is made dimmable and to do this you will need the assistance of the venue's or your own lighting technician.

The lighting plan
The technician will need a lighting plan to rig your lights. This will show at its most basic the position of the lanterns, any pairing necessary, each light with a channel number, and colors to be used. This plan should be a 2D overhead view of the rig, with simple symbols for the lanterns (and a key to the symbols), and an indication of the color to be used and the channel number of each unit written beside each lantern on the plan.

Gel color
Gels are sheets of colored plastic used to color the beam. They come in hundreds of colors, but a performance space will generally only stock the most commonly used. If you do not

tour with your own gels, you must ensure the technician is aware of this and can organize accordingly. There may be a cost implication if you use the venue's gels, or if they have to order any special colors for you. They are extremely easy to purchase yourself; ask your venue for their local supplier. If you do not know the number of the gel you require (they are all referred to by technicians by number and never name, for brevity and minimizing errors) then give an indication of the kind of color you need, e.g. rose.

Focusing notes

Ensure you have pre–prepared notes of how each lantern is to be focused; numbering each light, giving it a channel number to be used on the lighting desk, is the first step to ensure there is no confusion over which lantern is being used in which scene. Matching up the numbers on your plan to the numbers on the desk is called patching, it can sometimes seem to take a while for the technicians to complete the patch, depending on how this is done in each venue (usually a combination of physical cross–plugging and desk programing). When it is complete, however, the focus session can begin. Make sure that as the lanterns are focused you either have a person walking the scene or action, or bear in mind the height and movements of the relevant performer or performers.

Lighting desks & plot

In the vast majority of venues you will encounter pre–programmable lighting desks, rarely will you encounter a venue that only has a manual desk. Bearing this in mind the show will be plotted and recorded; each separate cue will be looked at, the scene will be visually balanced onstage in terms of which units are on, at what level, and then recorded with a number. The change between

cues will be timed and this will also usually be pre–recorded. This entire process can take a long time and will probably involve going back and forth over cues. Be patient; each cue involves a number of steps for the programer and dipping in and out of sequence just complicates the entire process. Be as systematic with your requests as possible and be methodical.

Power – lighting rig and additional power requirements

Lanterns come in a variety of sizes, and the lamps are subsequently in a variety of power, 500 watt, 650 watt, 1000 watt (or one kilowatt) and so on. These are often abbreviated to '1/2K', '1K', '2K' etc. Bigger is not necessarily better, and performance spaces will have lanterns that are lamped in the power appropriate to the playing area. Most small to medium scale spaces will have a mixture of 500w, 650w and 1K units. Select the strength of lantern according to the lighting effect you need; small and dim, use a lower wattage.

Performance spaces all have a finite amount of electricity available for use in the lighting rig. There will also be a finite number of lanterns they can use at any one time. A technician may ask if lights can be 'paired' to allow for optimal use of available channels; this is when a pair of lights always comes on together and with identical intensities. The theatre technical specifications should give the details of number of available channels.

Be aware that additional equipment you bring in will require power; ensure the technical manager is aware of what you are bringing and where you require power sources.

Design tips/alternative lighting sources

Lighting is as much about shadows and darkness as it is about illumination. You will need to illuminate the performers, and possibly the set; but visibility is often not the primary concern; it depends entirely upon the work. Be aware also that there are specific effects you may need to reproduce; car headlamps, candle–light, moonlight, or any number of directional or specific lighting effects, both naturalistic and non–naturalistic.

Remember you are working in a three–dimensional space; light it accordingly. Light from the front will illuminate expressions and detail, but overuse will create a flat two–dimensional appearance. Light from above and behind will give the third dimension. Lights from above and in front at a steeper angle will also give definition and shape. Lights from the side, which are used sometimes to the exclusion of all else in dance, give bodies shape and form. They can be at a variety of heights (shins, mids and heads and so on – all quite self–explanatory terms). Remember also that lights can be used for special effects, can be used singly to great effect, can be used from unusual angles, the possibilities are endless. Consider fast changes, imperceptibly slow changes of light, oppressive intensity of light, lights in the audience's eyes, light levels so low it is difficult to make out the actions.

Lighting has a malleable emotional effect; the number and types of units used, the color, intensity, direction of beam, the speed of changes, the shock value, the naturalistic or non–naturalistic use of light; used imaginatively the space can be sculpted with light and the emotional impact of the performance enhanced. Light from one direction only, for example, strong light from overhead could be oppressive, uplifting, ethereal or inspire any

number of emotions; it depends how you use it.

Think about alternative sources of light, especially in poorly equipped venues; strings of Christmas lights, flickering TV sets, flash guns of cameras, hand–held torches, domestic lights, fluorescent or neon lights, backlit viewing units for photographic slides, children's' toys, caving headlights, roadwork flashing lights, matches, cigarettes, candles, daylight. If you can plug it in, stick a battery in it, or light it with a match, then it's a valid light source.

Q – What about sound? What does the artist need to be aware of when using amplified sound?

Emma – In the majority of cases the sound system in the venue will be appropriate to the size of venue. You should consider augmenting this system only if the resident system can cope with additional equipment. In the majority of cases you will use the system as it is pre–set, but may wish to make adjustments based on any special needs of the show. These could include sub–bass under the audience for the physical experience of deep resonant sound, speakers behind the audience for a special effect, or a speaker in the set, again for a special effect.

You will need to advise the venue of what exactly you need to run through the sound system and what sound sources you will be using. Consider the following:

Minidisc, CD or cassette tape; will you use more than one of these sources?

Microphones. What are they to be used for? Vocal mics are very different from a variety of mics used for instruments. Do you require radio mics, and if so are they to be lapel or hand–held?

Be aware that if you tour with your own radio mic it is best to advise the venue of the frequency it operates on.

Consider other sound sources that may have to be fed through the desk, for example a video projector. Ensure there are the relevant connections (of the relevant length) in the venue to enable you to do this. Request foldback if required; this is a set or sets of speakers angled towards the performers so that they may hear the soundtrack or musicians more clearly; this

is imperative if there is any amount of singing in the performance.

Hints

Minidisc or CD are the best sound sources for live performance of this scale; they are the most responsive and adaptable, reproductive sound quality is good, they are easy to produce yourself relatively inexpensively, and minidiscs are particularly easy to edit and re–edit. If you tour with your own equipment, like a portable minidisc player, ensure you also tour with the relevant adapters to the desk inputs; inquire of the venue what you will need (there are very few permutations) and you can buy what you need relatively inexpensively from most domestic audio stores. Touring with your own connectors and adapters is always advisable.

Always carry a back–up copy of your soundtrack. Try also to always carry a second back–up in another format, if you use minidisc then carry a CD or an audiocassette copy of the soundtrack.

Q – What if the performance involves special effects?

Emma – The safety issue is of primary concern with all special effects. You must inform the venue in advance of your intention to use any effects as there may be licensing implications with the local authorities. Failure to do so could potentially result in the cancellation of your performance.

Strobe lighting can induce epileptic attacks and venues must warn the public in advance if it is to be used. Make sure that the front of house management has been informed, and if possible advise the venue well in advance (at the time of your show being booked, ideally) as they may wish to indicate the use of strobe in promotional literature.

Smoke machines must, if hired in, be approved by the venue for use. In rehearsal and performance mode it may then be necessary to turn off certain smoke detectors to ensure the building's alarms are not activated; this is primarily the responsibility of the venue, but be aware of the issue and ensure you raise the issue with the technical manager before any technical rehearsal

If smoking onstage check the local regulations with the technical manager of the venue; you may have to use sand in ashtrays, for example. Ensure they are advised of the extent and frequency of use of all naked flames, and how they are extinguished during the performance. In some cases where you may not be able to incorporate the elements into your performance, the earlier you discuss this issue with the venue the more time you have to address the problem in rehearsals.

If you are using pyrotechnics, or in fact anything flammable, you will be required by regulation to ensure they are kept in a lockable metal container. This is not only the safest method of transport, it protects the venue and you from unauthorized and possible dangerous use. Neglecting to do this can leave you open to liability and can jeopardize the licensing of your performance. Guidelines on use and storage will usually be supplied by the manufacturers on purchase.

You may be required to demonstrate any effects for the licensing authorities; be aware of the time of their visit and make sure that whoever operates or performs that effect is present to demonstrate.

Q – What research does the artist need to do in terms of the performance space?

Emma – Aside from constructing your own set and transporting it to the venue (in which case you must get the dimensions of any entrances to the venue to ensure you can actually get it in to the space), you may need to consider some of the following points:

What kind of floor is in the venue? If it is concrete you may have major problems when it comes to dance. Ask about the possibility of laying a sprung wooden dance floor if this is the case. Decide whether you need dance lino, or marley, and specify the color; black is usual, white or gray are not usually held in stock by most venues and you may need to hire it yourself if this is a design imperative. Be aware that there may be a considerable cost implication if this is the case.

Do you need any additional flooring needs laid prior to your arrival? It is advisable to specify this or you may lose a considerable amount of time on your first morning.

Assess your probable use of the intercom system, or cans, or comms, or whatever the local term is; you will need to determine who needs to speak to who during the show. Be aware that most venues will have hard–wired comms; however, if wireless comms are offered they should ideally only be used with headphones due to noise levels interfering with the performance.

You may need entrances and exits from the space itself during your performance; make yourself aware of these and adapt in rehearsal if necessary.

Advise the venue if you need anyone onstage or in the wings for scene changes or any technical operation.

Advise the venue if you require hanging points and indicate not only where but how much weight you need them to bear. Do this as early as possible; you may have to adapt in

rehearsal if what you want is just not possible.

Establish in advance the source of any perishable consumables you may need for your show. They are your responsibility not the venue's but they will be able to advise you on local suppliers if you have unusual requirements.

Q – What about pre–show preparation?

Emma – You should obtain the performance space's technical specifications well in advance; these should include if possible the following: a scale floor plan (to ensure the set fits within the space), a scale rig plan (for adapting the lighting design to the space), a list of lighting and sound department equipment available, electrical or other technical peculiarities of the venue, rigging issues (flying system, load–bearing capacities), and dimensions of entrances. Working within the allowed parameters, let the technical manager have the following well in advance of your arrival; this is not only a professional courtesy, it will also allow them to identify potential problems and will ensure they can schedule their work and crew accordingly:

A lighting plan, to scale.

A breakdown of the number of each type of lantern and a list of gel colors (for ease of reference when the technicians are preparing the equipment).

If you have no lighting design indicate exactly what effects and what states you would like to achieve (for example 'a general warm cover over the whole stage; a central white spot, from above, to accommodate one person standing still, very crisp edge; and two soft pools of light, one upstage, one mid–stage left, around 2 to 3 metres diameter each, both in a dark blue'). If you are in the position where you have to rely on the assistance of the theatre technicians to realize your ideas, keep it simple and indicate clearly your required lighting states. Don't assume they have design skills, though if they do and are happy to assist and advise you will have the skills of people who see shows most nights of their working lives at your disposal.

What sound source provided by the venue you will be requiring (minidisc, CD etc.), and any additional equipment you may be bringing that you require to feed into the sound desk.
What speaker configuration you need for the sound, i.e. anything that might alter the usual configuration of speakers in the space, for example speakers behind the audience, or in the set for special effects.

Do you need foldback; i.e. do you need to speakers pointing at the performers so that they

may hear the soundtrack more clearly?

How many technicians or crew you need from the venue to run your show, or how many tasks (for example sound and lighting desk operation if there are not many cues) can be operated by the same person.

If you need anyone onstage with you to assist in scene changes or costume changes.

What your intercom requirements are; who needs to speak to who during the show.

Any set or staging requirements; do you need a dance floor laid, and is that side–to–side or perpendicular to the audience?

Indicate how many people you think may be required to set the show up, though if this is more than your contract with the venue includes be aware that you may bear the additional wages costs.

If there is any smoking or use of naked flame in your performance.

If you use any special effects: pyrotechnics, use of water onstage, or basically anything else that could create a fire hazard or compromise electrical safety.

External to show – general production issues

Transport of people, equipment, set, and props – if you are hiring a vehicle who will drive? Do you have adequate insurance?

If you are transporting and/or using your own equipment/set/costumes, is everything of value covered by insurance in transit AND in the venue?

When you arrive is there parking available to you? How long for – the duration of your stay or just the unloading of your kit? Do you need to obtain a permit, do you need to obtain it in advance?

If the show is not in a conventional venue are you covered by a performance license? Is there a promoter/producer whose responsibility this is?

Setting up the show

There are several steps, but these are basically covered by the get–in/fit–up/bump–in (list of descriptions not exhaustive), the technical rehearsal, and the dress rehearsal. You may decide on additional rehearsals depending on your show, safety checks if you use circus

skills, fights scenes, or pyrotechnics, for example. If you have a stage manager or a technical manager it is they who will run the rehearsals; relinquish responsibility and let them do their job, which is to get your show looking good, running smoothly and going up on time. Get–in/load–in/fit–up/bump–in – this involves the obvious physical initial setting up (lights, sound, stage and so on), followed by focusing and programing of the lighting plot, sound–checking, any other technical elements set up and tested, costumes cleaned and prepared, props prepared, perishable consumables purchased, and so on.

Q – What happens in the technical rehearal? Are there any good general codes of practice?

Emma – Pre–prepared cue sheets for sound, lighting and a.v. operators, stage crew, i.e. whoever is involved in the running of your show, are essential. Have prepared clear paperwork with lighting changes (which lights change when, fade times, scene changes), sound levels and track listings, and so on. This will enable you to guide the technicians through the show clearly, sequentially, and without backtracking. If you do not keep as close to the true running of the show as possible you run the risk of general confusion, performance problems due to inadequate technical rehearsal, desk programing problems for the lighting operator, and very possibly frustrated and impatient technicians. Optimize your use of time by advance preparation.

Lastly, and this is extremely important, remember that this is primarily a rehearsal for the technicians and stage management, and probably the only one they will have. Be patient if they have to run a cue or sequence of cues repeatedly; there may be many things happening at once of which you or the audience are not aware. Do not use it as an opportunity to rehearse one more time that long soliloquy or block that complicated scene you didn't quite finish in rehearsal; be prepared to cut straight to the next point that involves a technical cue.

Q – ... and for the Dress Rehearsal?

Emma – This should run as close to a show with a paying public should run. The technical rehearsal should have ironed out any possible problems, so avoid any stoppages to the dress rehearsal (unless things go drastically wrong or there is the possibility of danger if you proceed), and deal with errors afterwards, just as you would do in the case of a full show. This is also an opportunity to establish who gives clearance at the top of the show, i.e. who indicates that the audience are seated and the doors closed (if relevant to your performance), how the house light system operates, and to eradicate all possible light leaks and spills that may compromise your show.

Of course, it may be that you do not have the luxury of time that will enable you to

schedule things so formally. Be prepared to adapt, to have a technical/dress rehearsal as one if necessary, and if you are unlucky enough not to have much rehearsal time of any sort you (and your technicians) will be thankful for your foresight in preparing all those cue sheets in advance …

Q – Are there any legal/insurance issues the artist should know about?

Emma – Make yourself aware on arrival if not before of meal and other breaks required by the crew. Infringement of breaks is strictly forbidden in some countries, but is entirely flexible and dependent on the goodwill of the crew in others. Be aware of cultural differences; crew in some countries will find a three hour lunch break entirely normal but will work late into the night without clock–watching, other countries will have crew that work to the prescribed minute and infringement may involve financial penalties at the very least. Similarly it largely depends on which country you are working in as to whether crew members multi–task or are restricted to one task only. Make yourself aware and don't abuse the local working practices.

Flameproofing – any specially constructed set will have to be flameproofed and may be tested by any licensing authority (holding a naked flame to the fabric/wood). This is simply done by spraying the set/set dressing with a specially formulated product readily available from general theatrical suppliers.

Electrical safety – if using any electrical equipment of your own you may have to prove it is electrically safe. Portable appliance testing is often requested and required by some venues, and although there may not be any enforceable legal requirement it is worth informing your venue's technical manager of any props or equipment that require electricity, and inquiring as to the venue's policy regarding the same. Anything you hire should be tested by the hire company prior to dispatch.

You will be required to demonstrate any potentially dangerous aspects of your show to the local licensing authorities; be aware that you will have to carry spare pyrotechnics/consumable props if this is the case.

Obtain valid parking permits for the venue.
Ensure your equipment/possessions are adequately insured.

If working at height or particularly in any position that may endanger members of the public, for example, directly overhead, you must ensure that you are covered by public liability insurance. This is to protect the public, you, and also the venue. Inquire of the venue if in doubt.

Q – Any last minute tips?

Emma – You should by now know enough basic terms to manage perfectly well when communicating with venue technicians if you are not touring with your own technical manager or technician. However, technicians will refer to lanterns, microphones, gel colors (or in fact most anything they work with), by what often seems to be a code designed to exclude and confuse. Speaking in trade names, makes and numbers is for brevity and accuracy, we just sometimes forget to revert to normal speech when speaking to non–technicians, so if in doubt ask. Don't be intimidated and remember terms will change a little from venue to venue; while technicians can often translate between themselves, there is no need for you to expect to do so yourself.

Sources of information and advice can include your local college or university drama department, especially if they have a functioning performance space as they will often employ professional technicians to assist in productions. Consider also approaching local theatres, presentation companies, or technical hire companies. Numbers can be obtained from trade magazines, from theatres' own contact lists, from websites. Ask for advice or contact numbers from fellow performers, theatre companies, community arts projects, or from the technical manager of your venue.

If in doubt over any issue connected with your performance in a venue, ask the venue's technical manager in advance. They would rather deal with potential problems before you even enter the building. Be aware that they will often be working on shows and difficult to reach in person, so try to contact well in advance and make a clear and coherent list of your queries to avoid repeated contact, and preferably by email or fax; memories of verbal agreements are notoriously fallible.

There is no secret to a technically professional production; it is simply a question of thorough planning, ensuring the venue is fully informed, arriving with the clear and well prepared information and cue sheets, and being flexible enough to accommodate loss of time due to unforeseen technical difficulties (and you will have those at some point, it's the nature of the job). Once you have all those aspects covered you will have to hope the venue equipment is well maintained and that you have technicians and crew who are competent and professional; it may not always work out as you may have hoped but you will have done all in your power to ensure your performance runs smoothly. However, a good theatre technician will do all they can to facilitate your work; they will want it to look good, sound good, they will want the performers to feel confident enough to be able to focus on their own performances, and they will take pleasure in operating a technically faultless show. And you will be able to relax in the knowledge that you can hand over certain responsibilities and concentrate on your performance. And, hopefully, you will enjoy your work.

Zara Waldebeck, Film & Video Production

Q – What are the most important elements of a successful shoot? What does a person need to be thinking about to get it right?

Zara – German filmmaker Werner Herzog once said that shooting films is 'athletic not aesthetic' – i.e., that once you are in the hectic production period it is hard enough to just get things 'in the can' (or in the box if you're shooting on tape) so all your good intentions can easily go out the window. This is a very common experience – you start out believing you will make the best film ever and end up hoping you will just make a film.

This is why it is so important to PREPARE. Because when you actually come to shoot, what you really want to be doing is not thinking about all those stupid little practical things, you want to CREATE. That is why we are working all those long hard hours for no money hiring hugely expensive gear, right? So once you start shooting, the filmmaker should preferably not have to think about reality hassles (that is the production personnel's job) but concentrate on the reason we are all there – to make a good piece of work.

Like most other art, this is about doing everything you can to 'be in the moment'. There is a paradox at the center of this: the more preparation you have done, the more flexible and open you can be on the day. Shooting isn't just about following your storyboard or script slavishly; it is also about using what presents itself on the day, taking chances, making last–minute changes, seeing something new you hadn't thought of. The better you know your material, or the focus of your work, the better you will be able to judge in a split second (you often won't have more) whether this might or might not be relevant to the piece you want to make. Once I lost my director's notebook on the second day of filming – all my preparation and background about various ways to direct the actors, develop the scene, visual variations. All gone. But because I had done the preparation, it was in my

head and I had the confidence of knowing that. So I just let go and found it left me more open, forcing me to just stay in the 'there and then' with the actors and not constantly refer back to previous thoughts.

Shooting is a precious and intense time and everything should be done to help you capitalize on that time as much as possible, to use its spontaneity and unpredictability and be in that moment, being open to change whilst knowing what you want. You have to be organized and focused for a good time beforehand. Personally, I also like to work in as pleasant an environment as I can – some people thrive on support, others on conflict. I like everyone to be as happy as possible and try to look after people so they enjoy themselves. However, this is not the most important thing in the end. Think about it - if people hate you for keeping them working all night but in the end the film is ten times better for it, then what will most people remember? The latter probably.

Having said that, I think it is up to you as the filmmaker/videomaker to ensure you get the maximum creativity out of all your collaborators – this is a collaborative art form. The crew should all be working together, supporting each other, and, furthermore, they should all be working on the same film! That is, the main creative personnel should all have reached an understanding about what the main objective/theme/focus of the piece is, and use their expertise in their special area to help pull this off.

As a director, I wouldn't 'pull rank' unless absolutely necessary, though I would remain focused and take responsibility for all decisions made. Sometimes people get so caught up in the stress of shooting that they totally forget they have all these people working for them, often for free. I'm not saying it should be all sweetness and light, but if you are better prepared, both in terms of being focused on your material and able to deal with pressure, then you should be able to make a film and be reasonably inoffensive to your co–workers. I would say this simply includes:

- feeding people regularly;
- keeping them warm and dry;
- informing them of any major changes to schedules;
- not losing your cool;
- not taking out frustrations on cast or crew.

Always remember that you have chosen to do this; you are ultimately responsible. You are always free to walk away, so if you don't then that is your choice and you have to deal with it.

Q – Do you notice any common pitfalls amongst artists new to shooting film and video?

Zara – Depending on the background of whom you ask, you'll get greatly varied responses. As a director I talk mostly about creative issues. Pitfalls to avoid:

Not preparing enough, both in terms of development (knowing what the project is about and how you will communicate that) and PRE–PRODUCTION, i.e. making storyboards or shotlists, realistic schedules that are more or less followed, making sure you don't shoot too much or too little stock and having an understanding of how the images you shoot will cut together, recceing a location properly. Staying focused during the shoot and not becoming too stressed. Dealing with stress and pressure is an important skill to hone.

Being too quick to get the camera out, being seduced by it. Sometimes the last thing you need on set is a camera, strangely enough, maybe you need to just look first, get your actors/subjects relaxed and settled, 'create a space', be it physical or mental. People are often too quick too assume it is only when the camera is rolling that something is happening.

Once the rush of shooting is over, a) realizing you might be on a downer for a while, simply in terms of 'energy' and that that's OK, and b) that it's almost essential to take some time away from the project and do something totally different. Don't even think about it for a couple of weeks. Then come back and spend a fair bit of time logging and doing a paper edit – you don't need to go into the (possibly expensive) edit suite straight away. Take some time to really look at your rushes and see what is in front of you and what you might do with it. Once you're in the edit you can then play with those possibilities.

Another hugely important thing is to not try and shoehorn your original intentions with the film into the edited final cut. Maybe your rushes present a totally different film; this can be a magical process when you suddenly 'view your unconscious' as it were, and realize you were trying to do one thing and actually something else came out, and it takes courage to go with this new thing sometimes.

Or maybe shots or sequences aren't working the way you thought. Maybe the structure needs drastically rearranging. Be bold; if you are stuck it can help to do totally the opposite, however mad it seems. I think it was David Lean who once said that if something isn't working in the edit, throw away that which you love most. Sometimes you are hanging on to shots that aren't right any more, perhaps simply unbalancing the rest. And that's the other thing in the edit: you have to learn to be ruthless, to chop stuff out however hard and long and expensive it was to shoot. Good intentions do not make a film – only ever keep it in if it works. Obviously it is to a certain extent down to style, but a lot of new filmmakers are too 'verbose', that is, they haven't learned to say things concisely (and thus often much more powerfully). There is a saying that being a good writer is less about what you write and more about what you cut out. This can also be applied to the editing process.

Sometimes novices think editing is just sticking the bits together and forget it is a creative process. The fact that things might not work as you thought they would isn't necessarily your downfall as a filmmaker (though it could be) but part of the process. If things didn't change in the edit, it wouldn't be creative, just a purely operational, technical part of the process.

Q – What about pitfalls in translating work from live performance to film or video?

Zara – People often try to squash one medium into another, without re-thinking the performance in light of the needs and possibilities of that new medium. The first thing to do is to ask yourself the questions: 'Why are you even thinking of translating it? Is it the right thing to do? Will it become a different piece of work in the process – should it?'

One of the most crucial differences between different media is the way the audiences experience them, and what this means for the interface the artist wants to use. Time can be a factor – are the audience able to go back and look at it again (interactive) or is it linear and out of their control? Is it a 'committed' audience, i.e. will they work hard at engaging with it or does the piece have to work harder at reaching them? At a live event people often pay and come to see a piece specifically and sit in their chairs from start to finish until it is over - not so with an installation that someone may come across accidentally. What will all this mean for the new transmogrified piece?

It is also worth remembering that in live work, people can look wherever they want, even at many places almost at once, and see relationships between various physical elements. Film and video are linear and also highly directed – though people can look where they want in the frame, you are choosing very specific areas of the 'stage' for them to look at. So you are representing the work much more, and should have a very good understanding of the grammar of the shot and the edit to make sure you are telling the piece in the way you want.

Q – Take for example an installation artist who is talented in spatial composition or a company talented in devising for theatre – what new vocabularies or methods would you suggest as helpful for them to learn if they want to try their hands at film or video production?

Zara – Learning the 'Grammar of the Shot' and the 'Grammar of the Edit'. They should keep firmly in mind that having experience in a different art form means that they can hopefully bring a wealth of new exciting methods and sensibilities to film or video. 'Video', for example, can mean a linear one–screen piece, an interactive website, a DVD, a CD–ROM or a multi–screen piece. The possibilities of interdisciplinary work excite me –

as long as people make an effort to understand the medium, the fact that they could bring new dimensions to the work is fantastic. Hopefully, the more they understand their own medium, the more they can find bridges between it and film/video. 'Creating space', for example, is a familiar concept, though in film as opposed to installation you cannot do it literally, since you are limited to two dimensions (though the frame also has depth). A film maker can experiment hugely with sound in creating a totally new dimension, and also, as we are talking about single–screen linear here, a director can use time, pace and rhythm to create an emotional space related to what they were interested in exploring spatially. It is all about not trying to repeat the same thing, not trying to make a new medium fit you, but evolving the piece into a new shape, which of necessity sometimes means losing elements and adding new ones.

Q – I've heard you say that you think sound design is the most commonly neglected aspect of low budget films and videos. Can you suggest any strategies for improving sound design in art videos – strategies that don't rely on having the money to hire a professional studio and sound editor?

Zara – In my experience it is the dub or mix that is really expensive. It is also what really cranks up the quality of the sound. So, if you can't get a dub, what can you do? Nurture contacts. Get to know a sound designer/editor and develop a working relationship. If you can't find people to work with on this, do a lot of reading on sound design, watch a lot of good films and pay attention to how sound is used. If you can't afford professional help, then try to afford the luxury of TIME – give yourself as much as possible when working on the film, try out stuff. You can tracklay on FCP and other home editing suites pretty well, so even if you can't get perfect levels or surround-sound, etc, you can still create a relevant soundscape. If sound quality is good, then audiences are a lot more forgiving about image quality.

Just as you have to practice to become good with the visuals, you have to practice to become good with sound. Allow it space, allow yourself to think about it, to play with it. What will happen if you remove the diegetic (belonging inside the scene) sound completely and add another unnatural one instead? What if you loop it or doubletrack it? What if you play around with volume in relation to pace? Sound is much more immediate for the human being, and not as in need of interpretation as the image. There is so much interesting stuff that can be done with rhythm, timbre, contrast, or collusion with the image. And it is all a lot cheaper than filming. Perhaps a good exercise would be to have a short film, made up of only five or six images and create three totally different films just by changing the soundscape. Or, you could go even further and just have one image ongoing for a couple of minutes and simply work on the soundtrack and experiment with how it impacts the image. This is a relatively cheap exercise but one that really forces you to focus in on the possibilities of sound without the need for fancy expensive gear.

Without going into too much detail and theory here, all I can say is that there are huge amounts you can do just by getting interested in sound and paying it attention. It is not just about music, it is about soundscapes in general (including silence) so even if you can't have someone creating it all for you, get a DAT recorder and go out and have a field day.

Q – For artists working on modest budgets do you think it is it better to rent production and post–production equipment or to try to buy equipment?

Zara – This is a thorny one which depends on each individual situation. Where do you live and who do you know? Personally I have found myself in a situation where over the years I have exchanged various kinds of labor (all reputable!) for use of gear, so I have got myself into that kind of routine and not felt the need to purchase too much myself. It is rare that I pay full whack for hiring equipment. I have worked voluntarily for media places, facilities houses, helped out on other people's films in exchange for their labor, shamelessly utilized and bled dry all my contacts' contacts, etc etc. If you can get into some kind of group and buy together, I think that's a great way to go, especially if you can also hire the gear out at modest rates to others. There are absolute positives to having your own gear, especially if you are shooting staggered dates. It means your gear is always available for you when you need it, and this has been one of the most infuriating things for me in getting cheap deals or favors: that you often get shunted to the bottom of the queue. If a paid job comes up you can get canceled. So yeah, in that way it'd be great to have your own gear like a good DV cam and a FCP suite.

Q – Is there particular hardware or software that you would recommend as essential tools of the trade right now?

Zara – Well, a lot of people are buying Final Cut Pro, a work station and a DV cam. There is a lot of good stuff out there getting cheaper by the day. As for what camera, ideally something with a good lens with ability to set exposure, etc manually, for example the Canon, so you have as much control as possible.

Because I work in both film and video and the industry is changing very rapidly, I have found myself going down a different route, which is nurturing relationships with people and institutions I can barter with rather than buying outright. I have chosen to pump the money I have into actually making the film rather than buying the equipment (costs such as stock, food, accommodation, travel). It all depends on where you live and who you know – it's fine if you are ten minutes away from Soho but if you are in a different part of the country, maybe there aren't any edit suites nearby and a FCP would be a great buy. I have a scanner, and a laptop computer which I think is essential, and though I can't do all the bells and whistles stuff on it – editing, post-production sound. I can write scripts (I use Final

Draft script writing software), create websites, access the Internet, create postcards designs, handle the paperwork, etc. The downside with buying hardware and software is that things invariably drop hugely in price just after you've bought them, and they become obsolete after about two weeks of purchase. This of course doesn't mean you can't use them, but it is still infuriating.

Q – DV seems to make everything cheaper and more flexible, but does the quality really hold up? If you shoot on DV, can the image hold up on a cinema screen?

Zara – Well, there is much debate about this and it depends on various factors. I would say, yes, DV does hold up on cinema screens in essence, as we have seen with the Dogme and Mike Figgis films. Audiences are getting more sophisticated all the time and used to seeing an awful lot of varied styles on TV and at the cinema and the gallery, so I think in general they don't have a problem with it. There are technical issues here, such as drop–out and pixellation, but if you are seriously concerned about these issues in relation to a particular project, you should speak to a cameraperson.

A lot happens to the image either in the grade or the telecine process, that is, making the DV image look better on film. I must say I'm pretty cynical, however. Commissioning bodies and producers say they love DV, but often, when it comes down to it, if they have a choice between a cheap DV and a glossy 35mm film, they'll go with the latter, whether the story is any good or not. There are, of course, many exceptions to this, but this is the reason I have stopped shooting things on DV – for the moment anyway. It is largely a question of distribution – if you are doing it for your own performance work rather than trying to get TV people to buy it, the film/DV debate matters less. What really matters most is to engage your audience.

Often when people shoot on DV they treat it haphazardly. DV can look great if and only if you treat the shoot like a 'proper' film shoot, that is, take your time to light it well and work out the shots. A lot of the time when DV looks crap it is not the camera's fault but a result of the working process being too slapdash. Since these cameras are so easy to operate, 'point and shoot', people don't take enough time to think about what it is they are trying to do or learn more about doing it. It is not just about light and framing, but about understanding how stories work on a bigger screen as opposed to TV.

A lot of the filmmakers who have made DV features are established, experienced directors. This means a) they know how to make films and b) they have the right contacts to do it properly. The Danish Dogme films were not, in general, cheap films to make even though they were shot on DV, and they certainly weren't quick, either. This is a common misunderstanding. They were actually produced and directed by people who had made many other films before, who had learnt the rules before they broke them, and who had

backing to enable them to do this. In the making of both *The Idiots* and *Festen* a long, long time was devoted to establishing the director–actor relationships through improvisations and creating a 'cast community' over many weeks. This kind of relationship-building can be time-consuming and expensive to do, but ultimately, as is often the case with documentaries, can pay huge dividends.

Q – What would be a guesstimate for how much money if would cost an artist to transfer a ten minute short from DV to film?

Zara – I'd suggest phoning up various telecine houses to get real quotes for specific projects. It differs depending on whether you want to blow up to 16mm or 35mm, and then there are a lot of editing issues that suddenly come into play, i.e. titles in any style other than black on white or the other way around – fades, dissolves, mixes and digital effects – all become incredibly expensive.

There are two ways you can do it: blowup either from created print or final master. The latter is what I would recommend, that is, finish everything on the DV tape first and then just blow it up from that. This way you don't have to pay extra for effects, dissolves etc, as it is just making a visual copy of the film and not an actual one (i.e. recreating dissolves physically on the film). There is also the question of grading – often they say it is better to blowup an ungraded online to film and then grade the film version rather than blowup the totally finished tape grade. Of course, this means more expense ...

Q – What would be the ideal crew for a location shoot?

Zara – Though there is a standard that is derived because it is useful, each project, just as it has its own style, might need its own working practices. You might have to shoot very suddenly and can't get hold of a big crew. You might want to shoot very quickly and unobtrusively and a big crew would defeat the purpose. Or you might simply not have the money or the contacts to fill all the positions.

The crew you need to assemble depends on whether you are shooting drama, documentary, art installation, etc, so the points below are guidelines to be adapted.

On my first proper DV drama shoot, lots of people had two or three functions, one main and another smaller one. This happens a lot on low budget shoots and there are pros and cons to this – more manageable, movable, less expensive crew; more possibility for things to go wrong. I think in general the crucials are:

- Director/producer. That is, one person or very close–knit team with the overall view to pull all the elements together, to make the final decisions, to understand how the whole will add up to more than the sum of its the parts. Of course, there can be creative partnership, but there has to be one clear voice directing the action.

- A cameraperson. Someone who really understands framing, light and lenses, etc, someone with a well–developed 'eye', and again someone who can bring a fresh vision to the director's so the director is free to look at what is unfolding and not be tied to trying to catch everything through the lens.

- A sound person. Poor sound quality is one of the worst offenders in low budget work. Since sound is mainlined directly to the brain, audiences tolerate poor picture quality with good sound much better than the other way around. So a good soundperson dedicated to listening out on set is really worth their weight in gold.

- A production person of some kind, preferably production manager. Someone to keep tabs on all the practical stuff: catering, weather, transport, maybe even props, the schedule (if you don't have a first assistant director). I cannot stress enough the importance of regular and good catering – feed people well and they will almost do anything for you! If really pushed for numbers, then the PA can also double by chatting to the cast (actors or documentary subjects) if needs be; keeping location people happy, etc. You really also need a runner to help – someone just to gofer everything so the PA doesn't have to leave the set.

- If shooting a drama or anything out of sequence, a continuity person is essential, especially as they can also keep a shot log and give you advice about crossing the line, coverage, etc.

- If you are using lights and track, you need a spark and a grip.

- Also, if you are shooting a drama, you really need a production designer to make the frame look as good as possible. The triumvirate of production designer, director and director of photography is essential in drama, however low budget.

In some documentary instances you may just want one or two people, maybe even a director shooting their own stuff on DV and using the camera mic. It all depends on the circumstances and the scene. As a rule of thumb, however, I'd say a crew of four to five people is the minimum you need, just because there are always a million things to do. I take it this is all shooting on DV – if on film, the crew grows larger as you need clapper/loaders, focus pullers, possibly cam ops etc.

Q – And what would be the ideal crew for a studio shoot?

Zara – The same as above, bearing in mind your location is static, so less running around and keeping traffic and bystanders at bay; fewer catering, toilet and transport issues. In a studio shoot, you might be more likely to have lights, so a spark or camera assistant is essential.

Important issues on set shoots are:

- Is there enough space to create the frame/depth of field you want and still fit camera, lights and crew in?

- How loud or silent is it, any regular noise problems?

- What is the access like, for example if having to cart loads of equipment? Is there nearby parking available?

Q – But some artists achieve fairly amazing results just shooting on their own with a tripod, right?

Zara – Absolutely. When it comes down to it, what is the point in hankering for idealized situations and top–of–the–range equipment if you can't have it? Better just to be working, keep exploring your creativity and getting to know yourself, your working processes and

your equipment better. New film/video makers should understand that on location, in a studio or in an edit suite, the most essential equipment they have is their eyes and brain. OK, so with better equipment and more money you can often do greater things and it can be really frustrating to work around limitations, but the most important thing is to have something to say and find the best way to say it. And for that you don't always need loads of money – in fact it is often when you have less money and less 'stuff' around that you can be the most creative.

Of course there are those situations when being alone with a tripod is essential to getting the material, being unobtrusive, intimate, spontaneous. It all depends on the project. In the past, I spent a lot of my time procrastinating because I told myself that if only I had the right circumstances or equipment then I would be making that perfect film, and that just isn't true. I would advise anyone new to film and video production not to worry about making the best film in the world the first time round, but more importantly to just do it. Then, hopefully you will be in a situation to actually use the best equipment to much better personal creative effect when it does present itself.

Q – What's the most important thing you've learned in the last three years?

Zara – Keep doing what you want to do, because otherwise, really, what's the point?

Ian Grant
Digital Production

Computer based digital technologies can provide an exciting environment for the production, dissemination and reception of text, image, sound and vision. The computer can be an environment, a space for performance and yet the same technology can also be coolly observed as a tool: applied in assisting administrative, promotional and artistic tasks. The answers below cover a range of issues from print, scanning and images, the Internet and website construction, audio and video production. Where possible I have only provided links to well established sites that have achieved some sense of permanence and have referred to the generic name for software packages. Reading about Photoshop 4 when Photoshop 7 is available is strangely nostalgic.

Q – **What is the best way to save digital images when you are sending them via email for a print publication? Is this different if you are sending them** for a website?

Ian – It is a digital designer's principle never to save images in a format that 'compresses' the data until it is necessary. Uncompressed files are huge – containing all the data (information) for color and shading nuances, and orientation for each printable dot. Often used graphic file formats – GIFs and JPEGs – compress the image data mathematically to make them convenient to use on slow machines and on slow modem email connections. One day images will not need to be compressed – all Internet connections will be superfast at the speed of light. Compressing data loses quality.

When images print, printers (primitive technology, under–evolved and prone to real world shit) need as much information as possible to print the best quality

236

images. Print compressed images, like a JPEG, and they will print looking like eighties knitting patterns, chunky. The file formats TIFF, PICT, or PSD (Photoshop Document) and many other formats, can be saved with no compression, i.e. less loss. These will help to maintain printability.

The main measurement of image resolution is Dots–Per–Inch (DPI). For print, as a rule–of–thumb, 300 dpi is big and good for color. 150 dpi is good for black and white. But please ask your printer what DPI will be best. It varies from printer to printer. Larger DPIs are slow on even modern computers and are often unnecessary.

For the world–wide–web, small, compressed images are the standard. Bigger image files means more cups of tea while downloading. 72 DPI is a standard for the resolution for web pictures. Your graphics program will give you the option to save files at this size – optimized for the web. It won't be long before our web and email connections are faster so it won't matter what the size image is.

But at the present time, always email previews to clients as 'low–res', compressed files (JPEGs or GIFs) then send the desired print orientated files as hi–resolution TIFFs or PSD files only if your band–width allows. Always give your files on ZIP or burnt on a CD to the printer in person if your modem is old and slow … or fed–ex copies of your disks if your budget allows.

Q – Which is best, PICTS, JPEGS, or PDFs, and what the heck is the difference between them? When to use which?

Ian – There are many, many graphic file formats – each slightly different because of how they compress the image information and dependent on what computer platform they emerged from. For further information about graphic file formats visit: www.lemkesoft.com, the site of the great program, Graphic Converter.

For the web, small is beautiful, hence compression. For print, large is beautiful. PICTs, TIFFs, hence uncompression. Of course, this all depends on what size (resolution) your original images were scanned and what computer you use. Apple Macs love PICTs and nearly any graphic format is natively displayed. Windoze machines do not. Anyway, it is crap to expect an image from the web (low resolution) to print at a decent resolution. There simply will not be enough data to print well. Although with the right software, Photoshop, you can resample print resolution images for the web. First: scan for print. Then: redeploy that image for the web. This way, the same source image can be used for dual purposes.

PDFs: this acronym refers to Adobe's Portable Document Format (PDF). This is a file

format that can contain nearly any graphic format (hi and low resolution), text and internal bookmarks and hyperlinks to other documents.

It is used to:

• layout and print for high quality books
• distribute online or CD–Rom low–resolution content with images, text and hypertext
• produce documents that can be read on most computer platforms. Mac, PC, Linux, Unix, Solaris, etc.

You will most commonly meet PDFs as downloads from the web. You can read them offline with Adobe Acrobat Reader 4 or5; and they are predecessors for the e–book.

If you want to make and produce PDFs buy any of the following software: Adobe Acrobat, Adobe Indesign, Apple Mac OS X. Soon, PDFs will be the de–facto on–computer screen and print format. With appropriate settings PDFs will 'print' to your computer monitor or to the printing press.

Q – What approach should I take when scanning images for print and for the web?

Ian – I remember when people loved the blurry images you got at office parties after photocopying your ass on the office copier – when you had to move in sync with the moving glass photocopy platter, and I remember when you could wobble your original image on the glass while scanning to achieve near–stunning art–morphs and image twists. Lets not forget the recent phenomenon of 'fax' art. Why am I writing this? Because worrying about print resolution and color fidelity do not guerilla art make! Should a guerilla worry about the 'science' of scanning or worry about applying exciting new digital tools for creative uses they were never intended for?

You can buy scanners for under $50 these days and other models for well over $5000+. The main differences are:

• Optical or scanning resolution
• Color fidelity
• Original media handling, for example small to poster size, matt or reflective surfaces, text, slides, transparencies.

All scanning machines get external stuff into the digital domain – onto your computers to be played with.

If you really want to join the (ink) jet set and operate at industry standards you should think of spending a little more for a scanner. Scanning for print is supposed to be an art in itself and the tedious amount of detail about dots–per–inch, color matching and file–formats may make the average guerilla sprint to the local print bureau. Don't be frightened into this. Check out the perceptual differences in a sad computer magazine between expensive and inexpensive scanner output. If you do not really care about subtle shifts in image hi–lights, low lights or hard and soft focus, stay in and scan at home.

If you want to (ab)use your scanner with liquids, foodstuff, leaves and other worldy objects, buy a cheap one.

If you want to scan images to project during performance and they will never be printed, the most inexpensive scanners should do the job. Video–projecting is an inexact science and most scanned detail: color fidelity, focus, etc will be 'transformed' into skewed, wobbled, light–satuarated images when projected anyway.

Q – How can I send a large document of images via email without it taking ages to download?

Ian – Don't. Deliver your files on ZIP disk by hand. Or get a fast ADSL or cable connection. Such connections will be available more widely soon in England, if we are to believe BT! Until fast connections arrive all big sends will grind your Internet connection to a halt and piss off the person you send them to. When ADSL is standard in the UK, we can send any stuff we want very fast. Make sure your client shares the same technology or slowness may prevail.

If you really need to email a print–resolution image to someone, make sure you compress the image file with a file archiving utility such as Stuffit (from Aladdin systems on PCs and Macs – www.aladdinsys.com). This will reduce the email's size a bit.

Q – What is the best and by that I mean EASIEST web software for making a site? Where can I get it from?

Ian – There are two main choices when it comes to self–authoring websites:

Construct a web–site automatically via another website or non–dedicated software.
There are some online services (for example, www.zy.com) that will generate cheap, quick and cheerful websites (normally photo–album sites) from a folder of images you need to upload. Some applications, like Microsoft's Word or Adobe Photoshop, will output your documents and images as HTML (the code of the web). Photoshop can automatically generate a image portfolio site. With this approach, you have little to no design freedom,

but it is quick and easy. Have a folder full of images, click one menu choice in Photoshop and voilà! One portfolio website ready to upload.

Make a web–site using industry standard authoring software
My preferred option. At first buying the software will be expensive. Solutions such as Adobe Golive, Microsoft's InterDev and FrontPage, and Macromedia's Dreamweaver (www.macromedia.com) all do a similar job. Of these, Dreamweaver gets my vote. It is cross–platform (available for both the Mac and PC). It is simple yet also capable of authoring the most current complex content. It can perform what–you–see–is–what–you–get (WYSIWYG) page layout editing and supplies you with the excellent O'Reilly's reference dictionary of HTML online. So you can drag and drop images easily onto pages, and when you get a little more familiar and ready to advance your knowledge, Dreamweaver can assist as an HTML learning aid. The HTML Writers Guild is an excellent source of online information about new web developments and can be found at: www.hwg.org.

The barest minimum suite of software needed is

(a) an image editing/creating package – photoshop is favored, fully featured but a bit expensive. There are shareware alternatives;
(b) a text editing environment to write the HTML code, your computer already has this, but you need to learn HTML; and finally
(c) a file transfer program (e.g. CuteFTP, Fetch, or Interarchy) to move the HTML files and images to a computer that is permanently attached to the Internet (a server).

Luckily, Dreamweaver takes care of (b) and (c). It is so easy to use. It does its best to hide you from the complexity of HTML. You do not need to know about HTML to use Dreamweaver. Check out www.macromedia.com. You can purchase online or get a good price via mail–ordering from a computer magazine

Q – What do I need to make Quicktime movies?

Ian – You need
(a) Digital video **source material** from either:
a digital video camera;
a VHS source (camera, video cassette, or TV) that will be converted, through your computers video card; or
pre–existing Quicktime movies.

(b) **A suitable computer:** I recommend the latest Apple Macintosh G4 machines. They have the input connections for digital video (known as firewire) and excellent software

options – free iMovie and it is the only platform that can run Final Cut Pro 2 (see www.apple.com). The latest top–end Apple Mac G4 models have DVD and CD burners built in! Input and edit your video material into you computer and output to DVD. This is very impressive. Especially under $4000. If your budget doesn't stretch, a special edition iMac would be perfect!

(c) **Software**. Quicktime comes pre–installed on Apple Mac computers. Most windows users need to download it. It is free, but if you want to use the Quicktime environment itself to edit movies you need to purchase a Quicktime Pro key from Apple for $29. Quicktime is currently at version 5 and there is more to it than movies. Virtual Reality (VR) environments and objects and interactive movies can be viewed with Quicktime.

There is a range of software that will allow you to edit and output Quicktime movies. Adobe's Premiere is a popular choice, quickly being out–stepped by Apple's Final Cut Pro. These are complete non–linear editing suites and are very high–powered. And expensive, running into hundreds of dollars. I use QuickEditor. This is a very elegant piece of software QuickEditor is available for the Mac and Windows (95/98/NT) computers with QuickTime 3 or better, and is priced at $35. (see http://wild.ch/quickeditor/).

When making Quicktime movies it is important to ask where will your Quicktime movie play? On the web, from a CD, on DVD or on VHS? Movies can make really huge file sizes and again, like images, need compression that balances quality with file–size. See http://www.apple.com/quicktime/

Terran Cleaner 5 from Media 100 (www.terran.com/products/cleaner/index.html) – formally known as Media Cleaner, easily allows the conversion, re–purposing and compression of existing digital video files to many targeted uses.

Q – Do you know of any good set design/costume design programs?

Ian – For 2D artwork, 'Painter' (www.metacreations.com) emulates natural media like airbrushes, paint, chalk, pencils, etc ... and with a Wacom (www.wacom.com) digitizing tablet and electronic pen you'll soon have a very clean digital artists environment.

For 3D work, the learning curve is steep, but photo realistic visualizations of 3D layouts and environments are possible with 3D Studio Max (PC only), LightWave 6.5 (www.newtek.com), and the even the lower end 3D packages like Cinema 4D.

Q – How can I get my website picked up by a search engine?

Ian – If you are patient and have time, visit as many search engines that you can think

of and manually follow the links on their pages to add your URL to their database. The main search sites are altavista.com, excite.com, lycos.com, aj.com and google.com. This is an effective but time consuming way to register your site. There are some online services (such as !Register–It!) and cheap software options that automate the submission of your URLs process (download 'DumpTruck', or look in the Internet utility section at www.download.com for other alternatives.)

There are deviant – not guerilla – methods for bombing a search engine with multiple references to your site. Like by putting loads of irrelevant keywords to'meta–tag' the HTML of your webpage. Search engines look to these tags to index web pages. This is really frowned upon.

Q – Any top Internet addresses for free or cheap downloads?

Ian – www.download.com is an incredibly thorough resources for 'freeware', 'shareware', demos of commercial software and updates for your current software. It has a customer–review section and clear stats about the most picked software.

The web pages of your operating system manufacturer will often have free–downloads. For example at www.apple.com, you can download iMovie, an elegant Quicktime movie editor, iTunes (see the cool TV ad campaign), a piece of software that will convert audio tracks into MP3 (an excellent music file format), and allow one–touch 'burner' of music and sound tracks to compatible CD–Burners.

Q – What is motion capture?

Ian – A number of performance artists and dancers have already utilized the promise of motion capture technology in documentation and in performance. What it is in a nutshell: in a big room multiple cameras are trained on a performer. All over her or his body the performer wears 'emitters' or special reflectors. The software that powers the computer 'triangulates' all of the data it 'sees' from the emitters and produces a file, a motion file. A bit of jiggery–pokery later, and the computer operater can apply the 'motion capture data' onto any computer generated 3D character. Commonly used for animating fight moves in computer games, motion capture has had prominent applications in teaching dance and documenting choreography. Examining movement with motion capture leads to an interesting deconstruction of gesture, balance and movement.

The software 'Life Forms Studio' (from Credo Interactive) is available as a demo and worth a look. See www.lifeforms.com: 'Life Forms Dance' is a product marketed as 'the choreographer's choice, this comprehensive stand–alone package for dance now dance tutorials'. Motion capture files can archive gesture and movement in 3D virtual space.

For the guerilla performance artist there is precedent for live performance interaction with motion capture systems. A performer will move, real–time live–capture data will be turned into projected video imagery, imagery with motion, shape, rhythm and impulse. The performer will respond to the computer–generated response. And the cyborg tango was born.

Q– How easy is it to work with motion capture?

It is still a specialist activity and motion capture studios charge accordingly. The cost of the kit is on a downward spiral and software such as 'Life Forms Studio' brings the application of other people's motion data files into reach of the 'desktop' or the performance studio. Universities with computer research strengths are likely to be interested in the fusion of motion capture work with the work performance artists, and it is in this domain the guerilla performance artist is most likely to encounter the specialists in 'live' and real time applications of such technology.

Q – Do you have any tips for live video streaming?

Ian – Most of us use the Internet with the status of 'clients'; other specialists host features of the Internet, such as video–on–demand or streaming video, and are as such 'servers' of content. When the culture of Internet connectivity is fast, broad–band (i.e. not telephone modems) and always 'on', we clients will also become 'servers' of such specialist content. As it currently stands, specialist companies mostly handle 'serving' content.

Streaming video is so–called because the end–user does not have to wait for a whole movie to download – a very long process on slow connections. The server delivers the movie in (near) real time. The standard Internet formats for streaming movies are, in order of penetration, RealNetwork's RealVideo and Apple's Quicktime.

Authoring 'streamable' movies is relatively straightforward. For example, take an original, large, high–quality Quicktime movie, and output it compressed for streaming from your video–editing software. Adobe Premier 6, Final Cut Pro 2, QuickTime Pro can all output compressed movies ready to upload to a streaming 'server'.

You may have noticed that I have focused on how existing Quicktime movies, pre–recorded content, can be compressed and streamed from an appropriately set up server. LIVE video streaming of high quality video is still an expensive process, where 'on the fly' video compression and encoding from the in camera image to sendable digital formats is handled by expensive hardware compression.

But, for the guerilla artist a tip from the online porn marketeers: who needs high–quality live video streams when low–quality video from 'web–cams', i.e. a jerky refresh rate of two frames per second, satisfies an audience? Web–cams and the appropriate streaming software are available very cheaply off the shelf at nearly any computer store.

Q – What do you think is the most essential gear an artist should invest in?

Ian – This is an expensive wish list, but as the cost of digital equipment is always coming down, cheaper stuff can always be found.

Computer Hardware: not wanting to start a fight, Apple Macintosh computers kick ass! Traditionally assumed to be for the 'creative' – a kind of meaningless statement, really, because most creative software applications will run on PC as well. Apple always innovate and are consistently producing software and hardware to cope with any multimedia artist's needs. Apple's recent step into introducing DVD authoring capabilities on a desktop machine at 'pro–sumer' prices is a sign of this commitment to creative applications. The recent DV iMac range is enabled to import digital video direct from digital video cameras. These machines represent really good value.

Imaging Hardware: a scanner, a digital still camera, a digital video camera, a video projector would provide a good set of the image producing and outputting tools for documenting performance work and usable in performance.

Software: A scary realization for anyone getting into digital multimedia is that once the expensive hardware has been purchased, the industry standard software creatives like to use will definitely cost more than the hardware. The video editing software Apple's Final Cut Pro 2 is over $1000. Dreamweaver, Photoshop and Cubase will set you back another $1000.

Even though there are inexpensive shareware alternatives for most applications, what of using 'naughty' pirated copies of commercially available software?

Most magazines and books will ignore and not publicize the fact that nearly all commercially available software packages are freely distributed, fully working and with serial numbers or 'demo–cracks' on various places on the Internet, particularly in the old, net–nerd provinces of USENET, and more recently in 'peer–to–peer' file–sharing environments like 'Hotline' (www.bigredh.com) and 'Napster'. Software piracy is a crime, normally enforced through the application of copyright laws. To use borrowed copies of software, or even install a purchased copy on two machines can be viewed as illegal piracy.

What should the guerilla artist do? Disrespect the copyright protection afforded to software

developers, that as artists we would normally expect of our own work? Piracy does affect the development of creative applications and push up the costs of software, and by so doing makes purchasing legitimate software by artists ever more difficult. Software companies should reform the way software is used and licensed. Some big companies talk about clients 'renting' applications, charging per use or even, with high–end 3D animation software (normally costing thousands of dollars), negotiating a share of artists' royalties in exchange for the use of their software. Things will change. At present it is up to the consciences of each guerilla artists: to pirate or go legit.

One could always go and join a university and get software at heavily discounted educational/academic rates.

Q – What do I need to burn my own CD–ROMs?

Ian –
- A CD writer or re–writer (a re–writer allows you to use CD re–writable disk more than once. New Macs have CD–writers built in;
- CD burning software – often bundled with your burner. Eg. Toast or Sony's Dis cribe;
- Material to burn.

Common uses of CD burning for the guerilla digital artist include:
- The creation of an audio CD soundtrack for a show;
- The production of documentation and promotional interactive CD–ROMs, for example Macromedia Director movies showcasing movie, audio, textual examples of your work;
- Backing up administrative data. This is very, very important.

Q – Any guerilla strategies for the artist trying to work with digital technologies?

Ian – I think the key thing to remember is that technology is fetishized. To use technology is to add an air of 'innovation' or newness to work. The words 'bandwag on' and 'jumping' come to mind. Take David Hockney's fax art as a good example of the guerilla spirit: a technology was re–purposed beyond its intended function. The playful appropriation and use of technology to your own creative needs is far better than learning to use it according to the rules of the 'industry standard'.

Finally, remember that technology is easy, sometimes flawed and flaky, but intrinsically easy. Programers, computer–technos and specialists will mystify what is completely within the faculties of an intelligent, creative guerilla artist. Good luck!

Documentation
& Marketing

Documentation and Marketing

More often than not, the artist must act as the chief archivist and promoter of their work. As discussed earlier in the context of funding, having an administrator to help with this can be a fantastic resource, but there are also some real advantages in taking responsibility for this aspect of the work yourself. If you neglect marketing because you are understandably engrossed with other aspects of your work, you may be in for some dreadful surprises. This section offers advice on strategies for marketing and publicizing an event as well as documenting and promoting your work in general.

What is your marketing strategy going to be?

How are you going to promote the work?

Who is your target audience?

Venues and festivals will usually include you in their program or brochure, which requires you to have copy and an image, both of which need to be strong and capture an essence of the piece.

What are the means of publicity at your disposal?

Can you get a press preview in a magazine or newspaper?

Is there something particularly topical about your work that could give you an angle to approach radio or TV?

In this section, marketing expert Chris Lord offers great advice on cost–effective marketing strategies and audience development strategies.

Videographer Frances McMahon Ward highlights some of the most important elements of a good demo tape, and gives suggestions as to how to make them professional looking on a low budget.

Tony Nandi offers tips on the important elements of performance photography, defines the pros and cons of analog and digital images and gives advice on formatting and image processing software.

Chris Lord
Marketing and PR Manager

Q – You were in charge of marketing and publicity for the Centre for Contemporary Arts in Glasgow for many years. What was that like?

Chris – A joy and a privilege. The Centre balanced a program of visual art, live art, music and video with literature events, talks and debates. CCA was born out of the Third Eye Centre which had championed Scottish and international contemporary art since the 1970s and enjoyed an international reputation. It worked superbly as a sort of one–stop shop for exciting ideas – as a visitor, you never knew what you were going to witness, there was always lots going on in the gallery and performance spaces along with a great shop and café/bar. You cannot underestimate the importance of being on a main street in the City Centre too.

A great reputation and track record is very important in terms of marketing innovative and risky work. A loyal audience who trust a program of work are much more likely to attend events by unknown artists. A curated program also provides opportunities to place emerging artists alongside established artists in meaningful and exciting ways – exploring issues or particular developments in areas of practice.

By developing a core audience who trust a program of work, curators can take more risks with projects. If you are marketing such a program, there is no need to hype elements in the hope that the shock/horror elements in some work will deliver bums on seats. This is a short–term approach with no relevance to the development of an artist's work or to development of audiences. By a careful approach to the context of an artist's work, interpretation for different interest groups if you like, everyone stands to benefit. One of the main challenges was balancing the needs of the core audience who have experience and knowledge of a lot of artists and work, with the needs of new audiences and casual visitors. It's all down to how art is interpreted for different interest groups.

Working at a leading venue also allows a long–term development of partnerships with the formal education sector and other interest groups – many visiting artists would be involved in work with one of Glasgow's universities or the art school, or with specific community

groups. These partnerships are important in terms of audience development and sharing of resources and to the influence on long–term development strategies/concept of broad cultural development. A thriving local arts scene needs the combination of educational opportunities, galleries and performance spaces and a broad support structure for artists to make new work.

On a personal level, it was rewarding to work with some of the most important and influential contemporary artists, particularly those who were presented at an early stage in their careers. I think CCA and Third Eye before it were hugely important in developing artists' careers.

Q – What are the most important elements to good publicity – what does a person need to be thinking about to get it right?

Chris – To think about it as a core part of the artist's work. It's not an add–on or an afterthought. Artists need to look at their idea and decide what it is, what they want to say and who they want to communicate with. Is it a piece of visual art? A performance, video, TV program or novel? If it's a performance, what scale? And for theatres, galleries or found spaces?

While acknowledging that most artists want to reach as many people as possible, there is always a core or ideal audience for any work. It's a principal that holds good for any product – not everyone is going to drink a new designer lager or wear a pair of Prada trainers. So it's important to assess what a project or idea is, who you want to reach with it and then to decide how to reach them. Is there anyone out there who already gets the audience you want? And can they help you?

Audiences generally need to know several key pieces of information: broadly Who?, What?, Why? Where? and When? It's often down to a question of why they should come to an event/exhibition rather than go to the cinema or stay in watching TV.

How you reach them is down to resources available – you're not often going to be able to do TV advertising or make the front page of national newspapers, so you need to decide on the kind of promotional campaign that is relevant to the scale and nature of your project and that you can achieve within available resources.

If you are working with a venue or venues, be really clear where responsibilities lie – will they be marketing your project? Can they and will they produce their own print materials and distribute them? Can they handle press? What do they need from you? And whatever it is, make sure they get it when they want it.

You are in a relationship with them so make sure it's a healthy one – keep in touch/monitor progress – is print ready? Has it gone out to agreed targets? Are there journalists who want to talk to me? Have they ensured the event is listed in what's on guides – local media and listings in national newspapers?

You also need to decide a press strategy, and whether you can afford to do advertising. Do you need to get printed material together and should this be a poster, flier or postcard? How many do you need/how many can you afford? It's no good producing a beautiful, enticing piece of print if there are not enough of them or you cannot afford to distribute them.

Decide on your available budget and cut your cloth accordingly.

Does another artist or venue have mailing lists? Can you get your information into their mailings? Do you have a web presence that you could get linked to other sympathetic artists or organizations? Is there a local venue/pub/club where your ideal audience hangs out? Direct mail is a very successful way of reaching people – but they have to be the right people; decide who might have a good list and explore ways in which you might be able to access them. A sympathetic venue or other artist/company might be prepared to include information about your project in their mailing or you may be able to offer them something in return.

Make sure that once you've agreed a deal that you have all your stuff ready by the agreed date. You should get your own mailing list together (and if this is to be kept on computer, remember that you need to register with the Data Protection Agency). Email has revolutionized the ability to keep in touch with people – you can send up–to–the–second news about your project at negligible cost, though bear in mind that only your close friends and family will appreciate getting mail every day!

Every town has a company that distributes posters and fliers around venues, cafes, bars etc. Decide what you can afford to pay them and use their expertise to decide how much material you need to provide and where it should go – you may want to reach gay bars or rock music venues, galleries or film students; they can often target material very accurately. If budget does not allow, you'll have to tramp between those key venues yourself.

If a venue has a show that is attracting an audience you want, ring them up and see if you can hand out fliers as the audience leaves.

Copywriting is very important; it should be sharp, succinct, an accurate representation or telling promise of an experience. If people turn up expecting sharp political cabaret, they'll probably be disappointed with improvised dance. Avoid clichés, don't write it's like Brecht

on acid if your target audience isn't going to know who Brecht is or what acid is!

Less is also more; younger audiences especially are resistant to huge amounts of text. And don't make promises that you can't deliver on.

Q – When you're doing publicity or graphic design for a gig or artist do you prefer to get raw materials that have been carefully selected – all meat and no fat – or is it better to get lots of raw material so that you can look at a wider range of options?

Chris – No hard and fast rules, though generally it's important to have a clear understanding of where an artist is coming from – who they are, some idea of history/track record, what the project is and what they hope to achieve. It's always good if the artist(s) have thought these issues through and have a strong relevant image in mind. Titles help locate the work too. However, it's always good to talk these things through with artists; different images can mean different things to different audiences and often artists are more eloquent talking to their immediate peer group (other artists and associates) than to new audiences who might need a different approach.

If budget allows, it can often be rewarding to produce different messages for different target audiences. For example, the way an artist describes a project to an arts council panel is likely to be different from the way they would describe it to an arts editor on a daily newspaper, or to their friends in the pub, or to their parents.

As a general comment, I am always surprised at the number of artists, even visual artists, who do not have good images of their work or do not have strong enough material to make an arresting poster image or interest a magazine.

Q – Is it becoming more the norm for artists to design their own publicity materials?

Chris – There have always been artists who have designed their own print material or who have a very clear, concise and strong idea of what they want and why. There are also many artists who have graphic designer friends. But a combination of tight budgets and access to desktop–publishing packages has meant many more people produce their own material.

However, like most things in life, an outside eye is often good, graphic designers will often work for arts clients for reduced fees (the work gets seen very publicly – good for business) and they can often get deals on outputting and printing not open to your average artist or member of public. If what you wish to produce has a lot of text, it's well worth talking to a typesetter – their specific skills and knowledge of type will make your text look very much better.

If you browse through one of the leaflet racks that most venues have these days, chances are the material that catches your eye has been done by a recognized designer or agency. It's the combination of image(s) and copywriting that sells.

Q – Do you notice any common pitfalls amongst artists new to marketing?

Chris – Anyone with experience of marketing knows never to take anything for granted. All marketing is really just common sense, but it always helps to come back to some basic principles: what do you want/need to achieve and then planning for that to happen – this is where all those clichés abound – fail–to–plan and plan–to–fail etc. First, is the **product** right? It's never worth marketing anything that you're not happy with. Many inexperienced artists want to get a lot of attention for work that is still in development. Much better to market it as work–in–progress/process – audience feedback can often be very useful at early stages of a project; you get to involve people who can become the core audience and ambassadors for the finished product.

Second, is the **place** for it right – is the project in the best or most appropriate venue or setting, both from artistic and audience viewpoint? Often artists have unrealistic expectations of venues, who may have all sorts of reasons for not pulling out all the stops to market a single project – they're working flat out to sell a Christmas show or a big season. However, the more ammunition an artist gives a presenter, the more likely they are to generate press and public interest. It's always a mistake to not keep in touch with anyone marketing your work – you may be unhappy, running way behind or unable to get good pictures together but by keeping in touch, marketing staff can plan for developments, get useful and usable information or anecdotes that may generate press interest or that they can use creatively to get results. They'll probably be able to help source images too. The more information they have, the better job they'll do.

Price. If anything in life is perceived as being too expensive, people won't buy it. There's still the black box/white box thing too, people are much more likely to take a risk on a work in a gallery – it's generally free, they can walk around in two minutes, hate it and leave. Knowing it'll be different, they're also likely to come back and see the next show too. People are more circumspect when it comes to buying tickets – there's the money factor and the idea they may be 'trapped' in the wrong place at the wrong time. This is where the honesty factor comes in to; you can hype people to something once but if you want them to come back you need to build up the right level of expectation.

I always think it's a mistake to boast directly in promotional material – the hottest show of the year etc., people see hype like this everywhere, but if the Guardian says you're the most exciting new installation artist in Fulham then that's their call; it's always good to get good witness statements! At the opposite extreme, audiences very rarely respond to elliptical

messages – I've seen an awful lot of 'copy' arrive from artists that combines a short, dense statement with a brief biography (educated at, etc.) and nothing more, nothing that allows anyone to grasp an aesthetic or make a decision to attend.

All in all, I think it has become increasingly important for artists to feel comfortable describing their work to different people, in different contexts, understanding the needs of a group of fourteen–year–olds and of an art critic.

Q – Do you have any advice for artists about audience development – how to come up with a good strategy for their individual type of work?

Chris – Have a plan, a loose long–term one and a project–by–project one and make it a part of your 'business plan' or goals for the future. Even if you don't care about who comes to see the work or who buys the work, chances are you'll need to 'sell it' to someone. Think about how you got to where you are now and decide where you want to go. Decide what you think it will take to get there. If you have a venue you want to work with talk to them. If you see someone out there who's doing something better than you, decide what it is and try to emulate them.

Decide what kind of audience you want to develop – should they be readers? TV viewers? Gallery visitors? Do you want to tour work or work in one place? Do you want to work with curators, producers, festivals? Venues? All collaborations or partnerships will help to deliver wider audiences or opportunities to reach different people. It's important to get your work seen by the key people, find out who they are and invite them.

Keep in touch with your audience. There is no substitute for having those names and addresses, whether for exhibition openings or touring performance. Make it easy for people to give you the information; attendees will respond to idea that you'll write to them and let them know next time you're in their area. If they've got email, it costs you next to nothing to keep in touch – if you were working on a long–term project, weekly 'diary' updates are great for your core supporters who feel involved in process and will talk to their friends about it.

If you are comfortable teaching, get in touch with tutors/colleges, etc. in towns where you are to tour, see if they'll take a talk from you prior to gig in the town, give them a ticket deal. Many of today's older audience members first saw artists they still love when they were students.

Above all, don't try to do too many things at once. Try a couple of ideas that you haven't tried before, that way you can monitor what works for you and what doesn't. Always explore opportunities to get what you need from someone else – get into a festival or the

right venue, share your mailing with someone else, get your website linked to the right places, get your event into the right listings in the right papers and magazines, make sure your materials address the needs of the audience you want.

Give your 'best customers', your loyal audiences, 'rewards' – everyone else is doing it (chances to pre–book, extra information, a card at Christmas – remember when you were in fan clubs?) Always go for the best you can afford. And don't do things that you feel uncomfortable with or that you don't believe will work. They won't.

Q – A lot of work is online now – do you find it harder to publicize events on–line?

Chris – If people are online no, not really, it's just a different audience or community and it's just communication; mailing lists can be shared and emailed, links established to sites of peers and collaborators. I think a lot of people in the traditional arts media are still finding their feet with the technology and the experience of web projects and a lot of the attention comes from publications aimed at a young audience, but that will change. The challenges for audience development are only different in the sense that web technology glitches are not problems at the printers or a cold wet night every time you perform – there are so many things to go wrong!

Q – If an artist is on a limited budget but really wants to get their publicity right, what is the most important thing to spend their money on?

Chris – The cheapest and most cost–effective communication: paper and stamps. Access to computer/printer/copier. Or even phoning people – cheaper! A lot of big arts organizations now do a lot of direct phone marketing – it's a one–to–one marketing pitch and can be 'tailored' individually! You need to get information out directly to the people most likely to be interested. You can beg or borrow the help, or do it yourself to stuff envelopes or stick stamps on. Work outward from your existing friends; you may need to offer a few pounds, but get your leaflet, letter or flier into mailouts from venues or other artists or groups. Use email. Find those newsgroups. Research the right media people and send them information they can use – press coverage is very cost–effective if you can get it.

Q – Is there a particular software package that you would recommend as an essential tool?

Chris – There are all sorts of sophisticated customer database systems in use in bigger venues and in the high street, but an individual artist or group just needs a database system that works for them (targeting fans in Yorkshire or promoters in Wales). A good email package that you can send clear images quickly – people always like getting a postcard. Design–wise, I've always used Apple Macs, Quark Express or PageMaker, but if you're not

'trained' in designing for print, it's always good to discuss the job with your printer/print producer – if they get the job in the way they want it, it'll be quicker and cheaper for you.

Q – Are you freelance now?

Chris – Yes, marketing and PR for arts clients, project management, writing, and developing projects.

Q – If an artist wants to hook up with a professional publicist, how do they go about finding you guys?

Chris – Like marketing, the best tool is always good word–of–mouth 'Jo Bloggs is getting lots of attention – who's she working with?' The Arts Marketing Association (01223 578078, www.a–m–a.co.uk) will put you in touch with freelance arts publicists across the UK.

Q – What next for Chris Lord?

Chris – I'm working with artists here in Scotland to explore ways in which the support structure for both emerging and established artists can be developed. I continue to work with clients across the UK, including Forced Entertainment – building wider recognition of their huge importance to contemporary British culture. I'm also developing plans for a new festival and exploring ways to get more contemporary art on TV.

Frances McMahon Ward

Q – What are the most important elements of a demo tape?

Frances – I like to think that the work should speak for itself but, unfortunately, this is not the case. Make no mistake, the strength of your work is the ultimate factor in securing any grant, fellowship, or show, but organization, presentation, and packaging of the demo tape are pretty critical as well.

First and foremost, thought should be taken to how the demo tape will be organized. Whether it is organized by date, theme, or category (video, performance, or combination) – whatever – it should remain consistent to that format. The demo tape is a sampling of your best work – if it is not a strong piece don't put it in just for extra filling. I would put my money on quality over quantity any day.

Another thing to consider while organizing your demo tape is how to best showcase the individual pieces, especially if you have a lot of different genres such as straight video, straight performance, or some combination of the two. Maybe you play the entire video in your demo tape, but for the performances you just show the highlights in some sort of swanky pre–edited masterpiece. You may feel that the best way to serve a particular piece

257

of work is to have a series of stills that fade in and out consecutively (like a mini slideshow) or if your video/film work runs on the long side (over twenty minutes) you might consider creating a 'trailer' for the demo tape. Just know that you can be as flexible and creative with your demo tape as you are with your work – you just want to remember to show each piece to its best advantage.

When your demo tape is organized the next step is presentation. This can include everything from the text and images used within the tape to denote different sections to perhaps additional information about the individual works or you the artist (demo tape/CV combo).

The last element of the demo tape that should be considered is packaging. This is the first thing that is seen before the tape is opened and slid into the VCR. What statement do you want to make? Whatever your choice may be – from a graphically designed full sleeve to simply the original VHS tape box – make sure everything is neat and labelled. Both box and tape itself should be labelled with name, address, phone number, e–mail address– any combination of these so that contact is assured. It is not hard to imagine tapes getting separated from applications or even separated from the case so make a pre–emptive strike and label everything.

Q – Do you notice any common pitfalls amongst artists new to shooting and editing?

Frances – One thing to remember is at first there will be a learning curve with regards to any equipment and/or software that is used to shoot and edit video. This should not be a source of discouragement because this can be overcome pretty readily with the help of manuals, hands on 'play', and online technical support teams. I have discovered that basically all cameras and editing software are the same (some may have a few more bells and whistles) so be comforted in the fact that you only really have to learn it once.

Once you have the camera and are comfortable using it, an important thing to remember when you are ready to shoot is to have a tripod so that the footage will be steady. If you find yourself without one, brace the camera against your body with both hands or set it down on some immovable object. Review the footage before you wrap up the shoot. If you like the shaky, roller coaster ride, *Blair Witch* type of footage and it suits the concept – have it – no tripod necessary.

Another tip for beginners is to keep the footage as pristine as possible. Many cameras have digital effects on board that can do all sorts of wild stuff to footage while in record mode, but it is smart to save that for the post–production edit bay. Who knows, at the time you might have thought the solarized fish-eye effect was too cool for words, but now the shoot is over (never to be recreated in quite the same way) and it just looks silly. You can always

add effects in post–production. Keep the original footage clean.

Lastly, it can be both inconvenient and costly to have to recreate a video shoot, or impossible if it happened to be a live event, so have plenty of tapes on hand. My work has never suffered from too much footage.

As far as editing tips go, the first step is to have at least a basic storyboard ready. The more organized and prepared you are, the smoother the edit will go. Remember that an edit means exactly that; no matter how much you love every single frame of video that you shot, most will end up on the cutting room floor. Be selective so that only the best of the best is used in the final piece. Selectivity happens when you have reviewed your footage over and over and over again– the strongest sections will begin to stand out.

The next thing to remember is that once you have it basically organized and know what you are going to do, don't be afraid to change your mind.

Q – You moved from visual art to performance and then to video work – what was that progression like?

Frances – My progression from visual art to performance and then to video work seems pretty natural. As an undergraduate I got really involved in making wearable objects. The piece was complete only after it contained the body. Once the objects were activated with the body it made sense to have them do something, so I began to create 'actions' and 'environments' for the wearable and wearer. Soon the object started to become less important than the action or concept I was communicating. I was encouraged to challenge myself by including text into my performances. I took the challenge and found my voice. Along with this added textual dimension I began to add a visual one as well that of video images. I found that it added a layer to my performance much the same way that another performer could.

This concept of 'video as performance partner' was intriguing. I could now have more than one view or voice with the addition of the camera. The performance/video work evolved further with the making of performance strictly for the camera. It came from a frustration with the quality of performance documentation footage. In terms of the final product, the performance for the camera worked well. However, the performance 'juice' was absent because the live element was absent. The audience's presence and the way they interact and respond to you during the performance are a big part of the entire event.

Q – If an artist is on a limited budget but they really want to get their demo tape right, what is the most important thing to spend their money on?

Frances – When working with a limited budget the most important thing to consider with regards to the demo tape is edit quality. Whether you decide to rent time on a professional system (Avid or Media 100) or buy editing software for your personal computer (Final Cut Pro or Premier) you want it to be seamless. You don't want any breaks in the flow of the tape such as a blip of blue screen or the 'white noise'. Edit quality translates into time spent on the project – the more time you put into the demo tape the better it will look.

If you hire an editor, be active in the process as much as possible to ensure they are following your instructions. Don't assume they will. Spend money for a few high quality master tapes but for the dubs a high end VHS tape is a waste of money. A medium–quality tape will get the job done. The cost of a video jacket is inconsequential and it not only protects your tape, but it gives you an opportunity to relay information about you and your work.

Q – You've worked extensively in professional studios, university labs and with home computers and lower end packages; what do you think: do you need to go with a professional system like Avid or Media 100 to get a professional looking demo tape?

Frances – Personally, I think the video editing software (Final Cut Pro, Premier) that is available today for the personal computer is really high quality. You can achieve a very high polished, professional demo tape without the expense of renting time on a professional system like Avid or Media 100.

Q – For a person with a limited budget would you recommend buying some lower–end gear, or simply renting higher–end gear when it is needed?

Frances – I think it would depend on the gear. There can be all sorts of equipment that a videographer might need depending on the type of shoot, but it is not necessary or economically possible to have it all. Lighting kits, sound recording equipment, other peripherals can be rented when needed. I think that the decision to rent or buy some of the more major components such as the camera or editing system will really depend on usage. It would be cheaper to rent instead of buy if you plan on shooting video once in a while. If you really get into the medium, invest in a digital camera and some sort of editing software. It is smarter economically, not to mention much more convenient.

Q – Is there a particular software package or piece(s) of hardware that you would recommend as essential tools of the trade?

Frances – If you feel that video is your medium of choice or you like to experiment with it in tandem with something else, I would recommend investing in a digital video camera and a video editing software package (if you have a computer). A camera alone can do basic video editing or there is the concept of the 'in camera edit' which takes a little more planning on the videographer's part but can have the benefit of being quite fresh. If you want to get some software I recommend either Final Cut Pro or Premier – both are excellent programs and not too pricey.

Q – What's the advantage to work that is shot specifically for video rather than adapted from performance footage?

Frances – Making work specifically for the video camera is going to be better looking. Video is cranky, it likes the lighting to be perfect for its lenses and the shots to be set up for its best taping advantage. If you shoot for the camera you can take all that into consideration, make the adjustments and specifically set up each and every shot. When you adapt from performance footage you don't have that advantage because in that case the video camera becomes a mere documentation device.

Q – What's the advantage to live performance footage?

Frances – The advantage to live performance footage is that it is exactly that, *live*, and therefore has a certain quality and a particular energy that an engineered video shoot lacks. The context will also come across better when using the performance footage.

Q – And once you have your demo tape – do you send it out unsolicited, solicited, only as part of application packs, to curators/programers at venues that you like?

Frances – All of the above! You spent a lot of time on that tape. You are proud of that tape and the work that it showcases. Don't be stingy. The more you send it out, solicited or unsolicited, the greater the chance of people learning about and engaging with your work, which can lead to – shows, grants, fellowships – whatever.

Tony Nandi
Photography & Digital Imaging

Q – You've specialized in photographing performing arts. What, based on your experience, are the most important elements to good performance photography? What does a person need to be thinking about to get it right?

Tony – Performance is narrative, and the photograph is static – a moment in time. The challenge for the photographer is to use composition to indicate for the viewer that the moment portrayed is a component part of that narrative.

Q – What do artists need to know about the difference between 35mm film and digital images in terms of documenting or publicizing their work?

Tony –First, taking a negative or transparency to digital format is relatively easy and even cheap. Going in the other direction, from digital to film, is problematic and expensive. Performers, or at least publicists, should make efforts to familiarize themselves with a basic knowledge of resolution and file formats. The resolution determines just what an image can be used for: such as print, online or the Internet; and the file format determines just where a file can be used: on what computer platform, and in desktop publishing or word processing applications.

Q –Does the move to digital imaging have much impact on the way performance photographs are shot or distributed?

Tony –There are two factors to consider when deciding on the film or digital debate: First, all images that are intended for publication will end up in digital format. Even if the images exist as prints or transparencies, digital copies will be useful for dissemination; Second, to date film is still the most versatile medium when working in difficult lighting conditions. Digital cameras are very similar to video in outcome from low light, in that they are extremely sensitive and can work to very low light levels. However, with film the

image becomes more grainy, whilst the digital camera produces more 'noise'. In this context 'noise' is unwanted data that reduces the quality of the image. Also, digital cameras work well within a limited tonal range. They can be great at shadow detail, but will invariably blow out highlights. So high–contrast theatrical scenarios are problematic. Finally, these are early days for digital cameras, and these limitations will disappear fairly quickly.

Q – What do people need to know when they are scanning prints to forward digital copies to publisher or marketing managers?

Tony – Usually the safe option would be to ask the recipient what they require. If that is not possible, then a safe option would be: 300 ppi and TIFF (PC) format. Do not save as JPEGs, despite it being an easy way to reduce file size. JPEG should only be used as a last resort or for the Net.

Q – What photographic formats do newspapers prefer? Magazines? Books? Websites?

Tony – Usually as above for magazines or books. For the Internet I would suggest scanning at 200 ppi, and then using your image software to reduce this to 72ppi. Scanning at a higher resolution will increase the information taken into your image application, and reducing it down to 72ppi makes it suitable for Net use.

Q – Is it becoming more the norm for artists to try to shoot and design their own images?

Tony – Not in my experience, although as a professional photographer I may only come into contact with those who seek professional help.

Q – Do you notice any common pitfalls amongst performing artists new to preparing their own images?

Tony –The major problem will be location. Professional photographers will view the image

as a whole: seeing the main subject in relation to its background. The amateur is likely to be preoccupied with the subject, and be unaware of the context. It's the old cliché of photographs with lamposts growing out of heads. The processing of a film can only be done once and so having films processed at a good laboratory is essential. This does not have to be a professional laboratory, although these are more likely to produce a good result, at a price. If you are unhappy with results by all means try complaining, but it makes more sense to go elsewhere as the company should care about their product. Few people realize how their bad photographs are a result of bad processing.

Q – If an artist is on a limited budget but they really want to get their publicity photos right, what is the most important thing to spend their money on?

Tony – Professional photographers should not be so precious or insecure that they will not give advice. If it is clear that the artist could not afford professional fees then most photographers will be happy to advise on film type for a particular product, or recommend a laboratory.

Q – Is there a particular software package that you would recommend as an essential tool of the trade?

Tony – I'm afraid that PhotoShop, which is the industry standard application, is hugely expensive. However, most scanners now come either with a restricted version of PhotoShop, or an amateur version such as PhotoDeluxe. It would be unwise to recommend in print any low–end applications as the market is rather volatile; however, it is worth checking in Digital Photography magazines as these review such applications on a regular basis.

Stay Out of Jail

Stay Out of Jail

And finally, the section on the things you know you ought to know but aren't altogether sure that you do know exactly, or even if you really want to know ... But hey, as the Dalai Lama said, 'Know the rules so you can break them properly'.

Here are some dos and don'ts of staying as legal as you can. Maybe you have some guerilla strategies of your own but for the record, and so you don't get one, here are some top tips on things legal, fiscal and business–like from our experts in the field. Legal consultant Ursula Smartt gives the lowdown on legal issues, the rights and wrongs of copyright, and the ins and outs of insurance. Charlotte Jones, Director of the Independent Theatre Council, gives a few key tips on just how to set up and register as a company, and accountant Steve Ehrlicher rounds off with a foray into the world of numbers as he helps you manage that huge grant you reeled in after reading Section 3.

Steve Ehrlicher, Accountant

Steve Ehrlicher provides the following information on all things fiscal, in collaboration with Arts Administration Ltd. 1996

Q – What is Finance ?

Steve – Finance is what you and I need in order to be in a position to spend. It is either there already, from personal wealth, or it needs to be acquired through employment, grants, sponsorship or patronage.

However it is achieved, it is likely that someone will want to know about its use. They will want to know, either because they gave it to you with some strings attached and they need to know you are keeping your part of the bargain; or they want part of it themselves; or 'they' are you and you will want to know when and if you will want some more.

Q – Who needs to know ?

Steve – First, you do. If you are starting work in the arts, one of the most useful tools you can have for judging your progress is a historical survey. Keeping finance records is an easy way of producing such information.

Once you are up and running, then other external agencies will need to know all about you: the Inland Revenue will want to know how much Tax and National Insurance they can collect from you and your company; if you have sufficient turnover, Customs & Excise will need to have you report how much VAT is collected or spent by you on their behalf; if you have a Management Board and/or Trustees, they will need to know that you are acting sensibly on their behalf, as they are ultimately legally responsible for the doings of the company; funding agencies will always want to know about the use of the funds they have given you; if you have dealings with a bank – taking out a loan, or asking for an overdraft facility perhaps – then they will want to know your future plans to repay or reduce the facility and even before they will consider you at all, they will undoubtedly need to know your financial background; if you become a registered Charity, then the Charity Commissioners will want your information; if you are a limited company, the Registrar of Companies will want to hear from you.

There are many other potential calls on your information, from suppliers wanting to know your credit–worthiness, to other administrators wanting to know how you do it so well.

Q – How will they want to know?

Steve – The single most important word here is <u>regularly</u>. You should produce a monthly report to yourself and/or management and – if you employ people – report monthly and annually to the Inland Revenue; a monthly, weekly or even daily cash–flow; and, if relevant, a monthly, quarterly or annual report to other bodies, such as Customs & Excise, funding agencies, Auditors, Companies House and the Charity Commissioners. It is quite easy to get into the swing of a regular reporting and it can have useful spin–offs such as building other administrative work around the same timetable.

Another important word is <u>irregularly</u>. This is the irritant; an occasional report – usually a one–off – requiring hours of slog at the worst possible moment in the middle of something you feel is much more important. If, however, you keep reasonably good records in the first place, this sort of interruption should be fairly easy to accommodate.

Q – What about Budgeting?

Steve – Budgeting is seen to be a mystical art by most people but it should be just a matter of common sense. The budget will be required for a given period of time (an annual budget, perhaps) or a specific project, regardless of the period of time involved. In either instance the following should apply.

The first step is to list all the possible headings that you might wish to spend under, for example 'Wages', 'Fees', 'Subsistence', 'Travel', 'Accommodation', 'Production' (split, perhaps, into such items as 'Set', 'Costume', 'Props', 'Fees', 'Design', etc.), 'Administration' (also possibly split into 'Stationery', 'Post', "Phone', 'Insurance', 'Bank Charges', etc.), 'Overheads' (maybe shown as 'Rent', 'Rates', 'Water Rates', 'Heat & Light', 'Maintenance', 'Repairs', etc.), 'Legal', 'Audit', and 'Capital Items' ('Land', 'Buildings', 'Vehicles', 'Machinery', 'Furniture & Fittings', etc.).

The next step is to create a similar list of potential income – 'Grants', 'Capital' (injected by you or others in the project), 'Fees', 'Sales of Merchandise', 'Sponsorship', etc.

When you have these two lists, you need to allocate figures to each of them. The basic rule here is to be as accurate as possible but, where you are having difficulty in assessing how much to allocate, increase the expenditure and decrease the income. So, if you think that you are doing ten performances in a variety of places, not all of which are known, work out the travel costs based on the known ones furthest away. Similarly, work out the income for the unknown venues based on the lowest income of the known venues. All figures used should be net of (minus) VAT.

When creating your figures for each heading, try to make notes as to the basis for your calculation or assumption. They will come in handy when you have to tweak or revise your figures later and also will be useful historically when you come to do the next set of budgets.

When you have your two lists, make the picture worse by adding a further expenditure item – 'Contingency'. This item is intended to cover all those small unforeseen circumstances, like a reprint of a script when the original ended up in the washing machine, or when the artistic director decides that red is now preferable to green. It is not intended to cover for a claim against your company for negligence or the like, when this should be covered by suitable insurance. 'Contingency' should be worked out as a percentage of all your expense items – say 5 percent of total costs up to £10,000 and 2.5 percent on totals above that.

Now is the time to take stock. You are more than likely faced with a gloomy picture of too many costs and not enough income. So, the hard work starts in checking the figures and seeing where any savings can be made or income increased. However, do not fool yourself. It will only end in tears. If the problem is really bad, talk it through with your board or director, or someone whose opinion you respect, as early as possible.

Hopefully, without too much effort, however, you will achieve that holiest of holy grails, the balanced budget – where the total budget income from all sources equals the total budget expenditure.

The final task is to try to squeeze the information you have into the various forms that you have to complete, in order to try for funding assistance. In most instances it will be self–explanatory as to which of your headings will have to be amalgamated to produce the category on the form. Occasionally, you will have to adapt your information to suit; where this is necessary, make notes as to what assumptions and adjustments you have made. As a last resort, alter the form to suit your needs.

An added element of budgeting, which proves to be very useful when talking to banks and the like, is an analysis of how the budget will work out over the period budgeted for. This will be dealt with under **Cash Flow.**

Q – What about Bank Accounts?

Steve – I assume that you have applied for some funds and have been successful. You will need to have a dedicated bank account for the safekeeping of them until they are spent. If you are a 'sole trader', that is – with no–one else involved in the work you are undertaking then the bank will probably need you to visit them and fill in an application form, show some means of identification and produce a letter head or the like, prior to their accepting

you and your money. If you are part of, or represent, a group – be it a partnership, club or a charity, then you will need to have some form of identification, a letterhead and an agreement between you, in writing, as to how you will operate. This is more frequently in the form of a document or two drawn up by solicitors and called Articles of Association. If you are a limited company, you will need both these and a company memorandum. These documents are also lodged with Companies House. Your copies will be needed to show the bank when you apply on behalf of the organization and an agreed number of signatures will also be required on the application form for the account. Each of these account types will take about a fortnight to set up, providing you have all the information to hand prior to your visit. A check with your chosen bank before you make the visit will confirm their needs.

Once open, you must assume that all cheques you issue will be cashed immediately and all payments made into the account will take three working days to clear. This then allows for a worst–case position to be reflected in your financial state and reduces the problem of going overdrawn.

If you are fortunate enough to have sufficient funds available for long enough, check out the interest to be earned on the money market. Your bank will advise, but you will generally need to have at least £10,000 available for a month for it to be worthwhile.

Unless you are a sole trader, you should always have more than one signatory to the account, to reduce the possibility of any misuse of funds. Do not go mad and have everyone, otherwise it will take too long to get any cheques signed; it is best to have any two out of three or four signatories listed on the bank mandate.

Banks are beginning to offer many more services to the trader – running credit control, payroll, cash flow services, etc. Unless you are very large and busy, then it is highly unlikely that it will be cost–effective for you to employ the bank. Costs for a simple cash flow service, which allows you to check your financial position at any time of day or night, will cost about £200 to £500 for a setting up fee (depending on your bank) and a running cost of about £20 permonth, plus an increased phone bill for the modem link. All you should need to get a good picture is a weekly statement and a few minutes of your time totting up all that is yet to hit the account.

If you have a large payroll, however, you might like to check out Bacs (Banks Automated Clearing System) that most banks offer. This allows you to give the bank (at least three days before the moneys are due to the employees) the definitive list of net pay and they will make the payments and take the money from your account – assuming there is any. This service costs, but it may be worthwhile, especially if you have a computerized payroll and you can produce the list of net pay at the tap of a key or two.

Q – And book–keeping?

Steve – The keeping of books of finance can be very therapeutic. There is nothing better than having an excuse to put aside all the problems of the day and do a bit of sorting, filing and writing.

You can either keep the books manually, or, if you have access to a computer, buy an accounting package off the shelf. None of them are ideal, all have their problems and foibles. They range in price from about £25 (Quicken, or MS Money), through to £1500 (the upper reaches of Sage, etc.) and beyond into the ridiculous. It is likely that you should keep below the £200 range for starters (for example Tas Books, about £100; Quickbooks, about £120; Sage Sterling, from about £130; MYOB, about £150). These will give you a basic set of accounts ledgers and, in some packages, more.

If you are doing it manually, then the most basic way is as follows:– you will need an analysis book, available from any reasonable stationers, preferably with enough columns in it to cover your needs and more. I would recommend going for the greatest number of columns you can get, say 24 or 32 across two pages. This will be your cash book, in which you can record all the movements of monies. You will also need a calculator or adding machine, a pen, a pencil, a rubber, a ruler and two foolscap–sized ring–binders. That's all. If you are running a **Petty Cash** system as well, the details and receipts for that will be dealt with under that section.

With the cash book, it is reasonable to lay it out with the income on the left-hand side and follow that with the expenditure. So, mark up the left–hand side of the first double–page spread with column headings something like this:

INCOME

1	2	3	4	5	6	...
Date	Details			Ref.	Total	
7	8	9	10	11		
VAT	Fees	Sales	Grants	Misc.		

Where 'Date' is the date of the transaction; 'Details' allows for a brief description of the nature of the transaction; 'Ref.' is for the unique reference of the paying-in slip, if any; 'Total' is for the gross total of the transaction; 'VAT' is that element of the gross figure; and then the net figure goes in the appropriate column ('Sales' being of merchandise, rather than of performances or workshops).

If you can afford the space, then leave one column blank before starting on the expenditure,

as follows:

EXPENDITURE

12	13	14	15	16
(blank)	Date	Details	

and here – or at the end of the left-hand page, which ever comes first – you stop.

Oh, and you'll need some scissors.

The next task is to estimate the number of double pages you will need to allow for a full year's trading to be entered. As you should start each month's activities on a fresh double–page spread (unless you have so few transactions in a month that this is a total waste of space), then you should assume to use double the quantity, to allow for busy periods, which means twenty-four double–page spreads. So, on the right–hand sheet, cut the top section off, where you would have entered the c olumn titles if you hadn't been interrupted, and do this on the next twenty-two right–hand sheets. When you have done this, continue to enter the column titles on the twenty-fourth sheet. You will see by this that it will save you writing out, time and again, the column titles for each page.

So, where were we? Oh yes, the column titles for the rest of the expenditure. After the 'Details', you will need something like this:

17	18	19	20	21	22	23–29	30	31	32
Chq. No.	Total	VAT	Wages	Fees	Set	etc.	P/Cash	Misc.	Notes

This should be self–explanatory – the 'Notes' column being a luxury.

Now you should be ready to enter every transaction that occurs, payments into the bank on the left (income) and cheques paid out on the right (expenditure). Once you have written all the transactions for a particular month, according to your paying-in book or slips and your cheque book, you will need to do a **Bank Reconciliation**, which will add the items that have moved directly through your bank account (direct debits and the like). Enter these below your existing entries on the income or expenditure side of the book, as appropriate.

Finally, enter the totals for each column, in pencil, and cross-cast (add all the totals of the details columns to prove to the total of the 'Total' column). If you have made an error, this cross-cast will show a difference and you can check back to see which element needs altering. It is usually just a matter of an incorrect addition in one direction or another and the pencilled totals can easily be changed without causing too much mess.

It is good practice to hide your Tipp-ex when it come to using the cash book. Your mistakes should always be shown, and neatly corrected, to allay any fears of fraud or cover–up.

Once you have a balanced page (if your month spans more than one double–page spread, you should do the calculation at the bottom of the first page and carry each total to the top of the following page as a carried–forward figure), then you should use any remaining space on the double–page spread for the **Bank Reconciliation**.

Of your two ring-binders, one will be called 'Debtors and General' and the other 'Creditors'. And you can now start to sort out all those bits of paper that have settled in your 'in' tray over the last days and weeks.

In the 'Debtors and General' file, you will need to have at least five sections (you can use old envelopes for dividers):– the rear one for invoices that you have issued that have been paid, the next one for unpaid invoices, the next section for **Credit Control** correspondence, including a list of outstanding invoices at each month end, a further section on general correspondence and the final section, at the front, for your bank statements.

In the 'Creditors' file, you will only need three sections: the rear section being for paid bills, the next one for unpaid bills and the final one for correspondence regarding your Creditors, including any disputed statements and a list of all outstanding invoices at each month end.

At the bottom of each list of Debtors or Creditors, it is a good idea to construct a chart which will show how old your outstanding items are. These are known as your Aged Debtors or Aged Creditors and the chart could look like this:–

Total Outstanding	Current Month	One Month Old.	Two Months Old.	Three Months & Older
£abcdef	£abc	£d	£e	£f
100%	w%	x%	y%	z%

You can then check how you are controlling your Debtors and Creditors over a period, when you have a number of these aged tables to refer to.

That's the easy bit and is all you will really have to do if you or your group are a small organization. If you are larger than small, or a limited company and/or a charity, then there is more to do.

Limited companies are required by law to make annual returns to the Registrar of Companies at Companies House. To do so, you will need to have an **Audit** of the accounts, by an Auditor.

If you are a charity, then you may well have to keep your books in such a way as to assist the making of returns to the **Charity Commissioners** and – depending on your size – comply with new regulations which have come into effect for financial years which begin on or after March 1st, 1996.

Q – What is Double Entry?

Steve – Double entry is the term given to the best form of book–keeping. It was devised in the fifteenth century by Mr. Pacioli, and has been going quite nicely since then. It is a self–checking system and its premise is to arrive at an accurate financial position.

Each transaction is entered twice, once as a debit entry and once as a credit entry. Debit entries represent expenditure on assets or expenses and credit entries represent income and receipts, as well as liabilities due to third parties (creditors). Therefore at the end of any accounting period the totals of the debits should equal the total of all the credits and the books will balance.

The double entry system should include the following records: – Sales and Purchases day–books, which summarize the relative credit transactions; a cash–book for bank and cash movements; a petty cash book for the obvious; personal ledgers for each customer and supplier; a general or nominal ledger which has assets, liabilities, sales and expenditure as necessary. Balancing entries have to be made in two of the above at any time. Thus, at the end of the period, a report can be produced which is called a Trial Balance and which proves that all the transactions have been allocated to both a debit and a credit position.

If you are buying a computerized system, then it will be inherent within it. I do not recommend that a busy arts administrator tries to keep the Double Entry system by hand – it will be much more cost effective to have the computer do it for you. If you are seriously interested, however, in Double Entry and Control Accounts, go to your library and look it all up – if you have a month or so spare.

Q – What is the Charity Commission's SORP and SOFA?

Steve – The Charity SORP is an acronym standing for 'Statement Of Recommended Practice', and is being urged on all Charities. It is not law, but it would be frowned upon if you and your Board/Trustees did not take it to heart. It is a moderately bulky document,

which is available, one free copy to each charity, £5.00 a copy otherwise, from the Charity Commission. If you are not a registered charity, but are a 'not–for–profit' organization, it would be well for you to get a copy, or borrow one, and do your best to work within the guidelines. It deals, primarily, with the accounting records, procedures and reporting.

If you are a smaller charity, then you should have, for free – again, from the Charity Commission – 'Accounting for the Smaller Charity' and 'Accruals Accounting for the Smaller Charity'. As before, if you are not a registered charity, but have similar ideals, you should acquire a copy of each, also.

The Charity SOFA is also new. This acronym stands for Statement Of Financial Activities, and is being urged on all charities whose turnover is over £10,000. <u>It is law</u> and it is required whether you are a Limited Charitable Company or just a charity. In the former case, you will have to produce, or have produced for you, an Income & Expenditure Account as well as a SOFA. If you are not a Limited Charitable Company, you will find that the first part of the SOFA will be similar to an Income & Expenditure Account, with the rest of it new requirements. The basic idea is to get a more accurate picture of the activities of the organization to enable scrutiny of its application in terms of its constitution. The underlying principle is described as follows: 'The statement of financial activities shall show the total incoming resources and application of resources, together with any increase or decrease in the resources of the charity during the financial year …' The detail is in the SORP document and gives various useful examples of layout and use.

Q – Any Petty Cash tips?

This is the bane of all administrators' lives. It should be simple, but because it is 'petty', it does not receive the attention it should. Also, when things go wrong, you often end up querying someone's honesty. It becomes a very emotive subject, so you should set up the best system you can and stick to it.

Assuming you are using a manual system, you will need a small analysis book, with around 12 or 16 columns. As with the Cash Book, you should lay it out with Income first, showing the 'Date' and 'Source' (cheque No.xxx, or cash dispenser, etc.) and the 'Amount'. The rest of the columns are for Expenditure, starting with 'Date', 'Details', 'Total', 'VAT', and then the specific net amount in the relevant column ('Costume', 'Travel', 'Post', etc.).

The most efficient way to manage petty cash is the Imprest system, whereby you give a set amount to the petty cash tin (which you should keep in a safe, or at least hidden and locked), or to the individual who will be responsible and then agree that, subject to review, that will be the size of the petty cash float. When all or most of that sum is used up, then the tin or the individual gives you the receipts to prove expenditure and you reimburse

it/them with the value of those receipts. You will note that two things happen here: the first is that the float should go back to the original level, taking into account the repayment of the receipts and any remaining money in the first float, and second that the tin/person loses out if receipts are not acquired or are lost.

It is up to you how you deal with this latter circumstance, but at least you know it is happening and how much is involved at the earliest opportunity. Normally, if the sum missing is not too large, then you would make it up, put in a petty cash slip for the value of the missing amount and call the shortfall 'Unders' in your analysis in the Petty Cash Book. If, however, you are presented with too many receipts for the value of the float used, you keep the difference and note it as 'Overs' in the Petty Cash Book.

It will be necessary to constantly remind people of the need to get receipts, especially if you take up the difference in 'Unders'. One way is to announce to all that 'no receipt means no reimbursement'. The use of this draconian measure will depend on the specific circumstances – if you have a persistent and wilful perpetrator or not.

Further than this, receipts should, wherever relevant, contain **VAT** information – at least a VAT number for items under £100 (known as a 'less–detailed invoice') and a VAT analysis for amounts above that sum. This means that you will at least be able to recover as much VAT as possible. For sums under £25, where VAT is known to exist (stationery, car parking, etc.) but no VAT receipt exists, you can claim the VAT anyway.

Q – What about Cash Flow ?

Steve – A cash flow is an extremely useful tool to guide your actions, be they to delay in ordering or paying for something, or exercising serious **Credit Control**, or plotting your options for the foreseeable future. It will be useful to show to management and to banks and funding bodies. In its simplest form, it is easy to do. Like most things, it can get wildly complex.

The simple version is:

	April	May	June	July	Aug	Sept
Brought Forward	0	500	750	250	450	–150
Income	1000	1000	0	1000	0	1000
Expenditure	500	750	500	800	600	500
Carried Forward	500	750	250	450	–150	350

This can be set out at the same time as you produce the **Budget** with the projections for the coming year, month or week, as required. As trading takes place, actual figures can supplant the estimated ones and a more accurate picture can emerge of your future flow of funds. Such a simple chart can easily be done on a manual system.

With computerized systems, you can build your own elaborate affairs on a spreadsheet, which will be able to tell you how much and when you are spending out on stationery or the like.

Having worked out your figures for the period, month by month, week by week or day by day, you now need to put them into a cash flow, as in our simple example above. With a spreadsheet you will be able to cross–refer the total cells with the cash flow chart and add in your formulae. When you have your final version, you will be able to see any potentially problematic occasions before they arrive and, as discussed in budgeting, take remedial action.

Q – What is Bank Reconciliation?

Steve – Every so often you will want an accurate picture of your account and your financial exposure. This can be achieved by a Bank Reconciliation and should be performed at least monthly, following receipt of the bank statement which includes the last day of the month in question.

Assuming this is the first one you have done, you will need to have at hand your cash book (see **Book–keeping**) and/or cheque book, with the stubs of all issued cheques filled in with relevant details, a paying–in book with similarly completed stubs or paying–in slips and one or more statements from the bank.

Tick the stub when the relevant cheque shows on the statement and tick the entry on the statement. When you have gone through the whole statement you will probably have a number of un–ticked stubs – these should be listed with the date of issue, cheque number and amount paid.

Then tick the paying–in stubs or slips as they appear on the statement and tick the relevant entry on the statement and list any receipts that have not yet appeared, as with the cheques above.

You may well have some items on the statement that have not been ticked, such as bank charges, interest, direct debits, standing orders, monies in or out from foreign transactions, etc. these items should be listed on the relevant side of the cash book.
(see **Book–keeping**).

Finally, you will be in a position to produce a reconciliation along the following lines:

Balance per Bank Statement at (last day of month)	**£4,500.80**
Less outstanding cheques (those that have not yet	**−1,565.87**
appeared on the statement)	
Plus outstanding income (as above)	**0.00**
RECONCILED BALANCE	**£2,934.93**

You can prove this by the following table:

Brought forward (this would normally be the Carried	**0.00**
Forward figure from the previous month)	
Less Expenditure (all the costs incurred in the month as	**£15,090.66**
shown in your cash book)	
Plus Income (all that received in the month)	**£18,025.59**
CARRIED FORWARD	**£ 2,934.93**

These two tables should be written or produced each month. If the Reconciled figure does not agree with the Carried Forward figure, then you will need to embark on a bit of detective work. The usual difference is to be found in something you have written up or added up, either in the cash book or on a stub, but it could be that the bank have made an error on the statement – it has been known. You will need to find this before you can produce a clear picture of your finances and before you can do the next month's Reconciliation.

A word or warning: if you leave it until 'later', you will undoubtedly be creating a headache for yourself along the line.

Q – What do we need to know about VAT?

Steve – You will need to register for VAT with your local Customs & Excise office if your turnover in the year past, or in any of the next three months is expected to reach £46,000. This figure changes each year, usually upward, but don't assume that. Once you have registered, you will be sent a VAT returns form for a specified period. If your net turnover is below £300,000.00 per annum, you can elect to produce figures annually, but you will have to agree to pay the bulk of an estimated amount over nine months by direct debit, with the annual return and the balancing payment due two months after the last of the nine payments. Otherwise, in the normal course of events, you would expect to receive a form every three months.

To enable you to complete this form, you will need to keep VAT records. That is, to separate out the VAT element of any transaction, be it a purchase or a sale, providing you have the authority to do so. This authority comes in the form of a note of the VAT number on a official document for the specific transaction. If the total is below £100, you will only need the VAT number. The document (invoice, receipt) is then known as a 'less–detailed document'. For transactions of £100 or more, you will need to have the VAT element analysed on the document.

So, having the return in front of you, you will see that it needs to be completed by a date one month after the last date in the period it is concerned with. This period will be shown near the top of the return. You will then have to calculate the various elements for the return from information that you have available for that period. This will be from the Cash Book (see **Book–keeping**), and from the **Petty Cash** book, if you are just keeping manual systems, or from a multitude of sources, if your accounts are computerised. If the latter, then you will, of course, have all the work done for you, as you will have bought a system that copes with VAT, won't you?

Your sales are known as Outputs and the VAT element of the sales is called the Output Tax. This goes in the first box on the return and is due to be paid on to Customs & Excise.. If you have purchased any goods from another European Union country, then the Tax element of those purchases should go in Box 2. Boxes 1 and 2 are then added to complete Box 3. Tax elements of the purchases made in this country and in the EU, known as Input Tax and due to be reimbursed to you by Customs & Excise, will go in Box 4 and the difference between Boxes 3 and 4 is entered in Box 5. This is the sum owing to Customs & Excise by you or owed to you by them.

Boxes 6 and 7 contain the net amounts (after deducting VAT) of your Outputs and Inputs. You will not include any amounts that are exempt from VAT, but you will include all items that are rated for VAT. Currently, these amounts are either 17.5% (most VAT–able items), 8% (some utilities) or 0% (zero rated – this relates to items that may one day have VAT added: newspapers, etc.).

If you were to acquire all the VAT publications, to assist you in deciding what should and should not have to be included in your return, you will need about two feet of shelf space. It is worth getting the basic guide, VAT 700, plus others that you think will apply to your specific field, but don't go for the whole package or you'll never get any work done.

Generally speaking, wages, pensions and contras should be excluded from your Inputs net total and donations, some grants and contras from your Outputs total.

I say some grants, because Customs & Excise require VAT to be paid on any income if it is for a service or product that you are selling. Therefore, some grants are offered for a specific purpose and have detailed requirements to be fulfilled before the grant is payable, for instance, a grant for one performance on a specific date at a particular venue. So far, project grants, fixed term funding and regular grants fall outside this and do not need to be included in your total of Outputs.

The final boxes on the form, Boxes 8 & 9, are for information on EU activities. If you are involved in transactions with EU countries, you will also have to complete returns analysing those. You are requested to obtain the VAT numbers of all the trading partners to enable Customs & Excise to do juggling acts with inter–nation taxes.

Again, it is a legal duty to collect the tax on behalf of the Customs & Excise and they have sweeping powers, similar to those of the Inland Revenue. It is likely that you will receive a visit on a two–yearly cycle from an Inspector and – unless you are particularly evasive and unhelpful – they will not be heavy with you. They enjoy finding some fault with your system, but they also point out ways in which you can make your life easier.

Q – Can you explain Contras?

Steve – An interesting aspect of book–keeping is the contra item. This causes quite a lot of work for no reward, but it is an essential element of small organizations living on the brink.

The basic premise is that the amounts of money involved are not yours and have no net effect on your books of account. But the money does pass through your hands. Take the following example. You are running a medium-size organization and you have several bank accounts for specific purposes. In error, you pay for something from the wrong account and do not realize this for some days. To cope with this, you enter the payment in your Cash Book in full in the Contra column. Your 'correct' account immediately reimburses the 'wrong' account and that income is entered in the income side of your cash book in full in the contra column. No deduction of VAT takes place, as the basis of contras is that the full amount is cleared and balances to zero each occasion.

Q – Any tips for Credit Control?

Steve – You have issued a number of invoices to various people and organizations for work your company has done or is about to do. Conversely, you have received a number of invoices in from suppliers of goods or services. Being a reasonable person, you agree to pay all these incoming invoices as near as possible within the terms stipulated, usually within 28 or 30 days. However, not everyone is quite as upstanding as you and you soon discover

that your funds are flowing out a little faster than they are flowing in – your debtors (those that owe you money) are increasing in number and value and your creditors (those you owe money to) are staying roughly the same in number and value. This is the time for a little Credit Control. You decide that, having agreed terms of payment with your customers, you will have to find ways of making them stick to them.

Traditionally, it starts with a reminder – a statement, perhaps, of outstanding invoices, with a gentle phrase on it about how you are starving, please pay. This is sent out as near to the end of the terms of payment period as you can. One or two organizations ignore these. If you are feeling especially benevolent, you may send out a second reminder or statement, about one month later than the first. Or you may not. You could 'phone them instead and suggest that they either query the bill or pay up by a date that you advise them over the 'phone, say – within seven days.

Should they still fail to get the money to you, assuming they have not queried the amount, then you are faced with a problem. It is likely that you may know of special circumstances forcing the debtor to delay paying you, inasmuch as it is a small world in the arts. You may need to discuss this with someone further up the decision–making process and treat the situation with some sensitivity – you will be thanked for this in due course, I hope.

On the other hand, you may be faced with an attitude that delights in forestalling payment, in which case you have to take the gloves off. You can first advise the culprit that you intend to charge interest from a specific date at a nominated rate on the outstanding debt. Then, if the debt is of sufficient magnitude, but not over the limit – currently £3,000, you can contact your local County Court for an application to recover your debt through the Small Claims Court. You should only do this if you think that you have some chance of getting your money, as it takes time and effort to follow this route and often ends in limited success.

Lessons should be learnt from this. Be firm with customers from the outset. Do not give credit unless you judge the customer to be reliable. Give realistic amounts of credit; that is, set a limit of outstanding debt for each customer that you could live with. Put your terms in writing – the different interpretations on verbal agreements defies calculation. Be prompt in your attention to following up outstanding debts. If a previously reliable customer starts to go a bit wobbly, reduce the credit allowed, either in value or in time to repay.

It is obvious to all that the money owed to you is better sitting in your bank account than in the debtor's, as far as your business is concerned. The control of the credit you allow is extremely important and has often meant the difference between a successful future and a failed one.

Q – What about Audits & Independent Examination?

Steve – After the end of each financial year you will be required to produce, if you are a big enough **Charity** or if you are a Limited Company, audited accounts; that is, accounts that have been checked by an authorized external agency – an auditor. These usually take a couple of months to get checked and, as you will be awaiting some information for a time after your year end and before you submit the accounts for audit, the whole process of getting the audited accounts back in your hands can take around four months.

You are required to hand the accounts to the Registrar of Companies within a given period from your end of year. However, you are also required to have an Annual General Meeting of your board, if you are so structured, within a period specified in the Articles of Association and usually around six months after your year end. The audited accounts must be approved and signed by the board, often at this meeting.

If you are a small enough **Charity** you may decide to use an Independent Examiner to check your accounts. If you do, you should be sure that they are approved by the Charity Commissioners and that they are not: a trustee; involved in the administration of the charity; a major donor or beneficiary; or a close relative, business partner or employee of any of the above. They are required to produce a report for the Trustees/Board – a copy of which is lodged with the Charity Commissioners.

When you receive the audited accounts back, they will have a statement by the Auditors, confirming the accounting conventions within which they operated and that they were happy with what they found or some comment on how they have some reservations about particular facets of the audit. There will then be a statement from the chairman of the board, or director, followed by an Income and Expenditure Account (assuming you are working in the 'not–for–profit' sector; the profit–making companies have a 'Profit and Loss Account', instead), a Statement of Financial Activities (new in 1996), a Balance Sheet and various notes to the accounts.

The Income and Expenditure Analysis shows how much surplus or deficit was achieved in the period in question (usually a year) and the Balance Sheet will show the worth of the organization. Both of these reports are snapshots of the general health and well–being of the organization on one day only, but it is generally considered a fair and as accurate a way as is possible. The notes usually expand on the information in these two reports.

These are draft accounts and can be discussed with both the Board and the auditors, prior to them being accepted and signed by the Board.

Q – What do we need to know regarding Employment?

Steve – If you are expecting to employ people, you will need to discover or decide whether any of them will be paid on the Pay As You Earn system of taxation or whether some or all are self–employed. As you are not likely to know in the first instance the tax status of those who will work with you, it is better to be prepared and register with your local office of the Inland Revenue as a tax collection agency, then follow the rules set out in the information pack that you will subsequently receive.

Basically, you will need to calculate, from the tables supplied, how much tax to deduct from an agreed wage or salary and, in a like manner, how much National Insurance you need to deduct. Manually, this calculation is easiest done on a form P11 – you will need one for each employee. If you have a computerized system, then you should look at acquiring a payroll package. However, this is probably only worthwhile when you have more than ten employees. Every month, by the nineteenth of that month, you will have to pay these deducted amounts, plus an added employer's element of National Insurance, to the Inland Revenue.

The individuals must be able to work for you, and, if unemployed, it must be made clear to them that they should declare their earnings and/or sign off. Ideally, each new employee will have a P45, which is an analysis of their earnings to date in that financial year. If they do not have one, you will have to follow the appropriate guidelines laid out in the information pack. Likewise, if an employee leaves your company, you will need to issue a P45 for them to take on to the next organization.

If these new employees are foreign nationals, you will need to contact the Foreign Entertainers Unit (F.E.U.) of the Inland Revenue and then negotiate with them how much tax, if any, you will need to deduct. If the engagement will result in payment of under £1,000 to each individual, including expenses, then you do not need to deduct tax. You will still need to report any payment on a quarterly return, however. If more than £1,000 is paid, then you will need to produce information to show how much income each employee will expect, after their expenses have been met. The F.E.U. will then agree a level of tax deduction that you will have to make from the employee's pay and which you should pay over to the F.E.U. when you make the quarterly return. The negotiations with the F.E.U. should be done at least a month before the engagement is due to start, wherever this is possible.

If your workers are self–employed, you will need to acquire their Schedule D number for your proof, in case you are asked for it by an Inland Revenue Inspector. You will then pay them gross the agreed sum, unless they specifically ask you to deduct National Insurance contributions. In this latter case, calculate from the tables supplied, and pay the deducted

amounts, together with the monthly Tax and N.I. deductions from PAYE staff, to the Inland Revenue.

At the end of each year, you will be required to produce a synopsis of the Tax and NI activities over the year, plus other expenses details, if relevant, on forms supplied for that purpose. P14s/P60s are the individual record for each employee that you have had in that tax year, and it gives a summary of the year's activity. The P14 (top copies) go to the Inland Revenue and to the Benefits Agency (NI) and the bottom copy, the P60, is given to the employee. You are not expected to have a copy at the office, but it is wise to take a photocopy. Someone always loses theirs. P35s are the forms on which you report the total tax and NI activities of the company.

With the new regime of self assessment, you are required to produce or have available even more information on expenses and benefits that your employee might have received, so make sure that it is all kept up to date throughout the year.

Check with the Inland Revenue office for further information on your duties as an employer. It is a legal requirement to keep these records and to make the payments as due. The Inland Revenue inspectors are said to have greater powers of search and questioning than the police.

Q – What is the lowdown on Credit Card payment?

Steve – If you are selling multiple items, be they tickets to performances or hundreds of artefacts, on a regular basis, then you should enquire as to the logistics of taking credit card payments. Your bank will advise, or you could ask another bank. You do not have to go with the system operated through your own bank if you don't wish, as you may well get a better deal from a rival. Yes, a deal.

You have to pay a commission for the privilege of collecting money via credit cards and it is not a small amount. Depending on your expected turnover via credit card sales, you will have to pay between 2.25 and 3.5 percent of all your income from that source to the card company. You do have some opportunity to negotiate, but it is limited. American Express and Diners are the most expensive to take, with little to choose between Visa and Access/ Mastercard. If you take Debit cards as well, there is usually a fixed fee, around 25p, for each transaction.

If you do decide to take credit or debit cards, then do be aware of the potential frauds that can be perpetrated with them. Your card company will advise, so follow their guidelines and tips.

Q – What about Contracts?

Steve – When it comes to handling contracts, unless you are a lawyer, try and use one. Either a free hearing with a board member, or advice from a friendly one or – in the last resort – a paid one.

A contract, whether it be initiated by you or whether it is being offered to you, is a minefield for the unwary. There are specific contracts which you may be able to use 'off the shelf' that are tried and tested, for terms of engagement say, available from an organization which supports your art–form, but mostly you will need advice.

Contracts often come attached to sales people and these can be the most dangerous. Never agree on the spot, especially when offered what seems like a tempting deal for, say, a photocopier. Always take time – days or weeks, perhaps – to think. After all, you may be committing your organization to paying well over the odds for something for far too long and even to acquiring something that you just don't need. Look out for penalty clauses tucked away inside contracts, as well. Again, try to take advice. Do not be rushed.

Q – What is the situation with returns for funding bodies?

Steve – As mentioned in the **Budgets** section, returns for funding bodies will vary and will also hardly ever tally with your own reporting requirements. Nothing to do but make the best match you can. If you are forewarned of the requirements, you could make allowances for analysing your figures in a slightly different way to accommodate the other bodies' needs. The golden rule is, if you have a problem of comprehension or logistics in completing a return, ask the funding body themselves for assistance.

Q – Any final tips? Sources of further information/training?

Steve – You can't be expected to know everything about finance, but you should be able to know how to find out most things. I hope this bit will assist you in that process. If you wish to train to become a financial controller or a book–keeper, then you should consider joining the Association of Accounting Technicians, the Book–Keepers Association or one of the number of Accountancy organizations (providing you are of a sufficient standard), as a student. You can then take the relevant course by day school, night school, or by distance learning.

It is more likely that you won't have either the time or the inclination to start with and you just need all the help you can get. Try one of the many support organizations for your field of artistic endeavours and you will be sure to find some assistance in either the broader terms or in specifics. Libraries are always of great help in providing the material, as long

as you know the problem and the potential source of information. You don't need to buy any of the hundreds of books on various aspects of finance; just find or order them through your local friendly library.

If you do want a book to refer to, two spring to mind immediately and are listed below. Don't be afraid to ask the official bodies for help and advice, be it the Inland Revenue, Customs & Excise, the bank, the specific funding agency, the Charity Commissioners or whatever. They all have resources at your disposal, either a library, pamphlets, publications or someone to talk to. There should always be someone available on your company board for you to discuss finance with; if there isn't try to get someone on with sufficient expertise as soon as possible.

The Arts Council of England produce a series of **Fact Sheets**, some of which cover financial aspects of administration. It would be useful to get on their mailing list. The Directory of Social Change publish a number of useful documents, including a very good guide to all this, called **Accounting & Financial Management for Charities**, by Michael Norton and Hilary Blume, revised 1989; if you only have one book, this should be seriously considered. Some of the information will be out of date, but the bulk of it is good.

The National Council for Voluntary Organizations also publish a variety of documents of use, including **Organising Your Finances**, by Maggi Sikkin, 1987, another useful item for your late–night reading. The Charity Commission produce a number of publications, many free, which will be of specific and general interest.

Your bank will have some literature to offer. The Inland Revenue have a few pertinent leaflets to refer to, from setting up in business, to specific aspects of employment law. Customs & Excise have hundreds of documents, none of a general finance nature, but all relating to aspects of VAT.

If you have read this from end to end, you won't necessarily know it all, but you are certainly thorough and that is a very good thing.

Good luck.

Charlotte Jones
ITC

Q – What can an artist or company approach the ITC for?

Charlotte – ITC (Independent Theatre Council)is a UK Management Association for companies and individuals in the performing arts. ITC believes that good art thrives on good management and looks to support individuals in organizations in all aspects of their development.

ITC currently has 500 companies, venues and individuals in membership. Members can receive management, legal and financial advice. Training courses covering many areas of arts management complement this. Individuals have access to a Continuing Professional Development (CPD) program.

ITC also provides a range of networking opportunities, conferences, publications and help–sheets and a regular newsletter and web notice board.

New organizations can use ITC's special Incorporation service to register as a Limited Company and apply for charitable status, contact: www.itc–arts.org.

Q – What are the first steps one should take when setting up a company?

Charlotte – Choose a unique name.

Decide the direction of the company:

If you want a commercial structure a company limited by shares or a Partnership would be most appropriate for this.

If you intend to seek public funding or become a registered Charity a non–profit distributing structure (or company Ltd. by Guarantee) would be most appropriate.

If you want to seek Charitable Status you will require an independent, volunteer board of directors (a minimum of three).

If you choose to become a limited company registration takes about two weeks. Application for charitable status can take two months.

To be a limited company you will also need:

- A Company Secretary
- Registered Office (can be your home or solicitor's/accountant's office)
- Memorandum & Articles (Constitution)

Q – Just what is the best type of company status? Partnership? Limited by Guarantee? Co–op? How to pick the right one?

Charlotte – There is no short answer as each case is different. ITC can advise according to your particular situation. For an organization wishing to apply for public funding or grants from trusts, however, a non–profit distributing structure such as a company limited by guarantee is the most appropriate.

ITC's incorporation service offers advice, drafting your memorandum and articles and a full registration service.

Q – What about solo artists? Are they supported by ITC? Do they need to register as a limited company? Does the same scenario regarding status hold true?

Charlotte – People can join ITC as individual members and access a variety of networking and development opportunities. ITC members do not have to be a Limited Company.

Q – Most artists work freelance – what legal/financial steps should be taken in terms of tax, National Insurance, etc.?

Charlotte – This is not strictly true. The majority of performers are recognized as self–employed by the Inland Revenue but as employed by the Contributions Agency (known as the 'Theatre Anomaly'), when working with theatre and dance companies and venues using the ITC/Equity contract.

Keep all records of any work done, income and expenditure for self–assessment purposes.

ITC offers advice to its members on these complex issues. You should also contact the Inland Revenue for guidelines.

Q – Does the whole Equity thing still apply?

Charlotte – The closed shop no longer exists. However, ITC is committed to good management practice and has negotiated minimum terms and conditions with Theatre Industry Unions for Performers, Stage Managers, Directors, Designers, Administrators and Writers. Companies with ITC 'Approved Manager Status' can use these contracts and benefit from the ITC/Union disputes resolution service.

Q – Should a company employ an accountant?

Charlotte – Companies with a turnover above £90,000 require an audit or accountant's report. An accountant can be useful, however, and potentially save the company money. Many funders require organizations to present audited accounts even if their turnover is below the threshold. For more details on audit exemptions it is best to contact Companies House.

Q – What is the secret to a successful company?

Charlotte – Every new company is started by huge amounts of creativity, enthusiasm and vision. The companies that manage to really hold on to this vision feed creativity into all aspects of their work, whilst at the same time maintaining a high level control over financial management systems, investing in their people and maintaining a highly professional edge in all their workings.

Some of the things you might do towards this might include:

Prepare own contracts to use with venues and employ staff.
Get anything you do in writing, don't assume anything. A verbal agreement is not sufficient.

Nurture the deal. This is a people orientated industry and good communication is key. Once you have these things in place, you leave yourself room to develop your creativity.

Ursula Smartt
Performance,
Multimedia and
Copyright Laws

Q – From a legal perspective, does a performance company or self–employed artist really need to be officially registered?

Ursula – It is important that the business, as well as the artistic side of a performer's career, is managed professionally. All individuals involved in the music, artistic or performance business must manage their individual affairs as well as possible. Do not forget about the Inland Revenue! All income should be recorded and accounted for, as should all items of expenditure. The type of artist in question is important. An individual could consider running his/her affairs as a sole trader or a company. A group of musicians may consider running their business as a partnership or a company. I would always advise that performance companies or individual artists seek an agent in their performance or arts field, be they an accompanying pianist, a mime actor or a fringe theatre company wanting to perform at the Edinburgh Festival. The agent will then handle not only the marketing side of the 'deal', make sure that the artist or TV script writer gets regular work, but also handles the legalistic side with a suitable solicitor in the field of creative art or performance–related work.

Let's look at the 'performance company' example. To set up a limited company, the group can buy a ready made company 'off the shelf' for around £125 (including VAT). Say, for instance, the four 'Punk Brothers' want to set up a company. Their solicitor would ring a company formation agent; she would then receive in the mail the company documents; these include a certificate of incorporation, a memorandum and articles of association, and blank share transfer forms, which would be signed by the subscribers. Buying a company 'off the shelf' in this way means that the Punk Brothers' company is dormant, i.e. it has not yet traded. If necessary the name, the objects, the capital and articles can be altered to coincide with the wishes of the shareholders. The one share held by each of the subscribers (each brother) to the memorandum of the company will be transferred to the four brothers. An equal proportion of shares will be issued to each of the brothers, who will all become directors of the company to enable them to participate in the management of the pop group. At this stage, the four brothers still own the assets of the partnership business; at

the same time, the four of them hold the shares in the dormant company. The assets will then have to be transferred to the company by sale or lease; this might include vehicle registration licences, insurance policies, instruments, premises, etc. Say the assets amount to £40,000 – then this will be issued capital 'in kind' rather than cash.

The practical legal position of a company is that the four brothers meet in an 'annual general meeting' (the AGM) to appoint directors. There should be no fewer than two directors, and there is no upper limit as to the number of directors. In reality, they probably do not bother to hold formal general meetings as shareholders, but merely draw up (or rely on their agent or professional adviser) minutes of the AGM which they then all sign. An AGM of all shareholders must be held every year (Companies Acts 1985 and 1989). If the company is doing well, the brothers take their income by way of salary. Realistically, the company will not make any profits for the first few years (but maybe, your pop group is so successful that profits can be recorded after the first three years).

The brothers now own the company through their shareholdings, whilst the company owns and will run the business. I will not go into capital gains tax here, since it is assumed that the start–up company will be very small. Though do watch out for tax payments – you ought to put money aside for tax purposes into a separate bank account, which you will then draw on, usually, in three years' time. If the company gets into financial difficulty and is unable to pay its debts (e.g. a bank overdraft), the bank may require each of the brothers to pay off to the bank what the company owes. The effect of this is immediately to destroy the benefit of limited liability in respect of liability to the company's principal creditor. If the company is wound up through death or bankruptcy, a liquidator may divide among the members the whole or remaining assets of the company between the members of the company. But in reality, the principal creditor, usually the bank, will liquidate the remaining assets. Since we are talking about a limited company, this means the director or shareholders (the brothers) are not personally liable in the case of bankruptcy. You might, of course, be asked by the moneylender for example the bank or mortgage company, to give personal guarantees. You must avoid this at all costs.

Q – What about insurance coverage? Does everyone in the company need insurance?

Ursula – The short answer is 'yes'. Every artist and self–employed person should not only automatically think about house or flat [apartment] contents, or car insurance, but also consider some form of personal risk– and/or indemnity and/or life insurance. Has the pianist insured his hands, for instance, as some famous tennis players have insured their legs? Has the camerawoman insured her expensive equipment? What if arthritis strikes the young violinist's hands? This could be the end of her career if she has not sufficiently insured herself. But alas, many individual performance artists (who are not a 'company') work on simple hire, session–type terms and tend to have no insurance. Be sure you spot the

force majeure clause in any insurance contract which deals with unforeseen circumstances beyond either party's control (for example when the Guns 'n' Roses concert had to be cancelled because the stadium was declared unsafe, in Gamerco SA v Fair Warning Ltd. [1995] EMLR 263). This is where 'frustration' of a contract may occur which will not entitle you to compensation.

Additionally, each artist ought to think about taking out a private pension scheme since the state pension will not tide him/her over by the time they get to 60!

Q – Are there certain articles or provisions artists should look out for in signing or drafting contracts with venues?

Ursula – The artist needs to make sure that no unfair obligations (liabilities) are being imposed on him/her and that s/he is not being asked to give warranties that s/he cannot give. It is impossible to say precisely what provision s/he should look out for as contracts vary wildly! The artist should take advice in each instance from a good professional lawyer in his/her field. Although a contract may be oral, ideally the terms should be set out in a written agreement which is signed by both parties. All negotiations should generally be conducted 'subject to contract'.

The terms to any contract agreement should be as comprehensive and certain as possible. They should be express terms, i.e. clearly spelt out between both parties and written down. You might be required to sign a 'lock–out' agreement in which you agree that you will not negotiate with any other party or parties, or play/perform, etc. elsewhere. In short: that for a specified time, you will not go elsewhere.

Basic contract checklist:

1. Who are the parties?
2. What rights are granted to whom? (copyright)
3. How exclusive are the rights?
4. For how long are these rights granted?
5. Terms should deal with the 'when' of an agreement (duration)
6. Where can the rights be exercised? (venue)
7. How much is the agreed fee? (payment terms)
8. Frustration (events that occur beyond either party's control)

A well drafted contract should contain all the above (express) terms, dealing with start and termination of contract agreement (fixed term) and frustration (for example *force majeure*). Always seek additional independent advice before signing any agreement. Don't rush into things, no matter how good the deal might sound!

Q – Are there any common liability issues for performers?

Ursula – This really links in with the 'insurance' question. Individual performance artists really should take out personal indemnity/liability insurance. What if you damage hired pieces of equipment, such as a Stradivarius violin, or some digital sound or lighting equipment? The company running the venue might well sue you personally for damage. Alternatively, what if you are let down by a venue, or you are not paid for your performance? You could then claim on your insurance for loss of earnings or profit or time wasted.

One additional piece of advice is possibly to join a professional association or trade union, for example the Musicians' Union, Equity or the National Union of Journalists [NUJ]. If you also teach as part of your career, the Association of University Teachers [AUT] also covers part–time workers (for example musicians; technicians; librarians; performance artists etc.) and will give you legal protection whilst at work, and travelling to and from the workplace; professional associations will also insure your equipment, such as your instruments or work tools, and can, of course, negotiate salaries and terms and conditions on your behalf. Here is a list of the most useful associations:

For Composers and Publishers
The Performing Rights Society (PRS) – for standard licences in 'public places'
The Mechanical Copyright Society (MCPS)
Video Performance Ltd. (VPL)

For the Record Industry
Phonographic Performance Ltd. (PPL) – negotiates and issues licences for broadcasting and public performance of sound recordings.
The British Pop Industry (BPI) – for record companies. Administers UK charts and Brit Awards. Anti–piracy and bootlegging.
Musicians Union (MU)

Generally for media and new media artists
Performing Artists' Media Rights Association (PAMRA) – joint venture between Equity, [actors' union], and the MU.
Artists United Recorded Association (AURA)
International Managers' Forum (IMF)

Q – What are 'implied terms'?

Ursula – As well as the express terms laid down in a contract, further terms are left unwritten or unsaid. These are implied terms, divided into four groups: terms implied in

293

fact; terms implied in law; terms implied in custom; and terms implied in trade usage. Let's deal with these one by one:

Terms implied in fact
It is assumed that both parties would have intended to include these terms if only they had thought about it; they left them out of the contract by mistake or oversight. Should there be any (legal) dispute, the courts have adopted the 'officious bystander' test and the 'business efficacy test'. The officious bystander test (laid down in Shirlaw v Southern Foundries [1926]) is something so obvious (to the obtrusive and forward observer) that it goes without saying, so that the bystander would say 'oh, of course'. The business efficacy test means that the contract would not work without this (implied) term, i.e. the parties must have intended the business terms so that the contract deal will work.

Terms implied in law
These are terms which the law dictates, usually by statue (i.e. Acts of Parliament). They are inherently present in certain contracts, like the Sale of Goods Act 1979, the Unfair Contract Terms Act 1977 or the Supply of Goods and Services Act 1982. Most contracts of employment include an implied term that an employer will supply the employee with a reference when leaving the employment. Further implied terms are that the employee and the employer will not engage in conduct 'likely to undermine the trust and confidence required if the employment relations are to continue'.

Terms implied in custom
Terms can be implied if, under local custom, they would normally be there, i.e. they are customary in a particular trade or profession or locality. This is a tricky area when you negotiate a contract abroad and you are strongly advised to seek a lawyer with legal and customary knowledge of that country.

Terms implied in trade usage
These are terms common to the trade and could therefore be implied in the performance contract.

In summary, implied terms in a contract vary in their level of importance. If there is a legal dispute the courts will seek to classify terms according to their importance, with the implications of a breach for the innocent party varying according to the type of term breached. Express terms (written and agreed) will always take precedence and a breach is obviously more significant than the breach of an implied term.

Q – What do artists need to know about copyright laws when using other media such as film, music, images in live performance?

Ursula –Copyright essentially prevents one person from benefiting from another's skill and labour or directly copying or passing off another's work. The owner of the copyright in a literary, dramatic, musical or artistic work, sound recording or film, or a broadcast or cable programme may prohibit others from broadcasting the work or including it in a cable programme service. Even if you consider making an adaptation of a literary, dramatic or musical piece of work then this too is restricted by copyright. An adaptation is defined as a 'translation' of the work or an 'arrangement' or 'transcription'. In summary, copyright owners of a song, a book or a particular recording expect to be paid for their rights.

Literary, dramatic, musical and artistic works and their 'performance in public' are now regulated by the Broadcasting Act 1990. Sound recordings and film are mostly 'derivative works'; i.e. they are based on other copyright works. The 'underlying rights' are very important here, and include all other rights in works which have their own copyright protection.

Take the example of recording a song. There is a copyright in the song itself and another in the sound recording of the song. The song is the 'underlying' piece of work. The permission from the songwriter who owns the 'underlying rights' must be obtained prior to the recording. Then there are the performer's rights and moral rights of the original artist which must be observed. Moral rights deal with the identification of the author of the work, sometimes known as the 'integrity right' and the right to privacy of certain photographs or film.

Copyright does not exist unless the following conditions are met for copyright protection:
1. the author; or
2. the country of first publication; or
3. (in the case of broadcasts) the country from which the broadcast was first sent.
Any one of these three conditions will suffice.

If a piece of work is commissioned from an independent third party, ownership of copyright should be dealt with at the time the work is commissioned. Express contractual terms should be formalized in a written contract dealing with copyright. Try to avoid implied terms! A 'licence of copyright' should be obtained in writing on terms agreed between the parties. Occasionally, the owner of the copyright (for example a songwriter or author) may assign a licence for performance or broadcasting of his or her work. The assignee (performer of that piece of work) may then use the owner's piece for repeat performances and in volume form. Such a licence may be exclusive or non–exclusive. An example might be that Donny Osmond agreed an exclusive recording licence with Decca Records or Ursula Smartt exclusively publishes with Waterside Press.

What is important to note is that each assignment you undertake will have to be looked

at in the light of the circumstances and conditions surrounding the event and the piece of original work. This is called 'consideration' in contract terms and the wording of each contract document needs to be carefully looked at – ideally by a qualified lawyer.

Q – Do the laws around copyright in live performance differ substantially from copyright laws around broadcasting? And the Internet?

Ursula – 'Live performance' in copyright terms means 'public performance'. The playing or showing of a sound recording, film, broadcast or cable programme in public is a restricted act governed by copyright and the 1990 Act. Music played in shops, over the telephone, in waiting rooms or shopping centres is regarded as a 'public performance' and a licence is required (assigned by the Performing Rights Society – PRS and/or the local authority).

Whilst we can generally say that the music business is based on the exploitation of copyright (in songs and sound recordings) and of performers' rights, the Internet remains highly unregulated. Innovative technology today presents new ways of exploiting copyright works, as the Napster case has shown. Song and sound recording are now included on computer games, in multimedia applications and in online on–demand services on the Internet and on WAP phones. Musicians tried to stop online piracy of their work being copied and essentially stolen in the Napster case (a technology company developed by a 19-year-old college freshman in 1999). The music industry became extremely concerned when Sade's single became freely available on the Internet in October 2000, before her single was even released by Universal. The Napster 'music sharing' business (by the creation of MP3 files) clearly amounted to piracy. By November 2000, the recording industry, led by EMI, started to fight complex legal battles against Napster. Individual artists such as Britney Spears and R. Kelly, and groups like Steps or Backstreet Boys, took Napster to court for unlawfully copying their CDs.

Even though the US Supreme Court eventually ordered Napster to stop, there is nothing to stop future 'pirates' to develop new systems. By December 2000 two British programmes calling themselves Xor and RandomDan were hoping to avoid 'piracy' problems by creating a system called Metallicster, that had no central server, so that end–users could not be identified. They issued a statement (via the Internet) that they planned to work on a 'non–trackable' system so that they could 'hack into' any music system without being noticed. Recording giant EMI tried to counteract piracy by releasing whole albums over the Internet following Napster, whilst the Recording Industry Association of America (RIAA) continues its litigation for copyright infringement on the Internet.

Q – The most common breach of copyright in performance probably occurs in the borrowing of sound recordings. What is the duration of copyright for recordings?

Ursula – There are various rules for the duration of copyright which depends on the type of work under consideration. Sound recordings and films are covered by the 50 year rule. Here the copyright lasts for 50 years from the end of the year in which a sound recording was made, and if not released immediately, the copyright will expire at the end of the period of 50 years from the end of the calendar year in which it was released. 'Released' means when the recording or film was first published, i.e. played in public, broadcast or included in a cable service. The term of copyright in films is increased to 70 years from the death of the last to survive from the principal director, the author of the film screenplay, the author of the film dialogue and the composer of music specifically created for and used in the film. 'Author' here extends to the principal director of the film, but does not apply to films made on or before 30 June 1994.

Q – And what is the difference between this and the duration of copyright for a script or score?

Ursula – Literary, dramatic or musical works are now covered by the extended 70-year rule as laid down by the Duration of Copyright and Rights in Performances Regulations 1995 (DCRP). Potentially, this can amount to perpetual copyright. There are some general guidelines under Section 12 of the 1995 Act:

Copyright lasts for 70 years after the end of the year in which the author dies (i.e. from the end of the calendar year in which the author dies);
Copyright in a work of unknown authorship expires 70 years from the end of the year it was written; or 70 years from the end of the year it was made available to the public.

Copyright will not be infringed if:
it is not possible to ascertain by reasonable enquiry the identity of the author, and
it is reasonable to assume that the copyright has expired; or
the author died 70 years or more before the beginning of the calendar year in which the act in relation to the work was done; or
where the work is anonymous.

Q – How can an artist acquire copyright protection for their work?

Ursula –There is no need for registration of copyright (unlike other types of intellectual property – patents, design or trade marks – where there is a requirement to register). Copyright is a right to stop others from copying works without your permission. There are many diverse categories covered by copyright, such as architecture, installations, dress design, computer software, etc. For instance, copyright arises automatically in a sound recording as soon as it is made (provided it is original), or in a written work as soon as it is 'recorded' in writing, or in a photograph as soon as it is taken and developed. The author

or creator of a piece is the first owner of the copyright in the work. It is that person who can deal with the copyright in the work. The author of a sound recording is the producer; the authors of a film are the producer and the principal director – therefore a film is usually a product of joint authorship.

Authors frequently sign contracts granting rights to individual and companies. These agreements may entitle others to some or all of the rights in the work. It should usually be obvious as to who is the author of a given work (for example with a novel it is the person who wrote it). 'Ghost writers' (for example a person who writes an 'autobiography' for a famous pop– or football star) will be covered by a contract between the person who wrote the book (the author) and the person in whose name the book will appear. In a news story it is usual to give the source of a story or news item unless agreed by contract. For instance, the BBC does not attribute to the Reuters news agency, because this has been agreed by contract. Reuters in this instance is regarded as 'source' of information; if whole stories or quotations are used, then the 'source' has to be attributed verbatim.

Important guidelines to authors

1. name a piece of work
2. put your name firmly on the piece of work
3. date the piece of work
4. put a couple of copies away for safekeeping (for example saved on floppy disc with friends or family)

Q – Can you acquire copyright protection for an installation or performance with no written script and no actual 'object'?

Ursula – Copyright only protects the expression of ideas. There is no copyright in a mere idea. Common ideas or themes do not merit copyright protection of their own; the story has to be written down first, the installation has to be installed, the photo has to be developed. Literary, dramatic, musical and artistic works must be recorded in writing or otherwise – then copyright exists immediately. Copyright is an intellectual property right and the Copyright Designs and Patents Act 1988 (CDPA) is the principal statute governing UK copyright law (though this was in parts amended by the Copyright Regulations Act 1995 and the Copyright and Related Rights Regulations Act 1996). International copyright is governed under the Berne Convention and the Universal Copyright Convention (UCC). Under the UCC, the copyright work must contain the © copyright symbol along with the name of the copyright proprietor and the year of first publication. There is no requirement for such a mark under UK law though it is advisable for international recognition. Under US law any piece of work would have to be properly registered for full protection (write to: The Register of Copyrights, Library of Congress, Washington DC, 20559, USA).

Q – If an artist were interested in reading up on Intellectual Property laws and precedents, where would you suggest as a good source of information on this rapidly evolving subject?

Ursula – Useful, but not necessarily easy accessible texts, are:
Flint, M. (1997) A User's Guide to Copyright, 4th Ed., Butterworths, London.
Nelson, V. (1998) Entertainment and Broadcasting Law and Practice, Sweet and Maxwell, London.
Carey, P. and Verow, R. (2001) Media and Entertainment Law, Jordans, Bristol.
Alternatively, go into Amazon.co.uk's search engine and look for a book on copyright and intellectual property related to your particular area of artistic expertise.

Q – What legally constitutes a 'public performance'?

Ursula – The CDPA 1988 (sections 19 to 25) largely regulates and defines this term. The 'public performance' (i.e. live) of a literary, dramatic, or musical work in public is an act restricted by copyright. Playing a recording or having friends round to watch a film at home will not be a public performance of a piece of work. Music played in shops, shopping malls, over telephones, in doctor's waiting rooms or hotels are a 'public performance'. If a film, play or gig is played in the dining hall of a university, an airport lounge or even a prison's association room, it constitutes a public performance. If you wanted to charge for your performance the performance must be live by one or more individuals. It does not need to be in front of an audience, i.e. it can be in a studio, theatre or concert hall. The performance is then protected by copyright.

Q – Who qualifies for protection under the 'performers' rights to their intellectual property'?

Ursula – This is the so–called 'qualifying individual' and means:

a citizen or individual resident in a qualifying country; or of a
corporation a limited company formed in the UK or other qualifying country (EC member state).

A 'public performance' requires a licence (for example radio and TV [BBC] licence, or one requiring Magistrates' Court or local council licensing).
'Public performance' of a work includes:
delivery of lectures or addresses;
speeches and sermons;
any mode of visual or acoustic presentation;

presentations of sound recording;
film broadcast;
cable programmes.
The right to perform your own piece of work (your copyright) is of enormous value when you perform in public (dealt with by the Performing Rights Society [PRS]).

Q – If you are performing in your own space (home, rehearsal space, studio) do you have to get any special insurance?

Ursula – How do you define 'own space'? For a performance not to be a public performance, it must be limited to the domestic situation. It all depends whether the premises you are intending to use for your performance are 'public' or 'private'. 'Places of public entertainment' (CDPA 1988, ss. 19 to 25) include premises which are occupied mainly for a variety of purposes, i.e. they are hired out for the occasional use of a 'public performance', like a live band. This might be a pub's back room or a function room at the town hall.

One note of warning on noise which can become a public or private nuisance (governed by tort law). You ought to ensure that your conduct (for example playing of an instrument or recording or display of an installation) does not amount to an unreasonable nuisance, in spite of the fact that you might exercise the act on private land or your own property. You should observe the new 'public nuisance' and 'noise pollution' laws enforced by statute (Environmental Protection Act 1990 and enforced by the Crime and Disorder Act 1998). Your local authority can now issue an 'abatement notice' in relation to unreasonable noise (after 11 p.m. and before 7 a.m.) if your neighbours have complained. An abatement notice can result on a criminal conviction at worst, eviction from the rented or council premises or certainly a hefty fine.

Q – Can you still charge for tickets?

Ursula – Only in a 'public performance' [see definition above under the CDPA 1988]. What you do in your own private home is your business and for you to be able to charge it should be classed as a 'public' (live) performance [see above].

Once again 'public performance' is defined as:

a dramatic performance (incl. dance and mime)
a musical performance
a reading or recitation of a literary work
a variety act

A licence will grant you that you can charge for multiple tickets and performances in a public space [see above]. This will, naturally, have to be declared to the taxman!

Q – Can an artist be sued for defamation for political work or work that makes explicit references to living persons?

Ursula – It depends. This is a vitally important and tricky area in the tort of defamation. You have to distinguish between libel and slander. Slander is defamation in form of the spoken word. Libel concerns the written word; this includes broadcasting, pictures, the Internet or sound recordings. Libel is now largely governed by the Broadcasting Act 1990. Libel can be extremely serious and can be actionable as a crime. Legal aid is not available, and most notorious libel cases are very expensive indeed (frequently issued by individuals against newspapers for example Elton John or Esther Rantzen) – especially when it comes to damages which can be higher than personal injury compensations. Both parties can choose to have trial by jury in the High Court. Unless you are very famous (like the writer and newspaper columnist Julie Burchill) or want to risk your savings, be very careful when you make statements or allegations against others. Slander requires proof of special damage, i.e. quantifiable in monetary terms. The defamatory statement must be understood by the 'ordinary person', i.e. the hypothetical reasonable reader is not naive.

What amounts to libel?

An intended defamatory statement against a person published with intention;
The statement must be communicated to a third party;
A re–publication of a defamatory statement (particularly tricky on the Internet for example a news website like the BBC);
False innuendo.

Can you get away with it (like the stand–up comedian Rory Bremner or the early 1990s TV Puppet Series 'Spitting Images')? If you need or want to joke about a living person in your stand–up comedy act or political sketch, or installation, you need to be absolutely sure that your claim or defamatory statement is justified, i.e. if the statement is true, for example a vicar who was convicted of bigamy (Defamation Act 1952, s.5). This may not be an easy task and many defendants eventually back down from their 'allegations' and pay substantial libel damages. Pleading justification as a defence is not easy as was proven for the defendants in the 'What's wrong with McDonald's' case proved (McDonald's Corporation v Steele and Another [1994] The Times, April 14).

What if you really believe that your statement is justified?

You must be able to prove (with supporting written or photographic evidence) that your

statement was true;

You must believe that your words were true;

Your opinion or statement must be based on fact;

You must prove that your words amounted to 'fair comment', i.e. that your words/comment should be a matter for public interest;

That your comments were made fairly and not maliciously.

This is a potential minefield for journalists and editors. Consequently, they usually ask for legal advice first if they are not sure about a publication.

Q – What if you have fallen foul of the law of defamation?

Ursula – You must offer to make immediate amends. Offers to make amends can involve:

Making a suitable correction of the statement accompanied by an apology (have a look in the daily papers; this happens frequently, tucked away in a tiny column which hardly anyone reads or sees except for the damaged party);

Publishing the correction and apology in a 'reasonable' manner;

Paying the aggrieved party compensation and costs (Defamation Act 1996, s. 2).

Q – Are there any 'self help remedies' you can recommend to an artist who is having trouble collecting payment for contracted work?

Ursula – Payment terms can be a tricky area. Contractual payment terms can vary enormously and you ought to have been specified clearly in the contract [see above] i.e. when, how often etc. (frequency) you will receive payment. This should be an express term in your contract. Payment terms can vary: the contract might provide for a 'one-off killer fee' (for example freelance journalists or photographs), a lump sum settlement (honorarium), royalty payments (preferred in the music and publishing businesses) or payment in kind. Royalties are usually a set percentage (around 10 percent) of income (net sale price) of the product in question. Remember that you can re–negotiate royalties after a while. Be bold, ask your publisher or producer to give you an advance on royalties (payment on account of future earnings).

A prudent artist should have negotiated a contract deal whereby his fee or income (payment terms) is paid directly into a bank account controlled by him/herself or the accountant. Publishing and recording income should definitely be handled this way. You can judge a company by the way and speed with which they handle your payments. If they do not perform don't use them again. If you are already famous, or the company employing you (or a publisher, film maker, theatre company, etc.) it will be in their interest to pay you as per contract; otherwise you can ask the court to set an injunction against the company, enforcing 'specific performance', i.e. payment to you. This will be handled as a breach

of contract. You can of course terminate the contract since the payment terms have been breached. If litigation is required to recover money, those costs should be added to the total payment due.

If in doubt, get a manager who will act as your agent. The relationship should be based on mutual trust and confidence. S/he can then negotiate contracts and venues for you and collect the payment for you. The downside is: s/he would also take a cut of your earnings i.e. between 15 and 25 per cent commission of the artist's gross income.

Q – And likewise, if an artist is concerned that their copyright has been breached, are there any self-help remedies you can suggest to them before invoking judicial remedy?

Ursula – If someone who doesn't own the rights to your piece of music, film script or image, goes ahead and 'uses' the piece (or worse, passes your piece of original work off as his or hers) you (the 'original artist' who owns the underlying copyright to work) can go to court and obtain an injunction which will stop the film, music or image being shown, recorded or performed. The broadcasting of a work does not essentially differ from the 'live' performance [see above]. Any broadcasting, publication, performance or inclusion of a work is an act restricted by copyright and must be honoured and attributed.

Artists should always send their works to themselves in sealed envelopes and copies to friends or members of the family. The postmark will then be evidence of the date of creation.

Contacts

Technical Contacts

http://www.iwaynet.net/~phantom/theatrelinks/index.html

massive database of links to companies under all technical headings, including
–lighting
–sound
–costume and make–up
–design
–education
–intercoms
–special effects
–touring
–professional organizations
–etc etc

http://www.techpages.net
links to manufacturers and hire companies supplying:
–stage lighting
–pyrotechnics
–drapes
–special effects (smoke, confetti etc)
–flameproofing
–staging
–etc etc
also links to professional organizations

http://www.stagetec.co.uk
general technical information and advice regarding lighting and sound
good range of links to more advanced equipment sites, e.g. moving lights

List below of selected UK based companies/organizations/publications.... these are from
my work database, and are ones I use most. Many more if you need more ...

Lighting

AC Lighting (lighting)
www.aclighting.co.uk

CCT Lighting (lanterns)

Contacts

Decoupe (lantern suppliers)

Lighting Technology (lighting)
www.technical–art–works.com

Lighting Technology (lighting and unusual lighting effects manufacturer)
www.lighting–tech.com

Stagetec (lighting)
www.stagetec.co.uk

White Light (lighting and effects sale and hire)
www.whitelight.ltd.uk

Sound

Canford Audio (sound spares and comms)
www.canford.co.uk

Studiospares (pro-audio equipment)
www.studiospares.com

Staging

Acre Jean (blacks)
+44 20 8877 3211

Blackout (blacks and starcloths)
+44 20 8944 8840

Flint (construction and tools suppliers)
+44 20 7703 9786

Unusual Rigging Ltd
www.unusual.co.uk

Effects

JEM Smoke Machine Company Ltd (smoke machines and pyros)
www.martin.dk/

Le Maitre (fireworks/pyros and smoke machines)
www.lemaitrefx.com
(this is a prime special effects company in UK, US and Canada)

MDG Fog Generators (smoke and fog machines)
www.mdgfog.com

Gobos and Gels

DHA Lighting (gobos)
www.dhalighting.co.uk

Lee Filters (gel colors)
www.leefilters.com

Rosco Entertainment Technology (gel colors)
www.rosco–ca.com

(Lee, Rosco, and Gamcolor are the three brands of gel in common usage worldwide)

Projection

Barco (video projectors)
www.barco.com

Gearhouse Video (hire)
+44 20 8900 1866

General Technical

RS Components (all electrical parts and fittings for effects, lighting and sound)
+20 8360 8600

Organizations

PLASA – the professional lighting and sound association
ALD – association of lighting designers
IALD – international association of lighting designers
USITT – United States institute of theatre technology

Publications

Contacts

The Stage
L+SI – lighting and sound international (published by PLASA) – this is the key industry publication by the way.

Artist Information –

Artsadmins Artists Bursary Scheme

Artsadmins Artists Bursary Scheme has provided much needed support to artists whose work could be defined as live art, performance, time–based, interdisciplinary, installation, new, or multimedia. The bursaries have also helped those innovative artists beyond categorization. The bursaries complement the One–to–One Bursaries provided by Live Art Development Agency for Artists with a significant body of work behind them, and the various Project, Production, and Research and Development funds provided by the Regional Arts Boards.

The bursaries offer artists time to experiment with new ways of working, to practically research or take an idea further, or to further their creative process without the pressure of having to realize a final outcome or 'product'. Bursaries of up to £4,000 will be given. The bursaries will be a combination of artistsí fees, material costs, access to studio space, video cameras and Media 100 editing facilities at Toynbee Studios.

Artsadmin is raising funds from various sources to continue this unique scheme. For more information e–mail manick@artsadmin.co.uk to be put on the mailing list.

Workshops

It is rare for artists from different disciplines to come together in a workshop context that is based on theoretical, conceptual and practical performance issues. Artsadmin has set up a regular workshop group that meets one Sunday each month facilitated by the award–winning performance artist Gary Stevens.

Gary Stevens Performance Lab attracts up to twenty artists at any one workshop, and is open to new participants.

If you're interested in joining the performance lab, please send your CV and a letter of interest to Manick Govinda at Artsadmin.

FAQ

Whom do I go to for financial support?

Raising money to support yourself and your practice is not easy. It takes talent, patience and an understanding of how funding bodies operate. You also need to show some strong evidence of your work to date. Normally this will mean that you have made and shown work within a professional context at a gallery, arts centre or public venue or that you have strong support from a producer, programmer or curator who is willing to advocate for you. It's worth doing your homework by researching into what sources of funding exists. There are a number of web–sites that are worth checking out:

http://www.artscouncil.org.uk
An important website providing comprehensive information on the national role that the Arts Council of England and advice for artists and companies. It also details all their funding programmes.This web–site contains information about all 10 English regional arts boards and their funding programs and strategies as well as highlighting some of their 'flagship' projects they've funded.

http://www.acf.org.uk/
The Association of Charitable Foundations is a membership body for grant-giving trusts and promotes good practice in grant–giving. They do not give advice and information to grant–seekers except in the information obtainable from their website. Lots of useful tips in approaching trusts.

http://www.nesta.org.uk
The National Endowment for Science Technology and the Arts support great ideas. Most of their schemes function through a nomination rather than an application process. However, they do have a few open schemes.

http://www.AandB.org.uk
Arts & Business formerly known as the Association for Business Sponsorship of the Arts helps to develop creative partnerships between business and the arts. They have information on some sponsorship schemes such as the Creative Briton awards. Also full of information and advice on matching business skills with arts projects.

http://www.nlcb.org.uk/index.html
This is the National Lottery Charities Board website. The arts are a little peripheral to social causes, but search for information on their Awards for All scheme. A good little source of money for small organizations (not individuals) who small financial turnovers. They do consider funding arts activities particularly if they have a social or educational impact on specific communities of interest.

http://www.ahrb.ac.uk_
The Arts and Humanities Research Board (AHRB) aims to promote and support excellence

in research in the arts and humanities. In the academic year 2000–2001 the AHRB piloted an awards scheme for doctoral study in the Creative and Performing Arts. The scheme provides awards for individuals intending to undertake a PhD in the following practice–based subject areas: art and design; practice–based media studies; creative writing; drama; dance and performing arts; musical performance. A number of artists working within live art, performance and time–based media have received AHRB awards!

What networks should I know about?

Most artists who consider their art to be within the realms of live art, performance, interdisciplinary practices, or time–based, find that they fall between the cracks of many artforms. Usually these artists have made a radical departure from the conventions of fine art, dance, theatre, literature and film/video. However, there is a network out there for artists who believe in interdisciplinary work, and who are pushing the boundaries of artistic practices. For information, critical dialogs, and networking with like–minded people the following sites, individual and organizations are worth checking out:

http://art.ntu.ac.uk/liveart/letters.htm
This is the site for joining the live art discussion email list. About 400 list members send or request information, post opportunities, events and have a good or bad debate on burning issues in relating to performance and live art. The views can get a little indulgent and unkind at times, but this email list is worth joining to be kept informed.

http://www.onelist.com/subscribe.cgi/newworknetwork
New Work Network (NWN) acts as an umbrella organization, bringing together artists, producers, venues, academics and others working in the cutting–edge of performance, live and interdisciplinary art. It organizes critical dialogs on a number of relevant issues such as documentation, collaboration, fundraising as well as debates on live art theory and practice.

Further details about NWN's program of events and activities are distributed through NWN's mailing list, NWN's electronic list and the NWN pages of liveartmagazine. You can join the NWN electronic list by visiting: http://www.onelist.com/subscribe.cgi/ newworknetwork. To become a member of NWN please send your name, address, phone/ fax, email and a check for £10 (yearly subscription fee payable to New Work Network) to New Work Network, Toynbee Studios, 28 Commercial Street, London E1 6LS. After joining NWN you will receive a NWN membership card and you will be entitled to free access to all NWN events taking place within the year of your subscription. To be put on the NWN database please simply send your details to the above address. To contact NWN's administrator Sophie Cameron please phone: 07944 661760 or e–mail: newworkntwk@hotmail.com.

www.liveartlondon.demon.co.uk
Live Art Development Agency is a key strategic organization for the live art sector in London. Run by Lois Keidan (former co–director for live art at the ICA) and Daniel Brine (former Live Art Officer for the Arts Council of England), they provide practical information and advice and contribute to research, documentation and training. It also runs the One–to–One bursary scheme, a significant source of support for mid–career and mature artists.

www.liveartmagazine.com
Liveartmagazine is a national bi–monthly guide to hybrid and live art, containing previews, listings, reviews and information, news, artists' opportunities, higher education courses, funding info, and much more. Subscriptions range from £6 to £24 per annum. However, it can be picked up free at many venues (such as Toynbee Studios).

mark.waugh@artscouncil.org.uk
Mark Waugh is the visual arts officer with responsibility for live art at the Arts Council of England. Besides being the lead officer for live art submissions to the National Touring Programme his role is to also advocate and negotiate on behalf of the sector.

www.thecpr@aber.ac.uk
Based in Aberystwyth, Wales, The Centre for Performance Research (CPR) publishes Performance Research, a specialist journal published 3 times a year which aims to promote a dynamic interchange between scholarship and practice in the field of performance. CPR also runs courses, festivals, workshops and lectures.

www.arts.org.uk/londonarts
Formerly known as London Arts Board, it supports Live Art principally through the Combined Arts Unit. Paula Brown is the Principal Officer with a remit for live art. However, artists should think strategically and investigate other departments, particularly if they're work marks a radical departure from conventional artforms. The Visual Arts Unit's awards for individual artists also welcomes applications from performance art.

www.baas.demon.co.uk
Black Arts Alliance (BAA) is the largest network of black artists in the UK. The term 'black' is used as to define artists of African, Asian, Caribbean and Indigenous American (North, Central and South). It runs courses, engenders dialog and debate, produces a newsletter, puts on events, and it has a bulletin board. It's based in Manchester, but serves black artists nationally.

www.arnolfini.demon.co.uk/live/at_live.htm

Contacts

The Arnolfini is one of the most exciting arts centres in the UK committed to live art and performance. Helen Cole, in charge of Live Art and Dance, has developed an exciting program of artists from the region, nationally and internationally. Innovative programmes such as Breathing Space which offers developmental support to artists and the new festival InBetween offers a platform for debate, performance, site-specific and installation work from both 'established' and emerging artists.

www.timebase.org
Hull Time Based Arts, is a dynamic organization based in north east England, produce a busy program of performance, residencies, workshops, training and events covering everything from web streaming to improvised sound. It offers artists and users a range of ways to create and experience work, from digital facilities to networking opportunities.

The Field
161 Avenue of the Americas (at Spring Street)
New York, NY 10013
212/691–6969
www.thefield.org

Artists New Works
New York Foundation for the Arts
151 Avenue of the Americas
New York, NY 10013
212/366–6900

Other Resources
 The Foundation Center
79 Fifth Avenue (near 16th Street
New York, NY
212/620–4230
http://fdncenter.org
Complete foundation library, free to the public + online site

Artswire
www.artswire.org
On–line database with information about venues, presenters, funding sources and other opportunities

Other sites worth looking at:

www.sitegallery.org

www.fierceearth.com
www.queerupnorth.com
www.iniva.org
www.nowfestival.org.uk
www.lux.org.uk
www.axisartists.org.uk
www.sexmutant.com
www.ietm.org
www.artsonline.com
http://mediaartprojects.org.uk/remnants.html
http://www.newmedia.sunderland.ac.uk/crumb/
http://art.ntu.ac.uk/dpa
http://www.middleeastuk.com/culture/art/dialogues/artists.htm
http://www.apexart.org/hassan.htm
http://www.iniva.org/010401/html/agenda.html
http://web.ukonline.co.uk/n.paradoxa/details.htm
http://www.artnet.com/Magazine/reviews/garnett/garnett7–24–00.asp
http://212.180.102.200/afa28/act_artmond.htm
http://www.studioxx.org/metaFB/
http://www.heise.de/tp/deutsch/inhalt/sa/3472/1.html

Legal Extras

Associations/Trade unions
For Composers and Publishers
The Performing Rights Society (PRS) – for standard licences in 'public places'
The Mechanical Copyright Society (MCPS)
Video Performance Ltd. (VPL)

For the Record Industry
Phonographic Performance Ltd. (PPL) – negotiates and issues licenses for broadcasting and public performance of sound recordings
The British Pop Industry (BPI) – for record companies. Administers UK charts and Brit Awards. Anti–piracy and bootlegging.
Musicians Union (MU)

Generally for media and new media artists
Performing Artists' Media Rights Association (PAMRA) – joint venture between Equity, actors' union, and the MU.
Artists United Recorded Association (AURA)
International Managers' Forum (IMF)

Contacts

Legal Websites

Media Law Online is an excellent site for the UK. It covers, for instance, reporting restrictions in court and inquiries; defamation and Internet libel; data protection; copyright and intellectual property; and many other new media related issues: www.MEDIA–SOLICITORS.CO.UK

The Law Index gives an update on media and entertainment related cases. It is an interactive site, but really meant for lawyers by David Swarbrick ('ask David') of Wrigley Claydon Solicitors: www.SWARB.CO.UK

For US law on copyright relating to media and entertainment law there is the site issued by the US Copyright Office, Public Information Office, which you can either phone: Tel.: USA + (202) 707 3000 (Eastern Time), or go into the interactive website: www.LAWYERS.ABOUT.COM/CAREERS/LAWYERS/CS/ENTERTAINMENTLAW

Authors' Rights, human rights issues and US copyright are further handled by: www.GN.APC.ORG/MEDIA/C–RIGHTS.html

Contributors

Contributors

Bobby Baker is a performance artist based in London. During the last two decades she has produced an extensive repertoire of work, including An Edible Family in a Mobile Home (1976) and Drawing on a Mother's Experience. In 1991 she began her Daily Life series in conjunction with LIFT, a domestic quintet, beginning with Kitchen Show, followed by How to Shop (1993) and Take a Peek! (1995), which all toured extensively world–wide. In 1999 Bobby performed Grown up School at a London primary school which took place as part of LIFT. The last of the series, Box Story, takes place in June 2001. Bobby Baker is currently Time Out's Artist in Residence as part of the national Year of the Artist scheme.

Johannes Birringer is an independent choreographer/videomaker, and artistic director of AlienNation Co., an international multimedia ensemble based in Houston, Texas (http://www.aliennationcompany.com). He currently also directs the Dance & Technology Program in the Dance Department at The Ohio State University, where he has conducted 'Environments,' an experimental laboratory for dancers, visual and media artists focused on new processes of 'folding' and 'liquid architecture' to enhance the organic integration of live performance with interactive design and 'distributed choreography.'

Daniel Brine is Associate Director of the Live Art Development Agency. Most recently he was co–director of the NOW Festival and Live Art Officer with the Arts Council of England. He has also worked for the Australia Council, American Craft Museum and as a curator for a consortium of contemporary craft organizations in Australia. Daniel has degrees in architecture and art administration.

Paula Brown began her career working in agit–prop theatre and then co–ordinated Women Live, the first ever national women's arts festival. She was deputy head of Community Arts at the GLC and later worked in marketing. Paula managed the Combined Arts unit at London Arts for ten years. Her current post focuses on the development of Live Art and Circus.

Sophie Cameron is a freelance co–ordinator and has been working for New Work Network since August 2000. Previously Sophie worked for the listings and artists news section of Live Art Magazine, both during and after the completion of a BA in Contemporary Arts at Nottingham Trent University. Sophie was also a founder member of the performance company TANKS, based in Nottingham from 1997 to 1999; she then went on to complete an MA in Performance Studies at the Central School of Speech and Drama.

Laurie Beth Clark is Chair of the Art Department and Professor of Non–Static Forms (Video, Installation, and Performance) at the University of Wisconsin–Madison. She has

recently been named the Emily Mead Baldwin Bell Bascom Professor of Creative Arts. Since 1985, Clark has produced large–scale, site–specific performances and installations as well as single channel video tapes. Her work has been recognized by grants from the Jerome Foundation, the McKnight Foundation, Arts Midwest, and the Wisconsin Arts Board, and has been included in historically significant exhibition venues such as Franklin Furnace, Randolph Street Gallery, and the Cleveland Public Theatre Performance Art Festival. Clark's works–in–progress include *The Everyday Life of Objects* a physical and virtual installation about the persistence of material culture in the electronic age, and *Yahrzeit*, a video about the performance of truth.

Helen Cole is the Live Art and Dance Programmer at Arnolfini. Since arriving at Arnolfini three years ago, she has concentrated on building artist support and an openness within the program to new experimentation in the form of commissions, laboratories and works in progress. Out of this strategy there has grown an entirely new touring commissioning programme, Breathing Space, and an annual festival, Inbetween Time. Helen Cole studied as an artist, becoming an independent producer in Manchester, before moving to the Tramway, Glasgow and then to Arnolfini.

Paul Couillard has been working as an artist and arts producer since 1985. Focusing on performance art with forays into theatre, writing, holography, installation, film and video, his work has been presented around the world. Paul is the Artistic Director of FADO, a Toronto–based artist–run centre for performance art, and one of the founding curators of the 7a*11d International Performance Art Festival.

Mark Dey, Visual Arts Officer for West Midlands Arts is a freelance writer and occasional curator. He studied Fine Art at Camberwell School of Art & Design and at the Slade School, University College London and holds an MA in Arts Criticism from City University. He practised as an artist and worked for a number of galleries, including Angel Row in Nottingham and Ikon in Birmingham, before joining West Midlands Arts in 1995.

Sara Diamond is Artistic Director of Media and Visual Arts at The Banff Centre, as well as Executive Producer of Television and New Media. At Banff she is responsible for the overall development of all programmes in the department as well as The Walter Phillips Gallery. Diamond is a writer, curator and artist, working with software, performance and video. Her work about social history, gender and technology, and emotional process in computing has been featured in exhibitions throughout the world. She has taught at UCLA, CAL ARTS and Emily Carr College of Art and Design.

Toni Dove is an artist who works primarily with electronic media, including virtual reality and interactive video installations that engage viewers in responsive and immersive narrative

environments. Her work has been presented in the United States, Europe and Canada as well as in print and on radio and television. Her most recent interactive movie installation, *Artificial Changelings*, uses motion sensing to allow a viewer standing in front of a screen to move a video character's body and generate speech and music. Her current project under development is *Spectropia*, a supernatural thriller about the infinite deferrals of desire.

Tanja Farman is currently the joint Creative Producer of the Commonwealth Games Cultural Programme to be held in Manchester in 2002. She has produced six festivals as the Director of queer up north which she co–founded in 1992 and continues to run, as Europe's leading presenter of contemporary queer performance, film and visual art.

Lizbeth Goodman currently directs the Institute for New Media and Performance Research and heads the Department of Theatre and Performance Studies at the University of Surrey. She has recently founded SMARTlab (Site Specific Media Arts Labs) as portable think tank and creative laboratory. The SMARTlab Centre will open at Central St Martin's College of Art and Design in September 2001. She works as a dramaturge, performer and creator of new media tools for creative content and collaboration. She is co–creator of the Viewhear interactive storyboarding programme (Broadcast Solutions 2000) and of the Stuckontheweb experimental webcast/online narrative project (Stuck, 1999). She has written and published some twelve books on subjects ranging across the fields of feminist theatres, cultural representation, canonicity and cultural change, literature and visual/ performative cultures, women and comedy, and new media and performance. Her latest book is forthcoming from Routledge in both print and multimedia format.

Manick Govinda was born in Mauritius in 1962. He migrated with his family to London, England in the mid–60s. He has worked in the arts since 1986 as a promoter, project manager, administrator, fundraiser, grants officer for various community arts, and in local government, Black and South Asian Arts projects. His achievements have included organizing large–scale South Asian arts festivals, co–founding and writing for a pioneering South Asian arts and lifestyle magazine in the 80s called Bazaar. He played a critical role in developing and managing an awards scheme for individual artists for The Paul Hamlyn Foundation from 1993 to 1995. Manick has sat on advisory and selection panels for the Arts Council of England, The Jerwood Foundation and the London Arts Boards, and has led workshops on various aspects of arts administration. He is Artists Advisor for Artsadmin, based in London, managing an information/advisory service and a bursary scheme open to artists whose work push the boundaries of contemporary artistic practice in new performance, installation, text, sound, digital technology and projected image.

Ian Grant is a Lecturer in Modern Drama Studies at Brunel University, UK. He is also a director of interactive media strategy at an Internet design and programing house, Complete Genius, www.completegenius.com. Complete Genius is so named to help

bridge the antipathy between technical programmers, who often view design as unnecessary and designers, who often view programmers as inartistic! At Complete Genius, the artist is a technician and the technician is an artist. Ian has his own puppet and object animation company, eMotion, and uses new technology to design puppet theatre. After engaging with a PhD in interactive and applied theatre, Ian has extended his interest into the 'technological' puppet exploring computer–generated imagery, lip–synch and character animation.

Hsin–Chien Huang was born in Taipei, Taiwan in 1966. He received his BS from the Art Center College of Design in Pasadena, and his MS in design from the Illinois Institute of Design. In the graduate school, Hsin–Chien focused his study on interactive story telling. His piece *The Dream of Time*, developed in workshop class, received the grand prize of New Voices New Visions. He then collaborated with performing artist Laurie Anderson in her first CD–ROM project, *The Puppet Motel*, and her web project, *Here*, as the interactive designer. The CD–ROM was released in conjunction with Laurie Anderson's tour, *The Puppet Motel*, and became a groundbreaking work for interactive media. Currently Hsin–Chien is art–directing a Playstation 2 project in Sony Computer Entertainment America, with the hope that the console platform will become a new media for artistic expression. In his spare time, he enjoys creating strange interactive toys.

Charlotte Jones led the negotiating team for the Independent Theatre Council/Equity contract and is the author of *Working in Schools: A Practical Guide to the Partnership*. She trained at York University and the College of Law and worked for two years with Strip Search Theatre Company. *Working in Schools* is available for £5.00. Individuals can join ITC's CPD programme cross–art form initiative addressing individuals' needs; this includes handbook, meetings and events, networking. Training courses run throughout the country throughout the year.

Lois Keidan is a promoter, facilitator and consultant for contemporary performance. From 1992 to 1997 she was Director of Live Arts at the Institiute of Contemporary Arts, London and is currently co–director, with Daniel Brine, of the Live Art Development Agency, a new organization developing strategies for the support and representation of new performance in London. She also works with Catherine Ugwu as Keidan/Ugwu, an independent partnership curating and developing new performance contexts in Britain and internationally.

Judith Knight, Director of Artsadmin, started working in arts administration at Hull Arts Centre in 1970. Over the next nine years she worked at Glasgow Citizens Theatre, the Arts Council of Great Britain and the Oval House London which was at that time the centre for experimental theatre and performance in London and where her particular interest in new theatre and performance began. After completing an arts administration course, she

set up Artsadmin in 1979 with her colleague Seonaid Stewart. Over the last 21 years, Artsadmin has expanded from its original tiny office in Clerkenwell with a staff of two and has supported hundreds of the most innovative arts projects in the UK and Europe. The last six years have seen the setting up of the rehearsal space, advisory service and resource centre at Toynbee Studios in East London. Some of her own particular client companies/artists have included Pip Simmons Theatre Group, Station House Opera, Mike Figgis, Bobby Baker and Graeme Miller, for whom she has managed an infinite number and variety of projects, many of them large site–specific pieces in unusual venues.

Joe Lawlor and **Christine Molloy** are desperate optimists. They both hail from Dublin, Ireland. In 1992 they formed the company, desperate optimists. desperate optimists make works for sites, galleries, cinema, new media, live performance and publications. Having toured their work extensively on the small scale performance circuit for over six years, desperate optimists are now focusing on digital art projects and one–off performance projects. Currently desperate optimists are involved in a unique, episodic webart project, www.map50.com. They are also working on a largescale community film project, *London Framed*, which can be accessed at www.londonframed.com.

Gill Lloyd, co–Director of Artsadmin, grew up in rural Wales, took a degree in Fine Art at Cardiff College of Art, worked on a variety of jobs at and around Chapter Arts Centre in Cardiff, and ran away to London with the People Show. After five years managing the People Show and setting up their studios, Gill started work with Artsadmin, bringing into the UK and Europe shows from the Market Theatre and much other South African work, as well as working with UK based Artists and overseeing the development of Toynbee Studios.

Chris Lord has spent twenty years working in contemporary arts and public relations, as a producer, researcher, marketing consultant and journalist. Chris is currently working with Forced Entertainment, Black Dog Publishing and various Millennium funded art projects. Recent and regular clients include the New Moves international dance festival, Theatre Cryptic, and Viz films. He was responsible for marketing at CCA, Scotland's leading contemporary arts centre, from prior to its launch through to its position as Scotland's fourth most popular free visitor attraction and the recipient of the highest arts lottery award in Scotland (1991–98). He has also provided media and public relations for the National Reviews of Live Art and worked with many of the world's leading contemporary artists including Derek Jarman, DV8, Anne Teresa De Keersmaeker, Annie Sprinkle, Ron Athey and Gil Scott Heron. He is a member of the Arts Marketing Association, and sits on the West of Scotland Committee of the Scottish Wildlife Trust and the committee of the Friends of the River Kelvin. Email: karpus01@ntlworld.com

Richard Loveless is an artist/teacher/researcher and advocate for the arts in American

culture. His professional contributions include planning, managing and teaching arts programmes for schools, universities, state departments of education, and visual and performing arts institutions. Since 1991, Loveless has served as the Director of the Institute for Studies in the Arts in the College of Fine Arts at Arizona State University. The ISA is a premiere arts research institute that has funded over 160 major creative projects in its eleven–year history. Research at the ISA spans the visual arts, music, theatre, dance and new media with emphasis on innovation and collaboration within the arts and outward to other disciplines. The goal is to challenge the artist to engage digital media technologies in creative ways and thus extend their reach into wider spheres of artistic and cultural influence in the coming century.

Kathy McArdle has worked as a theatre director with many of Ireland's leading theatre companies, and as a drama worker on a diversity of innovative youth and community drama/theatre initiatives in an Irish context. She has been Artistic Director of Project since 1999 and has a wide–ranging interest in performance practice.

Frances McMahon Ward is a video and performance artist who has won several national awards for her video work, including *Push me Pull You*. She has also received awards for her interactive media performance/video work, including *Hero Construct*, which uses the breath and pulse of the body to drive image–generating software, prototyping funded by the Institute for Studies in the Arts, Arizona State University. Her recent performance/video work, *Brave Bold Girls*, was commissioned by the Phoenix Art Museum. She is a founding member and co–artistic director of Live Art Platform, Phoenix Arizona.

Tim Miller is an internationally acclaimed performance artist. Miller's creative work as a performer and writer explores the artistic, spiritual and political topography of his identity as a gay man. Hailed for his humor and passion, Miller's has tackled this challenge in such pieces as *Democracy in America* (1984), *My Queer Body* (1992), and *Glory Box* (1999). Miller's performances have been presented all over North America, Australia, and Europe in such prestigious venues as Yale Repertory Theatre, the Institute of Contemporary Art (London), the Walker Art Center (Minneapolis), and the Brooklyn Academy of Music. He is the author of the book *Shirts & Skin* and his solo theatre works have been published in the play collections *O Solo Homo* and *Sharing the Delirium*. Since 1990, Miller has taught performance in the Dance and Theatre departments at UCLA and Cal State. He is a co–founder of the two most influential performance spaces in the United States: Performance Space 122 on Manhattan's Lower East Side and Highways Performance Space in Santa Monica, CA.

Thomas Mulready – As Founding Director since its inception in 1987, Thomas Mulready directs the Cleveland Performance Art Festival and Archives, the largest festival of performance art in the world. This multi–week festival annually featured over 100 artists

from around the world presenting performance art work, lectures, workshops, residencies, educational programmes, and showcase opportunities in collaboration with area schools, theatres, universities, art centers, shopping malls, night clubs, museums and public spaces. Since 1999, the festival has focused on its Archives of over 6000 photos, 2000 hours of video, artist bios, critical reviews and ephemera, and is developing exhibitions, DVD and video programmes, and interactive web sites to make performance art material available to the public.

Tony Nandi has been a professional photographer working in the performing arts in London for 25 years. His performance photographs have been widely published and he has been closely associated with the Laban Centre, one of the UK's leading centres for experimental dance. He is currently head of the photography department at the London College of Music and Media.

Guillermo Gómez–Peña's performance and installation work has been presented at over five hundred venues across the U.S., Canada, Mexico, Europe, Australia, the Soviet Union, Colombia, Puerto Rico, Cuba, Brazil and Argentina. The outcomes of Gómez–Peña's career have centered around his life mission: to make experimental yet accessible art; to work in politically and emotionally charged sites, and for diverse audiences; and to collaborate across racial, gender and age boundaries as a gesture of citizen–diplomacy. Chronicles and scripts of his large–scale projects can be found in five of his books: *Dangerous Border Crossers* (Routledge, 2000), *Codex Spangliensis* (City Lights, 2000), *Mexican Beasts and Living Santos* (PowerHouse, 1997), *The New World Border* (City Lights, 1996) and *Warrior for Gringostroika* (Graywolf, 1994). Gómez–Peña was a founding member of the binational arts collective Border Arts Workshop/Taller de Arte Fronerizo (1985–1990), which was featured in the 1990 Venice Bienale, a contributor to the national radio program Crossroads (1987–1990), and editor of the experimental arts magazine *The Broken Line/La Línea Quebrada* (1985–1990). In addition to his artistic activities, he is a regular contributor to the national radio news magazine *All Things Considered*, a writer for newspapers and magazines in the U.S. and Mexico, and a contributing editor to *The Drama Review* (MIT). Among numerous fellowships and prizes, Gómez–Peña was a recipient of the Prix de la Parole at the 1989 International Theatre of the Americas (Montreal), the 1989 New York Bessie Award, and the Los Angeles Music Center's 1993 Viva Los Artistas Award.

Nancy Reilly McVitie is an American interdisciplinary artist and senior lecturer on the Contemporary Arts degree at Manchester Metropolitan University. She spent the 1980s on the New York contemporary performance scene. As a performer / deviser she had the privilege to work with Richard Schechner, Richard Foreman and Mabou Mines. Her most significant collaborations were with The Wooster Group under the artistic direction of Elizabeth LeCompte. Reilly–McVittie was a Wooster Group associate for eight years and helped to develop four major works with the company, including the seminal, *LSD...Just*

the Highpoints.

Vanessa Richards is the artistic directors of Mannafest, a leading urban arts conduit delivering international platforms for the razor's edge of ultra–dimensional Blackcreativity. Formed in 1995 by Artistic Directors Khefri 'KA'frique' Riley and Vanessa Richards, Mannafest began as an idea for a collaborative multimedia show. Mannafest endeavour to maintain an intelligent hub of productivity yielding original multimedia works in the UK, North America and Europe. Creating and producing initiatives, the company aims to contribute to the worldwide resurgence of urban expression as a means for change, innovation and beauty. Arts in Education play a major part of Mannafest's agenda. Their multi–faceted approach includes writing, performance, creative expression and personal empowerment. These are tailored to suit a spectrum of outcomes and experiences for individuals, young people, institutions and communities. Clients include: The Architecture Foundation, LEAs, Apples & Snakes, RCA Records, and The Greenwich and Docklands International Festival. In December 2000 Mannafest was pleased to receive a prestigious Breakthrough Award from the Arts Council of England.

Rachel Rosenthal was born in Paris of Russian parents. Rosenthal's family fled Europe during WWII to New York where she graduated from the High School of Music and Art and became a U.S. Citizen. She studied art, theatre and dance in Paris and N.Y. after the war with such teachers as Hans Hoffmann, Merce Cunningham, Erwin Piscator and Jean–Louis Barrault. Rosenthal is an interdisciplinary performer who has developed a revolutionary performance technique that integrates text, movement, voice, choreography, improvisation, inventive costuming, dramatic lighting and wildly imaginative sets into an unforgettable theatre experience. Rosenthal formed the Rachel Rosenthal Company in 1989 in Los Angeles. The thematic emphasis of the Company's work encompasses artistic, social, environmental, technological and spiritual issues presented in a visually, viscerally compelling form. In the last 26 years she has presented over 36 full–scale pieces nationally and internationally. She is an NEA, J. Paul Getty Foundation and California Arts Council Fellow, and recipient of numerous awards, including an Obie for *Rachel's Brain*, the College Art Association Art Award, and the Women's Caucus for the Arts Honor Award for Outstanding Achievement in the Arts. In 1994, she was chosen by Robert Rauschenberg to represent Theatre in his suite of prints, *Tribute 21*, and in 1995 received the Genesis Award for spotlighting animal rights issues in her work and the Association of Performing Arts Presenters Award of Merit in 2001 for achievement in the performing arts.

Ursula Smartt – German born, she has lived in the UK for over 25 years, and is a specialist in European Union, Criminal and Media Law. More recently, she has emerged as one of Britain's leading prison researchers after her first visit to Wormwood Scrubs Prison in London. Her book *Grendon Tales* (2001, Waterside Press) features first–hand interview accounts with some of the most serious offenders in one of Britain's high security jails,

Grendon Prison in Buckinghamshire. Apart from on–going consultancy research to the Home Office, Ursula teaches law and criminal justice at Thames Valley University, West London. She has recently exhibited her extensive prisons and prisoner photography *Images of Incarceration* in London and Germany.

Barry Smith is Director of the Performance Arts Digital Research Unit in the School of Art and Design at The Nottingham Trent University.

Stelarc is an Australian artist who has performed extensively in Japan, Europe and the USA, including new music, dance festivals and experimental theatre. He has used medical instruments, prosthetics, robotics, virtual reality systems and the Internet to explore alternate, intimate and involuntary interfaces with the body. He has performed with a *Third Hand*, a *Virtual Arm*, a *Virtual Body*, a *Stomach Sculpture* and an *Exoskeleton*, (a six–legged walking robot, controlled by arm gestures). Other recent performances include the *Extended Arm* (with an eleven–degree of freedom manipulator) and *Movatar* (a motionprosthesis that allows an avatar to access a body and perform with it in the real world). *Fractal Flesh, Ping Body* and *Parasite* were Internet performances that explored remotely prompted involuntary actuation of the body. In 1995 Stelarc received a three year Fellowship from The Visual Arts and Craft Board, The Australia Council. In 1997 he was appointed Honorary Professor of Art and Robotics at Carnegie Mellon University. He was Artist–In–Residence for Hamburg City in 1998. He is currently Principal Research Fellow in the Performance Arts Digital Research Unit at The Nottingham Trent University, UK. In 2001 he was awarded an honorary Degree of Law by Monash University in Melbourne. His art is represented by the Sherman Galleries in Sydney. Email: stelarc@va.com.au, URL: http://www.stelarc.va.com.au

Julie Tolentino, director, performer, is of Filipino/El Salvadoran decent, originally from San Francisco where she began her formal training in dance, movement, theatre and yoga. She taught and performed as a senior member of David Rousseve's REALITY Dance Theatre Company from 1990–2000. Throughout her career, she maintained working, collaborating and touring with other performers, directors, companies and composers such as Ron Athey, Bob Flannagan, Margarita Guergue and Hahn Rowe, Amy Pivar, Joy Kellman, Abandoned Shores, Ibrahim Quarishi, curious.com, Gran Fury and others. Julie appeared in Red Hot and Blue's *Safe Sex is Hot Sex* , Gran Fury's national bus campaign *Kissing Doesn't Kill*, and Madonna's *SEX* Book. She has performed in various films, including appearances with Barbara Hammer, Tom Kalin and Ella Troyano/Carmelita Tropicana, as well as music videos of Diamanda Galas, Chaka Khan (choreography by Donna Uchizono), Primus and Madonna. She received a Franklin Furnace Performance Artist Grant 1999–2000 and an Arts International Grant in 2000 and is one of the recipients of a 2001 British Artsadmin Artists Bursary award.

Contributors

Zara Waldeback was brought up in Sweden but has lived in the UK for the past 20 years. She is an independent film and video maker and has extensive experience collaborating with performance artists on video work. She has worked as a script reader/editor and set up various writers' and networking groups in Glasgow, Brighton and London. As well as working in film she also teaches web design. She is currently a Senior Lecturer in Video Production at the London College of Music and Media. She is currently researching the potential of interactivity in film and working on a new feature.

Mark Waugh is the Live Arts Officer for the Visual Arts Department of the Arts Council of England. Once described as operating out of the cracks in Brighton's cyberspace, Mark is author of the cult novel, Come, director of media mercenaries Bluncut and was co director of Live Art nights at the Zap club, Die Lieber Rausch and the Transmautions Festival.

Lois Weaver is a co founder and the director of the Split Britches Company, with Peggy Shaw. She was the Artistic Director of Gay Sweatshop, a founding member of Spiderwoman Theatre and co founder of WOW, a lesbian performance space in NYC. Lois won a Village Voice OBIE award for her ensemble performance in Belle Reprive, a co production with Bloolips and Split Britches. Her many, many performance/directing credits include: *Dress Suits to Hire* and *Preaching to the Perverted* with Holly Hughes; *Lust and Comfort* and *Salad of the Bad Café* with Split Britches. Her solo performance, *Faith and Dancing*, was produced at La Mama in May 1997 and has toured the US, the UK and New Zealand. She is currently touring with *Double Agency*, a Split Britches collaboration with The Clod Ensemble. Lois teaches independently in the US and is a Senior Lecturer in Contemporary Performance Practice at Queen Mary, University of London. Routledge press has released a book on the company entitled *Split Britches: Lesbian Practice, Feminist Performance*, edited by Sue Ellen Case, which includes seven Split Britches' plays .

Emma Wilson works as a lighting designer and is currently based in London as Technical Director at Sadler's Wells Theatre. She works predominantly in the fields of live art, performance art and contemporary dance, and currently holds the position of Technical Director and designs for artists La Ribot (Spain) and Gilles Jobin (Switzerland). Aside from designing Emma is also a technical production manager, and has toured internationally in both capacities. She learnt her trade working as a technician in theatres of every size, dabbling in corporate work, and being overworked, underpaid, but very happily involved in festivals all over Europe. She has been fortunate enough to work with some exceptionally talented technicians, designers, artists and performers, to whom she owes a great deal, not least her perennial enjoyment of her career. Her latest project is finding time to get enough sleep.

Martha Wilson, performance artist, is Founding Director of Franklin Furnace Archive, Inc., a museum in lower Manhattan which, since its inception in 1976, has presented and

preserved temporal art: artists' books and other multiples produced internationally after 1960; temporary installations; and performance art. Franklin Furnace now exists entirely as a virtual museum on the Web. Trained in English Literature, Wilson was teaching at Nova Scotia College of Art and Design when she became fascinated by the intersection of text and image. As an artist, she has performed in the guises of Alexander Haig, Nancy Reagan, Barbara Bush and Tipper Gore. Wilson lectures widely on the book as an art form, on performance art, and on 'live art on the Internet.'

James Yarker is artistic director of Stan's Cafe, a theatre company he formed with Graeme Rose on graduating with a degree in Theatre and Independent studies from Lancaster University in 1990. Since then he has directed all the company's work across a range of media and lectured in universities across Britain. In 1998 he completed an MPhil exploring the use of electronic mediation on stage. Information about Stan's Cafe can be found at www.stans.com.

Photo Credits

Andrew Whittuck, Bobby Baker, *How to Shop*, page 4

Johannes Birringer, pages 10, 14, 15

Laurie Beth Clarke, *The Everyday Life of Objects,* pages 18, 20, 21, 24

Toni Dove, *Artificial Changelings*, page 26, 28
Toni Dove, *Spectropia*, page 31

Alan Crumlish, Leslie Hill, *Push the Boat Out*, page 33
Courtesy of Project Arts Center, Leslie Hill, *deserter*, page 35
Frances McMahon Ward, Hill, Paris and Bull, page 37
Courtesy of Project Arts Center, Leslie Hill, *deserter*, page 38

Self Portrait, Hsin–Chien Huang, page 40,
Hsin–Chien Huang, *Hall of Time*, page 41
Hsin–Chien Huang, *Ruin*, page 42

desperate optimists, Gillian Wilde, *map50*, page 44
desperate optimists, *Urban Shots*, page 47
Chris Dorely Brown, desperate optimists, page 49

Contributors

Cleaveland Performance Festival, Thomas Mulready, page 122

Digital Performance Archive, page 131
DPA, Machinal – VR Theatre, page 132
DPA, Wings – VR Theatre, page 133
DPA, ARW Robotics, page 134
DPA, Synfonica – Motion Sensors, page 135

Courtesy of FADO, Stephanie, page 137
Courtesy of FADO, Koren, page 140
Courtesy of FADO, Roddy, page 143
Courtesy of FADO, Sherri, page 144

Yvonne Brooks, Martha Wilson, 'Right Side of my Brain', page 147
Yvonne Brooks, Martha Wilson, 'Left Side of my Brain', page 155

Susan Kozel, Mesh Productions, page 158

New Work Net Work, pages 160, 164

Courtesy of the Project Arts Center, Kathy McArdle, page 165

Courtesy of queerupnorth, Tanja Farman, page 170

Courtesy of Arnolfini, page 190

Courtesy of Manick Govinda, page 196

Courtesy of Leslie Hill, Lois Keidan (also Catherine Ugwu xx,) page 200

Courtesy of Mark Waugh, page 206

Emma Wilson, Lighting/Sound Pictures, pages 213 to 217

Zara Waldeback, page 225
Zara Waldeback, crew, *The Bench*, page 232
Zara Waldeback, cast and crew, *The Pros and Cons of Camouflage*, page 235

Courtesy of Ian Grant, page 236

Courtesy of Chris Lord, page 249

Contributors

Leslie Hill, Frances McMahon Ward, page 257
Leslie Hill, Frances and Madison McMahon Ward, *Brave Bold Girls*, page 260, 261

Tony Nandi, Brenda Edwards Co, page 262,
Tony Nandi, Lewisham College Dancers, page 263
Tony Nandi, Javier de Frutos 264

Courtesy of Charlotte Jones, page 287
Courtesy of ITC, page 289

Ursula Smartt, courtesy of the author, page 290

Dolly 'Flipbook' Morph ©curious.com 2001